JOHN SINGER SARGENT

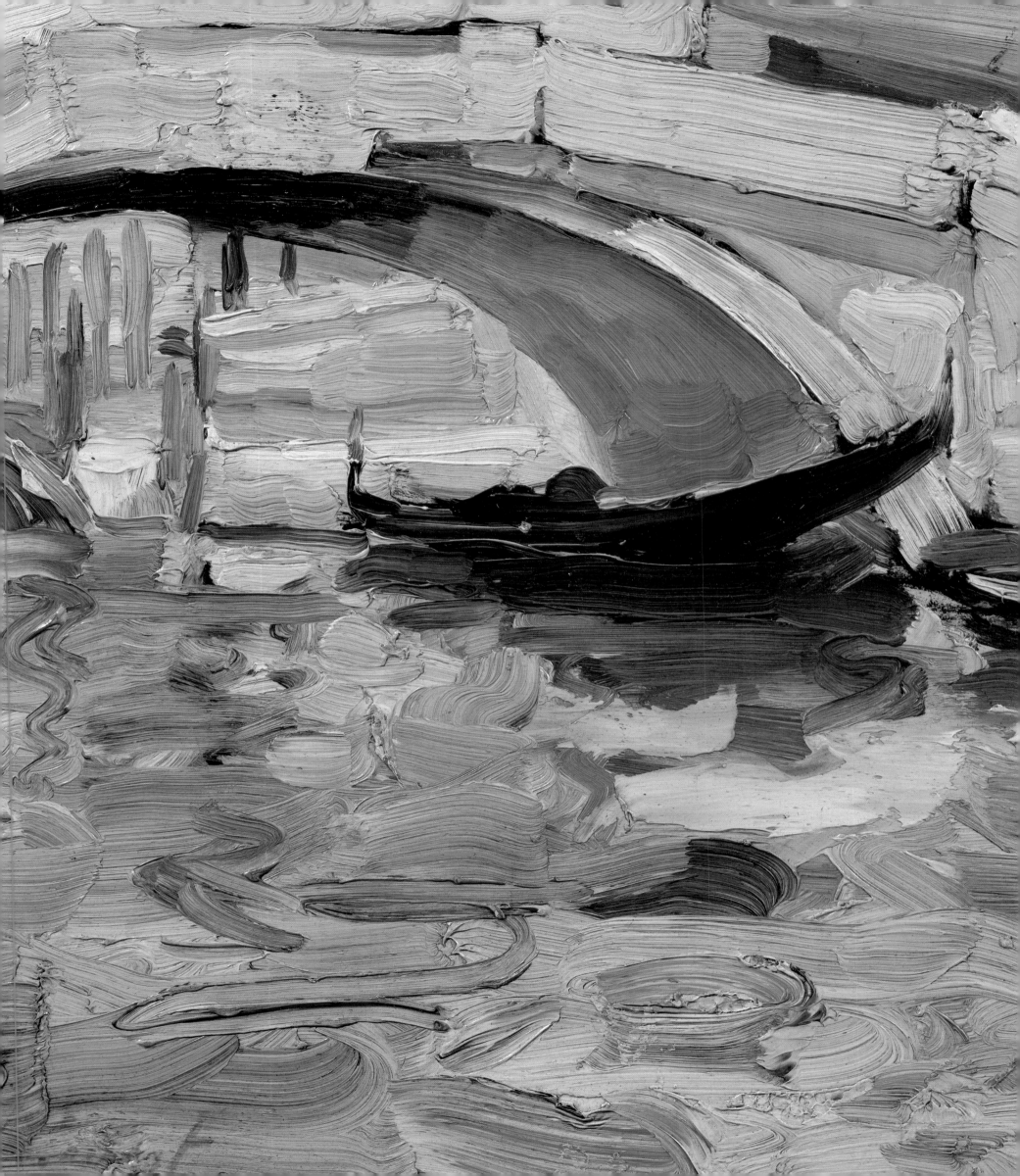

JOHN SINGER SARGENT

BY CARTER RATCLIFF

ARTABRAS

PUBLISHERS NEW YORK

Designer: Howard Morris
Editor: Nancy Grubb
Picture researcher: Christopher Sweet

COVER: *Lady Agnew*, major portion, c. 1892–93. Oil on canvas, 19½ x 39½ inches. National Gallery of Scotland, Edinburgh. See plate 239.

BACK COVER: *The Brook*, c. 1907. Oil on canvas, 21 x 27½ inches. The Ormond Family. See plate 313.

FRONTISPIECE: *Gondolas*, detail, 1899 (1905?). Oil on artist's board mounted on panel, 13¼ x 19⅛ inches. Private Collection. See plate 263.

Library of Congress Cataloging-in-Publication Data

Ratcliff, Carter.
 John Singer Sargent/by Carter Ratcliff

 p. cm.
 Includes bibliographical references and index.
 ISBN 0-89660-014-9
 1. Sargent, John Singer, 1856–1925—Criticism and interpretation. I. Sargent, John Singer, 1856–1925. II. Title.
ND237.S3R3 1990 90-42816
759.13--dc20 CIP

NINTH PRINTING

Contents

JOHN SINGER SARGENT

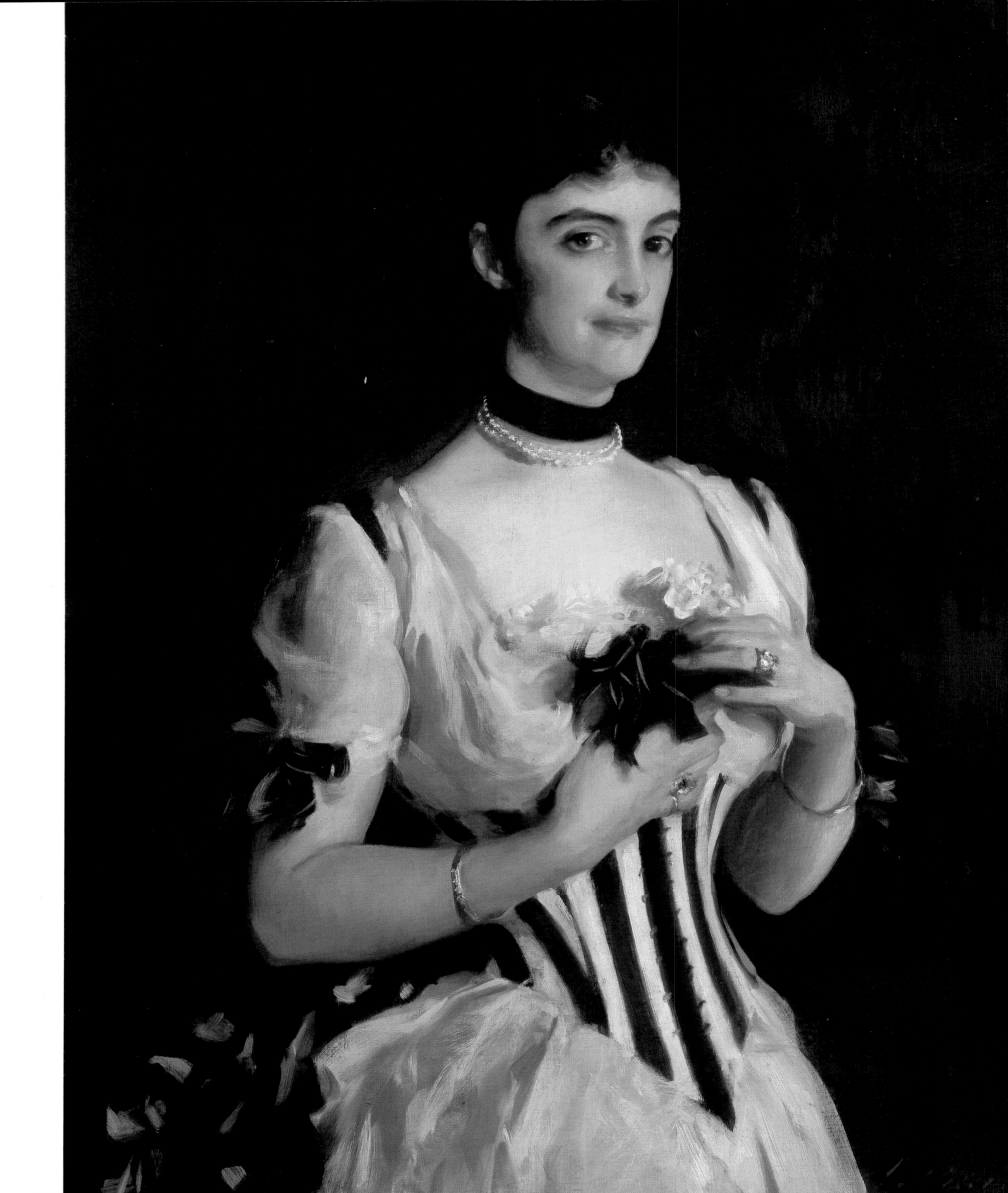

PROLOGUE: *Point of View*

A WORK OF ART, A FLOURISH OF MANNERS, even "the faintest hints of life" could strike Henry James with the force of "revelation." He always stood ready to be impressed, though his standards were so high he was often let down. James was a connoisseur of disappointment, but only reluctantly; when he found reason to hope, he celebrated. Of John Singer Sargent's *Lady with a Rose*, 1882 (plate 90), he wrote: "it offers the slightly 'uncanny' spectacle of a talent which on the very threshold of its career has nothing more to learn. It is not simply precosity in the guise of maturity—a phenomenon we very often meet, which deceives us only for an hour; it is the freshness of youth combined with the artistic experience, really felt and assimilated, of generations. . . ."[1]

James had no difficulty seeking out this new talent, for the world of expatriate Americans was heavily populated but tightly knit. James and Sargent met in Paris, sometime during the early 1880s. In a letter to his friend Grace Norton, James said: "The only Franco-American product of importance here strikes me as young John Sargent the painter, who has high talent, a charming nature, artistic and personal, and is civilized to his finger-tips. He is perhaps spoilable—though I don't think he is spoiled. But I hope not, for I like him extremely; and the best of his work seems to me to have in it something exquisite."[2]

Two years after Sargent's critical triumph at the Salon of 1882 with his *Lady with a Rose*, he sent only one picture to the Salon—his notorious *Madame X* (plate 120). The subject is Virginie Avegno Gautreau, in a haughty pose and a black dress with a deep décolletage. This image was so deeply offensive to Salon-goers that when Sargent left in June for a holiday in England, his Parisian career was in jeopardy.

Sargent had been preceded in London by Henry James, who immediately arranged a series of studio visits. The main stop on their tour was the studio of Edward Burne-Jones, then the leading light of the Pre-Raphaelite Brotherhood. At the opening of the Grosvenor Gallery in 1877 he had been "quite the lion of the occasion," according to James, who ranked him "at the head of the English painters of our day." Now, seven years later, Sargent and James saw Burne-Jones's *King Cophetua and the Beggar Maid* (plate 3), his latest venture into the

1. *Mrs. Wilton Phipps*, c. 1884. Oil on canvas, 35 x 25½ inches. Mr. R. P. Grenfell, London.

2

2. *Resting,* c. 1875. Oil on canvas, 8½ x 10½ inches. Sterling and Francine Clark Art Institute, Williamstown, Massachusetts.

3. Edward Burne-Jones. *King Cophetua and the Beggar Maid,* 1884. Oil on canvas, 115½ x 53½ inches. The Tate Gallery, London.

4. *Self-Portrait,* 1886. Oil on canvas, 12 x 10 inches (oval). Aberdeen Art Gallery and Museums, Scotland.

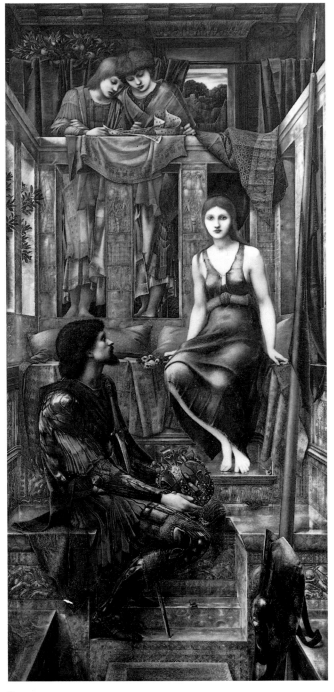

3

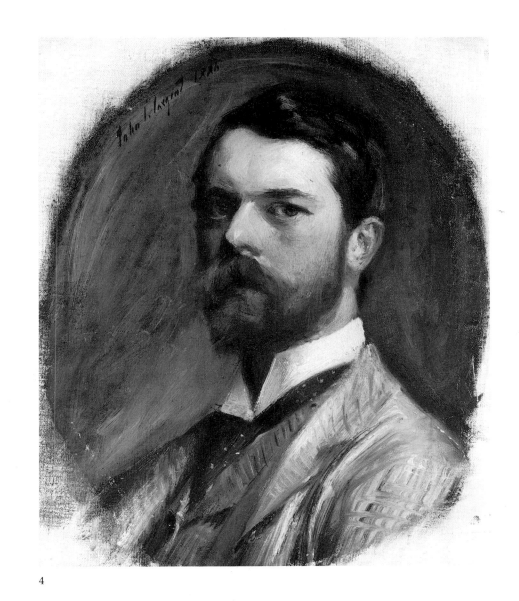

4

grand genre of history painting. Its subject, out of Elizabethan balladry by way of Tennyson, is that of a worldly ruler daunted by a superior spirit. The king has given his throne to the beggar maid, who consents to sit there but will not accept his crown. It was his "finest thing," according to Henry James—"very beautiful and interesting."

Sargent liked it too, though, James continued, "I am afraid poor, dear, lovely, but slightly narrow B.J. suffers from a constitutional incapacity to appreciate Sargent's [paintings]—finding in them 'such a want of finish.'"[3] The younger artist's elliptical manner was anathema to the Pre-Raphaelites, whose obsessive attention to detail inspired John Ruskin to praise them for "rejecting nothing, selecting nothing, and scorning nothing." Ruskin exaggerates, of course—every painter's image results from selection. Yet Burne-Jones, Dante Gabriel Rossetti, and the rest of the Brotherhood did attempt to make their art all inclusive, if only in the implications generated by an intricate machinery of symbols. By contrast, Sargent's style, like his way of life, was an unremitting process of selection and dismissal. He accepted nothing, in art or the world, that failed to please his relentlessly elegant eye. He rejected much. For all his generous appreciation of *King Cophetua and the*

5

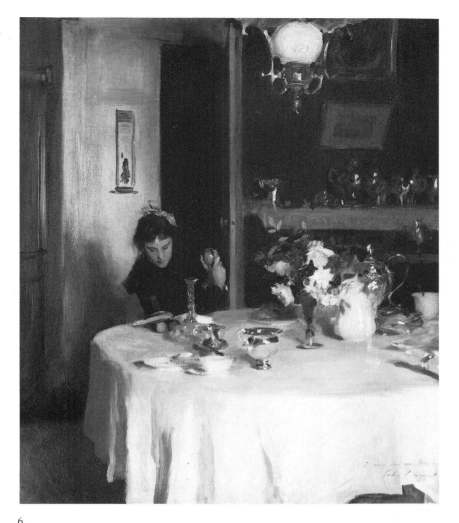

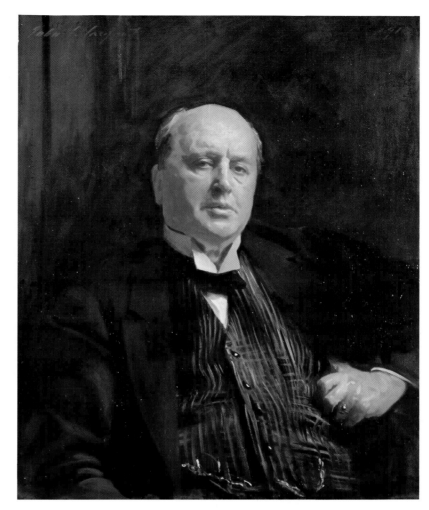

6

7

5. *Le Piano Noir*, c. 1880. Oil on canvas, 12 x 16 inches. Private Collection.

6. *The Breakfast Table*, c. 1883–84. Oil on canvas, 21¾ x 18¼ inches. Fogg Art Museum, Harvard University, Cambridge, Massachusetts. Bequest of Grenville L. Winthrop.

7. *Henry James*, 1913. Oil on canvas, 33½ x 26½ inches. National Portrait Gallery, London.

Beggar Maid, Sargent did not let it affect his own work.

Still, Sargent always got along well with the Pre-Raphaelite "lion," who was at the height of his career when the two met. Burne-Jones had even begun to receive portrait commissions—an odd development, considering that all his subjects, observed or imaginary, have the heavy jaw and lidded eyes of the ideal type he learned from Rossetti. Burne-Jones, for his part, liked Sargent. It wasn't so much an attraction of opposites as a kindly feeling between two cultivated individuals whose aesthetics belonged to incompatible worlds. Their differences were more than a question of meticulous finish versus painterly bravura. Burne-Jones's childhood, by his own testimony, had been a time of ugliness and deprivation. By the time Rossetti initiated him into art he was well into his twenties. Sargent had grown up in Florence, surrounded by artifacts of the Renaissance and encouraged to draw and play the piano by a mother who painted in watercolor herself. Sargent's best landscapes blend immediate observation with gracefully theatrical perspectives, while Burne-Jones's subjects direct the imagination to an otherworldly realm of idealized forms and transcendent symbols. *King Cophetua and the Beggar Maid* poses questions about the social and economic order; Sargent never for a moment doubted the fitness of that order.

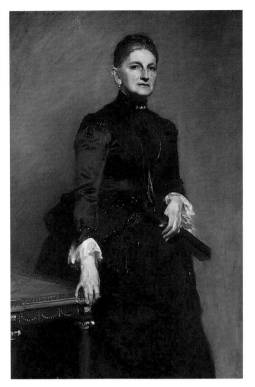

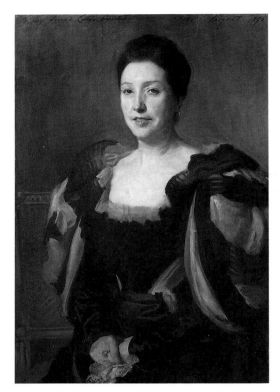

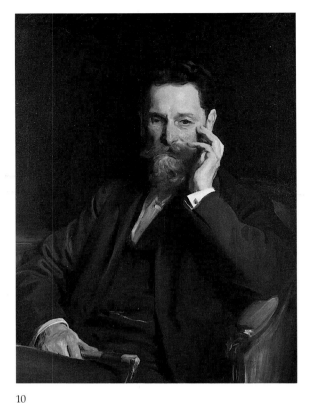

8

9

10

During the late 1870s Burne-Jones took an active part in the pro-democracy, anti-imperialism politics of England's Liberal party. Opposed by Disraeli, the Liberals faded. Burne-Jones withdrew to his studio, yet he always considered his art a higher form of political expression. Sargent was so indifferent to politics that his first thought, on hearing about the outbreak of World War I, was that he and some of his friends, caught behind unfriendly borders, were going to suffer passport difficulties. Sargent's view of the war deepened, of course. When a niece was killed during the shelling of a church, he felt a sadness that may never have left him. In 1918 he volunteered for duty as an official war artist, producing pictures of trenches and ruined French towns that are convincingly grim. Still, Sargent doesn't seem to have felt the horror, the doubt about the very premises of Western civilization, that afflicted Henry James during the war years.

Though he played significant variations on the radical styles of Edouard Manet and Claude Monet, Sargent never stood wholeheartedly with the modernists. Modernism challenges a faith that he always preserved, and that faith reached beyond art to affect his attitudes about society. Though the Sargent family was not rich by the standards of the Victorian plutocracy, his mother and father had enough money between them to maintain a respectable front in their travels through Italy, Switzerland, and France. Raised amid servants, Sargent took no notice of the poor who so disturbed a democrat and idealist like Burne-Jones. When peasants and workers appear in Sargent's art, they belong to the scenery. By the turn of the century, he had found a way to adapt the tradition of Joshua Reynolds to an age of railroad magnates and newspaper tycoons.

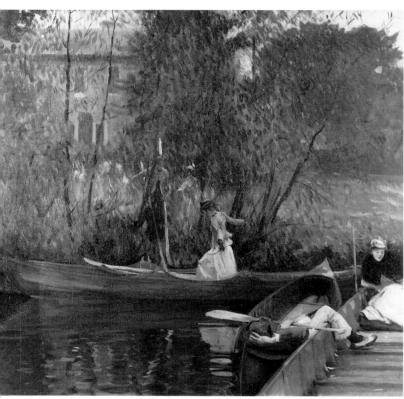

11

8. *Mrs. Adrian Iselin*, 1888. Oil on canvas, 60½ x 36½ inches. National Gallery of Art, Washington, D.C. Gift of Ernest Iselin, 1964.

9. *Mrs. Colin Hunter*, 1896. Oil on canvas, 37½ x 24⅝ inches. The Detroit Institute of Arts. Founders Society Purchase, Laura H. Murphy Fund.

10. *Joseph Pulitzer*, 1905. Oil on canvas, 38½ x 28 inches. Collection of Joseph Pulitzer, Jr.

11. *A Boating Party*, c. 1889. Oil on canvas, 34⅝ x 36⅜ inches. Museum of Art, Rhode Island School of Design, Providence. Gift of Mrs. Houghton P. Metcalf.

Within a decade of Sargent's visit to his studio, Burne-Jones came to realize that his career was slipping. Portrait commissions were fewer, and his large, still fervent scenes from mythology and the Bible were no longer selling. And he knew why—that is, he knew which London painter had replaced him at the apex of the pyramid: John Singer Sargent. Yet up until the time of his death in 1898, Burne-Jones felt kindly toward the younger artist. So, it seems, did everyone who knew him. To be "civilized to his finger-tips" was, in Sargent's case, to be the very image of a likable man.

In the eyes of an immense public, Sargent stood for artistic greatness. By the turn of the century, he had eclipsed every painter in the English-speaking world—including John Everett Millais, Frederick Leighton, and Lawrence Alma-Tadema, all of them knighted, all of them admired, but none so much in demand as Sargent. In 1901 he was asked to paint the coronation portrait of Edward VII. Sargent declined, with the astonishingly modest explanation that his reliance on "nature" left him "particularly unfit for this high task."[4] Six years later the king offered him a knighthood. Sargent declined this honor as well. To have accepted would have meant giving up his American citizenship, and even though Sargent was never tempted to settle in the United States, he held the country in high, patriotic regard. Nonetheless, his deepest allegiance was to that borderless realm of refinement where he and his friend Henry James were leading citizens.

James was orotund and, from time to time, oracular. According to Sargent's friend and biographer, Evan Charteris, the painter was very different. Of their first meeting he reported that Sargent talked "slower and with more difficulty in finding words than anyone I have ever met. When he can't finish a sentence he waves his fingers before his face as a sort of signal for the conversation to go on without him. . . ."[5] As Charteris got to know Sargent better, this first impression changed: "His conversation was never fluent but, like his painting, it could be immensely descriptive. He wasted no words—it may even be doubted if he had any to waste—but those he used were like strokes of his brush, significant and suggestive; indeed, he could convey a weight of meaning by a gesture or a truncated phrase."[6] In company or at his writing desk, James's drawn-out, elusive phrases precipitated meaning at a rate so slow as to be, on occasion, excruciating. Sargent made his points with quick ellipses. On canvas, the wry hesitancies of his verbal style became a flurry of grand and sweeping suggestions about appearance, about character, about the nature of art.

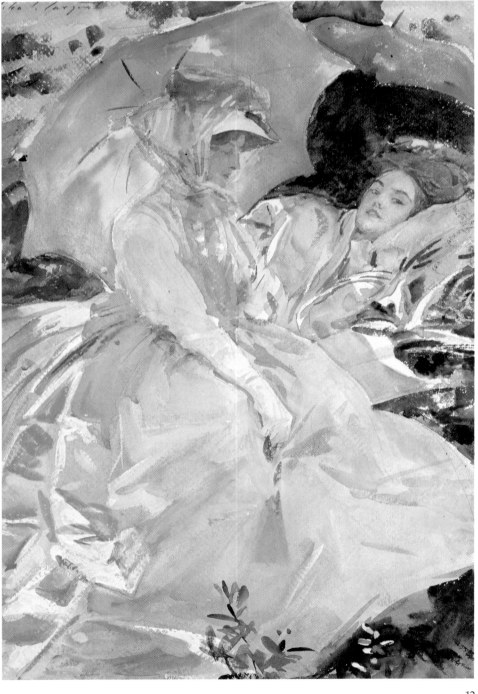

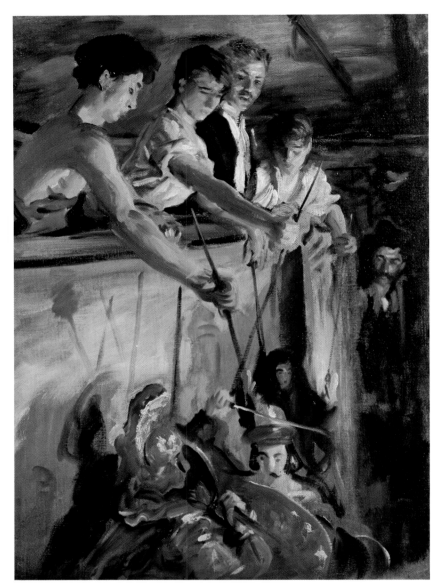

13

12. *Reading*, 1911. Watercolor on paper, 20 x 14 inches. Museum of Fine Arts, Boston. Charles Henry Hayden Fund.

13. *Marionettes*, 1903. Oil on canvas, 28½ x 20½ inches. The Ormond Family.

14. *Pomegranates*, 1908. Watercolor on paper, 21¹⁄₁₆ x 14⅛ inches. The Brooklyn Museum. Special Subscription Fund.

12

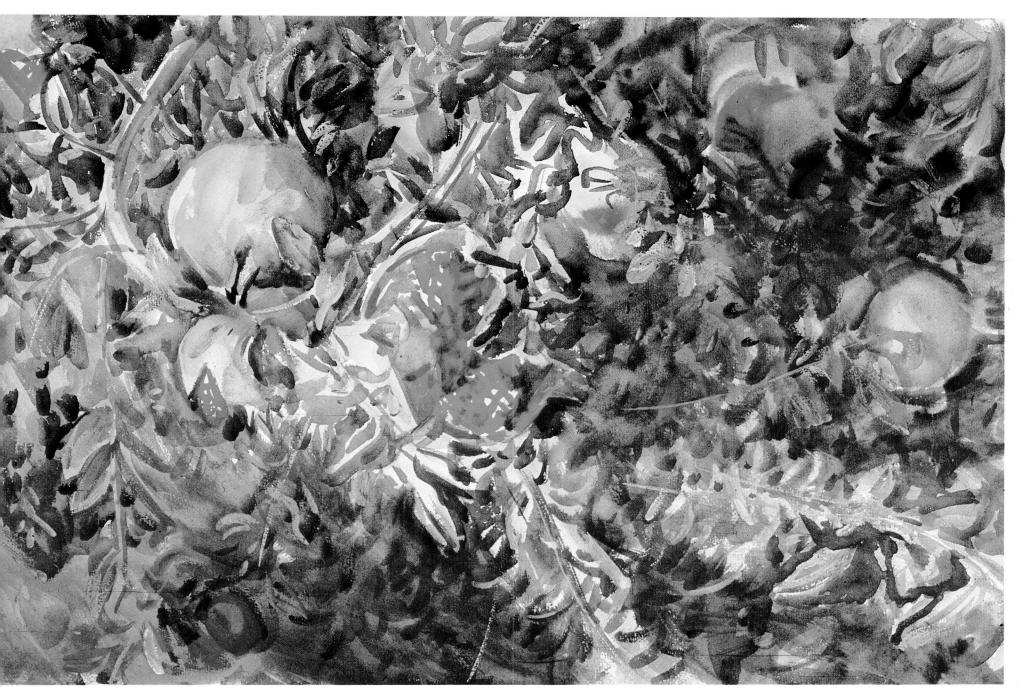

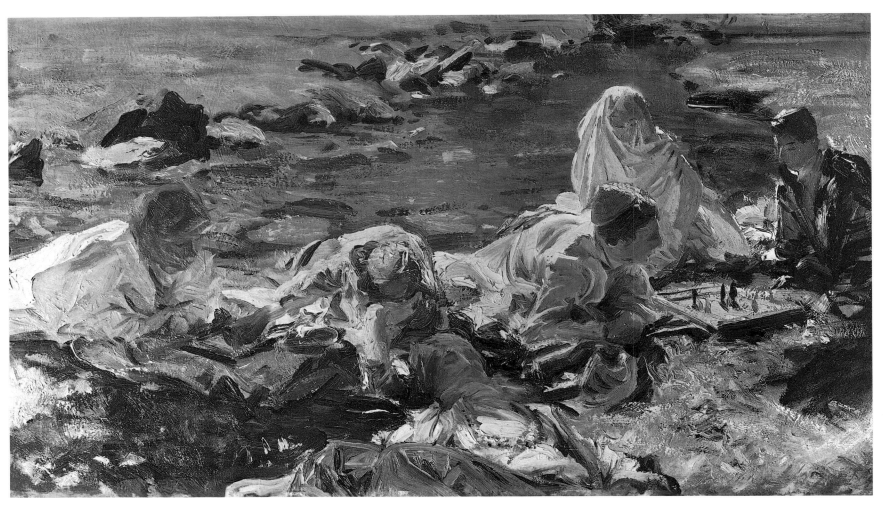

15

15. *Dolce Far Niente*, c. 1908–9. Oil on canvas, 16⁵⁄₁₆ x 28⁵⁄₁₆ inches. The Brooklyn Museum. Bequest of A. Augustus Healy.

16. *In a Medici Villa*, 1907. Watercolor on paper, 21⅛ x 14⅝ inches. The Brooklyn Museum. Special Subscription Fund.

17. *The Sketchers*, 1914. Oil on canvas, 22 x 28 inches. Virginia Museum of Fine Arts, Richmond. The Arthur and Margaret Glasgow Endowment Fund.

At an exhibition of Sargent's work, James is supposed to have said, "In seeing these pictures . . . I feel that I am such a poor painter"[7]—a remark premised on James's belief that novelists and painters pursue the same goal in different mediums. This anecdote may well be apocryphal, yet James had reason to envy the speed and sureness with which his friend's images made their large impact and, at the same time, conveyed the most delicate nuances. Sargent had little to say on these subjects. John C. Van Dyke, a critic and historian, wrote in 1919 that Sargent "is not a poet in paint, nor does he indulge in sentiment, feeling or emotion. He records the fact. If I apprehend him rightly, such theory of art as he possesses is founded in observation. One night in Gibraltar some fifteen years ago I was dining with him at the old Cecil Hotel. We had been on ship for a dozen days and were glad to get on shore. That night, as a very unusual thing, Sargent talked about painting—talked of his own volition. He suggested a theory of art in a single sentence: 'You see things that way (pointing slightly to the left) and I see them this way (pointing slightly to the right).' He seemed to think that would account for the variation or peculiarity of each eye or mind. . . . Such a theory would place him in measured agreement with Henry James, whose definition of art has been quoted many times: 'Art is a point of view, and genius a way of looking at things.' But whether

18

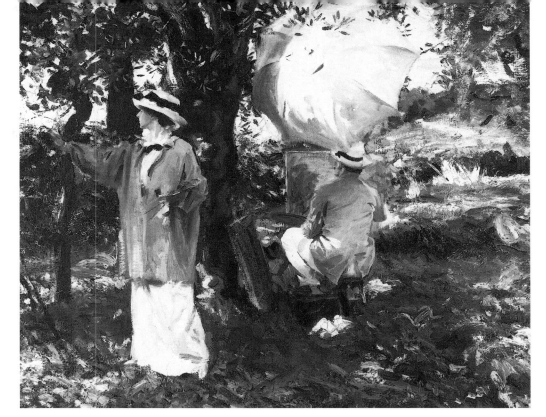

17

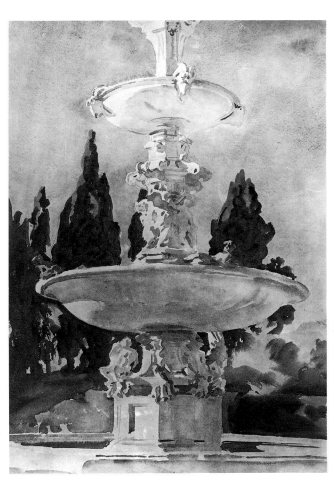

16

Sargent has followed James, or James followed Sargent, in that definition, I am not able to record."[8]

"As the eye, such the object," William Blake had said much earlier. The Romantics believed that the truth of appearances is created by an enlightened vision. This article of aesthetic faith led to the art of such Victorian visionaries as Burne-Jones. The same faith echoes, however faintly, in that one-sentence "theory of art" with which Sargent staked his claim to the particularity of his point of view. Blake wrote his comment in the margin of Joshua Reynolds's *Discourses*, in defiance of the Augustan decorum that required individuality to submit to the generalizations of a grand, Neoclassical manner. Sargent learned from that manner—indeed, he brought it into the twentieth century. In his formal portraits as well as in his ideas about painting there is a clash of Romantic and Neoclassical heritages. The conflict is just as sharp in Henry James's case. In James's novels each self, including his own, must be glimpsed through the ambiguities that the author's vision generates as it goes about the creation of its world. Likewise, Sargent encourages in us the sense that selves are fictions to be refined, perhaps reinvented, by art. Neither James nor Sargent holds out the hope of Blake—and Burne-Jones—that artist and audience can make direct contact with one another. The works of art that draw us together are also barricades that permit intimations and little else to cross from one sensibility to the next. This is an aesthetic of insinuation, and of course the novelist's use of it was very different from the painter's. Meaning in James's prose is subtle to the point of evanescence, while Sargent's large formal portraits came to dominate the annual exhibitions of the Royal Academy with their theatrical flair. Still, even his most spectacular canvases play nuance against the simple notation of fact. For all the luminosity of his style, Sargent never fails to let it be understood that much of the self, his own and the sitter's, remains in shadow.

I. *A Nomadic Sort of Life*

JOHN SINGER SARGENT WAS BORN IN FLORENCE, on January 12, 1856. One of his childhood friends was Violet Paget, an English girl who grew up to be a novelist and aesthetician with the pseudonym Vernon Lee. At the time of Sargent's death, in 1925, she wrote that "the summing up of a would-be biographer must, I think, be: *He painted.*"[9] This cannot be bettered, except to add that Sargent's life of painting led him to half a dozen styles—some intimate, others grandiose. In the 1890s he even tried his hand at sculpture and architectural embellishment. When he tired of formal portraiture, he spent more time at work in the open air. His mother and sisters appear now and then in Sargent's landscape sketches, the delicate treatment of these figures providing much of our evidence that he was close to his family.

There is no Sargent journal. By the standards of his time, he was an infrequent letter writer. He was often reserved with friends, though usually pleasant—"charming and all that,"[10] as James Abbott McNeill Whistler found himself obliged to admit. Some writers hint at love affairs with women.[11] Others claim a "homoerotic" tone for Sargent's drawings of male nudes.[12] It's certain only that he never married—and that he never ceased to paint. During the course of his life, Sargent traveled east to Jerusalem and west to the Rocky Mountains, always in search of subject matter. It was his habit to treat the world as an occasion for art. As Vernon Lee recalled at the time of his death, this habit began very early.

She met Sargent at Nice in the winter of 1866–67. They had turned eleven, and John's sister Emily was nine. The children played in the garden of the Maison Virello, where Dr. and Mrs. Sargent had leased a flat, and in the much larger garden of the nearby Maison Corinaldi. These playgrounds were on the outskirts of the city, a region of palm trees and fig orchards, dwarf rose bushes and empty villas. It was a marshy place, where reed beds ran wild. Lee describes the "gruesome, historical charades" she put on with the Sargent children and other young members of the Anglo-American colony. "Now, in these tragic representations there was always a boy, either decapitating Mary Queen of Scots with the fire shovel, or himself offering a bared neck on a footstool in the character of the Earl of Essex," with the future Vernon Lee herself "figuring as Queen Elizabeth."[13]

18. *A Hotel Room*, after 1900. Oil on canvas mounted on panel, 24 x 17½ inches. The Ormond Family.

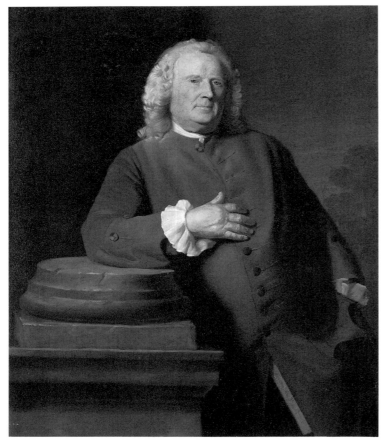

19

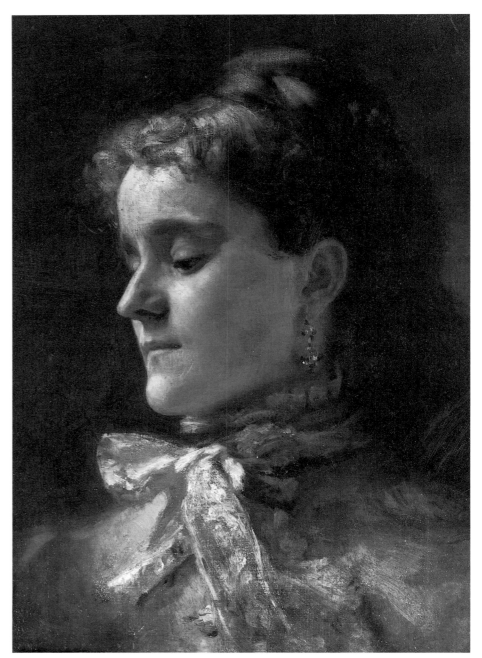

20

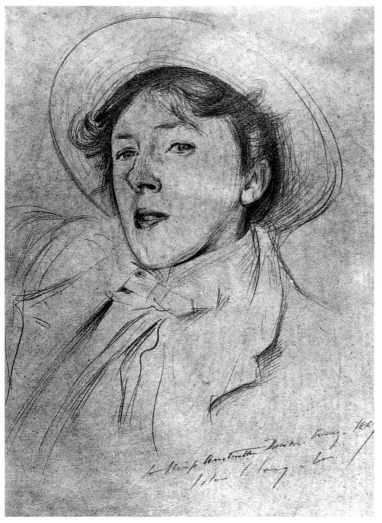

21

19. John Singleton Copley. *Epes Sargent*, c. 1760. Oil on canvas, 49⅞ x 40 inches. National Gallery of Art, Washington, D.C. Gift of the Avalon Foundation.

20. *Emily Sargent*, c. 1875. Oil on panel, 12¼ x 9 inches. The Ormond Family.

21. *Vernon Lee*, 1889. Pencil on paper, 13¼ x 9 inches. Ashmolean Museum, Oxford.

22. *Violet Sargent*, c. 1884. Pencil and watercolor on paper, 17¾ x 8⅝ inches. The Ormond Family.

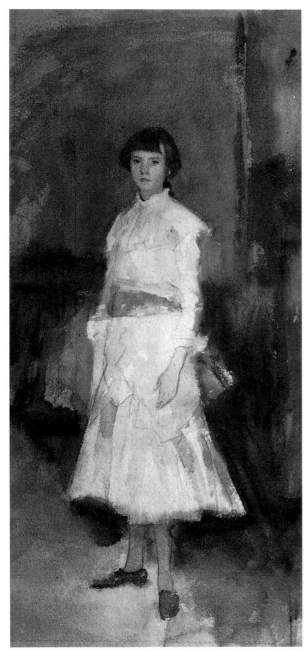

22

The following winter, with her family ensconced in a house over-looking the Promenade des Anglais and the sea, she no longer lived next door to John and Emily Sargent. But "dear, eloquent, rubicund, exuberant Mrs. Sargent," as Lee calls her, saw to it that the three children spent frequent afternoons together—"Afternoons, moreover *spent in painting*." The italics are hers, for she wishes to emphasize in her memorial sketch how early John had turned to art. Lee says she can't remember "whether at that time John Sargent yet possessed a paint-box of his own. He certainly used mine." By her own account, Vernon could only make "pictographs," primitive signs of a storytelling kind, while Sargent, "with miraculous intuition and dexterity," made pictures of ships at sea and houses. He was attracted to what he could see, in the world or in illustrated magazines, not to those fantastic things that children find when they follow their own narrative instincts. Sargent's imagination worked best in the immediate present.

Lee says, "I feel sure that my perennial supplies of water-colours and porcelain palettes and albums of vario-tinted paper were what drew him to me; and that our fraternal friendship grew out of these afternoons of *painting together*." She is being too modest here. Sargent cared deeply about her all his life, and from their days in Nice onward, they kept up a discussion of music and art. Later, they agreed on the importance of Henry James. Though Lee's mocking tone sometimes hid the fact, she and Sargent were acutely sympathetic to one another. They had, after all, shared an expatriate childhood. Born to English parents, she had lived in Germany until she was six; Sargent didn't see America until he was twenty. Both John and Vernon knew the oddness of growing up speaking English on the continent of Europe. So they learned other languages, which became as natural to them as their own. This raised a question—what *was* their own, linguistically, culturally, socially?

At eleven Sargent was fluent in French and Italian. He could get by in German, thanks to a nurse who had looked after him when he was very young. His patriotic feelings had their roots in vague notions about his forebears in New England and Pennsylvania. As an adult, Sargent felt his rootlessness much more sharply, so he planted himself deep in art. According to Evan Charteris, a sense of "national allegiance" prompted him to sacrifice private commissions for the sake of public—and poorly paid—projects in Boston,[14] yet his imagination's homeland was that cosmopolitan world of culture and elevated fashion to which so many American expatriates aspired in the nineteenth century. Among his

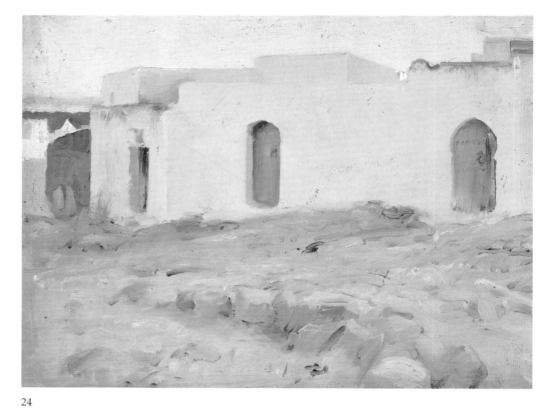

24

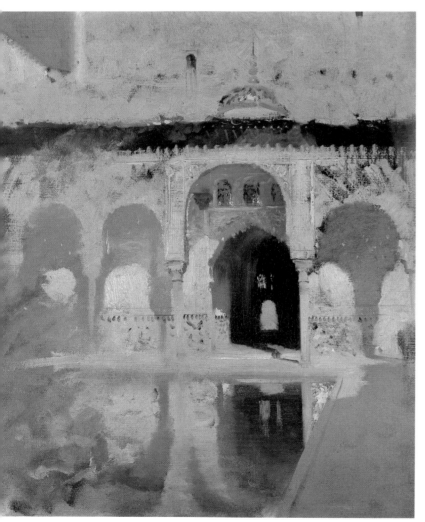

23

fellow citizens there were Henry James, Mary Cassatt, Lady Playfair (the American-born wife of Sir Lyon Playfair), and a pantheon of others —including, by the 1890s, Sargent himself. Yet he never seems to have shaken a sense that there was something peculiar about having a father who spoke with a New England twang, while his own accent was nearly always taken for British. How odd it was for an American boy to grow up playing the Earl of Essex in a wintry garden in Nice. How odd that one's family moved so often, but never to the place it called home.

The daughter of a prosperous Philadelphia merchant, Mary Newbold Singer had traveled in Italy when she was young. Back in Europe as the wife of FitzWilliam Sargent, a successful doctor with a distinguished Yankee background, she took up sightseeing and museum-going where she had left off years before. And whenever the family's wanderings permitted, she established a "day" on which to receive visitors. In Rome for the winter of 1868–69, she gave receptions that attracted Harriet Hosmer, Randolph Rogers, William Wetmore Story, and other artists from the city's American contingent. Dr. Sargent wrote on one occasion that he and his wife had "no superfluity of means." And yet that season, Lee remembered, the Sargents employed "a white-capped *chef* and gave dinner-parties with ices." The children were provided with piano teachers and sent to dancing class. Mrs. Sargent guided them through museums from the Vatican to Venice. When John was thirteen, the family visited Pompeii. "It is very interesting," he wrote to a friend from Nice, Ben del Castillo, "and you see the houses of Glaucus and the heroes of Bulwer's 'Last Days of Pompeii.' . . . In the house of Diomed you see the cellar where Julia and his daughter and a lot of women were suffocated, and we saw the oven where 81 loaves of bread

25

26

27

23. *Court of Myrtles in the Alhambra*, 1879. Oil on canvas, 20½ x 17 inches. The Ormond Family.

24. *Moorish Buildings on a Cloudy Day*, 1879–80. Oil on wood, 10¼ x 13¾ inches. The Metropolitan Museum of Art, New York. Gift of Mrs. Francis Ormond, 1950.

25. *The Artist's Mother Aboard Ship*, 1876. Oil on canvas, 11 x 7¾ inches. Courtesy of Coe Kerr Gallery, New York.

26. *Mrs. FitzWilliam Sargent (Mary Newbold Singer)*, 1887. Oil on canvas, 16¾ x 13¾ inches. Sargent-Murray-Gilman-Hough House Association, Gloucester, Massachusetts.

27. *Dr. FitzWilliam Sargent*, 1886. Oil on canvas, 14½ x 13½ inches. Sargent-Murray-Gilman-Hough House Association, Gloucester, Massachusetts.

28

were found, which have been taken to the museum, they are cooked enough by this time. . . ."[15] Sargent's early letters are clear-headed and factual, with a few—a very few—touches of humor and even fewer errors of punctuation.

Dr. FitzWilliam Sargent was successful at his Philadelphia practice, yet he was willing to give it up for a life of leisurely refinement in Europe. The income from his wife's inheritance, added to the dividends from investments he had made, was enough to stave off serious financial difficulties. With that point settled, Dr. and Mrs. Sargent sailed for Europe. It was 1854, two years before John's birth. Though his father never again worked for a living, he struggled until his death in 1889 to sustain his heritage of New England propriety.

29

In her memorial to the son, Vernon Lee recalled that "Dr. Sargent could not have been so very tall, but his head seemed higher up than other people's, and his thin back (I see him clad in sober pepper and salt) longer and stiffer." It was he, she thought, who banned novel reading on Sunday, though he was not absolutely rigid in matters of religion. When John was seven or eight years old, Dr. Sargent wrote to his own parents in America: "The boy is very well; I can't say he is very fond of reading. Although he reads pretty well, he is more fond of play than of books. And herein, I must say, I think he shows good sense. . . . I think his muscles and bones are of more consequence to him, at his age, than his brains; I daresay the latter will take care of themselves."[16] The father goes on to describe his son's eye for natural fact, which has been encouraged by a steady supply of books of "natural history." The children are also given "nice little books of Bible stories, so that they are pretty well posted-up in their theology. I have not taught them the Catechism, as someone told me I should. . . . Emily and Johnny, I believe, can give the substance of everything in the Catechism important for them to know, as yet . . . I confess (and I hope you will not be hurt) that I am not able myself to give the exact replies to the questions of the Catechism. To me it is the dreariest of all books."[17] Throughout this letter to his parents, Dr. Sargent advances with extreme tact a notion that would have been anathema to his Puritan forebears—that of treating religion as a matter of feeling, not strict observance of form. For him the forms that demanded respect were those of decent behavior and, perhaps, of music, literature, and art.

Mrs. Sargent, "always painting, painting, painting," was the one who insisted on the importance of aesthetic matters. It was her need to see the architecture of Pompeii and the Roman Forum, to hear the opera at Nice, to visit the picture galleries and sculpture gardens of southern Europe that kept the family on the move. And it was her desire for the upper reaches of art and culture that led her and her husband to Europe after only four years of married life in Philadelphia. Later in his life, John Sargent contributed to a genealogy that two of his cousins were compiling. About his mother he wrote, "She is believed to have been the dominant force in the family and to have obtained everything she really wanted." His father, who spent much of his time in Nice in the company of officers from the American fleet, wanted John to serve as an officer in the United States Navy. By the time he had turned thirteen, it was clear—at least to his mother—that John would be an artist. His mother got her way.

28. *A Venetian Interior*, 1882. Oil on canvas, 19¹⁄₁₆ x 23¹⁵⁄₁₆ inches. Sterling and Francine Clark Art Institute, Williamstown, Massachusetts.

29. *Santa Maria della Salute*, 1904. Watercolor on paper, 18⅛ x 23 inches. The Brooklyn Museum. Special Subscription Fund.

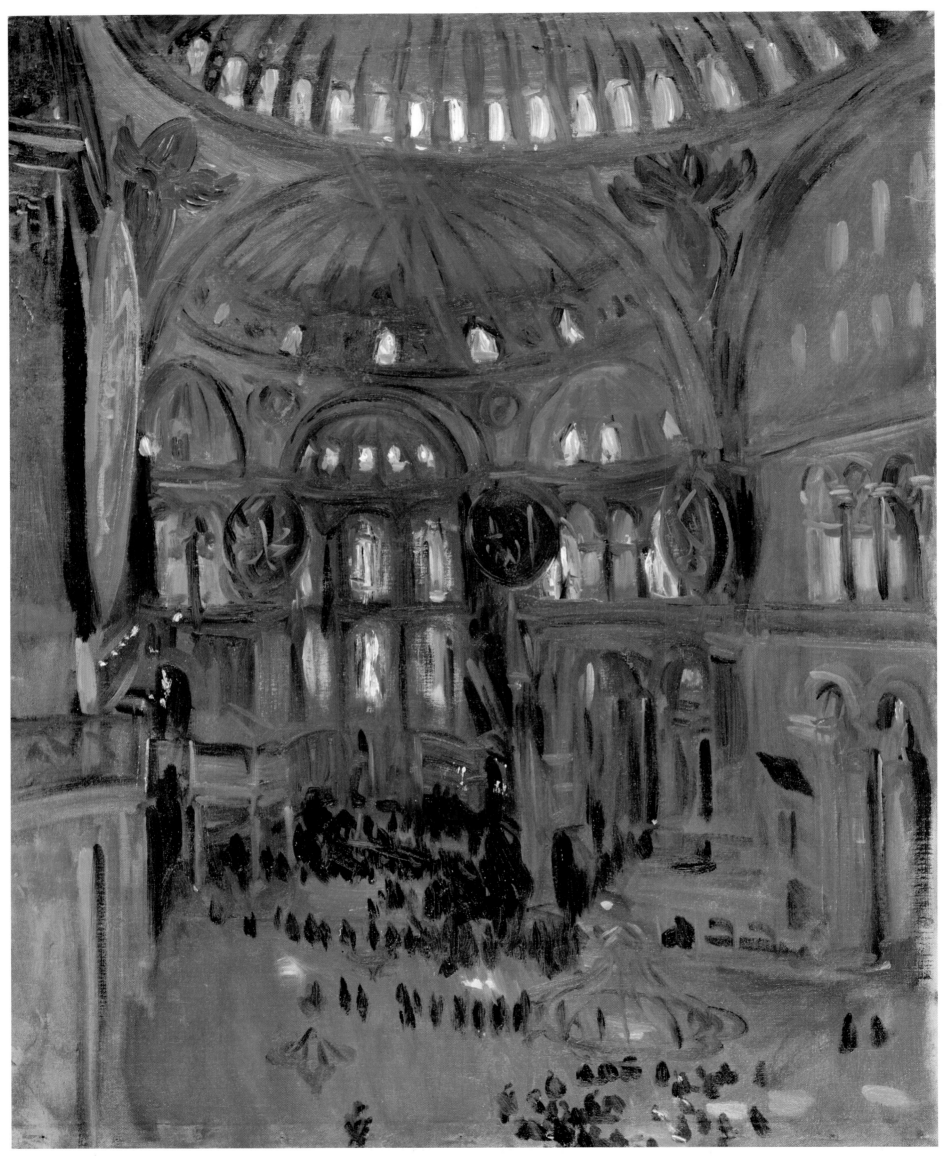

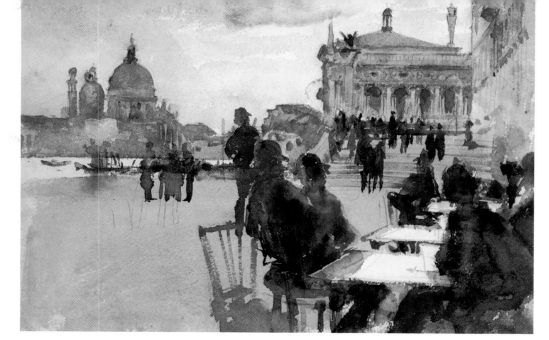

32

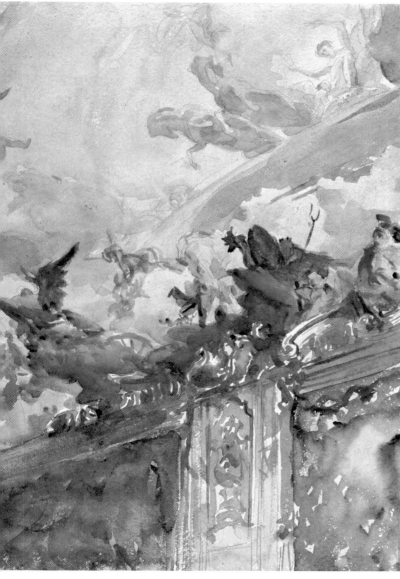

31

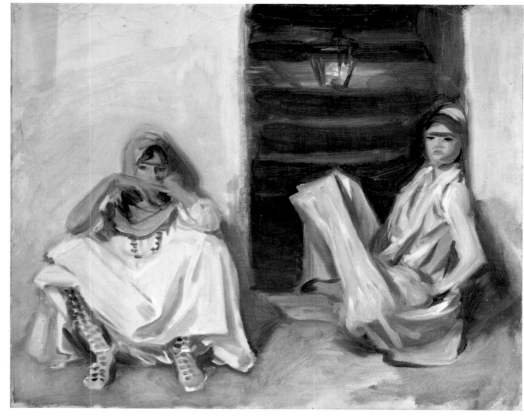

33

30. *Sketch of Santa Sophia*, 1891. Oil on canvas, 31½ x 24¼ inches. The Metropolitan Museum of Art, New York. Gift of Mrs. Francis Ormond, 1950.

31. *Tiepolo Ceiling, Milan*, c. 1904. Watercolor on paper, 14 x 10 inches. The Metropolitan Museum of Art, New York. Gift of Mrs. Francis Ormond, 1950.

32. *Cafe on the Riva degli Schiavone, Venice*, 1880. Watercolor and pencil on paper, 9½ x 13½ inches. The Ormond Family.

33. *Two Arab Women*, c. 1905. Oil on canvas, 21 x 25¼ inches. The Metropolitan Museum of Art, New York. Gift of Mrs. Francis Ormond, 1950.

In earlier generations the Sargent men had tended to have things their way. In the late seventeenth century William Sargent came from England to Massachusetts. His third son, Epes Sargent, was a ship captain, and prominent enough to have his picture painted by John Singleton Copley (plate 19). Among his descendants was Henry Sargent, who traveled to London to study with the renowned American-born history painter, Benjamin West. Back in America by 1799, Henry painted portraits and genre scenes, entered politics, served in the militia, and left the faintest of traces as an early nineteenth-century inventor. The Sargents sent a major to the War of Independence and a general to

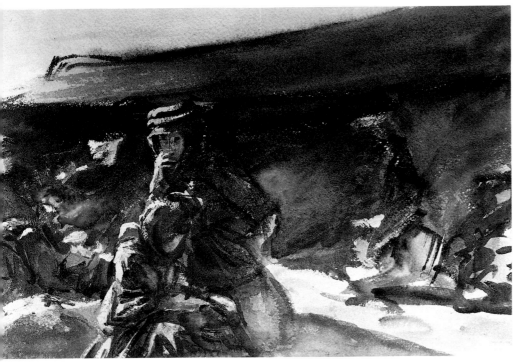

the Civil War. Chiefly, though, they sailed ships. John Singer Sargent's father was descended from men of action, he had made a success of his medical practice, and now there was little for him to do in the course of a day. No wonder the presence of the American fleet in Nice was of such importance to him. He liked the atmosphere of service, even if he didn't contribute to it. His wife was the family's executive spirit. Their son, too, managed things well.

John knew very early how he wanted to spend his life, and Dr. Sargent decided not to stand in his way—nor in Mrs. Sargent's, for that matter. Vernon Lee claims that the father saw God's work in the son's obvious talent, and thus felt obliged to be cooperative. The family spent the winter of 1869–70 in Florence, where Violet, John's youngest sister, was born. He enrolled at the city's Accademia delle Belle Arti, and promptly won that year's prize for excellence. During the summer he toured the Tyrol with the German-American artist Carl Welsch, a member of Mrs. Sargent's Roman circle. They sketched when the light was good and when it failed, they fished.

His family traveled, too, as they did every summer. The year before, Dr. Sargent had written: "I am tired of this nomadic sort of life: — the Spring comes, and we strike our tents and migrate for the summer: the Autumn returns and we must again pack up our duds and be off to some milder region in which Emily and Mary can thrive. I wish there were some prospect of our going home and settling down among our own people and taking permanent root."[18] Biographers have heard an echo here of Henry James's "The Pupil," a short story about the Moreens, a family of Americans who wander through Italy and France, trying to keep up appearances and not always succeeding.

James's Moreens "overflowed with music and song, were always humming and catching each other up, and had a sort of professional

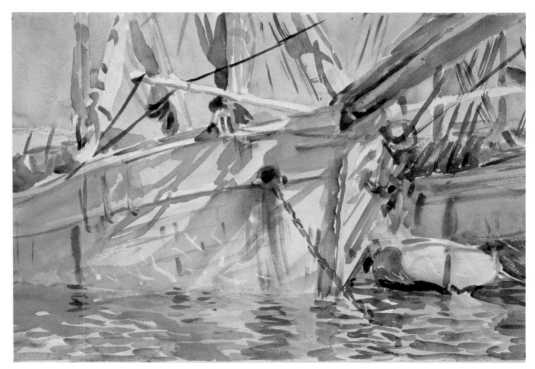

36

acquaintance with Continental cities. They talked of 'good places' as if they had been pickpockets or strolling players. They had at Nice a villa, a carriage, a piano and a banjo, and they went to official parties. They were a perfect calendar of the 'days' of their friends. . . ."[19] Mrs. Moreen cannot be imagined "painting, painting, painting away, always an open paint-box in front of her," as Vernon Lee remembers Mrs. Sargent. Mr. Moreen is an utterly hollow "man of the world," with none of the compunctions that had led Dr. Sargent to publish an anti-slavery tract during the Civil War. If indeed James's Moreens are the Sargents in disguise, the transformation is a cruel one. Yet it is tempting to hear an echo of the young John Sargent's voice in this outburst from "the pupil" himself, Morgan Moreen, on the subject of his family: "Are they rich, are they poor, or have they a *modeste aisance*? Why are they always chiveying me about, living one year like ambassadors and the next like paupers? Who are they, anyway, and what are they? . . . They're so beastly worldly . . . all they care about is to make an appearance, and to pass for something or other. . . ."[20]

Directed at the Sargents, the first question is fairly easy to answer. They were neither rich nor poor, but well-to-do. Sometimes they chose a flat for its attractive price, but there was never a need to scrape or scant, only to be prudent. As for who and what the Sargents were—it's clear that they were not the "Bohemians" and "adventurers" of James's story. Mrs. Sargent was a determined yet always genteel seeker after the light of European refinement. Her husband joined in the search out of devotion to her, if not always with ready enthusiasm. In their time, such Americans were numerous enough to have formed colonies in London, Paris, and the major cities of Italy.

According to Sargent's friend and biographer, Evan Charteris, the seventeenth-century migration from Europe to America had been re-

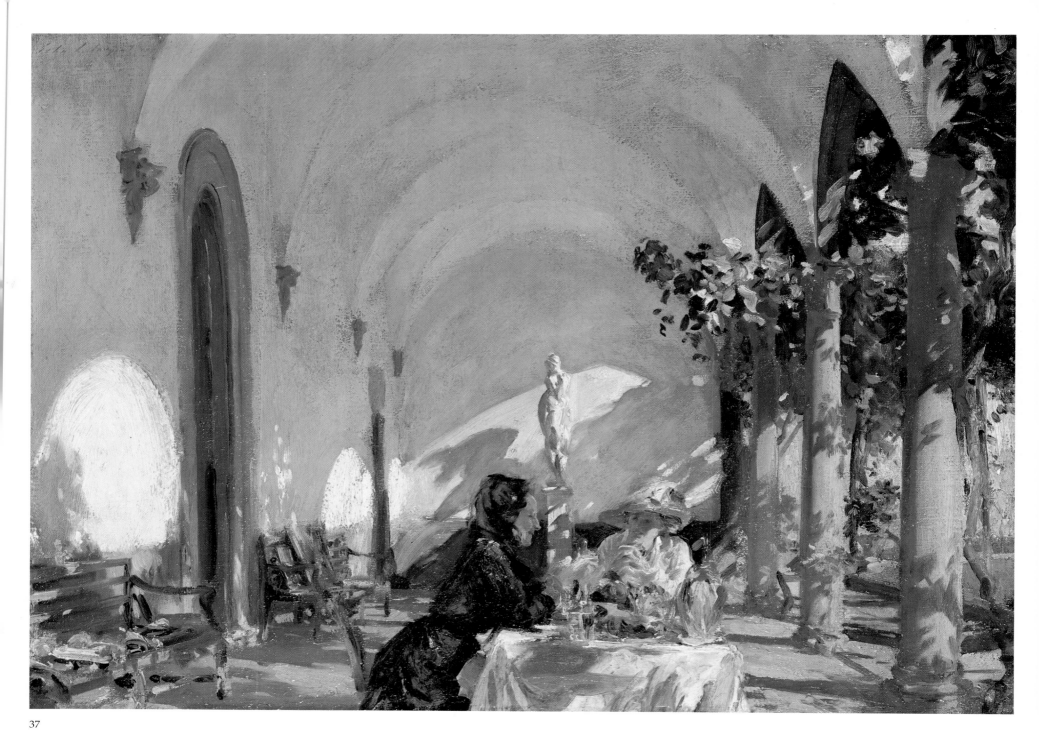

37

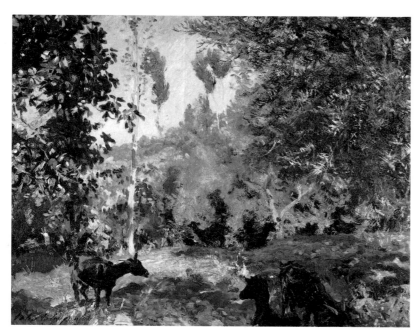

38

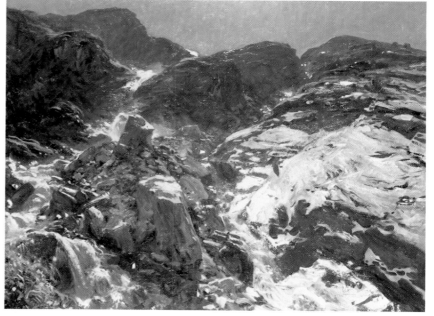

39

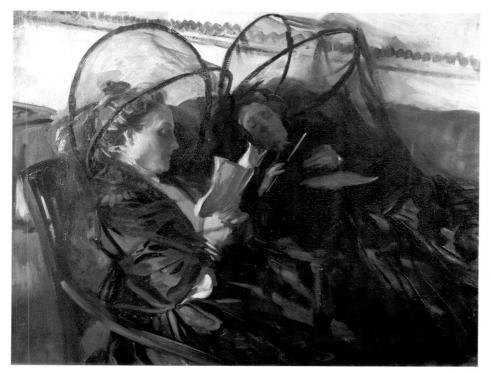

40

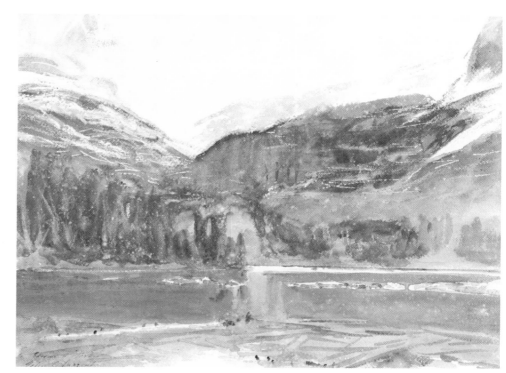

41

37. *Breakfast in the Loggia*, 1910. Oil on canvas, 20½ x 28 inches. Freer Gallery of Art, Smithsonian Institution, Washington, D.C.

38. *Landscape with Goats*, c. 1909. Oil on canvas, 22 x 28 inches. Freer Gallery of Art, Smithsonian Institution, Washington, D.C.

39. *Glacier Streams, The Simplon*, c. 1910. Oil on canvas, 34⅝ x 44¾ inches. Museum of Fine Arts, Springfield, Massachusetts. The Horace P. Wright Collection.

40. *Mosquito Nets*, 1908. Oil on canvas, 22¼ x 28¼ inches. The Ormond Family.

41. *Lake O'Hara*, 1916. Watercolor on paper, 15¼ x 20½ inches. Fogg Art Museum, Harvard University, Cambridge, Massachusetts. Gift of Edward W. Forbes.

versed by the mid-1800s, so that it was "as an already recognized type of pilgrim that the Sargent family arrived in the old world."[21] None of Charteris's comments on this subject take into account those large historical patterns that brought wave after wave of European immigrants to America from the 1840s well into this century. His view seems astonishingly narrow, until one notes his background. Charteris was the sixth son of the tenth Earl of Wemyss, and he saw history as the province of the sort of people he would be likely to know. It tells us something about the Sargents that they succeeded so well in qualifying for a place in Charteris's view of the world. This descendant of a noble house didn't merely approve of Sargent's paintings; he thought highly of the artist himself and of his antecedents as well. The Sargents were American but not provincial. They had no claim to high birth, yet they were irreproachably proper. Above all, they could be counted on to understand the means by which the status quo was maintained. Given the Sargents' relatively modest fortune and their indifference to European politics, Charteris's approval went first to their command of social form, then to the family's yearning for high culture.

Sargent's art owed much to an idea—originally his mother's—that the spirit can will into existence all the fineness it requires. Talent counts for much, but effort counts for more. By relentless force of personality, Mrs. Sargent made her life harmonious, then saw her achievement mirrored and multiplied by the refinements of her son's formal portraiture. For Sargent not only accepted the status quo of the world he shared with Evan Charteris, he provided images that were crucial to that world's good opinion of itself.

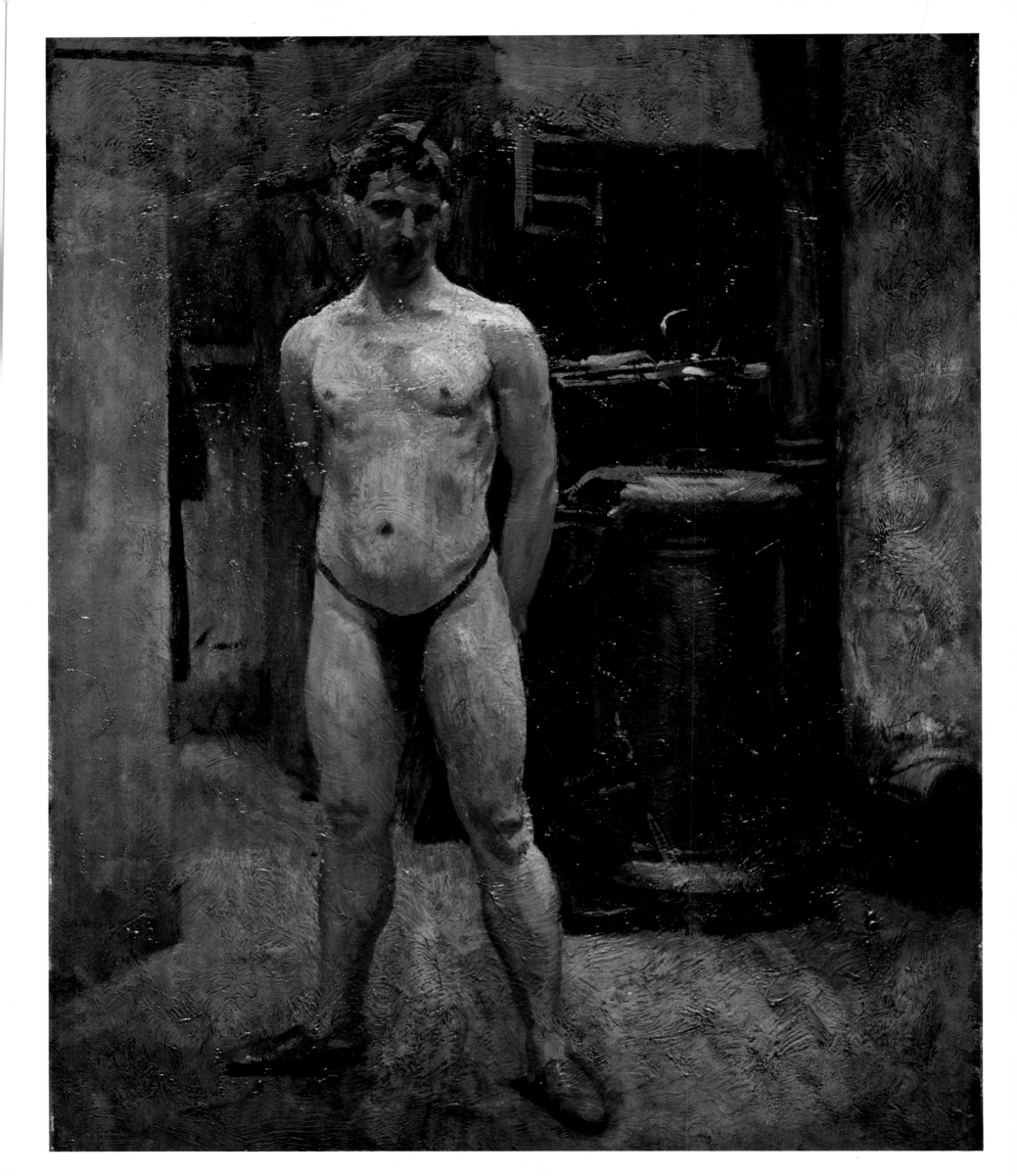

II. *A Student in Paris*

ON APRIL 25, 1874, JOHN SARGENT WROTE TO MRS. AUSTIN, a cousin living in Dresden. He thanks her for the photographs of art works she had sent him, then gives the family's itinerary for the coming months. The Sargents had planned to depart for Venice the first week of May, but John has badly sprained his ankle, so he's not sure when they will leave. And there are reports of Venetian cholera. The proposed destination is now Paris, with its "unique artistic training."

> . . . we are bound for the latter place where we hope we may perhaps meet you. The Academy in Paris is probably better than the one here and we hear that the French artists, undoubtedly the best now-a-days, are willing to take pupils in their studios. I do not think however that I am sufficiently advanced to enter a studio now, and I will probably have to study another year at the Academy in Florence. . . . This unhappy Accademia delle Belle Arti in Florence is the most unsatisfactory institution imaginable, human ingenuity has never contrived anything so unsatisfactory. It was closed for two months from Christmas to March while the Professors and the Minister of Public Instruction deliberated a thorough reform in its organisation. . . . However, this has been of no more consequence to me since my sprained ankle keeps me home where I have a very handsome Neapolitan model to draw and paint, who plays on the Zampogna and tamburino and dances tarantellas for us when he is tired of sitting. I hope Mary perseveres in the Fine Arts and compells her model to dance when he is tired.
>
> I am,
> Yr. affectionate cousin,
> John S. Sargent.[22]

After a stay in Venice, the Sargents left for Paris, arriving in May 1874. Dr. and Mrs. Sargent had been warned about that dissolute art center—morally and socially, London was much safer for a young man. This argument weighed heavily in the Sargents' balance, an instrument constructed along lines as Puritan as they were genteel. Nonetheless, they wanted their son to have the best instruction. So the family traveled to Paris, settled into a hotel, and Dr. Sargent set off with John for the atelier of Emile Carolus-Duran.

42. *A Male Model Standing before a Stove,* c. late 1870s. Oil on canvas, 28 x 22 inches. The Metropolitan Museum of Art, New York. Gift of Mrs. Francis Ormond, 1950.

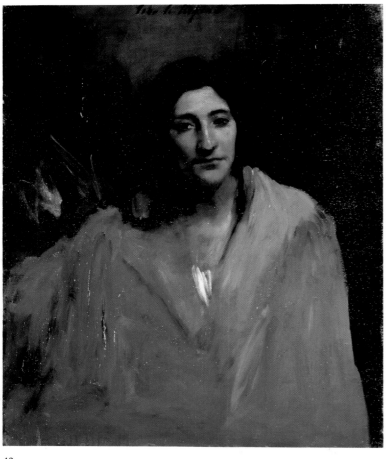

43

44

When he knocked on the door of that establishment, two flights up in the depths of the Latin Quarter, it was opened by a young painter. This personage enquired, very softly, what "the gray-haired gentleman" wanted. To meet Carolus-Duran, was the answer. "Le patron" was busy examining his students' work. The gentleman would have to wait. And the whispering would have to continue, for Carolus-Duran permitted no distractions during his critiques. In the course of this conversation Dr. Sargent realized that he was talking to a countryman. They switched from French to English. The young student was Carroll Beckwith, a Missourian who went on to a career as a portrait painter in New York. Later, he remembered the eighteen-year-old John Sargent as a "tall, rather lank youth with a portfolio under his arm."[23] Hamilton Minchin, an Englishman who entered Carolus-Duran's studio in 1878, described Sargent a bit differently—"a tall, burly and genial young American."[24] Perhaps Sargent had fleshed out between his eighteenth and his twenty-second year, or perhaps Minchin recalled not the young but the middle-aged Sargent, who was burly at the very least.

Lank or not, Sargent had no opportunity to be genial or otherwise on his first day at Carolus's atelier. The presence of the master made the occasion far too formal. His students rose when Carolus entered the studio, which he did only on a regular schedule—Tuesdays and Fridays of every week. He would examine each student's work in turn, never deigning to look at the student himself. When the time came, he would hold out his hand, leaving his eyes fastened on the object under inspection. This was the signal for a brush or a stick of charcoal to appear. A novice once misunderstood the ritual. Thinking Carolus-Duran had extended his hand to offer congratulations, the student seized it warmly. Le patron's response to this gaffe is not recorded. It must have been some nuance of dandified horror—but a silent nuance, for Carolus-Duran hardly ever spoke to his students. His criticisms took the form of corrections made directly on their canvases and drawings, as the class followed him from easel to easel to watch them being made. No one rebelled against these peremptory marks—at least not openly.

Having set his students right, Carolus-Duran would disappear until his next visit. Like other masters of the period, he accepted no fee. Carolus-Duran did his students the honor of teaching them, and they did him the honor of learning. On the day of Dr. and John Sargent's visit, Carolus stopped on his way out to examine the young man's portfolio. According to Carroll Beckwith, the master looked impressed. His verdict was that Sargent's work gave evidence of "much to un-

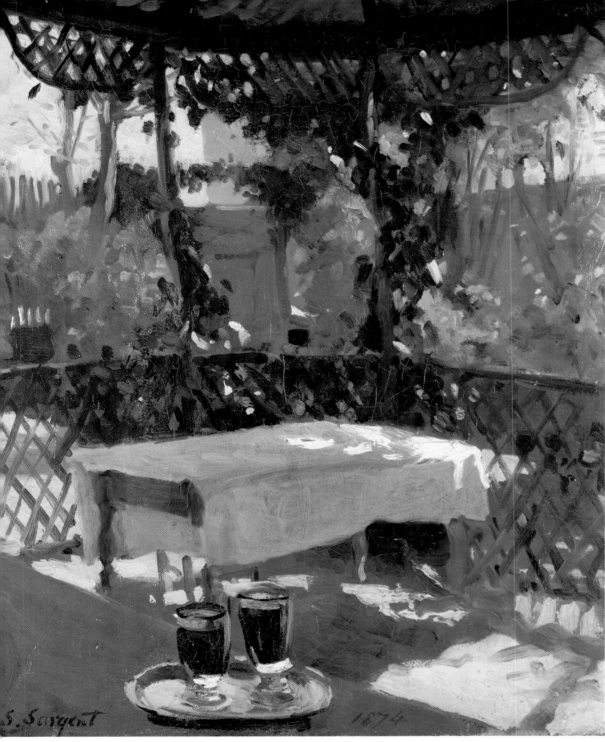

45

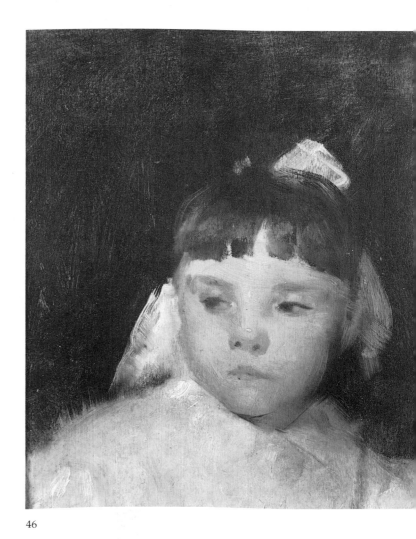

46

43. *Gitana*, 1876. Oil on canvas, 29 x 23⅝ inches. The Metropolitan Museum of Art, New York. Gift of George A. Hearn, 1910.

44. Emile Carolus-Duran. *Lady with a Glove*, 1869. Oil on canvas. Musée du Louvre, Paris.

45. *Two Wine Glasses*, c. 1875. Oil on canvas, 18 x 14½ inches. The Marchioness of Cholmondeley.

46. *Violet Sargent*, c. 1875. Oil on panel, 10½ x 9¼ inches. The Ormond Family.

learn," but he showed "promise above the ordinary." He was accepted into the atelier. When Carolus had finished his examination, the class crowded around the open portfolio. They were all "astonished at the cleverness shown in the watercolor and the pencil work." Soon they were astonished by Sargent's speed in mastering the master's instruction—indeed, in mastering Carolus-Duran's very style.[25]

Carolus had won his first Salon medals in the 1860s, when he still worked in the manner of Gustave Courbet. Then he traveled to Spain, where his French Realism gave way before the influence of Velázquez —rather, Carolus saw in the Spaniard's elegance a way to bring Realism out from under the weight of Courbet's heavy palette and thick facture. This amended style made its first appearance at the Salon of 1869, in Carolus's *Lady with a Glove* (plate 44). Within a few seasons, he was one

37

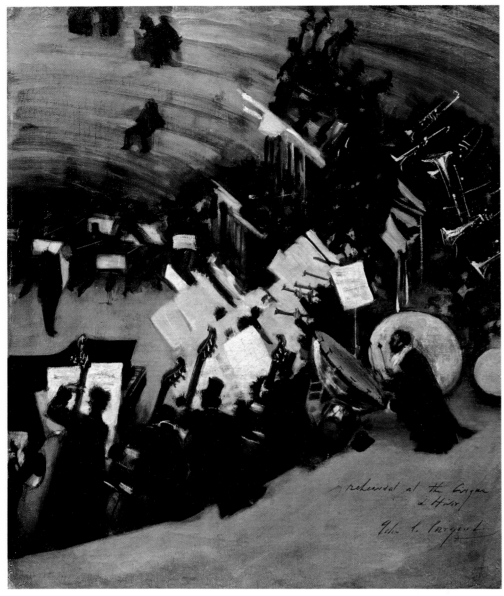

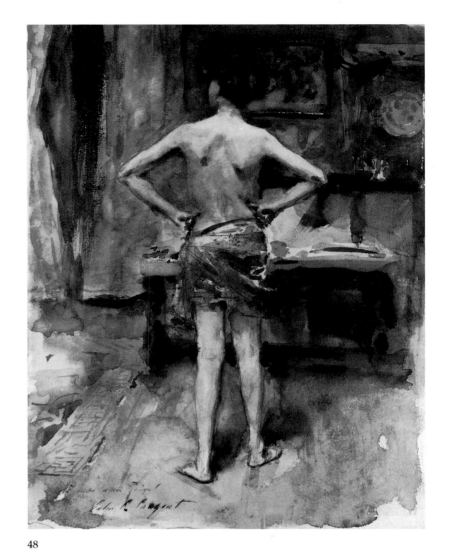

47

48

of the most successful portraitists of his time. Soon he had become a dandy, hyperactive socially and habitually alert to the politics of the art world. In 1890 he helped found the Société Nationale des Beaux-Arts; in 1904 the Académie des Beaux-Arts elected him to membership. The same year, he was appointed director of the Académie Française in Rome, a post he held until 1913. Carolus died four years later, his prestige still intact.

There were about twenty-five students in his atelier, of which two-thirds were usually English or American. They liked his indifference to academic drawing and its tedium. Among the English was Robert Alan Mowbrey Stevenson, a cousin of the writer Robert Louis Stevenson. In an article R. A. M. Stevenson wrote toward the end of the 1880s, he still seems dismayed by his countrymen's fear of instruction—their belief that to follow Carolus's teaching too closely would be to lose whatever originality they possessed. Sargent, by contrast, "devoted himself to the routine of the studio without seeking to appear original."[26] Thus he learned technique, and this permitted him within a very few years to convey his "personal taste and tendencies." In other words, he had mastered his means and now could achieve whatever goal he set himself. In his book *Velazquez* (1895), R. A. M. Stevenson takes the Spanish

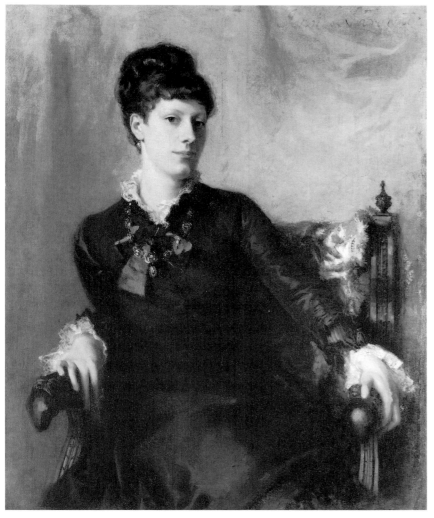

49

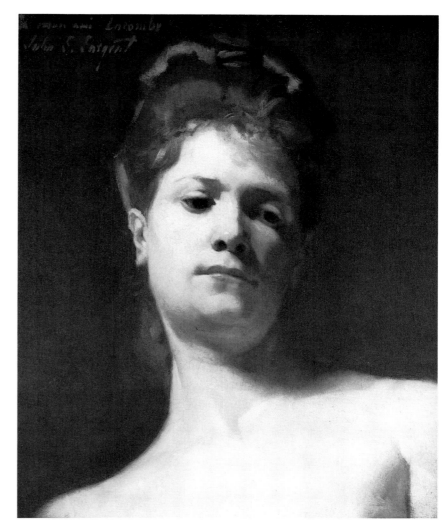

50

painter's means, transmitted by Carolus-Duran, to be those of painting itself. This was the blinkered doctrine that Carolus as well promoted. "Velázquez, Velázquez, Velázquez," he would say to his assembled students, "study Velázquez without respite." Carolus's own studies had led him to this principle: "Express the maximum by means of the minimum."

In practice this meant that a portrait was to begin with a sketch made directly on the canvas, with no guidance from previous drawings—"a slight search of proportions with charcoal," R. A. M. Stevenson calls this stage. Next

47. *Rehearsal of the Pasdeloup Orchestra at the Cirque d'Hiver*, 1876. Oil on canvas, 21¾ x 18¼ inches. Museum of Fine Arts, Boston. Charles Henry Hayden Fund.

48. *The Model*, 1876. Watercolor on paper, 11¼ x 8½ inches. Museum of Fine Arts, Houston. Gift of Miss Ima Hogg.

49. *Miss Fanny Watts*, 1877. Oil on canvas, 41⅝ x 32⅞ inches. Philadelphia Museum of Art. The Mr. and Mrs. Wharton Sinkler Collection.

50. *Head of a Female Model*, 1877. Oil on canvas, 17¹⁵⁄₁₆ x 14¹⁵⁄₁₆ inches. Sterling and Francine Clark Art Institute, Williamstown, Massachusetts.

the places of masses were indicated with a rigger dipped in a flowing pigment. No preparation in colour or monochrome was allowed, but the main planes of the face must be laid directly on the unprepared canvas with a broad brush. These few surfaces . . . were painted quite broadly in even tones of flesh tint, and stood side by side like pieces of a mosaic, without fusion of their adjacent edges. No brushing of the edge of the hair into the face was permitted, no conventional bounding of eyes and features with lines that might deceive the student by their expression into the belief that false structure was truthful. . . .[27]

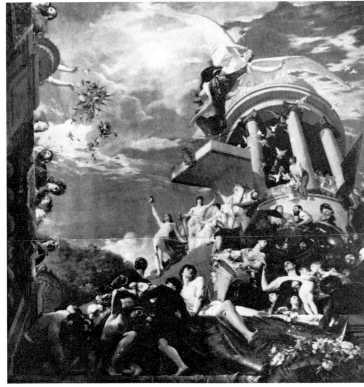

51

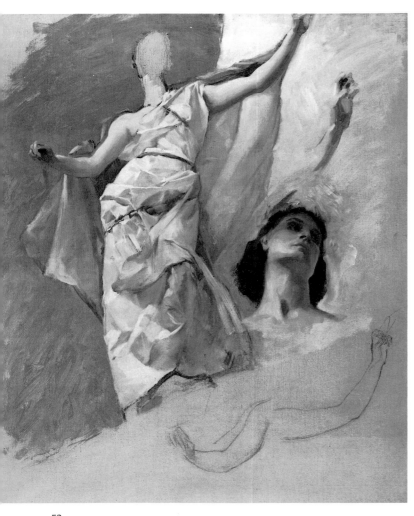

52

Making "a tone for each step" around the surface of a contour, the painter eventually arrives at a certain truth to what he sees. Under the influence of Velázquez, Carolus had sensitized his eye to the most delicate inflections in the flow of light. Attentive to surface instead of mass, he had no use for traditional drawing, which binds color and shades of light and dark to a substructure of fully modeled volumes. Calmly and deliberately, Carolus sacrificed that solid architecture to the momentary effects of light on form—and Sargent soon learned to do the same. *A Male Model Standing before a Stove* (plate 42) substitutes a few quick indications for the careful rounding of bodily forms. For the most part, alternations of lights and darks point up the play of light over objects whose exact shape is left for the eye to interpret.

Even in the most traditional ateliers, students were encouraged to make studies of this sort, which were thought to help loosen up the flow of tone across the surface. Of all the influential teachers, however, only Carolus-Duran went directly from tonal sketches to finished works. To conservatives at the Ecole des Beaux-Arts, this gave him the appearance of a radical. Adolphe Bouguereau, with his endless homages to Raphael, thought him hopelessly wrong-headed. Yet Carolus was cautious, even genteel, next to his friend Edouard Manet, who pushed the implications of Velázquez's style much farther than Carolus ever did.

Carroll Beckwith, the American student that John Sargent and his father had met the first day at the atelier, was troubled by his teacher's neglect of drawing. He decided to study it at the Ecole des Beaux-Arts. Sargent, who had soon become a friend of his, agreed that this would be a good idea. Carolus-Duran was accredited by the Ecole, and, officially, Beckwith and Sargent were enrolled there as pupils. However, they still had to pass an examination before they could attend drawing classes. In addition, the office of the Ecole's director, Adolphe Yvon, required a letter of recommendation from the American chargé d'affaires in Paris. This personage, Wicksham Hefferman, stated that John Sargent came from a "very respected" family in Philadelphia. Nonetheless, there was still a three-week examination to pass.

Applicants were examined in perspective, anatomy, design, and life drawing. Moreover, there was a language test designed to keep foreign students from swamping the Ecole. After the first week of the ordeal, Sargent wrote to his friend Ben del Castillo: "The épreuves de Perspective et d'Anatomie are over; I wish I might say as much for the Dessin d'Ornement which is in store for us tomorrow morning [October 5,

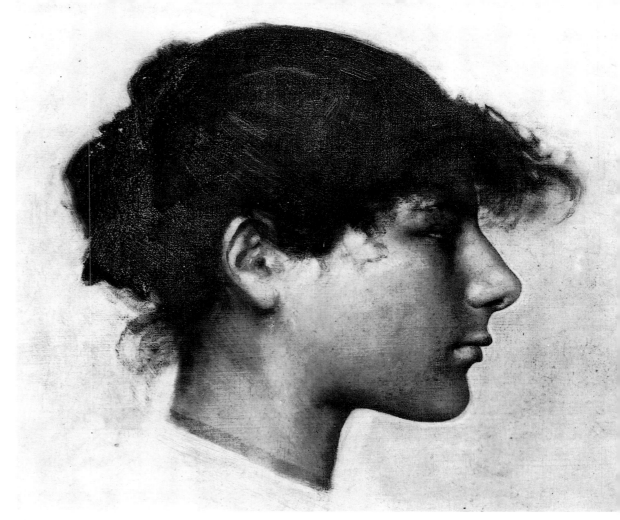

53

51. Emile Carolus-Duran. *The Triumph of Maria de Medici*, 1878. Oil on canvas. Musée du Louvre, Paris.

52. *Sketch for Carolus-Duran's "Triumph of Maria de Medici,"* 1877. Oil on canvas, 32 x 25¾ inches. Portland Art Museum, Oregon. Gift of Mr. and Mrs. Orrin June.

53. *Head of Ana-Capri Girl*, 1878. Oil on wood, 9 x 10 inches. The Ormond Family.

1874]. But the supreme moment is one of twelve hours wherein we must make a finished drawing of the human form divine.

Heaven only knows whether I shall get through; also Heaven alone could bring such a miracle to pass, therefore let us implore its aid and do our best. . . ."[28]

Sargent passed, Beckwith did not—a failure that Carolus-Duran seems not to have held against him. When classes at the atelier commenced on October 21, Beckwith was once again monitor, the student who kept order and collected from every new arrival a twenty-five-franc fee for heat and models. On Monday mornings the students set up their easels in whatever place they could find. There they would remain all week. Sargent always came early to get a good spot—according to Charles Merrill Mount, he was usually the first to arrive, though sometimes he came in second to a classmate who had stayed up late Sunday night and slept on the street outside the atelier.

In September 1877 Emily Sargent wrote to Vernon Lee that her brother "works like a dog from morning till night. Part of the time last winter we would breakfast together between 7 & 8 o'clock, & he would only return for a hasty dinner & be off again to the Life School until after ten. Afterwards he would still leave us early, but would go to the Beaux-Arts [for Yvon's life class] before dinner"[29]—and spend his evenings at the studio of Léon Bonnat, one of Carolus's colleagues and competitors for portrait commissions. Bonnat was an extraordinarily eclectic painter—traces of Velázquez and Impressionism, of Michelangelo and proper nineteenth-century academic practice appeared in his work over

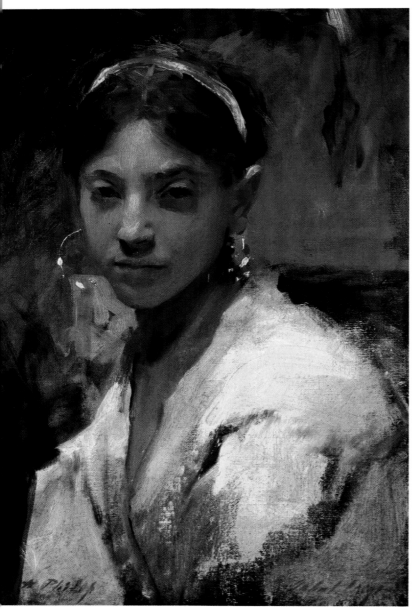

54

the years. On Sundays Sargent worked at home, often with Carroll Beckwith and J. Alden Weir, a young American enrolled in the atelier of Jean-Léon Gérôme. Dr. Sargent understated the case when he wrote to relatives in America that John "is working with immense good-will and enthusiasm and industry at his business:—it is a pleasure to see so young a boy so industrious, so cohesive to his particular work amid so many distractions of all sorts as Paris presents."[30]

Sargent was well aware of "l'existence debraillée des rapins"—the loose life led by the art students of the Latin Quarter—but he had no time for it, nor any inclination. Paul Helleu, then a student painter too, remembered later that Sargent was always respectably dressed and therefore slightly odd in a milieu of velvet jackets, bright sashes, and peg-pants. One of Sargent's friends at Carolus's atelier was Will H. Low, later an exceedingly proper muralist in the American Renaissance movement, who in his student days wore a silk hat above a ragged suit. On October 4, 1874, J. Alden Weir wrote: "I met this last week a young Mr. Sargent about eighteen years old and one of the most talented fellows I have ever come across; his drawings are like old masters, and his color is equally fine. He was born abroad and has not yet seen his country. He speaks as well in French, German, Italian as he does in English, has a fine ear for music, etc. Such men wake one up, and as his principles are equal to his talents, I hope to have his friendship."[31] Those principles, which John had learned from Dr. Sargent, are what led Vernon Lee to call them both "puritans." Since they were Weir's principles as well, the two did become friends. The rowdier members of Carolus's class, even those to whom New England-style uprightness was a mystery, found Sargent amiable at the very least. According to Hamilton Minchin, his presence at the easel tended to subdue the atelier's more "rabelaisian" currents of conversation. Of course, Sargent's primness would have had no authority if his talent had not been awesome—especially in that studio, which produced so few stars.

Every January, Carolus's students put on a banquet for him. After the 1875 celebration, he and three of his American students took a trip to Nice. Sargent was included, Beckwith left behind. The Latin Quarter celebrated Mardi Gras soon after, then Sargent settled back into his seven-day-a-week routine. In May of 1876, Mrs. Sargent, John, and Emily sailed to America. He was now twenty and required by law to set foot in the United States if he wanted to keep his citizenship. With Dr. Sargent and Violet summering in Switzerland, the rest of the family saw New York City, Niagara Falls, and the Centennial exhibition in

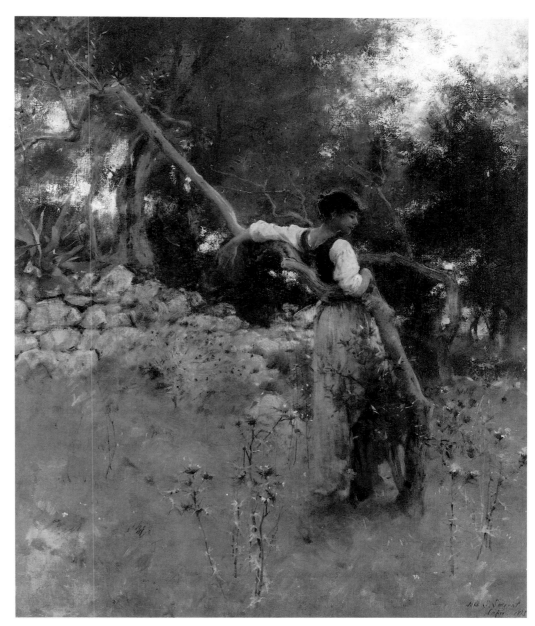

55

Philadelphia. They got as far north as Quebec, as far south as Washington, and even visited Chicago.

During the winter of 1871–78, Carolus-Duran launched an immense canvas, *The Triumph of Maria de Medici* (plate 51), for the Palais du Luxembourg. He chose Beckwith as one of his assistants; the other, inevitably, was Sargent. By this time the atelier had tagged him teacher's pet. Sargent painted Beckwith's face into the composition, and his friend did the same for him—twice. (Their faces appear at the base of the pavilion.) Hamilton Minchin recalls walking through the atelier with Sargent that winter. They stopped before a study of a head for the Palais du Luxembourg project. Minchin was dazzled. Suddenly Sargent burst out, "I painted it!" Minchin pointed to the master's signature. Yes, said Sargent, Carolus had touched it up a bit, then signed it. During this period, Carolus also did his prize pupil the honor of sitting for him. The result was a portrait of the teacher in his own most elegant manner (plate 58).

Sargent spent the summer of 1877 at Cancale, on the Brittany shore, where he made the oil sketches that led to *The Oyster Gatherers of Cancale* (plates 67–72). The next summer he traveled to Capri, by way of Naples,

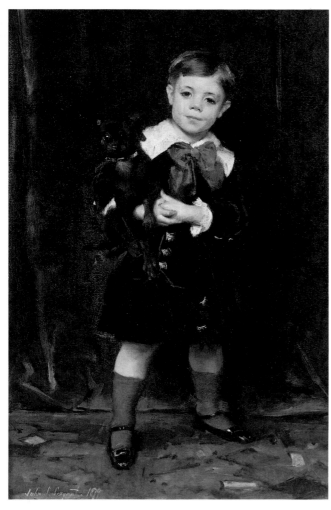

56

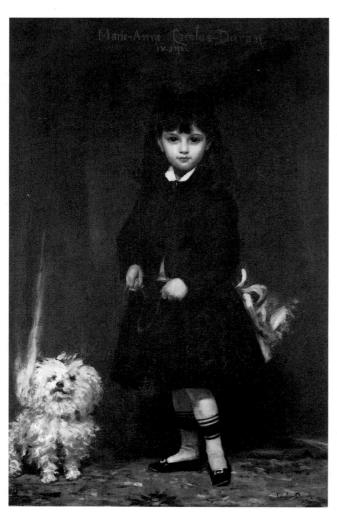

57

56. *Robert de Cévrieux*, 1879. Oil on canvas, 33½ x 19¼ inches. Museum of Fine Arts, Boston. Charles Henry Hayden Fund.

57. Emile Carolus-Duran. *The Artist's Daughter*, 1874. Oil on canvas, 51¼ x 33½ inches. The Fine Arts Museums of San Francisco. Mildred Anna Williams Collection.

58. *Portrait of Carolus-Duran*, 1879. Oil on canvas, 46 x 37¹³⁄₁₆ inches. Sterling and Francine Clark Art Institute, Williamstown, Massachusetts.

where "they eke out their wine with spirits and drugs," as Sargent wrote to Ben del Castillo, "so that a glass of wine and water at a meal will make a man feel drunk. I had to take bad beer in order not to feel good-for-nothing. I could not sleep at night. In the afternoon, I would smoke a cigarette in an armchair or in my bed and at five o'clock wake up from a deep sleep of several hours. Then lie awake all night and quarrel with mosquitoes, fleas and all imaginable beasts. I am frightfully bitten from head to foot. Otherwise Italy is all that one can dream for beauty and charm."[32]

On Capri, Sargent met an English artist, Frank Hyde, who had set up a studio in the abandoned monastery of Santa Lucia. He invited Sargent to share the place with him and even found a model—Rosina, who appears in a number of Sargent's paintings from this summer. "I am painting away here very hard," he wrote to del Castillo, "and shall be here a long time." *Capri* (plate 55) shows Rosina leaning with self-conscious grace against the sloping trunk of an olive tree. The surface of the painting is brushy, filled with flickering shifts of tone and sudden accents of color. The method is Carolus-Duran's, but the refinement is Sargent's. At the age of twenty-two the young student is already in possession of a style. In another work from that period Rosina dances on a rooftop against an early evening sky. The building is Sargent's hotel, and the occasion is a party he threw for Hyde and the rest of Capri's small colony of painters.

The Oyster Gatherers of Cancale won an honorable mention at the Salon of 1878. Soon afterward, an American collector bought it. An oil sketch for this painting appeared the same year at the first exhibition of New York's Society of American Artists, a group Sargent had helped to found. *Scribner's Magazine* singled out the sketch for its "poetry"—a trait the magazine's anonymous writer felt was missing from most American art. In 1879 Sargent sent his portrait of Carolus-Duran to the Salon, along with *Capri*. *L'illustration* reproduced the portrait on its cover, as much in tribute to Carolus-Duran as to Sargent. Nonetheless, the picture helped Sargent's career. As Dr. Sargent said in a letter to his American relatives, "There was always a little crowd around it, and one heard constantly remarks in favor of its excellence. But as the proof of the pudding is in the eating, so the best or one of the best evidences of a portrait's success is the receiving by the artist of commissions to execute others. And John received six such evidences from French people. He was very busy during the two months we were in Paris."[33]

Among the six were orders for portraits of Edouard Pailleron and the

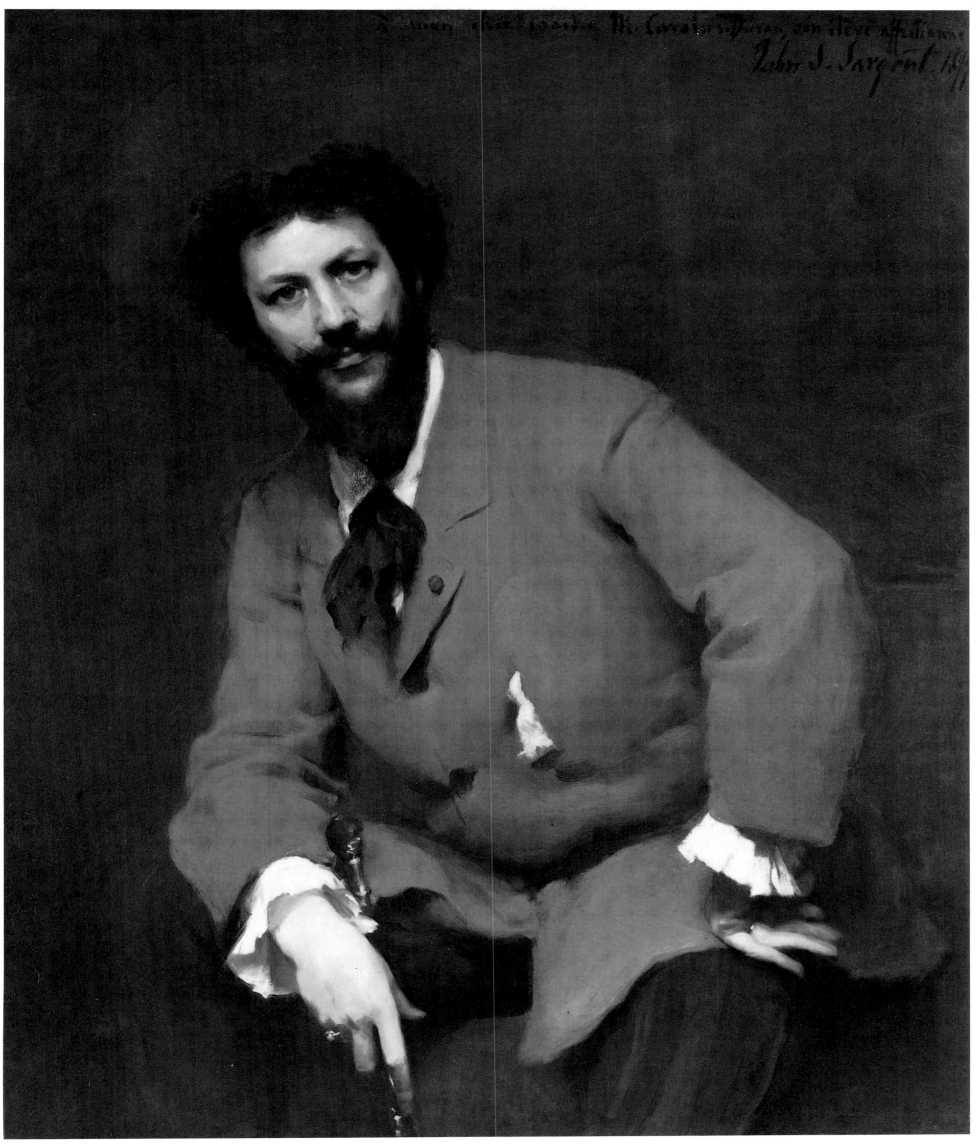

58

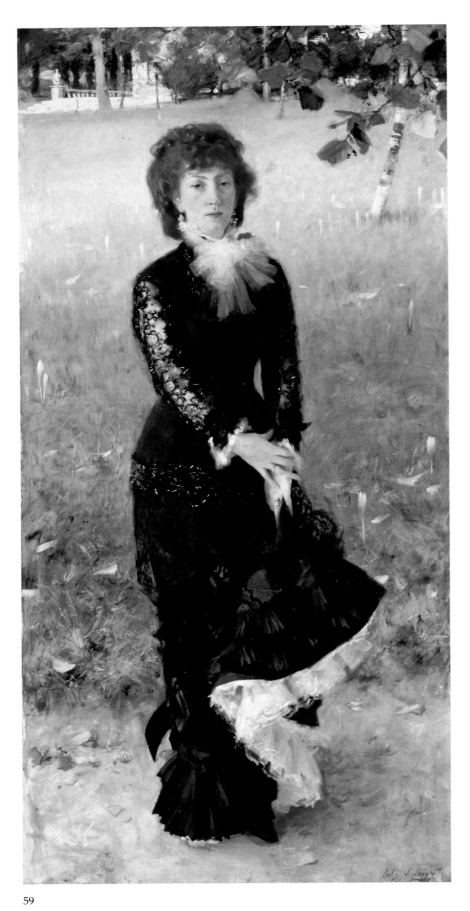

59

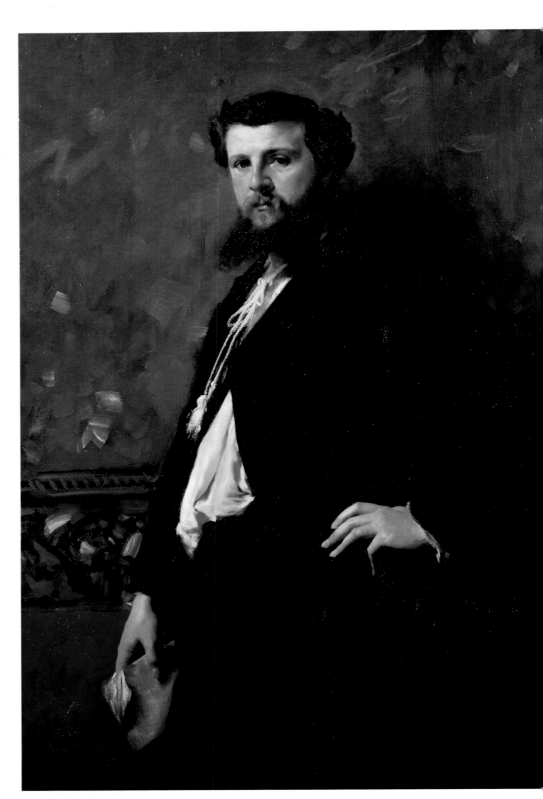

59. *Madame Edouard Pailleron*, 1879. Oil on canvas, 82 x 39½ inches. The Corcoran Gallery of Art, Washington, D.C. Gift of Katharine McCook Knox, John A. Nevius, Mr. and Mrs. Lansdell K. Christie.

60. *Edouard Pailleron*, 1879. Oil on canvas, 50 x 37 inches. Musée National, Versailles.

60

young Robert de Cévrieux. Both are in the Carolus-Duran high style. As Charles Merrill Mount notes, even Sargent's signature in the Cévrieux portrait (plate 56) looks a bit like his teacher's. In *Edouard Pailleron* (plate 60), the debt is just as clear, though Sargent treats the background with a freedom that was soon to appear in his subject's clothes and then, by the mid-1880s, in the modeling of their flesh. Pailleron was a poet, playwright, and son-in-law of Charles Buloz, the editor of a journal that came to be important to Sargent's Parisian career—*La revue des deux mondes*. The two had met at one of the musical and literary salons where the stylish young artist had begun to appear. Sargent talked as he painted, and Pailleron left the studio impressed by Sargent's knowledge of contemporary French literature and music. Furthermore, he liked his portrait. That summer he invited Sargent to the Buloz estate in Savoy to paint a picture of Mme. Pailleron and their children.

Sargent had trouble persuading the six-year-old Marie-Louise to pose, though he did manage to make an oil sketch of her dressed up and stretched out on the grass. He painted Mme. Pailleron out-of-doors as well (plate 59). She faces forward, flouncing her skirt, her image made from bravura flurries of tone and texture. The high-keyed setting of branch, lawn, and distant terrace is a degree more agitated—sunlight in this painting falls through a breeze. The Paillerons approved. Sargent had brought the independence of his Capri paintings to the task of formal portraiture.

Carolus-Duran had reason to be alarmed, and it came to be said that he painted Sargent's face out of his *Triumph of Maria de Medici*. That is legend. Sargent's face is still there, and Carolus kept a friendly eye on him for as long as he remained in Paris. Yet the stories of their falling out persisted, and even Sargent believed them. Many years later he wrote, "Carolus-Duran hates me."[34] Gossip, at any rate, confirmed this. In 1902 the *Magazine of Art* reported that Carolus-Duran routinely warned his students against wandering down Sargent's path. Though he had been promising at one time, "Sargent—ça n'existe plus!"—he no longer exists.[35] Carolus-Duran may or may not have said this. In any case, Sargent always insisted, rightly, that he owed his teacher a great debt. That mastery of tones he had learned at Carolus's atelier always remained crucial to Sargent's art.

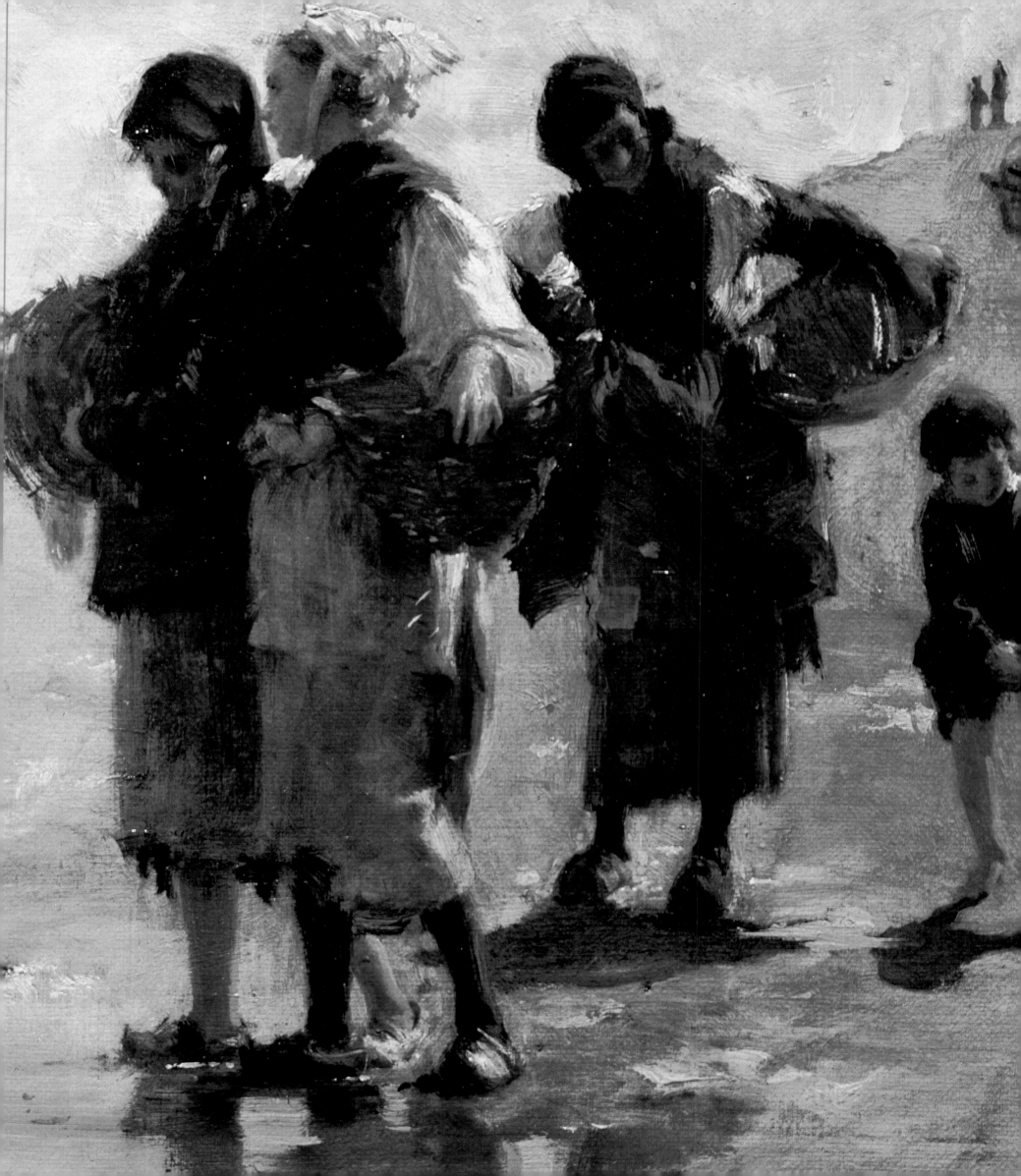

III. *Independence*

IT IS TRADITIONAL TO SAY THAT *The Oyster Gatherers of Cancale* (plate 71) shows Impressionism's early impact on Sargent. The remark is convincing, up to a point. The artist has filled his canvas with warm, "blond" passages of sand and sky. He seems to have accepted permissions granted by Claude Monet (whom Sargent had met, and painted, sometime before this period). Yet there is a full range of tones in the painting—the fisherfolks' dark clothes give them the sharp contours of silhouettes. Sargent has not thrown over his Beaux-Arts training for that Impressionist web of color that blurs the outlines of objects and underplays the difference between near and far. Throughout the 1870s Monet, Alfred Sisley, and Auguste Renoir all pushed their palettes farther and farther toward the bright end of the tonal scale. Hence the overall glow of their canvases, an effect they intensified locally by building images from *taches*—small touches—of contrasting hues. Even a shadow might bring together a blue and a green, an orange and a light blue. Not always, but often, they set down these colors straight from the tube, undiluted.

In devising their new way with color, Monet and the others came up with a new "hand," a new method of putting paint on canvas. Sargent's *Oyster Gatherers* shows none of this. He painted it with colors mixed on the palette, and he used a traditional brushstroke—quick, alert to nuances of light, but far from Impressionist. In the late 1870s Sargent displayed an elegance of touch that Monet had unlearned (and some of his avant-garde colleagues never possessed). Both the oil sketch and the final version of *The Oyster Gatherers* get their glow from translucent glazes, set one over the next with astonishing finesse. Particularly in the sketch, the blacks of the women's dresses and scarves shimmer with their denial of opacity. Passages that might be expected to absorb light seem to generate it.

It was during the summer of 1877, spent at Cancale, that Sargent first took Carolus-Duran's method out of the studio into the open air. The beach scenes of Eugène Boudin offered him guidance. So did the landscapes of the Barbizon painters—Camille Corot and Constant Troyon, in particular. The Barbizon School served as a stopping-off point on the way to Impressionism, hence these artists now look to us like radicals.

61. *The Oyster Gatherers of Cancale.* See plate 72.

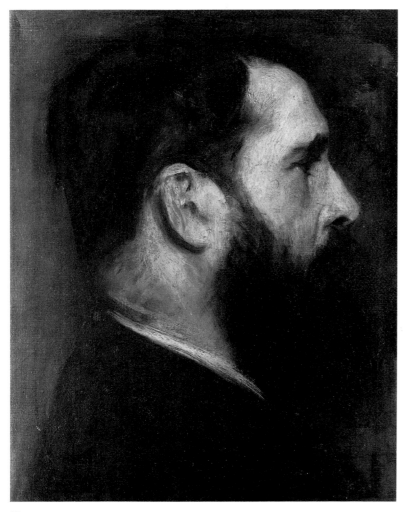

62

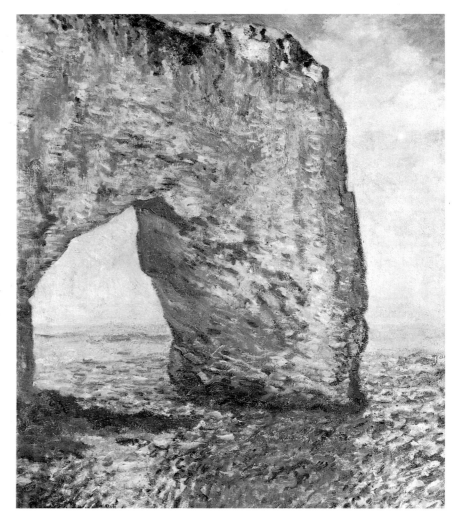

63

62. *Claude Monet*, c. 1889. Oil on canvas, 16 x 13 inches. National Academy of Design, New York.

63. Claude Monet. *La Manneporte près d'Etretat*, 1883. Oil on canvas, 25¾ x 32 inches. The Metropolitan Museum of Art, New York. Bequest of William Church Osborne, 1951.

64. *In the Luxembourg Gardens*, 1879. Oil on canvas, 25½ x 36 inches. John G. Johnson Collection, Philadelphia.

65. James A. McNeill Whistler. *Brown and Silver: Old Battersea Bridge*, c. 1865. Oil on canvas, 25 x 30 inches. Addison Gallery of American Art, Phillips Academy, Andover, Massachusetts. Gift of Mr. Cornelius N. Bliss.

66. *Luxembourg Gardens at Twilight*, 1879. Oil on canvas, 29 x 36½ inches. The Minneapolis Institute of Arts. Gift of the Martin B. Koon Memorial Collection, 1916.

They were, after all, extremely acute about that play of light and atmosphere that became Monet's primary subject. Yet Barbizon was in part a Rococo revival. Its plein-air effects charm as well as convince, arranged as they are with an eye for decorative artifice. The composition, the formal architecture, of a Barbizon painting is likely to borrow its calm from the high style of seventeenth-century France—the orderliness of Claude Lorraine and Nicolas Poussin. So Corot and the rest can be seen as avant-gardists or as conservatives. As he moves beyond *The Oyster Gatherers*, Sargent too takes on this doubleness.

If Sargent had simply become an Impressionist, Carolus-Duran could have written him off, with regret, as a young American soul lost in the radical wilderness. As it was, Sargent had begun to play styles and their masters off against one another. *In the Luxembourg Gardens*, 1879 (plate 64), is made of grays that suggest Whistler. Sargent and Whistler may have met three years earlier, or their meeting might have been in 1880 —the biographers of both artists disagree on this point. However, *In the Luxembourg Gardens* makes it likely that Sargent had seen his fellow American's *Nocturnes* and *Harmonies* by 1879. Each of the two versions of the painting offers its own suggestion about a dusk so delicate, so diffused that shadows dissolve and objects seem almost to float. The

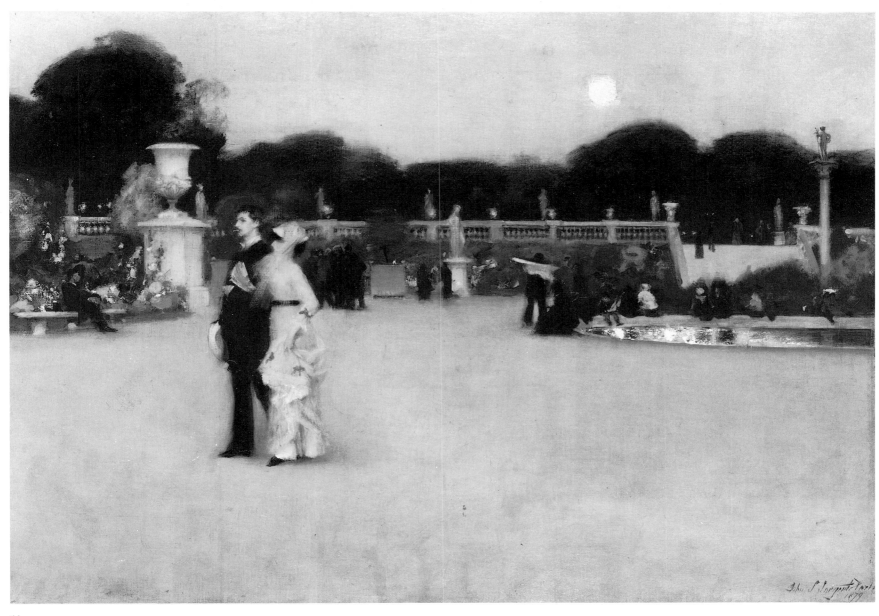

64

65

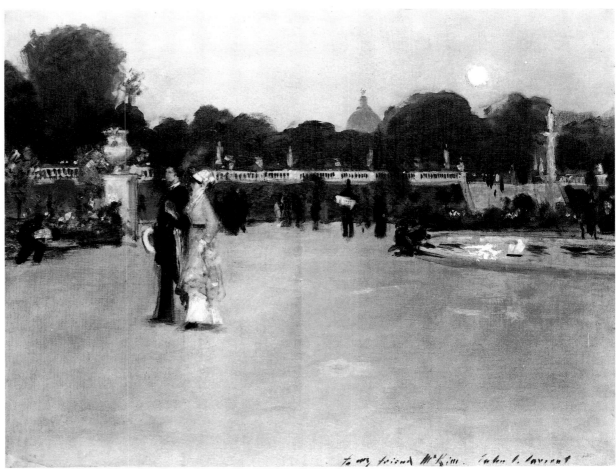

66

67

67. *Low Tide at Cancale Harbor*, 1877. Oil on canvas, 18¾ x 11 inches. Museum of Fine Arts, Boston. Zoe Oliver Sherman Collection.

68. *Female Study for "The Oyster Gatherers of Cancale,"* 1878. Oil on canvas, 19 x 11½ inches. Terra Museum of American Art, Evanston, Illinois. Daniel J. Terra Collection.

69. *Male Study for "The Oyster Gatherers of Cancale,"* 1878. Oil on canvas, 17¼ x 10⅛ inches. Terra Museum of American Art, Evanston, Illinois. Daniel J. Terra Collection.

70. *Second Female Study for "The Oyster Gatherers of Cancale,"* 1877. Oil on canvas, 19 x 11 inches. Terra Museum of American Art, Evanston, Illinois. Daniel J. Terra Collection.

71. *The Oyster Gatherers of Cancale*, 1878. Oil on canvas, 31 x 48½ inches. The Corcoran Gallery of Art, Washington, D.C.

72. *The Oyster Gatherers of Cancale*, c. 1878. Oil on canvas, 16¼ x 23¾ inches. Museum of Fine Arts, Boston. Gift of Mary Appleton.

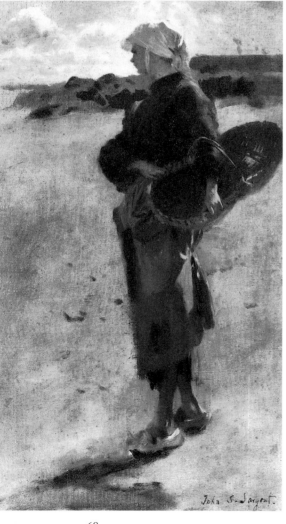

68

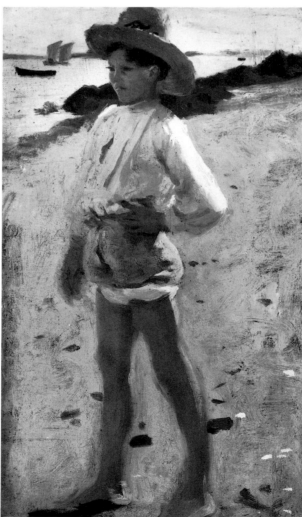

69

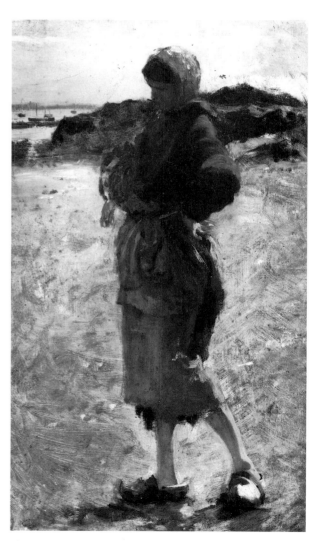

70

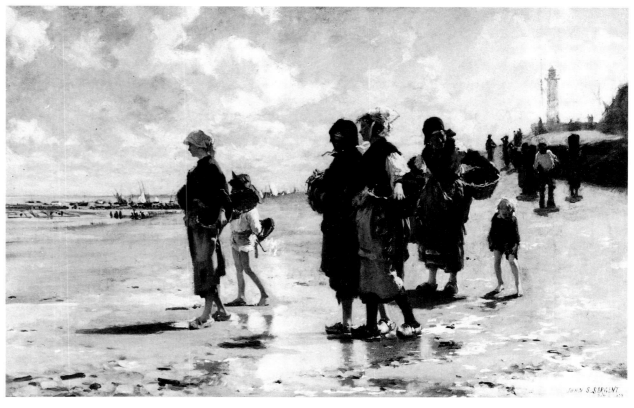

71

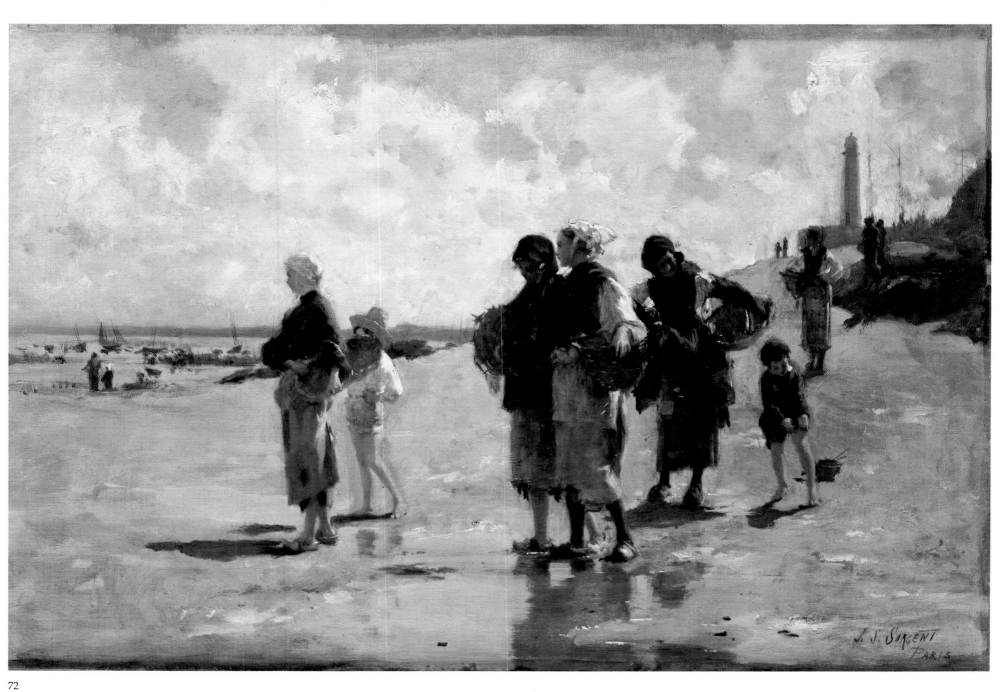

72

73

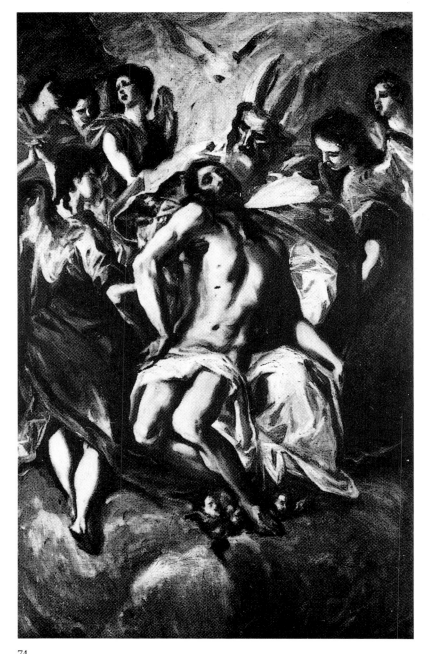

74

73. *Head of Aesop* (after Velázquez), 1879. Oil on canvas, 18 x 14½ inches. The Ackland Art Museum, University of North Carolina at Chapel Hill. Ackland Fund.

74. *Copy of El Greco's "Holy Trinity" at the Prado*, 1879. Oil on canvas, 31 x 19 inches. The Marchioness of Cholmondeley.

75. *Moorish Buildings in Sunlight*, 1879–80. Oil on wood, 10¼ x 13⅞ inches. The Metropolitan Museum of Art, New York. Gift of Mrs. Francis Ormond, 1950.

76. *White Walls in Sunlight, Morocco*, 1879–80. Oil on wood, 10¼ x 13¾ inches. The Metropolitan Museum of Art, New York. Gift of Mrs. Francis Ormond.

77. *Fumée d'Ambre Gris*, 1880. Oil on canvas, 54¾ x 35¹¹⁄₁₆ inches. Sterling and Francine Clark Art Institute, Williamstown, Massachusetts.

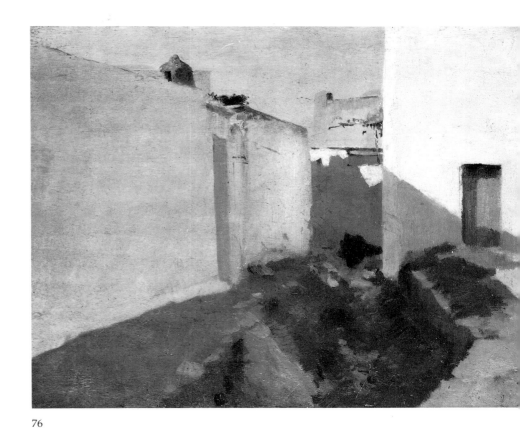

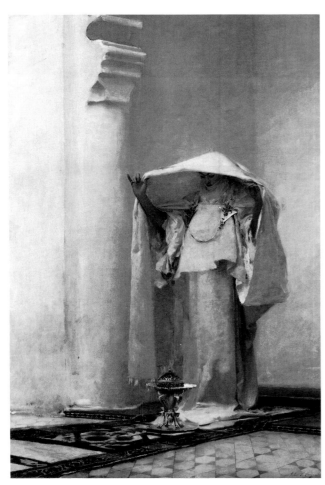

reds and oranges of the garden's flowers serve as accents in a tonal scheme that glides to extremes of light and dark. A painting built from tones, a large effect achieved with sparse means—Carolus could hardly have objected, save for the shadow of Whistler.

During the winter of 1879 Sargent traveled to Madrid with two young French painters known only as Daux and Bac. From the capital they went to Gibraltar and, in January of 1880, on to Tangier. Sargent made copies after Velázquez in the Prado (plate 73). Throughout the streets and churches of Spain he made oil sketches—one of these subjects, *A Spanish Madonna* (plate 212), reappears over a decade later as *Astarte* (plate 210), a heathen goddess in Sargent's murals at the Boston Public Library. The oil sketching continued in Morocco. Sargent took advantage of the new setting, the unfamiliar light and architecture, without letting himself be bowled over by it. In a letter to Ben del Castillo, he writes about the exotic with a mixture of admiration and practical skepticism.

We have rented a little Moorish house (which we don't yet know from any other house in the town [Tangier], the little white tortuous streets are so exactly alike) and we expect to enjoy a month or two in it very much. The patio open to the sky affords a studio light, and has the horseshoe arches, arabesques, tiles and other traditional Moorish ornaments. The roof is a white terrace, one of the thousand that forms this town, sloping down to the sea. All that has been written and painted about these African towns does not exaggerate the interest of, at any rate, a first visit.

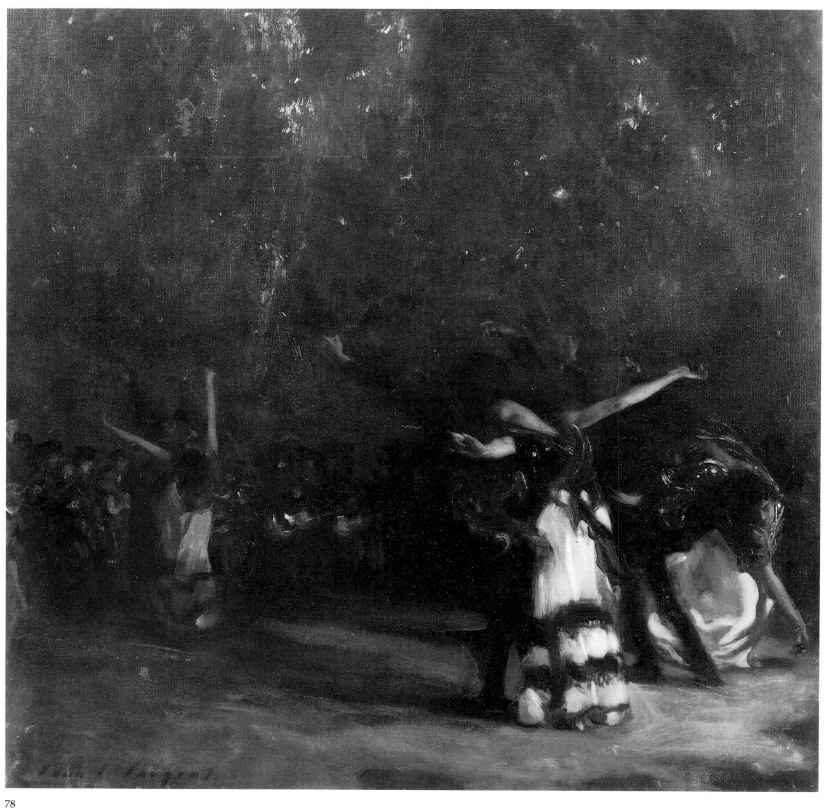

78

78. *Spanish Dance*, c. 1879–80. Oil on canvas, 33½ x 35½ inches. The Hispanic Society of America, New York.

79. *La Femme aux Fourrures*, c. 1880. Oil on canvas, 11⁵⁄₁₆ x 8¾ inches. Sterling and Francine Clark Art Institute, Williamstown, Massachusetts.

80. *Mrs. Charles Gifford Dyer*, 1880. Oil on canvas, 24½ x 17¼ inches. The Art Institute of Chicago. Friends of American Art Collection.

79

80

Of course the poetic strain that writers launch forth in when they touch upon a certain degree of latitude and longitude—is to a great extent conventional; but certainly the aspect of the place is striking, the costumes grand and the Arabs often magnificent.[36]

As in the Luxembourg Gardens, so in North Africa—Sargent builds his images from the play of tones. The sunlight leads him into the brighter regions of the scale, yet he always balances slabs of warm white with cooler passages—blocks of shadow on whitewashed planes and quick, dark indications of doorways, gullies, and patterned cobblestones. In *Fumée d'Ambre Gris*, a watercolor of a Moorish woman inhaling incense, the white of Sargent's paper joins with the thinnest washes of white pigment to produce an astonishingly intricate play of high-keyed color. Sargent made a full-sized version of the subject in oils (plate 77), and sent it to the Salon of 1880. Critics admired its mysteriousness.

On his way to and from North Africa, Sargent kept an ear out for Spanish music. Back in Paris, he wrote to Vernon Lee:

You wished some Spanish songs. I could not find any good ones. The best are what one hears in Andalucia, the half-African Malagueñas and Soleàs, dismal, restless chants that it is impossible to note. They are something between a Hungarian Czardas and the chant of Italian peasants in the fields, and are generally composed of five strophes and end stormily *on the dominant*, the theme quite lost in strange fiorituras and gutteral roulades. The gitano voices are marvellously supple. If you have heard something of the kind you will not consider this mere jargon.[37]

The songs Sargent liked best were the ones he heard in the fields as he and his friends rode by on horseback, though he listened to the music of the towns as well. Sargent's sketches from the winter of 1879–80 are filled with the singers, dancers, and café loungers of Granada and Seville. Perhaps he found this urban music less appealing because it was more polished, better adapted to the café patron's wish to be entertained. In any case, Spanish guitarists and flamenco dancers provided him with the subject for his first major Salon painting—*El Jaleo*, 1882 (plate 99). This is a studio product of the most traditional kind, preceded by a number of trials in oil paint—including *Spanish Dance*, c. 1879–80 (plate 78), a dark, brilliantly fluid painting that shares only its subject and its theatrical flair with *El Jaleo*.

Spanish Dance opens out into the shadows of a cavernous room. The dancers posture, yet seem abandoned. The row of musicians dimly

81

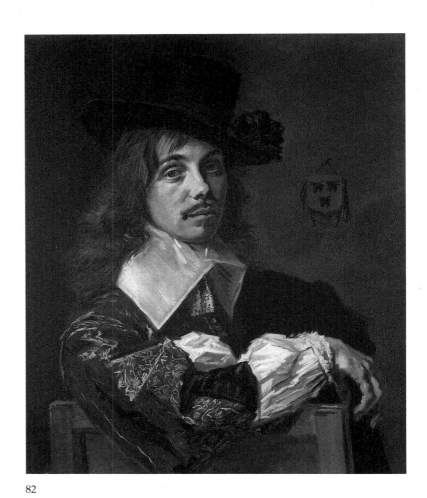

82

81. *The Pailleron Children*, 1881. Oil on canvas, 59¼ x 69 inches. Des Moines Art Center, Iowa. Edith M. Usry bequest fund in memory of her parents, Mr. and Mrs. George Franklin Usry, and additional funds from Dr. and Mrs. Peder T. Madsen and the Anna K. Meredith Endowment Fund, 1976.

82. Frans Hals. *Balthasar Coymans*, 1645. Oil on canvas, 30¼ x 25 inches. National Gallery of Art, Washington, D.C. Andrew W. Mellon Collection.

83. *Portrait of Ralph Curtis on the Beach at Scheveningen*, 1880. Oil on board, 11 x 14 inches. High Museum of Art, Atlanta, Georgia. Gift of the Walter C. Hill Family Foundation, 1973.

58

seen in the depths of this painting swings around in *El Jaleo* to face us directly. In the latter the wall has moved closer, the light is brighter, and now there is only one dancer, whose abandon is rigidly stylized. *Spanish Dance* is Sargent's record of a spectacle. *El Jaleo* is a spectacle itself, a product of the artist's desire to have an impact at the Salon.

Sargent worked intermittently on *El Jaleo* for nearly two years. All that time, he was reaching beyond the lessons of Carolus-Duran. Early in 1880 he, Beckwith, and the painter Paul Helleu set out for the Netherlands with two other artists—the Americans Ralph Curtis and Frank Chadwick, both students of Carolus. As always, Sargent made oil sketches, one of which shows Curtis reclining on a Dutch sand dune. There is a temptation to look for signs of Frans Hals, the master whose works these young artists had traveled to Holland to see. And indeed, as Sargent developed, Hals came to be as important to him as Velázquez. A spearlike brushstroke that appears in his mature repertoire looks like a nineteenth-century reinvention of a similar device in Hals's painting. This narrow, pointed mark is not used in Sargent's *Portrait of Ralph Curtis on the Beach at Scheveningen* (plate 83)—at least, no more than one would expect in an oil sketch by a student of Carolus-Duran. He put down paint in wide, square-ended marks, and as he drew his brush over the surface, the bristly texture of a pigment opened up to the color underneath. Thus he gave his image a translucent glow—a quietly dazzling evocation of North Atlantic light. This was a high-

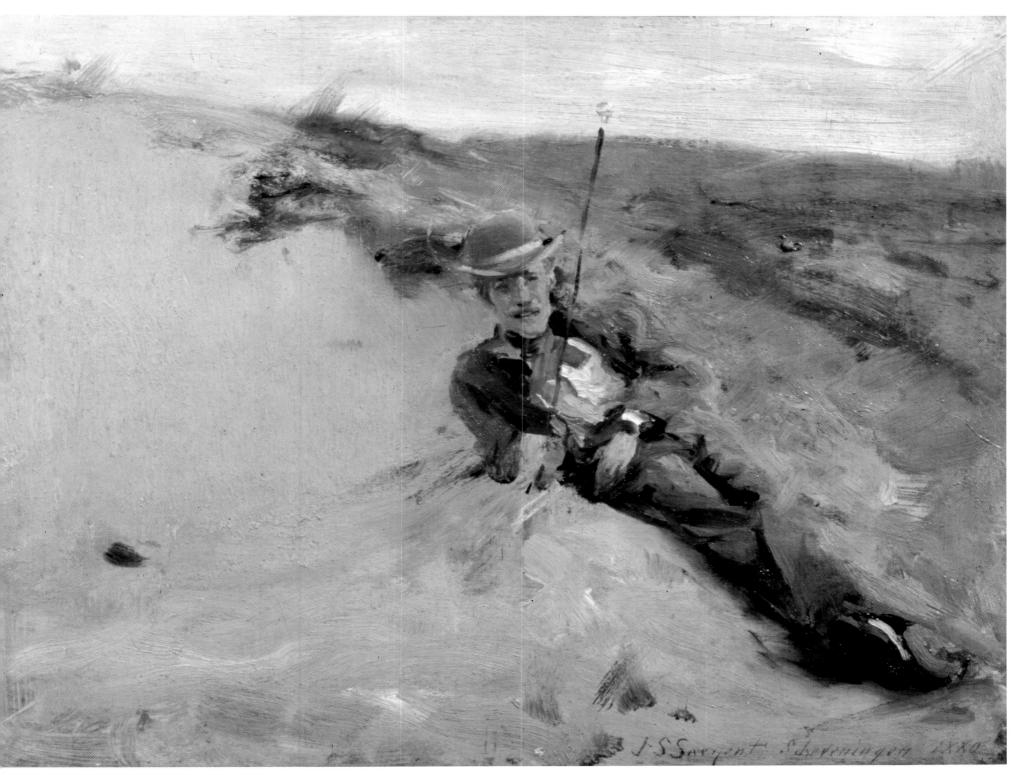

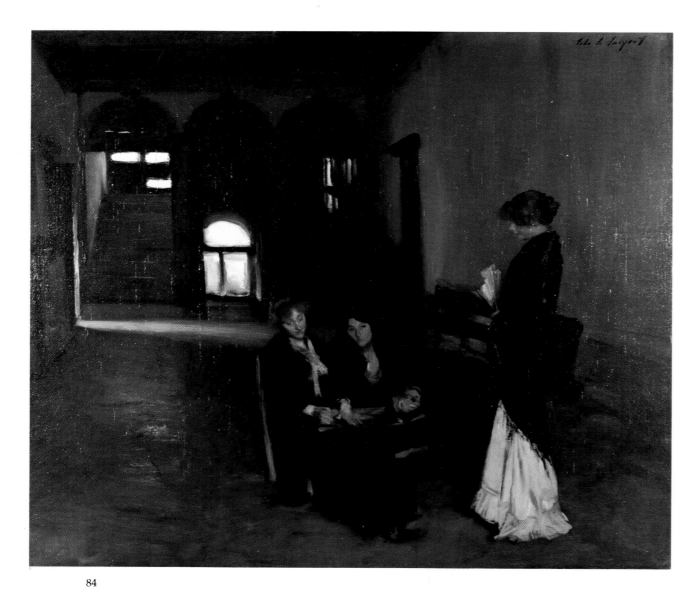

84

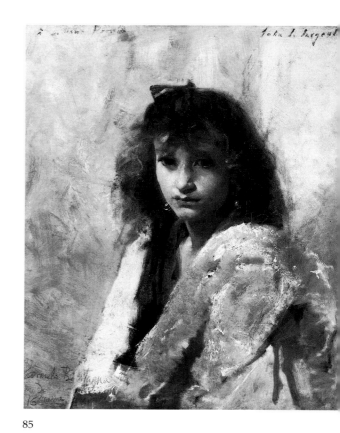

85

86

60

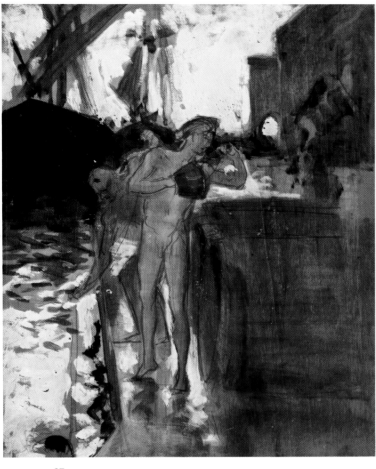

87

84. *Venetian Bead Stringers*, c. 1880–82. Oil on canvas, 26⅜ x 30¾ inches. Albright-Knox Art Gallery, Buffalo, New York. Friends of the Albright Art Gallery Fund, 1916.

85. *Carmela Bertagna*, c. 1880. Oil on canvas, 23½ x 19½ inches. Columbus Museum of Art, Ohio. Bequest of Frederick W. Schumacher.

86. *George Hitchcock*, c. 1880. Watercolor on paper, 8⅞ x 11⅜ inches. Courtesy of Richard L. Feigen & Co., New York.

87. *Two Nude Bathers on a Wharf*, 1880. Oil on wood, 13¾ x 10½ inches. The Metropolitan Museum of Art, New York. Gift of Mrs. Francis Ormond, 1950.

speed performance, parts of it executed wet-on-wet. Sargent had his means so much under control that, on occasion, he put brushy textures to work in the most literally figurative way—as notations of beach grass against the luminous sky. All this virtuosity was displayed even before Sargent had thoroughly assimilated the lessons of Hals.

At the Salon of 1880 Sargent exhibited his portrait of Mme. Pailleron (plate 59) in addition to *Fumée d'Ambre Gris*. Though he won no honors, Mme. Ramon Subercaseaux, a Chilean lady of fashion, commissioned a portrait. Soon afterward, the Paillerons asked Sargent to paint a double portrait of their children (plate 81). With that painting under way, an American by the name of Henry St. John Smith appeared at Sargent's studio. Smith noted in his diary that he didn't much like the looks of the young painter's work. Nonetheless, he too commissioned a portrait— "Sargent is said to be the best pupil of Carolus-Duran and Duran is one of the most celebrated (many say the best) portrait painter in Paris." According to Smith's remarks to himself, he chose Sargent "chiefly on the advice of Frank Chadwick who has been painting here seven years and ought to know artists. Arthur Roach of Boston also recommends him highly . . . Roach said he would rather have a portrait by Sargent than by Millais, but of course, that is bosh. . . ."[38] Mr. Smith was on the lookout for a respectable portrait at something less than Carolus would have charged. There's no record of his response to the outcome, though he said in his diary several times that he had had "a pleasant sitting" at Sargent's studio.

Sargent traveled to Venice that summer of 1880 for a visit with his parents. He found a studio in the Palazzo Rezzonico, an old palace on the Grand Canal where a number of artists had set up shop. Among them was Giovanni Boldini, who painted genre pictures in those days, and James Abbott McNeill Whistler. Sargent himself turned genre painter in Venice, with his scenes of dim interiors and shadowy streets. Figures, most of them black-shawled women, appear in deep, narrow spaces. There are browns familiar from Sargent's Carolus-style portraits, but blacks and grays predominate. The depths of these paintings are gloomy yet intimate—the grays are often warm, the women are weary, refined, and sensual all at once. Evidence of Frans Hals's example is strong—especially in flickering, feathery touches of orange and lavender—though he can easily be overlooked in favor of Velázquez. Sargent appears to have learned from the Spaniard how to hollow out an interior with shadows, how to give it grandeur with the sparse

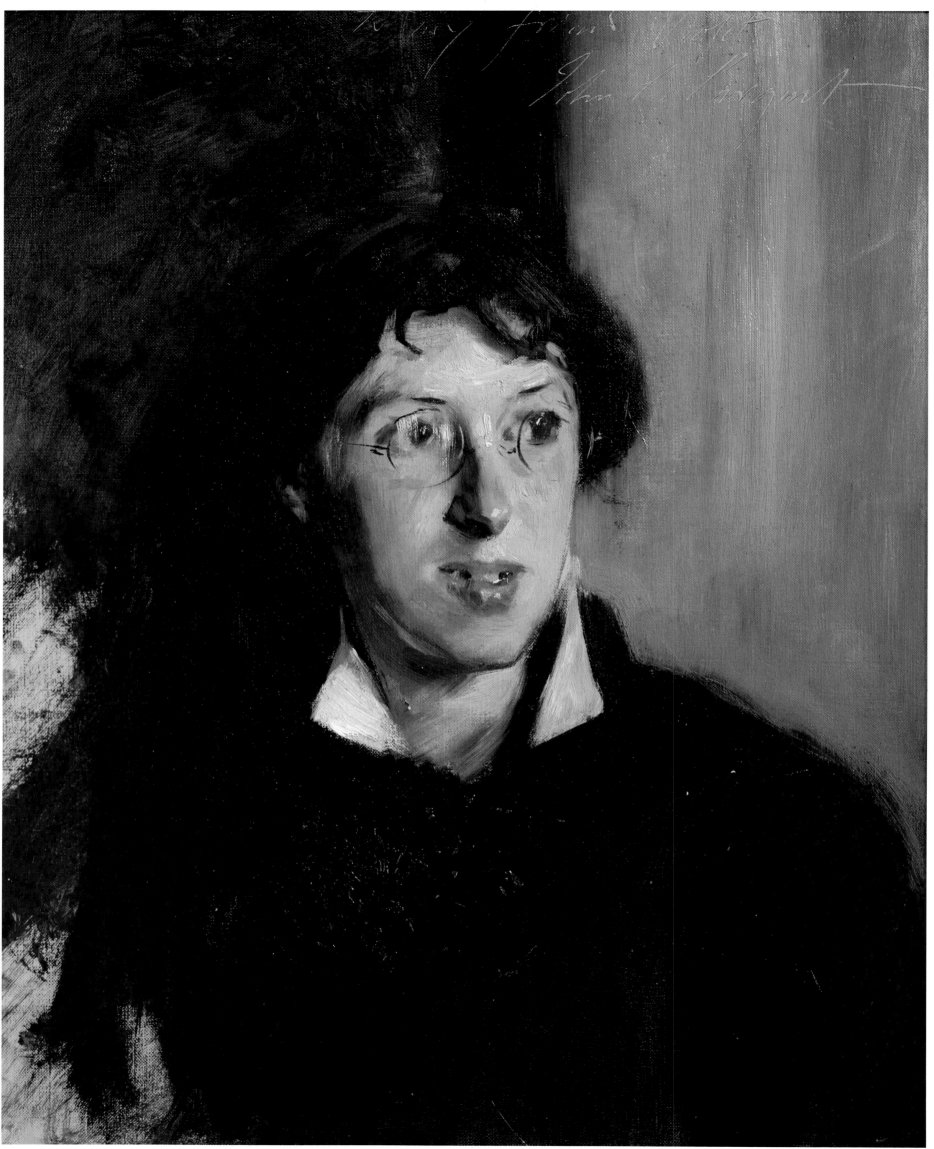

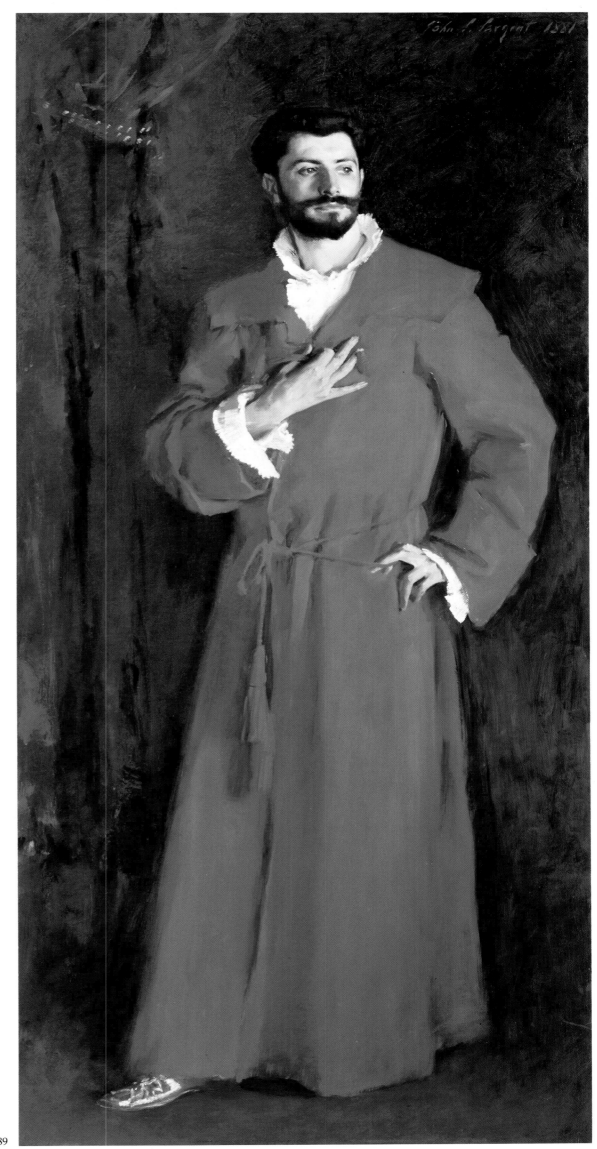

88. *Vernon Lee*, 1881. Oil on canvas, 21⅛ x 17 inches. The Tate Gallery, London.

89. *Doctor Pozzi at Home*, 1881. Oil on canvas, 80½ x 43⅞ inches. The Armand Hammer Foundation, Los Angeles.

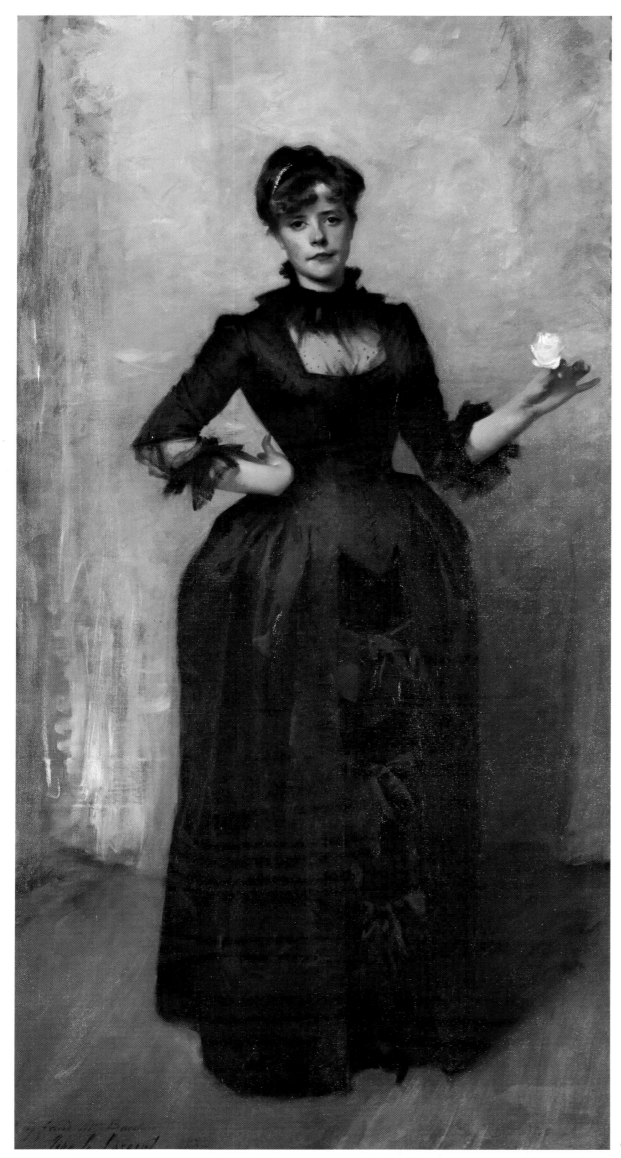

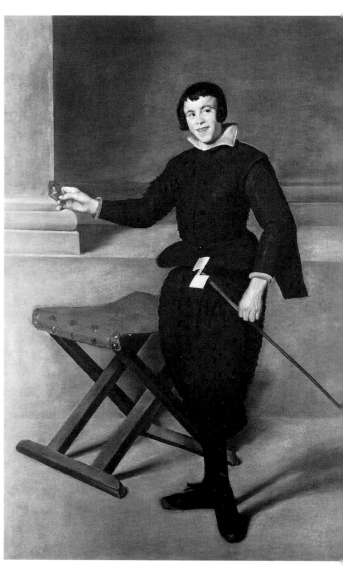

90

91

92

90. *Lady with a Rose (Charlotte Louise Burckhardt)*, 1882. Oil on canvas, 84 x 44¾ inches. The Metropolitan Museum of Art, New York. Bequest of Mrs. Valerie B. Hadden, 1932.

91. Diego de Velázquez. *Portrait of the Jester Calabazas*, c. 1628–29. Oil on canvas, 69 x 41¾ inches. The Cleveland Museum of Art. Purchase, Leonard C. Hanna, Jr., Bequest.

92. *Mr. and Mrs. John W. Field*, 1882. Oil on canvas, 44 x 33½ inches. The Pennsylvania Academy of the Fine Arts, Philadelphia. John Wm. and Eliza Field Collection.

placement of architectural forms. Sudden streaks and small blocks of light—touches of the sun—suggest a world beyond the intimacy of these paintings.

In late fall Sargent's parents left Venice for Nice, and he returned to Paris. That November he wrote to Vernon Lee to say that he had finished two portraits "and the Spanish Dancers are getting along very well."[39] One of the portraits was of the Pailleron children, the other of Dr. Pozzi (plate 89), a friend of Carolus-Duran and the Pailleron family. Sargent executed them both in a style that must have pleased Carolus. There is a report that he visited Sargent's studio during this period and pronounced himself satisfied by what he saw. In June of 1881 Sargent wrote to Ben del Castillo: "Just a few frantic arabesques to acknowledge the receipt of your pleasant letters and communicate my plans. In the first place I have got a 2ieme *medaille* at the Salon and an *hors concours* and a great swell. I accept your congratulations. It is for the portrait of a Chilean lady (Mme. R.S.) that I was painting last summer. . . ."[40] No doubt Carolus was gratified when Sargent's portrait of Mme. Subercaseaux won a second-class medal. He was a member of the jury.

After the May 1 opening of the 1881 Salon, Sargent had traveled to England with his parents and sisters. Having seen them off on a voyage to America, he settled into the London studio of his friend and fellow painter, Joseph Farquarson, who was away in Egypt. Sargent traveled too—he painted the portrait of Joseph's brother, Robert, in Scotland. Back in London, he made an oil sketch of Vernon Lee (plate 88). They had written to each other over the years, but this was their first meeting since age sixteen. The sketch is another of Sargent's bravura successes. Its open manner didn't match that of the artist himself—or at least not in the judgment of Vernon Lee. In June she wrote to her mother about her meeting with Sargent: "When we returned home, the maid said there were visitors in the drawing room, Mr. Sargent—so I rushed up to John and past the two others . . . John is very stiff, a sort of completely accentless mongrel . . . rather French, faubourg sort of manners. . . . He was very shy, having I suppose a vague sense that there were poets about." They visited Burne-Jones's studio and saw the latest works in his *Briar Rose* cycle. These Vernon Lee "admired extremely, & so did John; I think John is singularly unprejudiced, almost too amiably candid in his judgments. He remained to tea. . . . He talked art and literature, just as formerly, and then, quite unbidden, sat down to the piano & played all sorts of bits of things, ends & middles of things, just as when he was a boy."[41]

93

94

93, 94. *Two Sketches for "El Jaleo,"* c. 1879. Ink and wash on paper, 5 x 8 inches each. Fogg Art Museum, Harvard University, Cambridge, Massachusetts. Gift of Mrs. Francis Ormond.

95. *Study of Musicians for "El Jaleo,"* 1879. Charcoal on paper, 9½ x 12⅞ inches. Isabella Stewart Gardner Museum, Boston.

96. *Study of "El Jaleo,"* before 1882. Pencil on paper, 10¼ x 5¼ inches. The Metropolitan Museum of Art, New York. Gift of Mrs. Francis Ormond, 1950.

In her memorial sketch of Sargent, Lee says that "in 1881, he described himself as an impressionist and an 'intransigeant' entirely given up to the faithful reproduction of 'les valeurs'"[42]—values or tones of light and dark. Now, Sargent (or perhaps Lee) has gotten the Impressionist program wrong. At best, "the faithful reproduction of 'les valeurs'" is only part of it. At worst, tonal painting and Impressionism are at odds. Very late in his life, Monet said that Sargent had never been an Impressionist, and he certainly wasn't one in 1881. During the summer of that year Sargent painted a head of Poppy Graeme, another member of Joseph Farquarson's family. Having set the pale face above a bright scarf, Sargent renders hair and dress in dark glazes. With the young woman's features in three-quarter profile, the far side of her face is almost lost to the shadows of the background. This portrait follows the manner of Velázquez to extremes of moodiness, yet it is delicate throughout. Sargent was saving all his pictorial violence for *El Jaleo*.

The latter was his entry in the Salon of 1882, along with a portrait of Charlotte Louise Burckhardt, which has come to be known as *Lady with a Rose* (plate 90). Jules Comte, of *L'illustration*, let himself be impressed. Of this portrait he said, "one does not know which to admire most, the simplicity of the means which the artist has employed or the brilliance of the result which he has achieved."[43] This echoes the lesson Carolus-Duran had learned from Velázquez. *Lady with a Rose* is executed very much in the manner of Carolus himself. *El Jaleo*, by contrast, is touched with extremism—five years later, Henry James wrote that "it looks like life, but it looks also, to my view, rather like a perversion of life, and has the quality of an enormous 'note' or memorandum, rather than of a representation."[44] The painting shows that Sargent has looked at Velázquez, yet it doesn't strike James "as having come into the world under the same star as those compositions of the great Spaniard which at Madrid alternate with his royal portraits."

Lady with a Rose borrows its composition from Velázquez's *Portrait of the Jester Calabazas*, c. 1628–29 (plate 91). Perhaps James knew this, perhaps not. At any rate, he feels that the painting has "much in common with a Velasquez of the first order." It translates "the appearances of things into the language of painting with equal facility and brilliancy." Olivier Merson, writing in *Le monde illustré*, simply gushed:

"Ah well, this image of a young lady is everything one could possibly wish. Her pose is at once unexpected and unconstrained, her coloring exquisite, and her face, which is pretty and sweet, has charm. The drawing, like the modeling, is as supple as it is correct, and—here is the miracle—gathering all together, joining detail to ensemble, is the artist's facture, the free and frankly stated feathering of which hides no subterfuge, masks no treason against the truth."[45]

In July of 1882 London's *Art Journal* published "The Salon from an Englishman's Point of View." Its anonymous author says Sargent's art is filled with "reflexes of Spain and its great master, Velasquez." As for *El Jaleo*, he praises its "powerful and masculine rendering." Sargent, he goes on, is "now the most talked about painter in Paris."[46] In September the *Art Journal* offered "A Frenchman's Point of View." This particular Frenchman, Victor Champier, is "not infatuated" with *El Jaleo*, "as everyone else is," though he's willing to "admit its power."[47] Champier sails by the portrait of Charlotte Louise Burckhardt without a word. Antonin Proust, a critic for the *Gazette des beaux-arts*, is less grudging. Sargent, he says,

is an artist who has been called to a great future. His progress since 1879 has been rapid and sure. Every day, he seems to possess a more original talent. The portrait he shows here [*Lady with a Rose*] is a work which lacks for nothing. These days, when so many women wonder who might best paint them, M. Sargent's command of portraiture leads one to doubt that he will abandon his art. . . . *El Jaleo*, a gipsy dance, shows the most remarkable qualities of observation and invention. M. Sargent is especially admirable in so far as he never subordinates his impressions to those devices which he may have drawn from the methods of others. The dancer's movement, which he renders by the vagueness of her outline, is a striking effect. And if the background figures are not drawn as correctly as one might desire, the eye is so taken by the principal figure that one is ready to pardon M. Sargent for this lapse in transferring to canvas the results of those very close studies after nature which, evidently, he has made for each figure of this lively scene.[48]

Sargent had indeed made studies for every figure in *El Jaleo* (plates 93–97). Starting out with his Spanish drawings from the winter of 1879–80, he worked his way through oil sketches of hands, faces, and other details. He drew minutely accurate studies of costumed models. He tried a variety of compositional experiments in pencil, ink, and paint. Each of these steps had to be made during time taken off from portraits

97

98

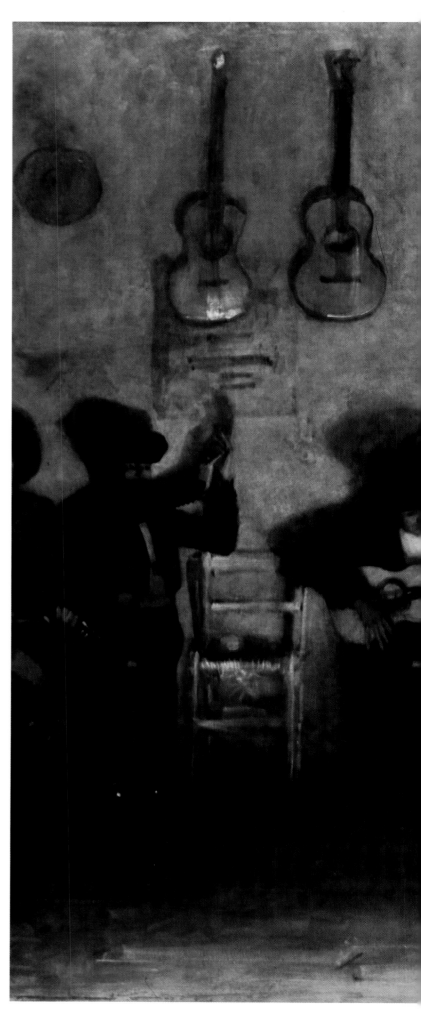

97. *Sketch for "El Jaleo,"* 1879. Charcoal on paper, 9¼ x 13 inches. Isabella Stewart Gardner Museum, Boston.

98. Edouard Manet. *Spanish Dance*, 1862. Oil on canvas, 24 x 36 inches. The Phillips Collection, Washington, D.C.

99. *El Jaleo*, 1882. Oil on canvas, 94½ x 137 inches. Isabella Stewart Gardner Museum, Boston.

99

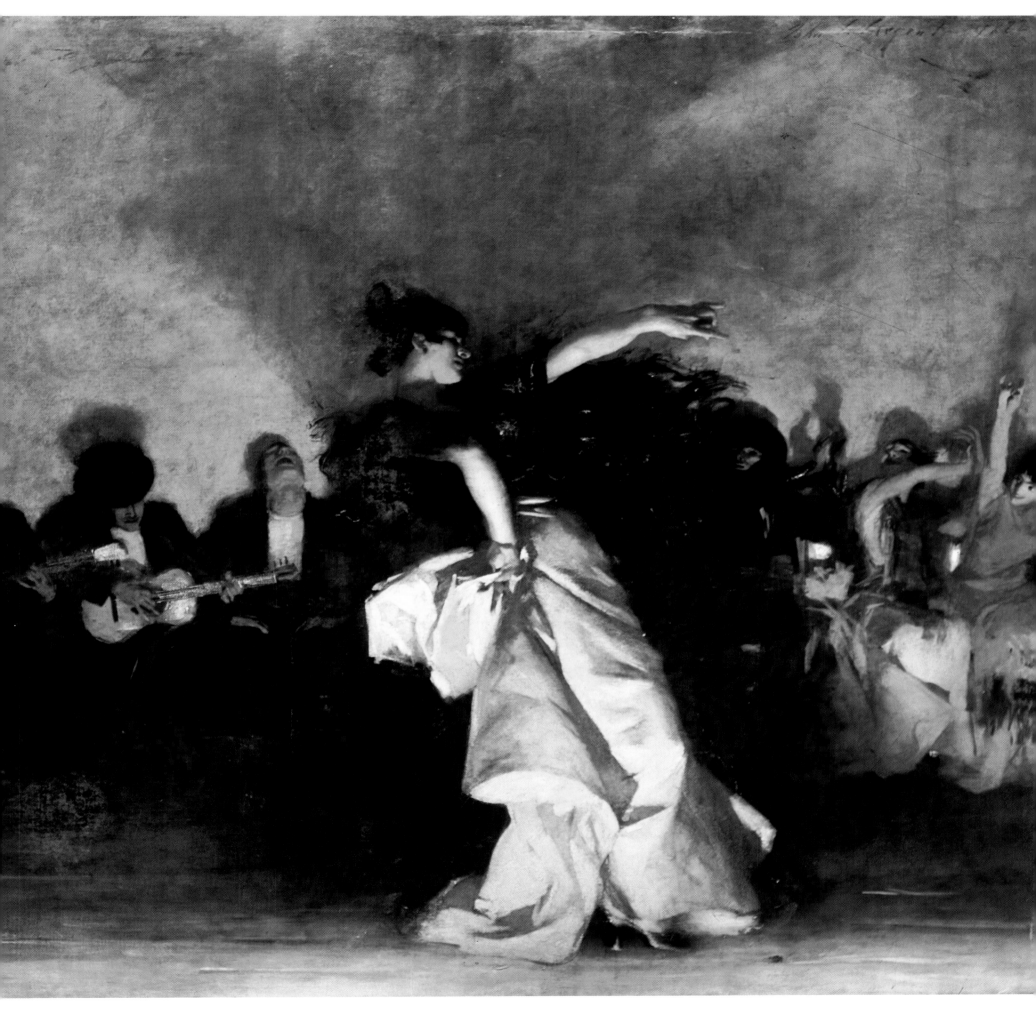

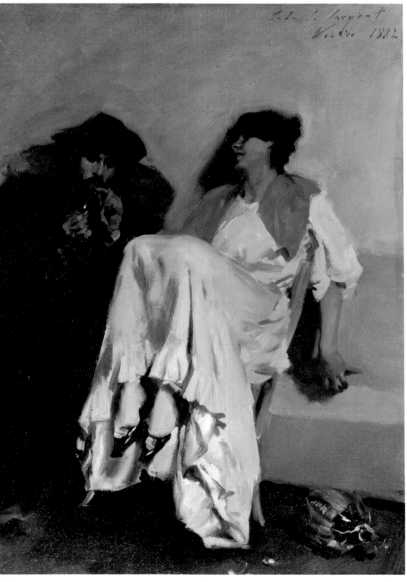

100

100. *The Sulphur Match*, 1882. Oil on canvas, 22¹³⁄₁₆ x 16⅜ inches. Collection of Jo Ann and Julian Ganz, Jr., Los Angeles.

101. *Italian Girl with Fan*, 1882. Oil on canvas, 93¾ x 52½ inches. Cincinnati Art Museum. The Edwin and Virginia Irwin Memorial, 1972.

of Dr. Pozzi, of the Pailleron family, and other commissioned work. Every time he found a new pose for a "Spanish" model or flattened the space of the painting a bit farther, he sought to give studio artifice more impact. And now a London critic had called him the most talked-about painter in Paris. Very soon, Sargent's critical success was seconded in the marketplace: *El Jaleo* was purchased by an American.

El Jaleo celebrates a Spanish subject. It celebrates as well the power of tonal contrast. Sargent modulates his tone with a masterly flow of glazes over the surface of the painting, thus acknowledging Velázquez —and thereby Carolus-Duran. Yet the whites of *El Jaleo* are so white, and its blacks are so black, that pictorial flair threatens always to lurch off into theatrical excess. Carolus might well have disapproved. In particular, the highlights of skirts and guitars are piled on and keyed up to the point where they are almost chalky. This points away from Carolus-Duran to another disciple of Velázquez, Edouard Manet.

Unlike Sargent's teacher, Manet had looked closely at Goya too. He had rid his art of that genteel, old-masterish air that was Carolus's stock-in-trade. In Manet's paintings, tonal transitions are blunt. As he himself puts it, in a memoir published by Antonin Proust in 1913, "The light presents itself to me with such unity that one tone is sufficient to render it, so it is preferable, even if it seems brutal, to pass brusquely from light to dark rather than accumulate things the eye cannot see and which not only weaken the vigor of the lights, but attenuate the coloration of the shadows which are important to render its correct values."[49] At the time Manet first began to exhibit, his style was indeed perceived as brutal—or simply laughable. When his *Olympia* of 1863 was seen at the Salon two years later, a critic for *Le figaro* said "you scarcely knew whether you were looking at a parcel of nude flesh or a bundle of laundry." Théophile Gautier, that fastidiously Romantic poet, diarist, and social observer, said a few years afterward that "despite his tremendous faults, Manet has the knack of rousing one's lively curiosity. One worries about what he does. One asks oneself: 'Will there be some Manets at the Salon?' He has his fanatical followers and his detractors. Very few remain indifferent to this strange painting, which seems to be the negation of art and yet which adheres to it."[50]

Not every critic admitted to worrying about Manet. The *Revue des deux mondes*, edited by Edouard Pailleron's father-in-law, had kept silent about the painter throughout the 1860s. But in 1882, the year of Sargent's success with *El Jaleo*, the *Revue*'s critic Henri Houssaye was forced to take Manet into account. By his tally, at least two hundred of the

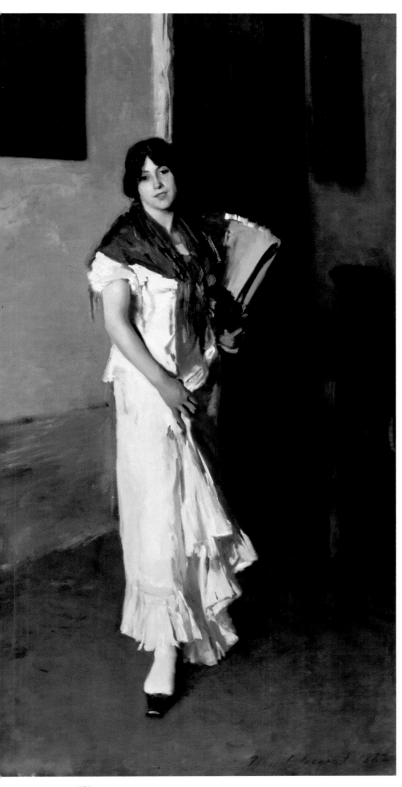

paintings in that year's Salon had been influenced by Manet or by Jules Bastien-Lepage, his "Glorious Apostle." If there was a School of Manet, then surely his friend Carolus-Duran belonged to it. So had Claude Monet, at least in the 1860s. In the 1870s, when Impressionism flowered, it could be seen as a brilliant reaction to Manet's "brutal" way with tones. Instead of carrying lights and darks to extremes, Monet, Renoir, and the others went a step farther—they concentrated on the very lightest tones, thus opening up their palettes to a vast range of undiluted colors. All the rest of Impressionism followed, including the new divisionist paint handling.

Whether or not Manet's impact actually could be seen in two hundred of the paintings at the Salon of 1882, his example is obvious in *El Jaleo*. Houssaye liked the painting—it "is the work of a true painter"—and yet "even painters in full possession of their talent are troubled by Impressionism," a label the critic (like Sargent himself) applied first of all to Manet. "Does one imagine there is no preoccupation with this new art in Vibert's *Portrait of a Child*, in Sargent's *El Jaleo*?" Of Manet's *Bar at the Folies-Bergère*, 1882, he asked, "In all honesty must we admire the chalky face of the bargirl, her flat bust, her offensive color? Is this painting true? No! Is it attractive? No!"[51] Sargent's dancer, on the other hand, is brilliant—light coming from below "gives superb highlights to her white satin dress and a shimmer to the green spangles of her mantilla. On the flesh of arms and face, the artificial light [of the scene] brings out . . . intense shadows and . . . reflections; day breaks on the flesh of forehead and deeply shadowed neck." Houssaye understood Sargent's tactic—to transform Manet's "brutal" manner into a swirl of theatrical gestures. And he congratulated Sargent for executing the maneuver so well.

The Paris Salon was, above all, a marketplace where every year over four thousand works of painting and sculpture competed for the attention of potential patrons. Of course few among those who crowded into the galleries of this immense exhibition actually bought landscapes, commissioned portraits, or assigned artists to projects of public decoration. Nonetheless, the response of the general audience was important. Parisian Salon-goers formed the major constituency for art, and an ambitious artist had to court them much as a politician courts voters. In this century, we have inherited the attitudes of those avant-garde artists who felt that a concern for public taste was a betrayal of their integrity. Yet even so radical a painter as Manet showed at the Salon year after year, and on those occasions when the jury rejected his work,

102

103

he arranged to exhibit it in a makeshift gallery while the Salon was in session. Earlier, Courbet had done the same.

Like their conservative colleagues, these painters believed that art was addressed to the culture at large, not to an elite audience with narrowly aesthetic concerns. Critics hesitated to approve and patrons were reluctant to buy if public opinion ran strongly against an artist. The indifference of the crowd was even more damaging than its dislike. An artist's first step was to attract the attention of his constituency—to announce himself, so to speak, as a candidate for serious attention. Sargent did that brilliantly with *El Jaleo*. The critics, each of whom took it upon himself to speak for some faction of the general audience, could not afford to ignore this painting. At the age of twenty-six, Sargent had made himself an important contender in the politics of style, which had its parliamentary arena in the Salon. By switching his allegiance from the proper Carolus to the still risky Manet, Sargent offered the public all that it liked in the more radical artist and little it distrusted. The subject, the lighting, the poses of *El Jaleo* give passionate immediacy to those pictorial devices—tonal separation, in particular—that had become detached and cerebral under the pressure of Manet's extremism. Manet's own *Spanish Dance*, 1862 (plate 98), is a stiff, deliberately difficult exercise in confronting the viewer. This painting stops one cold, then challenges the eye to find the life at the heart of its artifice. In *El Jaleo*, mannerisms of style blend easily with the dramatic occasion of the dance. This canvas sweeps the imagination into its theatrics. Sargent emerged from the Salon of 1882 with the support of a vocal constituency. It seems fair to assume that he had adjusted *El Jaleo* to the prevailing climate in hopes of achieving just this result. Once again, avant-garde ultras would hold his calculation to be sheer cynicism. For Sargent, as for nearly every other artist of his time, such purism would have been self-defeating. A responsible maneuver in the politics of style required a high degree of respect for the educated public that served as the repository of culture. Art found its vindication by attracting a serious, widespread audience.

104 105

In August of 1882 Sargent visited Ralph Curtis and his family in Venice. The Curtises had lived for four years in the Palazzo Barbaro, on the Grand Canal. Mr. Daniel Curtis was a cousin of Dr. Sargent's; Mrs. Curtis was the daughter of an English admiral. Every spring and summer they received visitors at the palazzo. Over the years these included Henry James, Isabella Stewart Gardner, and, in 1885, Vernon Lee. "These sort of Americans," Lee wrote, "who shudder at [William Dean] Howells, look up to James as a sort of patron saint of cosmopolitan refinement."[52] She's willing to allow, however, that they are "indeed most friendly & amiable." On his first visit Sargent stayed until late in the year. Among his paintings is a head of Mrs. Curtis, another set of pale features against a dark, lush background (plate 102). He also painted more of his Venetian genre scenes. In December, after his hosts had left and Sargent had moved to other quarters, he wrote to Mrs. Curtis: "If you stay there late enough you will perhaps see how curious Venice looks with the snow clinging to the roofs and balconies, with a dull sky and the canals of a dull opaque green, not unlike pea soup, con rispetto, and very different from the julienne of the Grand Canal in summer."[53] Sargent has one of his canvases in mind as he writes—*Venise par temps gris* (plate 105), a near monochrome. Leaden at first glance, it takes on an inexhaustible delicacy in the course of a longer look.

Sargent sent *A Street in Venice* (plate 106) to the 1883 exhibition of the Société Internationale des Peintres et Sculpteurs, Rue de Sèze, in Paris. A critic for the *Gazette des beaux-arts*, Arthur Baignères, dismissed Sargent's Venice as a "banal and worn-out" place. "M. Sargent leads us into obscure squares and dark streets where only a single ray of light falls. The women of his Venice, with their messy hair and ragged clothes, are no descendents of Titian's beauties. Why go to Italy if it is only to gather impressions like these?"[54]

Sargent had made a mark with the theatrical flair, even harshness, of *El Jaleo* and with the exceedingly picturesque atmosphere of his Venetian pictures. These qualities had their admirers, but then so did the finesse, the gentility, of Sargent's portraits—*Lady with a Rose*, in particular. Sargent was developing two strong positions in the politics of con-

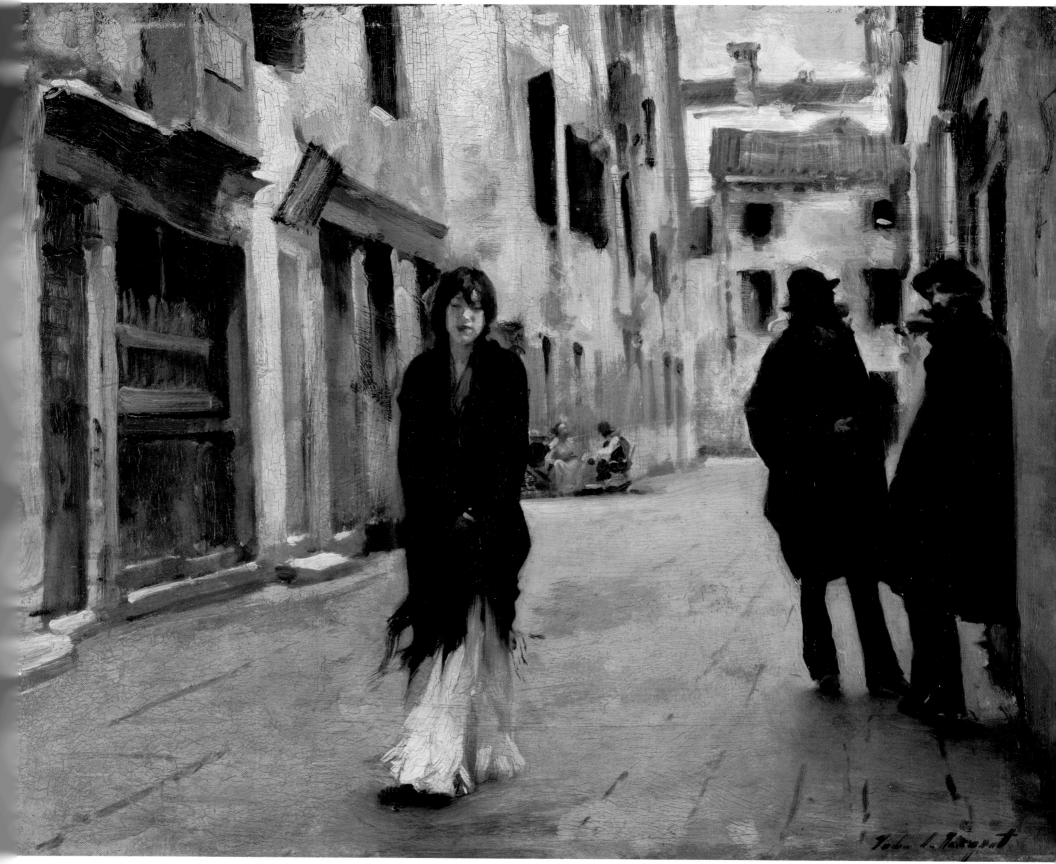

temporary style. Then, with *The Daughters of Edward D. Boit*, 1882 (plate 107), he consolidated them. Arthur Baignères, who found *A Street in Venice* so dull, thought Sargent's painting of the Boit girls one of the best paintings at the Rue de Sèze show—this despite the fact that it repeats on a large scale much of what Sargent had been developing since 1880 in his Venetian paintings.

Henri Houssaye, writing in the *Revue des deux mondes*, said that *The Daughters of Edward D. Boit* is "composed according to some new rules, the rules of the four corners game,"[55] for the painting is square—87 by 87 inches—and this was odd in the 1880s.[56] Turner had experimented with the same format. So had Albert Pinkham Ryder. Sargent himself employed a nearly square canvas in the *Spanish Dance* of c. 1879–80. Yet he never used this shape to challenge traditional picture making, as Turner and Ryder had done. His picture of the four Boit girls places them in patterns that imply a variety of more usual compositions—some of them horizontal, others vertical, all of them homages to the structure of *Las Meniñas*, 1656 (plate 109), of Velázquez. By squaring off this large canvas, Sargent was able to immerse formal portraiture in the dark, mysterious atmosphere that fills his Venetian genre pieces.

Sargent's facture is as vigorous here as in *El Jaleo*, and the tonal contrasts of this portrait are as extreme as those in the earlier work. But Sargent now leans toward the fluency of Frans Hals, away from Manet's "brutal" style. The critic for the *Gazette des beaux-arts* is enchanted.

> Must one count M. Sargent among the foreigners? He was born in America, but he learned to paint in Paris, under the tutelage of M. Carolus-Duran. He does an honor to our city and to his teacher. . . . What strikes one first of all is the degree to which he enjoys his metier. As a natural consequence, he provides enjoyment to others. One is able to follow the trace of his brushstroke over the canvas, as it leaves its mark. And the palette knife makes no attempt to preserve its anonymity. Large and small, his pictures are executed with the same passion.[57]

But only in this large formal portrait, with its unimpeachable propriety, were Sargent's pictorial passions completely acceptable. Henry James said in 1887 that Sargent "has done nothing more felicitous and interesting." He found this painting of the Boit girls "astonishing" for "the sense it gives us as of assimilated secrets and of instinct and knowledge playing together." It seems as though Sargent had set out to consolidate the respectable side of his reputation with the more extreme

106. *A Street in Venice*, c. 1882. Oil on canvas, 17¾ x 21¼ inches. National Gallery of Art, Washington, D.C. Gift of the Avalon Foundation.

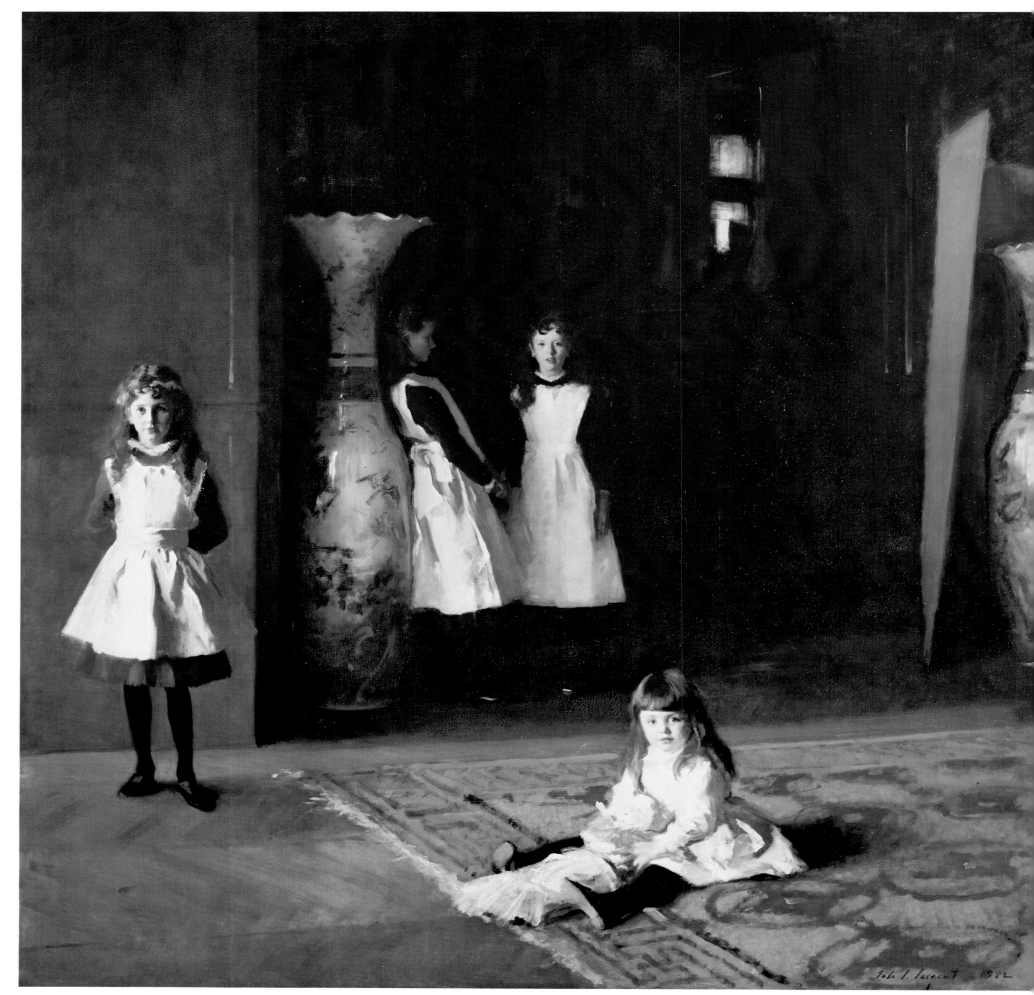

107

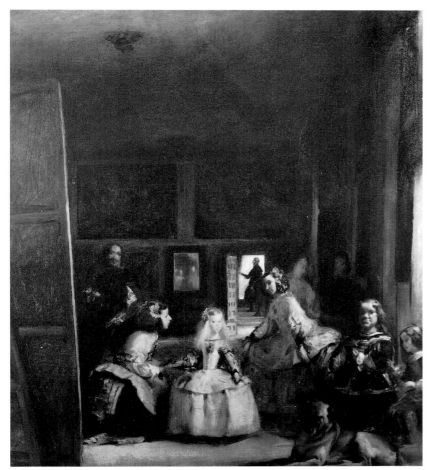

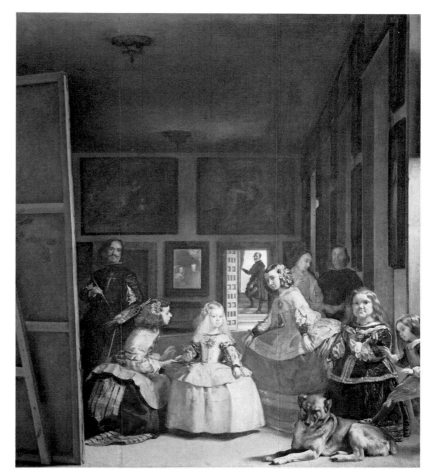

107. *The Daughters of Edward D. Boit*, 1882. Oil on canvas, 87 x 87 inches. Museum of Fine Arts, Boston. Gift of the daughters of Edward D. Boit.

108. *Las Meniñas* (after Velázquez), c. 1879. Oil on canvas, 39½ x 44½ inches. The Ormond Family.

109. Diego de Velázquez. *Las Meniñas*, 1656. Oil on canvas, 125 x 108⅝ inches. Museo del Prado, Madrid.

posture established by *El Jaleo*. He succeeded. Now he waited for portrait commissions to come in. There were a few, including an order from Henry St. John Smith for a small picture of his wife. But most of his portraits continued to be presentation pieces—likenesses taken for no fee, out of friendship and in hopes of generating commissions.

Sargent might have solved his problems by setting out along that avant-garde path that led past general neglect to a scorn of the public, all in the name of radical discovery. In other words, he could have become the ''intransigeant'' he had claimed to be in 1881. The avant-gardists would certainly have welcomed him. Two years later, Berthe Morisot worked hard at persuading Sargent to show with the Impressionists. So did Mary Cassatt, though her efforts may have been tempered from the outset by that skepticism toward her fellow American that made her later remarks about him so bitter.[58] Sargent never broke completely with the avant-garde during the 1880s. His political sense would not have permitted that. In 1884 he did show with Monet, not at an official Impressionist exhibition, but in a group show at the Galerie Georges-Petit, in Paris. The summer of that year Sargent sent his portrait of Dr. Pozzi to be shown in the company of *Les XX*, an avant-garde group in Brussels with amorphous borders. Sargent was always reluctant to close down possibilities. His hopes for his art were large and, in the early 1880s, still not fully focused. He knew, though, that he wanted to address a large audience. The lack of commissions made clear the need to deploy other tactics. Rather than elaborate his style any further, he decided to bolster it with a dramatic subject—Madame Pierre Gautreau.

IV. *The Scandalous Madame X*

MADAME GAUTREAU WAS A FIGURE OF FASHION and notoriety. Née Virginie Avegno, she grew up in Louisiana amid the luxuries of plantation life, or at least that was the Parisian understanding of her past. During the Civil War her father fought for the Confederacy and was killed. With the war over, she and her mother moved to Paris, where Virginie made a match with a prosperous banker, Pierre Gautreau. Sargent may have met her in 1880, when he painted Dr. Pozzi, who was said to be one of Mme. Gautreau's lovers. Knowing that she was a friend of the del Castillo family, Sargent wrote to Ben: "I have a great desire to paint her portrait and have reason to think she would allow it and is waiting for someone to propose this homage to her beauty. If you are 'bien avec elle' and will see her in Paris you might tell her that I am a man of *prodigious talent*."[59] Early in 1883 Madame Gautreau agreed to pose. She sat for a few drawings—a very few—and the artist learned that he had an extremely restless sitter on his hands.

That spring Sargent received another commission, this one from Mrs. Henry White, wife of the American chargé d'affaires in London. Like her friend Henry James, she had been impressed by *Lady with a Rose* (plate 90). (Mr. White was more cautious—he chose to sit for Léon Bonnat, Sargent's former teacher.) Presented full-length, Mrs. White looks out at the viewer with a dignity touched, perhaps, by apprehension. Many of Sargent's sitters have an expression of this sort. We interpret it as evidence of his insight into their personalities, and no doubt this is often correct. Still, it does seem odd to meet dignified tenseness so frequently in a single portraitist's oeuvre—surely the inward states of Sargent's clientele were more disparate. This persistent similarity may signal a common response to a shared experience—that of offering oneself as the subject of formal portraiture, a genre devised in earlier times to celebrate the highest political and ecclesiastical authority. Realist conventions teach us to discount the effects of the image-making process, yet it appears likely that many who posed for Sargent found it an uncomfortable responsibility. To the sophisticated, sitting for a formal portrait was a challenge to be met. Would one come across as worthy of the genre? Sargent could not be counted on to grant the

110. *Madame X*, detail. See plate 120.

anxious a look of seignorial calm. Some of his subjects do have such a look; most, however, do not. Of the latter, a few appear to be enjoying themselves—see *Mrs. Edward D. Boit* (plate 153) and *Mrs. Carl Meyer and Her Children* (plate 245). Some look bored; several show a touch of Mrs. White's uneasiness. Of course, Sargent was a master of likenesses, capable of giving a face any expression he pleased. At the same time, he was a traditionalist who considered posing an occasion to which the client should rise. And he was enough a realist to record precisely the degree of success each of them achieved.

Work on Mrs. White's portrait progressed serenely, but Mme. Gautreau chose to be more difficult. Since she didn't want to complete her sittings in Paris, her portrait would have to wait until summer, when she and her husband would be at Les Chênes Paramé, the Gautreau estate in Brittany. Since Madame Gautreau's portrait was not commissioned, and she had done the artist a favor by consenting to serve as one of his subjects, Sargent was in no position to object. He traveled to Les Chênes Paramé, set up his easel, and tried, in the course of roughly thirty sessions, to find an effective pose. He sketched her sitting upright, lounging on a sofa, standing. Mme. Gautreau's restlessness worked against Sargent's efforts to capture the clarity of her profile.

There were other difficulties as well. In February of 1883 Sargent had written to Vernon Lee from Nice: "Do you object to people who are fardées [made up] to the extent of being a uniform lavender or blotting paper colour all over? If so you would not care for my sitter. But she has the most beautiful lines and if the lavender or chlorate-of-potash-lozenge colour be pretty in itself I shall be more than pleased."[60] Does this letter mean that Sargent had never stood close enough to Mme. Gautreau to decide if her peculiar make-up was "pretty in itself"? That summer he seems to have decided that it was not. In drawings he could ignore the lavender tint. In an oil sketch of Mme. Gautreau making a toast (plate 121), he dissimulates, giving her skin the glow of an atmospheric effect. This sketch is a brilliant performance, rapid and delicate. Sargent's brush seems nearly weightless as he extends the woman's arm across the canvas. Spearlike brushstrokes suggest candlelight caught in chiffon. Sargent executes with finesse the pictorial tactics that join the glow of the polished table top to the shadowy depths of the room. Nothing of this work survives in the finished portrait, save the painter's fascination with Mme. Gautreau's profile.

Back in Paris on the fourteenth of July, Bastille Day, Sargent suffered his own attack of restlessness. On the spur of the moment he, Paul

112

113

114

115

116

112. *Madame Gautreau* (two studies), c. 1883. Charcoal on paper, 16 x 22 inches. British Museum, London.

113. *Madame Gautreau*, n.d. Pencil on paper, 9⅝ x 10⅜ inches. Fogg Art Museum, Harvard University, Cambridge, Massachusetts. Bequest of Grenville L. Winthrop.

114. *Madame Gautreau*, n.d. Pencil on paper, 13³⁄₁₆ x 9¾ inches. The Metropolitan Museum of Art, New York. Gift of Mrs. Francis Ormond and Miss Emily Sargent, 1931.

115. *Madame Gautreau*, before 1884. Pencil on paper, 9¾ x 13³⁄₁₆ inches. The Metropolitan Museum of Art, New York. Purchase, 1970; Charles and Anita Blatt Fund, John Wilmerding Gift, Rogers Fund.

116. *Madame Gautreau*, n.d. Pencil on paper, 12⅝ x 8¼ inches. The Metropolitan Museum of Art, New York. Gift of Mrs. Francis Ormond and Miss Emily Sargent, 1931.

Helleu, and another young painter, Albert Belleroche, took a night train to the Netherlands. The next day they visited some of Frans Hals's paintings in Haarlem, then returned directly to Paris. Traveling on to Brittany soon afterward, Sargent found Mme. Gautreau less cooperative than ever. He wrote to Vernon Lee: "Your letter has just reached me, still in this country house struggling with the unpaintable beauty and hopeless laziness of Mme. Gautreau."[61] To Belleroche he wrote, "Madame Gautreau is at the piano driving my thoughts away."[62] It was usually Sargent who played the piano while his sitter rested, and ordinarily the effect was refreshing.

When Sargent left Les Chênes Paramé for Paris, the portrait was only half-finished. And his restlessness now, in October, was as acute as it had been on Bastille Day. Sargent traveled to Italy, but was soon back in Paris, hard—even desperately—at work on Mme. Gautreau's portrait. Sometime late in 1883 he wrote to Ben del Castillo:

> The painting is much changed and far more advanced than when you last saw it. One day I was dissatisfied with it and dashed a tone of light rose over the former gloomy background. I turned the painting upside down, retired to the other end of the studio and looked at it under my arm. Vast improvement. The *élancée* figure of the model shows to much greater advantage. The picture is framed and on a great easel, and Carolus has been to see it and said: "Vous pouver l'envoyer au Salon avec confiance." Encouraging, but false. I have made up my mind to be refused.[63]

Because he had so heavily worked and reworked the canvas, Sargent decided to make a copy of it (plate 117). Like so many of the sketches he had made at Les Chênes Paramé, this turned out to be a false start. The copy was never finished—perhaps another sign of Sargent's anxiety.

The portrait of Mme. Gautreau was the culmination of all Sargent's calculations about style and subject matter. He had made gains with *El Jaleo* (plate 99), *Lady with a Rose*, and *The Daughters of Edward D. Boit* (plate 107). This painting would consolidate his position, or so he hoped. Having finished it, he waited for the opening of the Salon in a fog of doubts. Toward the end of 1883 Sargent decided on a course of militant optimism. He moved from his fifth-floor studio on the rue Notre Dame des Champs to a larger, more fashionably situated place on the boulevard Berthier. Only one flight up from the street, the new studio had an apartment for Sargent downstairs, with servant quarters attached; he promptly hired a cook and an Italian manservant.

117

117. *Madame Gautreau* (unfinished copy), c. 1884. Oil on canvas, 81¼ x 47½ inches. The Tate Gallery, London.

118. Charles Baude. Wood engraving after Sargent's *Madame X* in *Le monde illustré*, July 5, 1884.

119. Gustave Courtois. *Madame Gautreau*, 1891. Oil on canvas, 41¾ x 23 inches. Musée du Louvre, Paris.

One of Sargent's few sitters that spring was Mrs. Wodehouse Legh. Another may have been Auguste Rodin, although he may have sat to Sargent later in the year—there is a presentation piece, a small head of the sculptor, inscribed "A mon ami Rodin John Sargent 1884." Certainly, though, the painter spent the months and weeks leading up to the May 1 opening of the Salon in a state of anticipation shaded with other, less pleasant, feelings. In a letter to his parents about the Salon of 1884, Ralph Curtis says that the night before the opening Sargent was "very nervous." But the letter goes on: "his fears were far exceeded by the facts." Curtis himself was very nearly scandalized by the *Portrait of Mme****, as the painting was listed in the catalog of the Salon. Looking for Sargent, Curtis "found him dodging behind doors to avoid friends who looked grave. By the corridors he took me to see it. I was disappointed in the colour. She looks decomposed. All the women jeer 'Ah voila "la belle!" Oh quelle horreur!' etc."[64]

That evening Sargent was visiting his friends the Boits when an enraged Mme. Gautreau and her mother stormed into his studio. The mother later came back alone and, according to Curtis, made a "fearful scene." "All Paris is making fun of my daughter," Mme. Avegno said. "She is ruined. My people will be forced to defend themselves. She'll die of chagrin." When she demanded that Sargent remove the picture, he refused—it was against the rules and against his principles. "Defending his cause made him feel much better," writes Curtis. "Still we talked it over till 1 o'clock here last night and I fear he has never had such a blow."

Nothing said about Mme. Gautreau at the Salon was any worse than what the fashionable world had said of her already,[65] but the critics made a louder fuss about the painting itself, and the brouhaha went on for week after week. Louis de Fourcaud, a critic for the *Gazette des beaux-arts*, said, "Epithets crisscross in the air—Detestable! Boring! Curious! Monstrous! . . . One could darken ten pages with the one-word comments heard in front of this picture."[66] Henri Houssaye, art critic for the *Revue des deux mondes*, had been enthusiastic about *El Jaleo* in 1882 and *The Daughters of Edward D. Boit* the year after. Nonetheless, Houssaye's review of *Madame X* ticks off a series of impatient objections: "The profile is pointed, the eye microscopic, the mouth imperceptible, the color pallid, the neck sinewy, the right arm lacks articulation, the hand is deboned. The décolletage of the bodice doesn't make contact with the bust—it seems to flee any contact with the flesh."[67] Houssaye treats all the painting's oddities as if they were, purely and simply,

118

119

faults. Sargent has made "a sort of caricature" of a "young woman justly renowned for her beauty"—and "that is what comes of slack execution and unmeasured praise." Houssaye isn't satisfied to condemn *Madame X*; he must also take back his approval of Sargent's earlier work.

Trevor J. Fairbrother has found evidence in contemporary magazine illustrations that the portrait was originally even a touch more risqué (plate 118). At the Salon, Mme. Gautreau's shoulder strap was seen to have fallen and come to rest suggestively on her upper arm. Sargent repainted this detail soon after the exhibition closed, though the revised image was not seen until 1903, when Alice Meynell included it in her book on the painter. Even allowing for this change, however, the bitter outrage of Houssaye and his colleagues now seems odd. We've forgotten—indeed, find it difficult to imagine—how rigidly decorum was observed just a century ago, no less in Paris than elsewhere. Though Mme. Gautreau's adulteries were well known, thanks to gossip and to scandal sheets, they were not considered a fit subject for polite conversation. It was unthinkable for a painter to offer emblems of her way of life to audiences at the Salon, that sacrosanct institution of French culture. Yet that is what Sargent did. His painting rendered faithfully her covering of lavender powder, an affectation of the most brazenly voluptuous sort. Moreover, Sargent emphasized the arrogance with which she flaunted her décolletage. Leering instead of sputtering, Albert Woolf of *Le figaro* said, "One more struggle and the lady will be free."[68]

Jules Comte, a critic for *L'illustration*, took the higher road that leads from formal analysis to measured judgment: "Not a trace of drawing in the mouth; the nose is neither modeled nor simply outlined; there isn't a plane in this face, which looks plated; and what tints, what colors. . . ."[69] There is "suppleness," even "grace" in this painting, Comte admits. Yet like Houssaye, he feels he must go back on his own high estimation of Sargent. "Two years ago," he says, "M. Sargent had just returned from Spain. His paintings led one to speak of Goya. We don't know where he went next, but one might almost say that he has looked at nothing but Japanese art." In fact, Sargent did look at prints from Japan during his Parisian years; but even if that influence were much more obvious in *Madame X*, that alone certainly would not explain the impulse to write him off. Sargent had offended the public morality of fashionable Paris, which was just as strict in its way as the provincial variety.

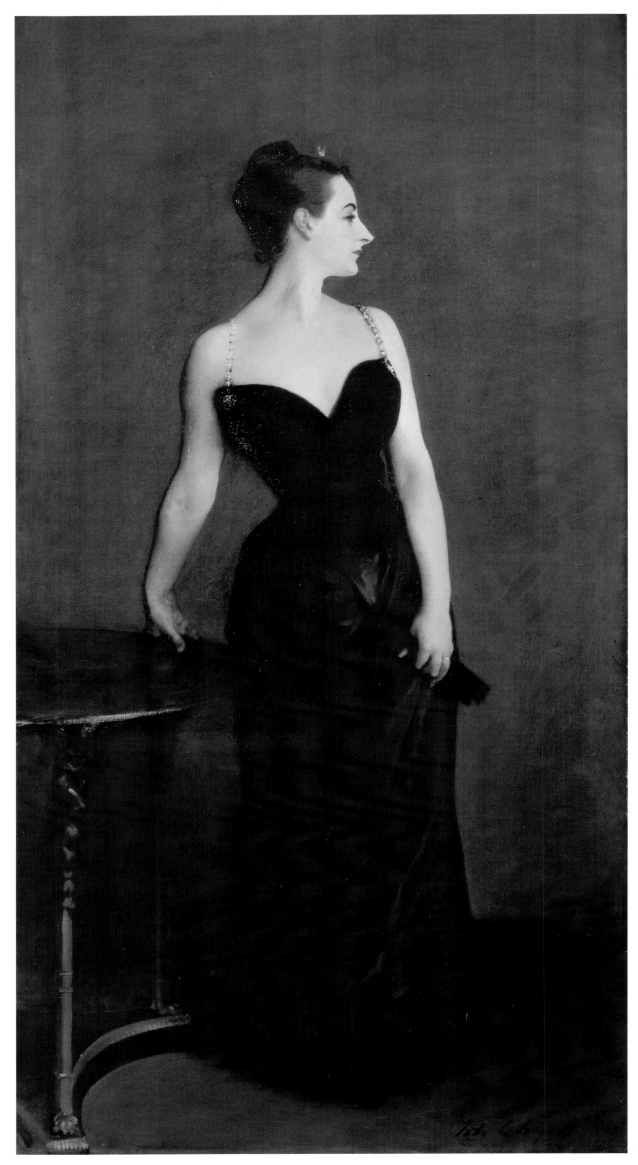

121

120. *Madame X (Madame Pierre Gautreau)*, 1884. Oil on canvas, 82½ x 43¼ inches. The Metropolitan Museum of Art, New York. Arthur H. Hearn Fund, 1916.

121. *Madame Gautreau Drinking a Toast*, 1882. Oil on wood, 12½ x 16⅛ inches. Isabella Stewart Gardner Museum, Boston.

André Michel's review in *L'art* touches sympathetically on Sargent's gaffe. "We must speak," he says, of the "small riot" the painting set off at the opening of the Salon. But

this topic is always delicate . . . and the critics of the next generation will be freer to comment on this troubling work. They will look here, no doubt, for a "document" of the "high life" of this year of grace 1884, an image of a woman which an overheated and contrived civilization, with a taste less for fresh, healthy flowerings than for the blossoms of the boudoir . . . has been pleased to fashion; and if it is true that each generation remakes in its own image the work of nature, then future critics will see here our Parisian cosmopolitanism manifested in ideal form.[70]

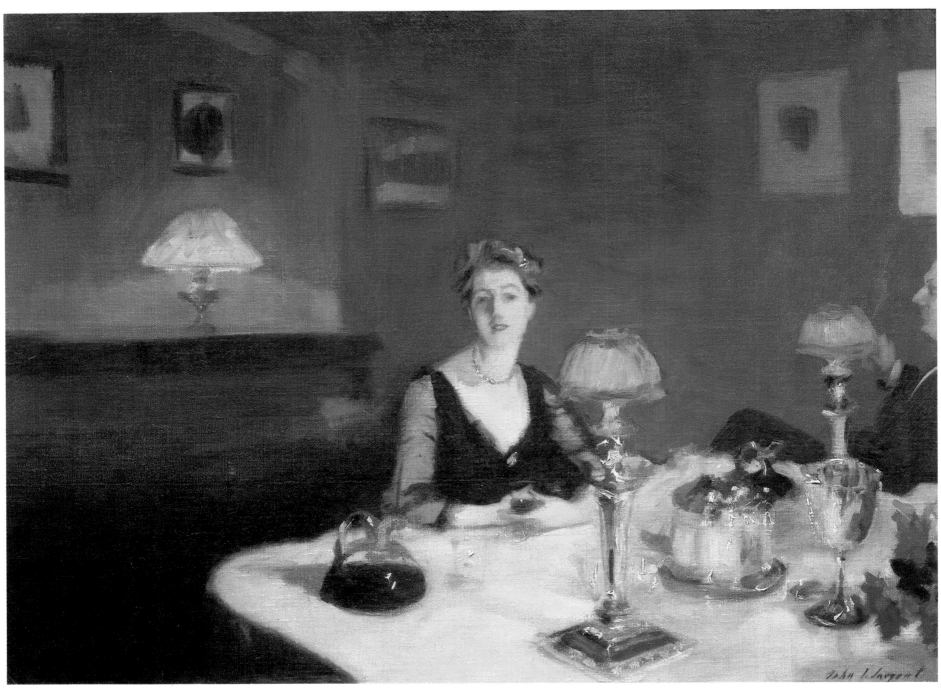

122

122. *The Dinner Table at Night (The Glass of Claret)*, 1884. Oil on canvas, 20¼ x 26¼ inches. The Fine Arts Museums of San Francisco. Athol McBean Foundation.

123. *Judith Gautier*, c. 1885. Oil on wood panel, 39 x 24½ inches. The Detroit Institute of Arts. Gift of Mr. and Mrs. Ernest Kanzler.

124. *Mrs. Katherine A. Moore*, 1884. Oil on canvas, 70 x 44 inches. Hirshhorn Museum and Sculpture Garden, Smithsonian Institution, Washington, D.C.

Fourcaud, Sargent's strongest critical defender in this debacle, makes the same point less gingerly. For him, this is a painting of "curious intentions and strange refinements . . . a complicated rendering of a complicated subject." Mme. Gautreau "was raised to be an idol constantly mentioned in the fashionable, worldly journals"—a "professional beauty." She is "not a woman" but a "sort of canon of worldly beauty." Sargent "has expressed the idol, and that is what one must see. The purity of his model's lines must strike one first of all. He has been so taken up by this aspect of her that his portrait is something like an immense cameo. . . . From head to toe, the form 'draws' itself—in one stroke, it becomes a harmony of lines."[71]

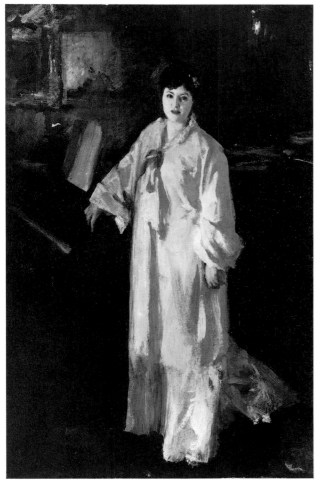

123

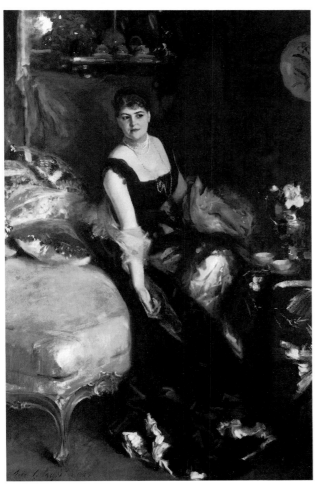

124

Sargent was in England by June 10, just as these remarks had begun to appear in the French press. Sitters awaited him across the Channel. His portrait of Mrs. Henry White had been included in the annual exhibition of the Royal Academy. Yet even though there were several reasons for Sargent's long-planned trip, his biographers have often pictured him as fleeing to England from the storm raised at the Salon by *Madame X*. And, given the critical thunder, Sargent may well have felt like a fugitive. Soon, though, he was settled in at Lavington Rectory, the house of Mr. and Mrs. Albert Vickers, near Petworth in Sussex. Sargent had met the Vickers family through Albert Besnard and Gustav Natorp, two of his friends among Parisian artists, who had reported some success in introducing English eyes to French styles. Sargent painted a full-length portrait of Mrs. Vickers and a number of oil sketches. *The Dinner Table at Night (The Glass of Claret)* (plate 122) plays bright, heavily impasted highlights off against deep, delicately glazed passages of shadow. Sargent continued, nearly to the end of his life, to paint pictures like this—images of interiors whose elegance has been permitted to take a step or two toward informality. His *Garden Study of the Vickers Children* (plate 138) presents children and flowers, emblems of an innocence prior to manners. Here Sargent's eye is concerned less with social nuance than with a quality of light. His palette, his touch, his entire style becomes less theatrical, more contemplative. He was never, strictly speaking, an Impressionist, yet subjects such as these brought him as close as he would ever come to Monet's defenselessness before the effects of light.

In July, Sargent visited another branch of the Vickers family, in Sheffield. Colonel Thomas Vickers had commissioned a portrait of his three daughters, Florence, Mabel, and Clara. Sargent had met them, a year or two before, in Paris, where they were studying art. Early in 1884 Sargent wrote to Vernon Lee about the task that lay ahead of him in England: "I am to paint several portraits in the country and three ugly young women in Sheffield, an ugly hole."[72] The result is a complex, perhaps overly ingenious arrangement of the Vickers sisters (plate 145). Each seems to strain slightly. Sargent strains, too, as he pushes the contrast of bright faces and dark backgrounds to extremes. The theatrical flair of *El Jaleo* reappears, drastically transformed by the artist's respect for the genteel and the domestic. Yet Sargent has restrained his taste for pictorial spectacle not at all. When *The Misses Vickers* was shown at the Royal Academy two years later, the English critics brought out their heaviest cudgels.

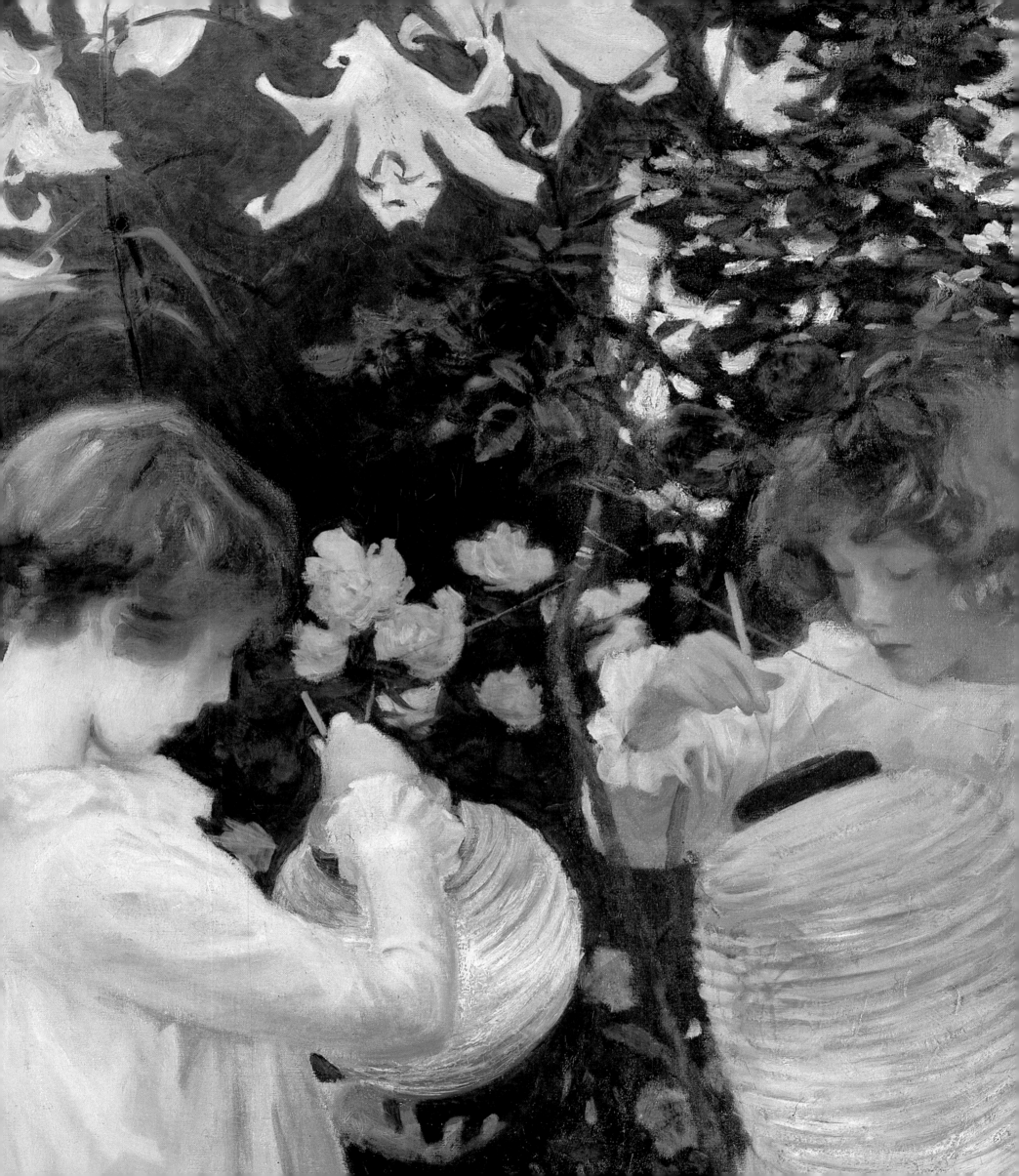

V. *Starting Over in England*

THE LONDON ART WORLD WAS DETERMINED from the outset not to be taken in by Sargent. With *Madame X* (plate 120) still scandalizing Paris, an anonymous reviewer for London's *Art Journal* took a very close look at the portrait of Mrs. Henry White (plate 111), which Sargent had sent to the Royal Academy. "Clever," pronounced the critic.[73] His equally anonymous but less charitable colleague at the *Athenaeum* said that Sargent "has been the victim of a reputation too easily acquired." The artist is, in other words, a stylish imposter. The picture of Mrs. White "is hard, the painting almost metallic, the carnations are raw, there is no taste in the expression, air, or modelling, but the work is able enough to deserve recasting."[74]

The *Academy* sent its reviewer to the Paris Salon of 1884, where he came up against Sargent's *Madame X*. He saw "extraordinary skill and almost cynical audacity" in this image of "enamelled flesh and hair which owes it gold to art." (Mme. Gautreau was internationally known to use henna.) The critic goes on to say that Sargent's "intention, no doubt, was to produce a work of absolutely novel effect—one calculated to excite, by its *chic* and daring, the admiration of the ateliers and the astonishment of the public. And in this the painter has succeeded beyond his desire."[75] There's nothing especially hostile in these remarks, only an uncomfortably close reading of Sargent's motives—and of his situation after the '84 Salon. William Sharp, of the *Art Journal*, took a sterner view:

> Visitors to the Grosvenor Gallery will have noticed his "Portrait of Mrs. Legh"; but poorly painted and artificially clever as this painting is, it is surpassed in unpleasantness by the extraordinary "Portrait of Madame Gauthereau" [sic]. The latter, it is true, is produced with something more than artificial cleverness, but there is an almost willful perversion of the artist's knowledge of flesh-painting. . . . The result of [his] experiment or willful indifference, whichever it is, it more resembles the flesh of a dead than a living body.[76]

In the summer of 1884 Sargent met with Vernon Lee, Henry James, Walter Pater, and others. In the fall James introduced him to the director of the Grosvenor Gallery, J. Comyns Carr, who had exhibited

125. *Carnation, Lily, Lily, Rose*, detail. See plate 139.

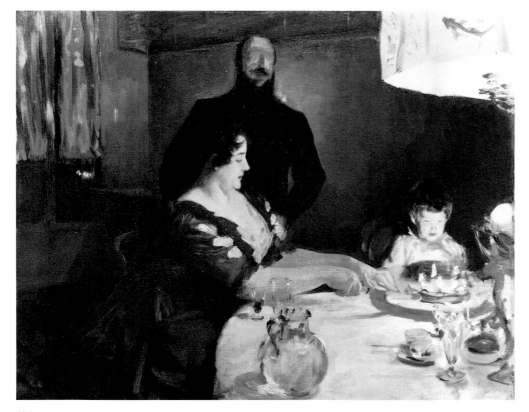

126

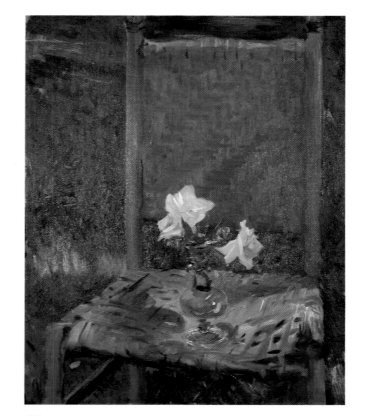

127

128

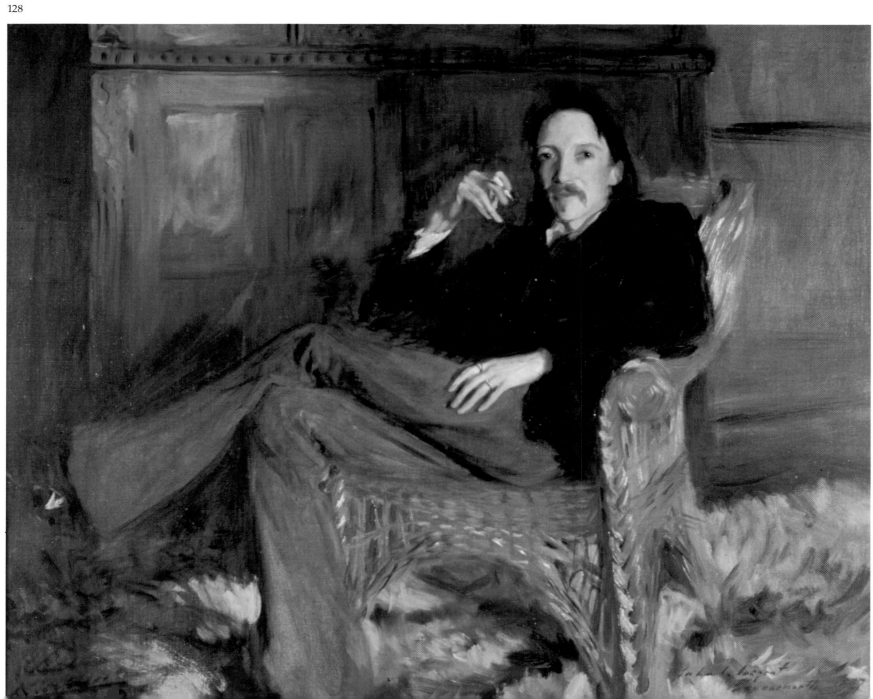

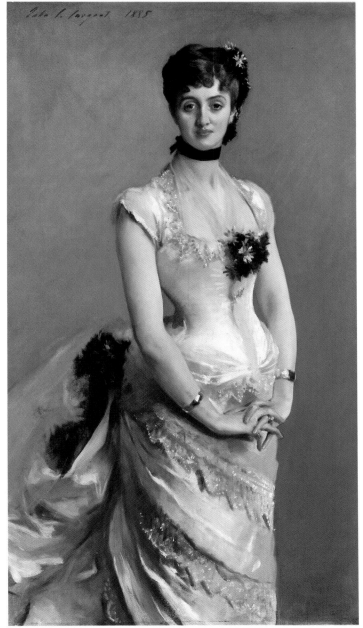

129

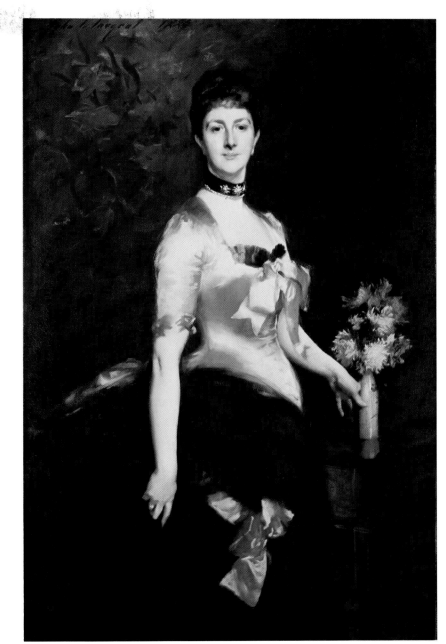

130

126. *Fête Familiale: The Birthday Party*, 1885. Oil on canvas, 24 x 29 inches. The Minneapolis Institute of Arts, Minnesota. The Ethel Morrison and John R. Van Derlip Funds.

127. *The Old Chair*, 1885. Oil on canvas, 26½ x 22 inches. The Ormond Family.

128. *Robert Louis Stevenson*, 1884. Oil on canvas, 20 x 24½ inches. Taft Museum, Cincinnati, Ohio.

129. *Madame Paul Poirson*, 1885. Oil on canvas, 59 x 33½ inches. The Detroit Institute of Arts. Mr. and Mrs. Richard A. Manoogian, Beatrice Rogers, Gibbs-Williams, and Ralph H. Booth Funds.

130. *Edith, Lady Playfair (Edith Russell)*, 1884. Oil on canvas, 59 x 38 inches. Museum of Fine Arts, Boston. Bequest of Edith Russell, Lady Playfair.

Sargent's portrait of Mrs. Wodehouse Legh earlier that year. In her *Reminiscences*, Mrs. Comyns Carr recalls the young painter's odd behavior when they met. He threw back his head and narrowed his eyes, studying her as if she were an object to be painted. But quickly enough he substituted drawing-room manners for this studio mannerism. Sargent got along well with James's circle, even before it had fully accepted his paintings. Mrs. White kept her portrait on display at her house in Grosvenor Crescent and there, according to Evan Charteris, "where it formed the subject of constant discussion, not always well-informed but nonetheless dogmatic, it fulfilled a missionary and educational purpose, making the name of Sargent familiar to many and gradually enrolling supporters to a new canon of taste in portraiture."[77]

Sargent traveled to Bournemouth in November to paint Robert Louis Stevenson. This portrait is an oil sketch pushed to extremes of painterly delicacy (plate 128). The casual—or perhaps bewildered—eye of the period might have seen it as an Impressionist painting, yet Sargent constructs it from tonal contrasts learned at the atelier of Carolus-Duran

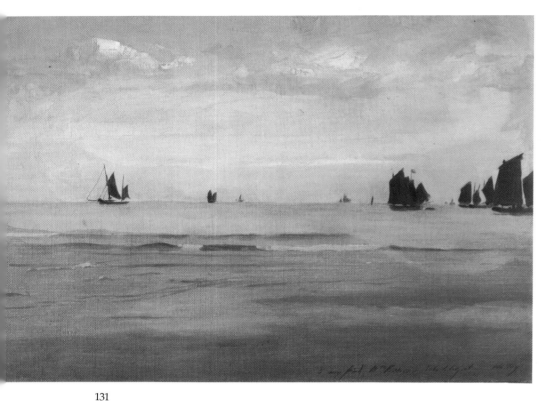

131

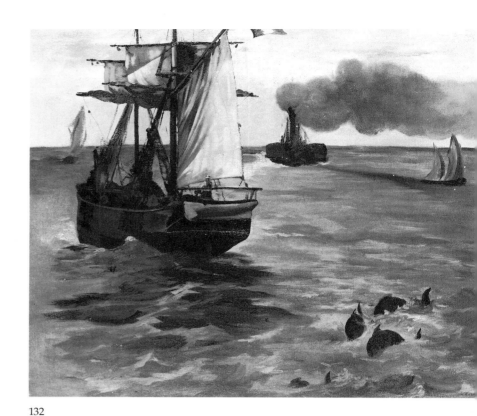

132

and from the works of Velázquez. Similarly, Sargent's *Edith, Lady Play-fair* (plate 130) is like a pledge of allegiance to those two masters, one grand and distant, the other nearby and far less imposing.

Toward the end of 1884, Sargent returned to his studio on the boulevard Berthier. He did not have much to do. His landlord, Paul Poirson, gave him a commission—a portrait of his daughter, Suzanne. A painting of Mme. Paul Poirson (plate 129) followed. Tradition says that Sargent did these portraits in lieu of rent. No evidence supports the claim, yet Sargent must have had financial difficulties at the outset of 1885. The Burckhardt family ordered a portrait—*Mrs. Burckhardt and Her Daughter Louise*—nonetheless, Sargent still needed more work than he was able to find. Spring came and Sargent dismissed his cook, suggesting to his sister Emily that she come to Paris and keep house for him. She doesn't seem to have taken him up on the offer. Soon afterward, his portrait of Mrs. Vickers, exhibited in the Salon of 1885, was drawing the fire of the *Athenaeum's* reviewer. In *Mrs. Henry White* he had found "metallic" paint handling and "raw" carnations. This new picture inspired the judgment that "Mr. Sargent is a pseudo-Velasquez whose sense of tone is exquisite but not chastened by fine taste." In "the Portrait of Mme. V— . . . we see at once that the crudity of the carnations and harsh definition of the local tints, tones and shadows are due to the painter, not to the model. . . . Let us hope that this very clever pupil of M. Carolus-Duran may by-and-by do justice to all his extraordinary powers and accept the refining canons of taste. . . . Centuries of time will not harmonize these works, which seem quaintly to unite the qualities of Frank [sic] Hals and Velasquez."[78]

This review appeared in May of 1885. By the time Sargent read it

(which he surely did; he was always alert to the state of his reputation), he was back in London, where he met Edwin Austin Abbey, a painter and illustrator from Philadelphia. That summer they took a boat trip on the Thames, setting out at Oxford for Windsor. At Pangborne, Sargent dove into the water, struck a spike, and seriously injured his head. Abbey suggested that he recuperate at Broadway, a village on the River Avon, twelve miles south of Stratford. Sargent did, settling in at the Lygon Arms. Abbey lived at Farnham House, in the same Worcestershire village with Francis (Frank) Davis Millet and his family. Millet, also American, had studied at the Royal Academy of Arts in Antwerp and then gone on to success as a portraitist. Among the rest of the colony were Edwin Blashfield, later a leading figure in the American Renaissance movement; Alfred Parsons, a landscapist; and the Barnards —Frederick (an illustrator), Alice, and their two young daughters. The poet and art critic Edmund Gosse summered at Broadway, too, as did Henry James, who reflexively called the place "picturesque."

Nearly thirty-five years later, Gosse wrote that "the Millets possessed, on their domain, a medieval ruin, a small ecclesiastical edifice, which was very roughly repaired so as to make a kind of refuge for us, and there, in the mornings, Henry James and I would write, while Abbey and Millet painted on the floor below, and Sargent and Parsons tilted their easels just outside. We were all within shouting distance, and not much serious work was done, for we were in towering spirits and everything was food for laughter."[79] The exception was James— "serious, mildly avuncular, but very happy and un-upbraiding." Peacefulness seems eventually to have won out over hilarity, for a great deal of work did get accomplished.

In and around the village of Broadway, where no building erected later than the seventeenth century seems to have caught Gosse's attention, Abbey developed the style that came to be known as the Cotswold Picturesque. Sargent's eye was very differently focused. It was here that he came as close as he ever did to joining the French avant-garde. At Broadway and at other villages along the Avon in the summers to follow, he very nearly turned into an Impressionist. He had the aptitude for it—that is, his perception of color was sufficiently acute and unencumbered. In August of Sargent's first summer in the Cotswolds, Edmund Gosse found him painting

in a white-washed farm-yard, into which I strolled for his company, wearing no hat under the cloudless blue sky. As I approached him,

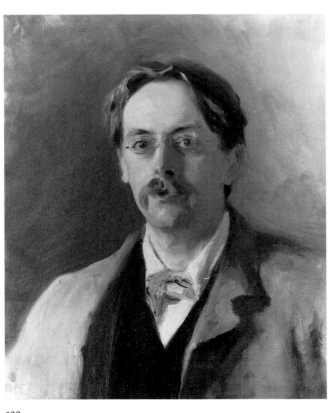

134

135 136

Sargent looked at me, gave a convulsive plunge in the air with his brush, and said "Oh! what lovely lilac hair, no one ever saw such beautiful lilac hair!" The blue sky reflected on my sleek dun locks, which no one had ever thought "beautiful" before, had glazed them with colour. . . . The real colour of the hair was nothing, it existed only in the violet varnish which a single step into the shade would destroy forever.[80]

Sargent was frantically busy that summer. Every day he would set up a large easel "nowhere in particular," as Gosse puts it—"behind a barn, opposite a wall, in the middle of a field." Sargent's seeming arbitrariness astonished Abbey and the rest, who were much choosier about subject and point of view. He explained to Gosse that he wanted "to acquire the habit of reproducing precisely whatever met his vision without the slightest previous 'arrangement' of detail, the painter's business being not to pick and choose, but to render the effect before him, whatever it might be."[81]

"The *Impressionist* painter's business" might have been more accurate, for this was a version of the plein-air program developed in the late 1860s and early '70s by Monet, Alfred Sisley, and the rest of their group. Sargent possessed the Impressionist rhetoric, as well as the Impressionist eye for fleeting effects of color—Gosse's "lilac hair," for instance, or the vibrant shadows in the screen of trees that divides his *Reapers Resting in a Wheatfield* (plate 136) into separate, complementary regions of light. This painting is filled with convincing weather, yet it is not simply a transcription of what Sargent saw. Having assimilated the pictorial conventions of Carolus-Duran, Velázquez, and Hals, Sargent was now finding his own uses for the radical picture-making devices of Monet. The landscapes of this period are built from the sort of tonal contrasts the Impressionists abandoned. Even the brightest of the watercolors Sargent painted in the last two decades of his life show a richness of color and sensitivity to the play of light that raise the question of an Impressionist allegiance while simultaneously denying it. Even in the summer of 1887, when Sargent is said to have painted side by side with Monet at Giverny, he declined to step over the border into that new region of light and atmosphere the Impressionists had invented. This meant, in effect, that he refused to give up his power to model form with transitions of light and dark.

It is customary to say that Impressionist canvases are "high keyed"—that is, composed of colors drawn from the bright, upper ranges of the tonal scale. This is correct, yet the gauziest of Monet's pink and lavender canvases show occasional touches in a darker key. Impressionism

134. *In a Garden*, c. 1883–85. Oil on canvas, 24 x 29 inches. The Ormond Family.

135. *Teresa Gosse*, 1885. Oil on canvas, 25 x 19 inches. Dr. and Mrs. John J. McDonough, Youngstown, Ohio.

136. *Reapers Resting in a Wheatfield*, 1885. Oil on canvas, 28 x 36 inches. The Metropolitan Museum of Art, New York. Gift of Mrs. Francis Ormond.

never censors low tones. Instead, it separates them with bright touches, much as it breaks secondary colors down into primaries. So, just as the eye reads dabs of blue and yellow as green, it also blends light and relative dark into a tone somewhere above the middle range. Of course, these two kinds of blending join together, each reinforcing the other's tendency to immerse landscape in a bright, slowly flickering light. Sargent was willing to go quite a way toward dividing colors, but he refused to separate tones in the Impressionist manner—or perhaps he never recognized that radical possibility. At any rate, he always employed traditional modeling, no matter how Monet-like his palette or his motifs. Sargent had supposed, four years earlier, that his dedication to "les valeurs"—contrasts of light and dark—made him an Impressionist. But his way of handling these contrasts is precisely what excludes him from the group.

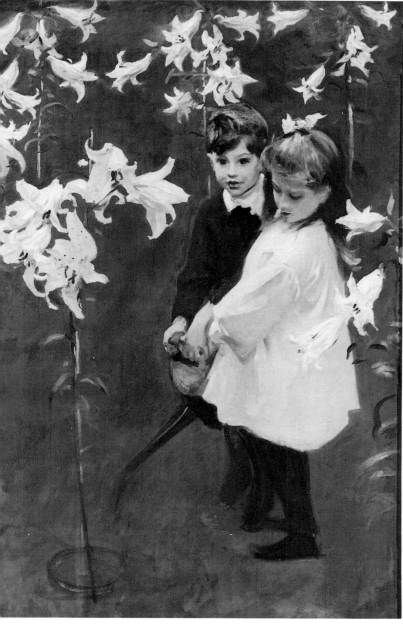

138

The Impressionists, led by Monet, learned to use the same touch no matter what the subject, rendering clouds and stone the same way. Broken down into minute, intricately modulated bits, their colors and tones offer the eye a seamless web of images. This deemphasizes the physical weight of things. When Sargent draws out a brushstroke to indicate a fence rail, when he folds a touch of white in on itself to suggest the fall of a cotton dress, he insists with elegant precision that objects have weight. And he evokes texture, the rough and the smooth. For all the quickness of his eye and hand, for all his mastery of sunlit color, Sargent was too concerned with the bodily presence of things ever to give himself over to Impressionism. This of course did not prevent him from talking like a member of the group on those summer days in and around the village of Broadway.

As Edwin Austin Abbey remembered it, Sargent's diving accident on the Thames had been so severe that he needed to lay over at Pangborne for a few days. During the wait, "he saw the effect of the Chinese lanterns hung among the trees and beds of lilies." Sargent made a quick notation of the scene, with its echoes of the previous summer's *Garden Study of the Vickers Children* (plate 138), which had shown the young daughter and son of Mr. and Mrs. Albert Vickers amid the blooming lily stalks of the garden at Lavington Rectory. In that canvas Sargent has dimmed Impressionist brilliance to a moody dusk, in which flowers glow as if lit from within. Sometime in August of 1885 he began to work the Pangborne sketch and the *Garden Study* into his first major subject picture since *El Jaleo* (plate 99). Eventually it picked up the name *Carnation, Lily, Lily, Rose* (plate 139), the refrain of a song popular that summer.

Sargent continued to paint landscapes. There was no break in what Gosse calls his "daily plan," which was "to cover the whole of his canvas with a thick coat of colour, so as to make a complete sketch which would dry so rapidly that next morning he might paint another study over it. I often could have wept to see these brilliantly fresh and sparkling sketches ruthlessly sacrificed."[82]

Then, just after sunset, he would rush to *Carnation, Lily*, first conceived as a picture of a young girl lighting a Chinese lantern as the atmosphere around her gently darkens. Sargent's original model was the Millets' daughter. He thought her dark hair should be light, so he found a blonde wig for her to wear. Next he discovered the daughters of Fred and Alice Barnard, who were blonde and needed no wigs. They had the further advantage of being older than the Millet girl—seven

137. *Home Fields*, c. 1885. Oil on canvas, 28¾ x 38 inches. The Detroit Institute of Arts. City of Detroit Purchase.

138. *Garden Study of the Vickers Children*, c. 1884. Oil on canvas, 54³⁄₁₆ x 35⅞ inches. Flint Institute of Arts, Michigan. Gift of the Viola E. Bray Charitable Trust.

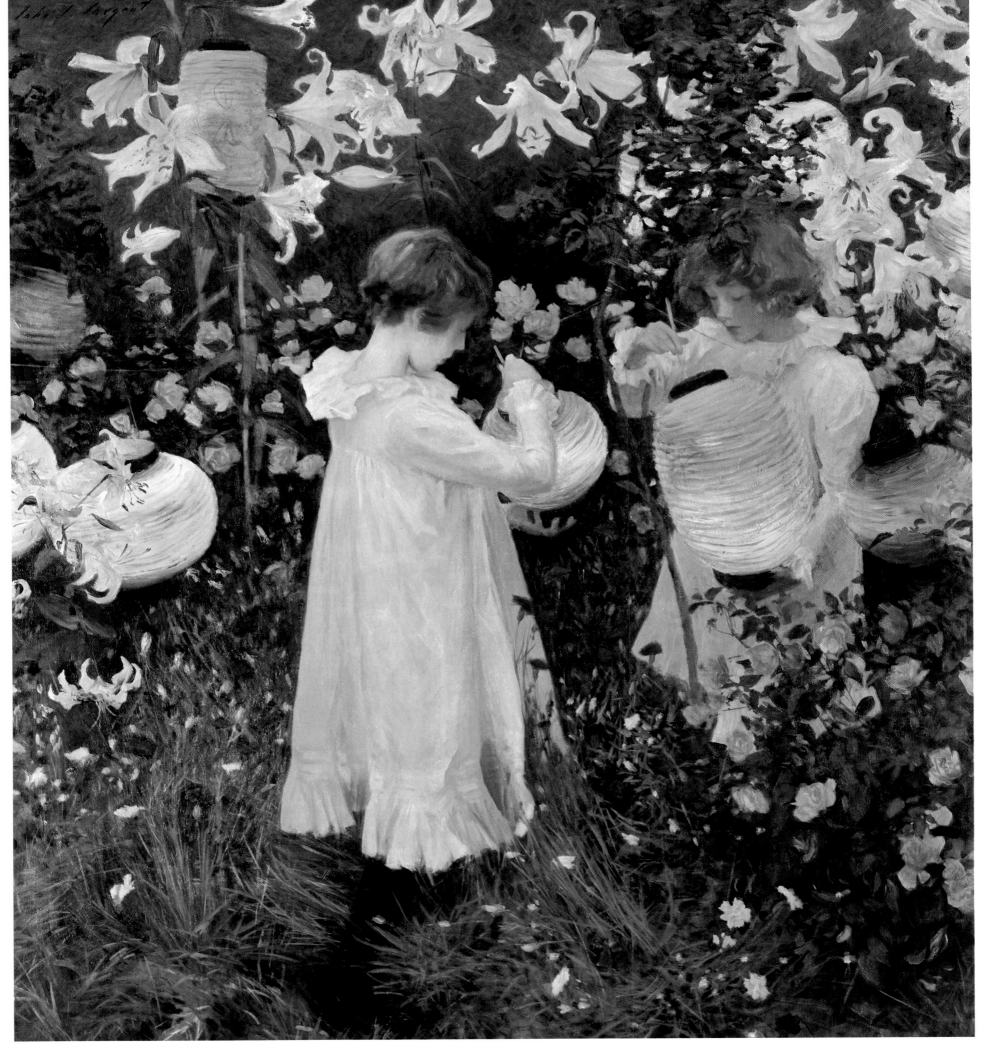

140

141

139. *Carnation, Lily, Lily, Rose*, 1885–86. Oil on canvas, 68½ x 60½ inches. The Tate Gallery, London.

140. *Study for "Carnation, Lily, Lily, Rose" (Dorothy Barnard)*, n.d. Pencil on paper, 8¼ x 7¼ inches. The Tate Gallery, London.

141. *Study for "Carnation, Lily, Lily, Rose" (Polly Barnard)*, n.d. Pencil on paper, 8¼ x 6½ inches. The Tate Gallery, London.

and eleven—so they didn't squirm so much when they posed. Still, they squirmed quite a bit. *Carnation, Lily, Lily, Rose* was an arduous project. "Everything used to be placed in readiness," Gosse wrote,

the easel, the canvas, the flowers, the demure little girls in their white dresses, before we began our daily afternoon lawn tennis, in which Sargent took his share. But at the exact moment, which of course came a minute or two earlier each evening, the game was stopped, and the painter was accompanied to the scene of his labours. Instantly he took up his place at a distance from the canvas, and at a certain notation of the light ran forward over the lawn with the action of a wag-tail, planting at the same time rapid dabs of paint on the picture, and then retiring again, only with equal suddenness to repeat the wag-tail action. All this occupied but two or three minutes, the light rapidly declining, and then while he left the young ladies to remove his machinery, Sargent would join us again, so long as twilight permitted, in a last turn at lawn tennis.[83]

This procedure combined all the disadvantages of plein-air painting with those of studio composition. Sargent's "machinery" consisted of lily stalks and Chinese lanterns; as November approached, artificial flowers had to be used. (Even Monet's Impressionism advanced under the occasional burden of props that we usually consider studio devices.) Sargent's chief difficulty was the brevity of his painting's moment. Monet sometimes kept a dozen paintings at hand, one for each inflection of the sun. Sargent spent his days on one oil sketch after the next, waiting for the two or three minutes of dusk he felt were right for *Carnation, Lily*.

Though relentlessly busy, Sargent was sometimes despondent in the summer of 1885. Gosse remembered that he was dissatisfied with Paris —"determined to shake its dust off his shoes"—yet not the least drawn to America. England, on the other hand, was not drawn to him. That summer, Vernon Lee wrote to a relative with the news that Henry James "seems to think that John is in a bad way. Since Madame Gauthereau [sic] & one or two other portraits, women are afraid of him lest he should make them too eccentric looking."[84] In September, Sargent wrote to a fellow artist, John Russell: "Just now I am rather out of favour as a portrait painter in Paris, although my last salon, two portraits done in England, rather retrieved me—I have been coming to England for the last two or three summers and should not wonder if I some day have a studio in London. There is perhaps more chance for me there as a portrait painter, although it might be a long struggle for

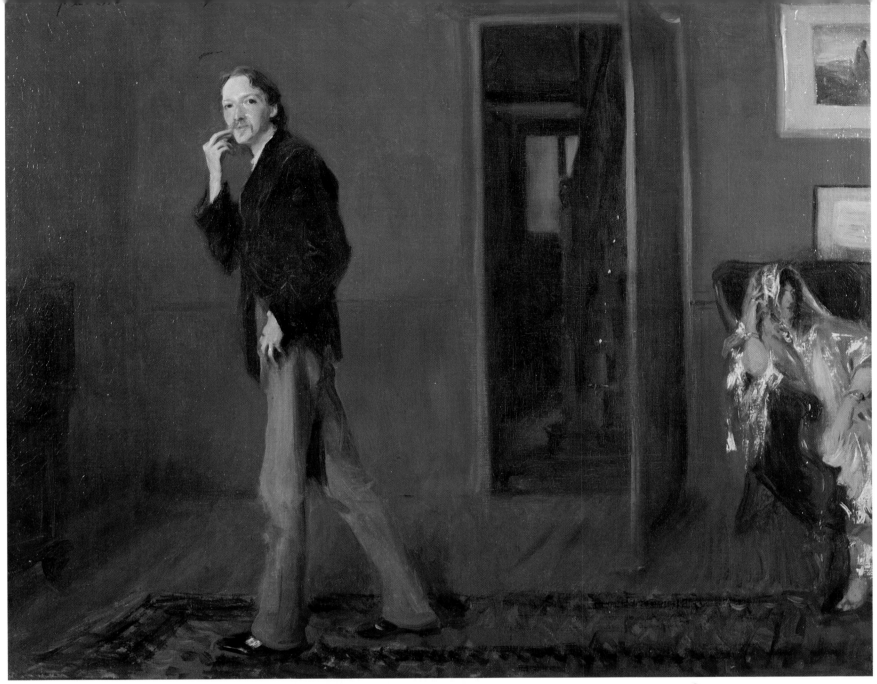

142

143

my painting to be accepted. It is thought beastly French.''[85]

The next month Sargent took time off from *Carnation, Lily* for a trip to Bournemouth, and another portrait of Robert Louis Stevenson. When the picture was done, Stevenson wrote about it to Will H. Low, Sargent's friend from their days in Carolus's studio: ''It is, I think, excellent but it is too eccentric to be exhibited. I am at one extreme corner; my wife, in this wild dress, and looking like a ghost, is at the extreme other end. . . . All this is touched in lovely, with that witty touch of Sargent's; but, of course, it looks dam queer as a whole.''[86]

Sargent couldn't hide all his anxieties, no matter how busy he kept himself that first season at Broadway. The *Athenaeum*'s critic had not only cultivated a dislike for Sargent's way with carnations, he had repeated the standard English judgment that the painter was too ''clever.'' Though he acknowledged Sargent's command of tonalities learned in Paris, this critic condemned his lights and darks as ''harsh'' and

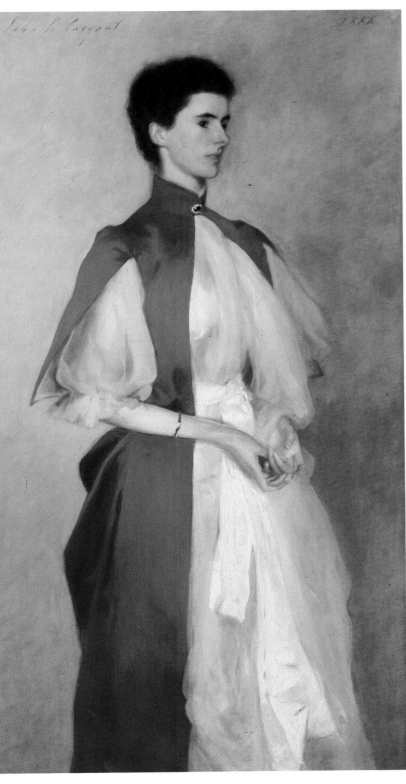

144

tasteless. And with a harshness of his own, he spotted Sargent's debt to Hals and Velázquez, then mocked it.[87] Nor were clients crowding around, in defiance of the critics. No wonder Sargent told Edmund Gosse that he might quit painting. "I remember him telling me this on one of our walks, and the astonishment it caused me. Sargent was so exclusively an artist one could think of no other occupation. 'But then,' I cried, 'whatever will you do?' 'Oh,' he answered, 'I shall go into business.' 'What kind of business?' I asked in bewilderment. 'Oh, I don't know!' with a vague wave of the hand, or 'go in for music, don't you know?'"[88] Yet he never missed his daily two to three minutes with *Carnation, Lily,* nor did the landscape sketching ever let up. In November, the large canvas far from finished, Sargent stored it in the Millets' barn, then settled into 13 Tite Street, London, where Whistler had once kept a studio.

In March of 1886 Henry James wrote about Sargent to a friend:

> I don't in the smallest degree agree with the idea that Sargent has done an unwise or an unfair thing to come to this place to live and work. He seems to me to have got from Paris all that Paris could give him—viz. in perfect possession of his technical means. . . . I think an artist does his work better in the conditions in which the whole man is happier and finds a larger and more various life. I mean by this that Sargent seems to me to *like* London, its social opportunities, and great variety, and that in itself is good for him, even as an artist.[89]

Among the painter's new acquaintances were Mr. and Mrs. Robert Harrison, a flamboyant and—at the time—scandalous couple. He was a rich stockbroker. She, the daughter of an industrialist turned politician, was cited as a correspondent in a suit for divorce, in which her married sister was also implicated. Nonetheless, Mrs. Harrison found time to pose for Sargent, and he sent her portrait (plate 144) to the Royal Academy exhibition of 1886, along with *The Misses Vickers* (plate 145). Sargent may have been discouraged by the English critics, but he was never intimidated by them—after all, Gosse and James admired his work.

The *Spectator*'s anonymous critic said that *The Misses Vickers* was "in its way probably the cleverest thing in the exhibition. It is the *ne plus ultra* of French painting, or, rather, of the French method as learned by a clever foreigner."[90] The critic doesn't linger over this slur, though he very well might have. Perhaps he hoped that his readers would note for themselves that Sargent's foreignness was manifold. First of all, he was the product of a Parisian atelier, yet not French; neither, thanks to

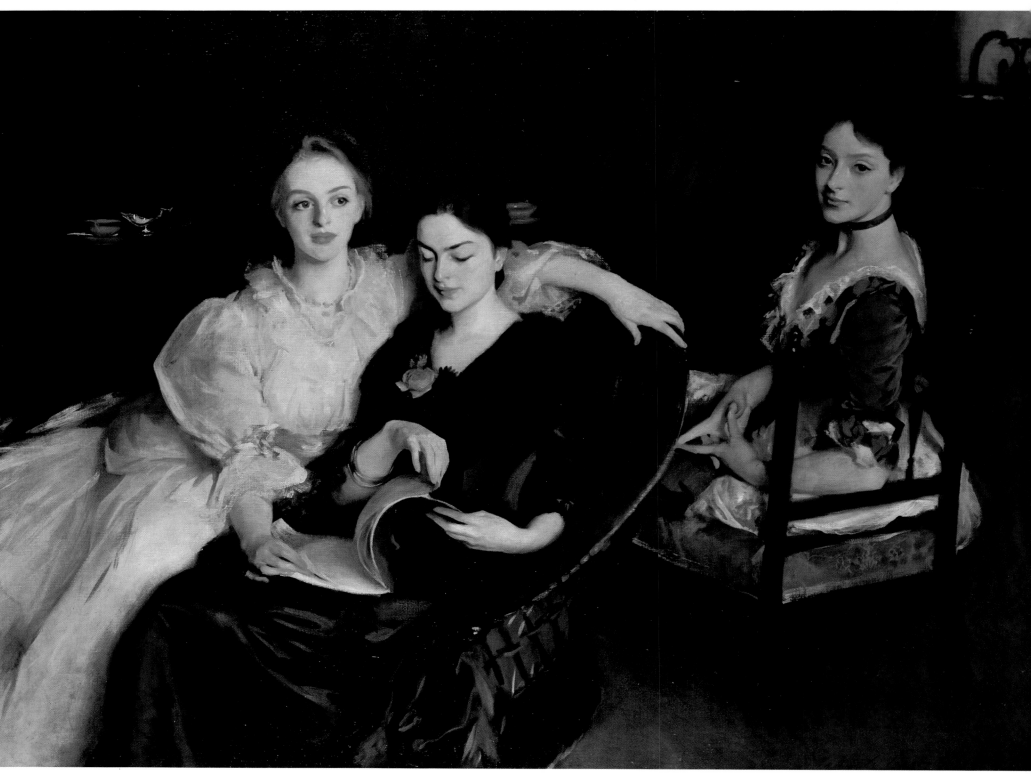

145

145. *The Misses Vickers*, 1884. Oil on canvas, 54 x 72 inches. Graves Art Gallery, Sheffield, England.

146. Thomas Gainsborough. *Portrait of Mrs. Philip Thicknesse*, 1760. Oil on canvas, 77⅜ x 53⅛ inches. The Cincinnati Art Museum. Bequest of Mary M. Emery.

147. Sir Joshua Reynolds. *Lady Stanhope*, 1765. Oil on canvas, 93 x 57½ inches. The Baltimore Museum of Art. Bequest of Mary Frick Jacobs.

148. *Violet Sargent*, 1886. Oil on canvas, 27½ x 22 inches. The Ormond Family.

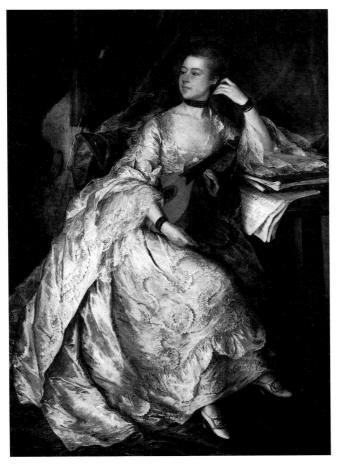

146

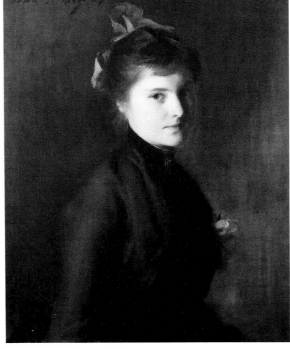

148

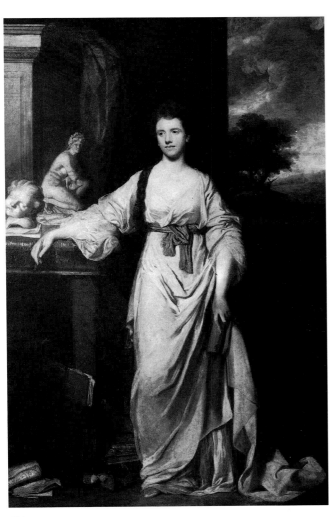

147

his American citizenship, was he English. And his Continental up-bringing disqualified him as a genuine American. Thanks to his clever-ness, he has skill at deploying "values" and yet, the critic goes on, "when it is all done, what good is it? Could we fancy anyone a hundred years hence caring to possess such a picture as this, where colour and imagination have really no place, which calls aloud to us to admire its artistic dexterity, but seems never to have felt at all that there was any-thing more in its subject than a good opportunity of displaying the painter's power?"[91]

The critic of the *Athenaeum* railed once again at the portrait of the three Vickers girls, using almost exactly the same terms as those he had used to condemn the painting and that of Mrs. Albert Vickers in his review of the 1885 Salon.[92] His major platform, however, is the por-trait of Mrs. Harrison, from which he launches his main attack. This is one of Sargent's best early portraits. He gives his sitter's dress a clear, simplified outline without sacrificing the delicacy of its materials. Mrs. Harrison's silhouette is nearly as pure as Mme. Gautreau's, yet the brushwork here is even more open, economical, and assured than in the portrait of Mrs. White. Sargent's "English" style is beginning to appear full force, with its evocations of Joshua Reynolds, Thomas Law-rence, and Thomas Gainsborough. The *Athenaeum*'s unsympathetic critic dismisses the painting as an "exercise in red, white and grey"—per-haps an unkind allusion to Whistler's *Arrangements* and *Harmonies*. And in this exercise he sees only the "rawness and crudity of an uncompro-mising treatment of the features, forms and expressions"—in other words, "decidedly unpleasant as a household companion, and, for the owner's sake, we hope unjust to the lady."[93]

VI. *A Critical Success*

SARGENT SPENT THE WINTER OF 1885–86 IN LONDON. The following spring he gave up his studio on the boulevard Berthier to his friend Giovanni Boldini. And, given another chance to show with Monet and Renoir at the Galerie Georges-Petit, he declined. That same year, Sargent helped found the New English Art Club. Among the other founding members were Philip Wilson Steer, John Lavery, and Fred Brown; Walter Sickert joined the group in 1888. At first it was to be called the Society of Anglo-French Painters—most of its original members had studied in Paris, though none of them was a radical by Parisian standards. Their teachers had been Bastien-Lepage, Carolus-Duran, and other adventurous academicians, not such avant-gardists as Monet and Renoir. By settling on the name New English Art Club, they signaled that the true center of their interest was London, not Paris. The club's chief purpose was to organize a series of annual exhibitions, as a less stuffy alternative to those at the Royal Academy. From 1886 on, Sargent sent work to both shows, having closed out the Parisian phase of his career with deliberation.

Sargent's family spent the summer of that year in Gossensass, in the Swiss Alps, which Evan Charteris recalls as "no more than the hotel and few chalets, near the newly opened railway on the Brenner."[94] At Gossensass, as elsewhere, Sargent arrived

> at the station loaded with canvases and sketch-books, bristling with the equipment for *plein-air* sketching, and with these piled up round him in a fly he would draw up at his destination dominant and smiling. . . . it was away from his portraits, on the canals of Venice or the plains of Palestine, in the passes of the high Alps or among the dancers of Spain . . . that his spirit was most at ease and serene—anywhere, in fact, where he could 'make the best of an emergency,' as he called painting a water-colour."[95]

Later on in the season Sargent returned to Broadway, on the Avon, where he went back to oil sketches and the evening's rush to put a few more touches on *Carnation, Lily, Lily, Rose* (plate 139). Cold weather arrived before he managed to finish the canvas.

Late that fall of 1886 Isabella Stewart Gardner stopped off in London

149. *Claude Monet Painting at the Edge of a Wood*, detail. See plate 169.

150

152

150. *A Morning Walk*, c. 1888. Oil on canvas, 26⅜ x 19¾ inches. The Ormond Family.

151. Claude Monet. *Woman with Parasol*, 1886. Oil on canvas, 51½ x 34⅝ inches. Jeu de Paume, Paris.

152. *Elizabeth Allen Marquand (Mrs. Henry G. Marquand)*, 1887. Oil on canvas, 66½ x 42 inches. The Art Museum, Princeton University, New Jersey.

on her way from Boston to the Continent. Henry James brought her to Sargent's Tite Street studio, where she asked him to show her *Madame X* (plate 120). She liked the painting, as much for its notoriety as for its pictorial virtues. Sargent and James hoped she would commission a portrait of her own, though a couple of years went by before she did (see plate 161). The artist found other worthy sitters that season, including Mrs. William Playfair and the academician Lawrence Alma-Tadema. Then, early in 1887, he received a letter from Henry G. Marquand, a railroad tycoon and benefactor of the Metropolitan Museum in New York. Marquand wanted Sargent to sail to America and paint a portrait of Mrs. Marquand. Sargent preferred to stay in England, now that his career seemed to be gathering momentum, so he quoted Marquand a fee three times higher than normal. The tycoon accepted immediately. Sargent managed to put off this second trip to America until September.

In May of 1887 Sargent sent *Robert Louis Stevenson and His Wife* (plate 142) to the New English Art Club. While Stevenson had thought it "dam queer" in 1885, the critic for the *Art Journal* now thought it "a piece of sparkling and well-manipulated colour."[96] Sargent's entries in the 1887 Royal Academy exhibition were *Mrs. William Playfair* and *Carnation, Lily, Lily, Rose*. The *Spectator* trod carefully here, allowing that "despite the apparent *bizarrerie* of its subject, despite the audacious originality with which [Sargent] has treated it," *Carnation, Lily* "is purely and simply beautiful as a picture."[97] *Athenaeum* pronounced the picture "extremely curious, highly scientific and novel, if not wholly beautiful" —progressing to coldness from the invective the magazine had earlier poured on Sargent's art.[98] In May, *Portfolio* took a dim view of the "idiosyncracies" displayed by "clever Mr. John Sargent," whom it labeled a "French painter."[99] In June, the same journal said that *Carnation, Lily* "would leave a permanent note" in the history of English painting.[100]

In 1887 those London critics who had earlier offered Sargent their condescending advice began to accept instruction from his art. It took *Portfolio* a month to master its lesson. Claude Phillips, reviewing the Royal Academy show for the *Gazette des beaux-arts*, underwent the process much more quickly. Of *Carnation, Lily*, he says: "This conflict of lights and colors is rather embarrassing to the eye at first, and harms the first general impression, but little by little the artist's idea and conception, at once bold and feeling, reveal themselves and charm us. It is especially in the two delightful types of young girls that he manifests a tenderness he has not often shown us."[101]

The painting was bought for the Tate Gallery by the trustees of the

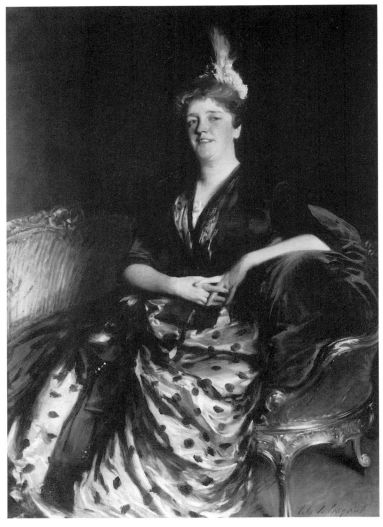

153

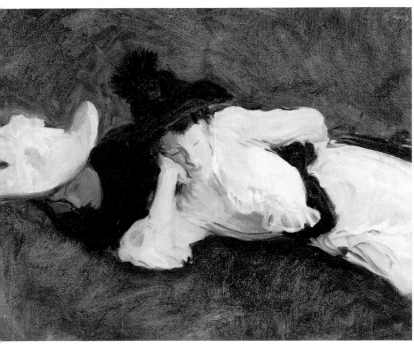

154

Chantrey Bequest, soon after it went on view. In its June issue the *Art Journal* praised a painting by Frank Bramley as "a good example of the 'dab and spot' school, which has its arch-apostle in Mr. J. S. Sargent, and its apotheosis in that wonderful production . . . 'Carnation, Lily, Lily, Rose.' As artists almost come to blows over this picture, a difference of opinion about it is at any rate allowable, and we can only hope that the British public, when it sees it in the Chantrey collection, may be of the same opinion as those who bought it."[102]

The *Art Journal* also reports that "some enthusiasts declare" Sargent's *Mrs. William Playfair* "to be the best female portrait of the year."[103] As at the Salons of 1882 and '84, Sargent is tagged "the most discussed artist of the year." The *Magazine of Art* takes a less gossipy tone, singling out *Carnation, Lily* as a "masterpiece" that "may be cited as marking an epoch."[104]

Sargent was at last a critical success in England, and soon he would succeed professionally in America. He spent part of the summer with the Broadway colony and part of it with Monet at Giverny—or so some biographers claim.[105] In any case, Sargent embarked for New York on September 17, 1887. He may never have felt at home in the United States, but he was always comfortable there. Arriving in Newport, Rhode Island, to paint Mrs. Marquand's portrait, he stayed with Admiral and Mrs. Goodrich. A former officer in the Mediterranean fleet, the admiral had been a friend of Dr. Sargent's in Nice, and Mrs. Goodrich had been one of John's Sunday school teachers. Sargent found Mrs. Henry G. Marquand a "dreary" subject, but there seem to have been no complaints about his picture of her (plate 152). He moved easily in the world of Newport's plutocratic villas, so much so that he became friends with the architect who did more than any other to create the look of that world—Stanford White. They had mutual acquaintances, among them Frank Millet and Augustus Saint-Gaudens, and, more importantly, they were in immediate sympathy. The architect, an aggressive, even contentious promoter of the American Renaissance, made it a point from then on to assist the career of this reserved, gentlemanly purveyor of high-style portraiture.

Having done with Mrs. Marquand, Sargent left Newport for New York, where he met his old friend Carroll Beckwith, who had developed a modest practice as a portrait painter. He was soon off to Boston, where pictures had been commissioned by General and Mrs. Lucius Fairchild, Mrs. Gardner, and Mrs. Edward D. Boit. Painted early in 1888, his portrait of Mrs. Boit (plate 153) seems calculated to

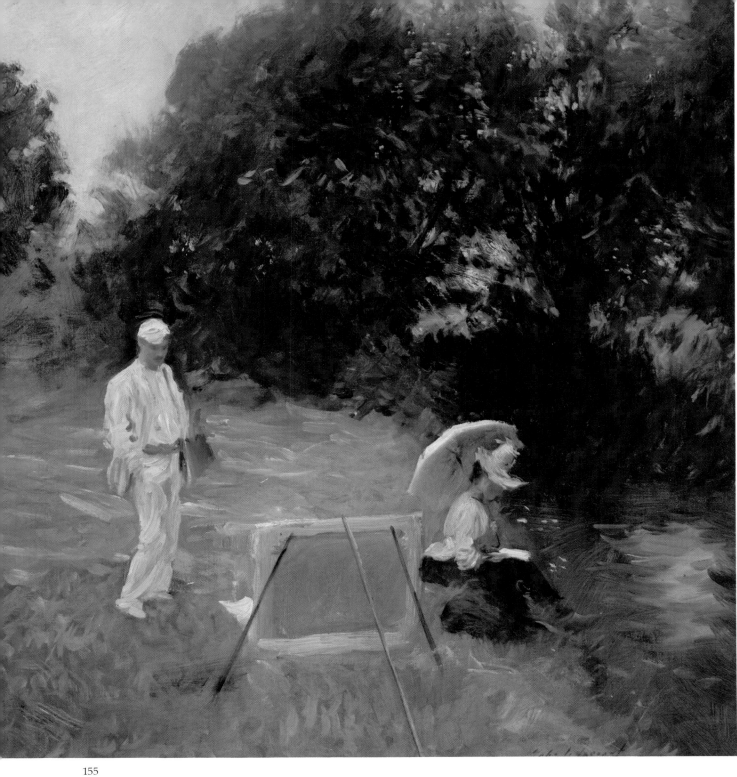

155

156

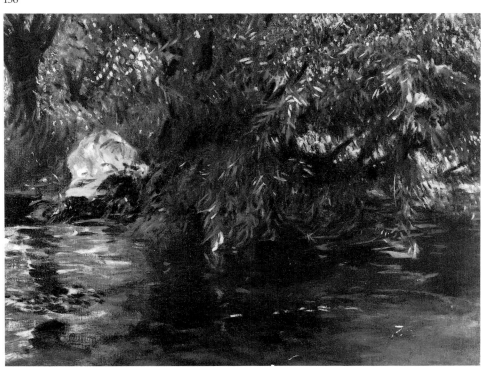

153. *Mrs. Edward D. Boit*, 1888. Oil on canvas, 60¼ x 42 inches. Museum of Fine Arts, Boston.

154. *Two Girls on a Lawn*, c. 1888. Oil on canvas, 21⅛ x 25¼ inches. The Metropolitan Museum of Art, New York. Gift of Mrs. Francis Ormond.

155. *Dennis Miller Bunker Painting at Calcot*, 1888. Oil on canvas, 26¾ x 25 inches. Terra Museum of American Art, Evanston, Illinois. Daniel J. Terra Collection.

156. *A Backwater, Calcot Mill, near Reading*, 1888. Oil on canvas, 20 x 27 inches. The Baltimore Museum of Art. Gift of J. Gilman D'Arcy Paul.

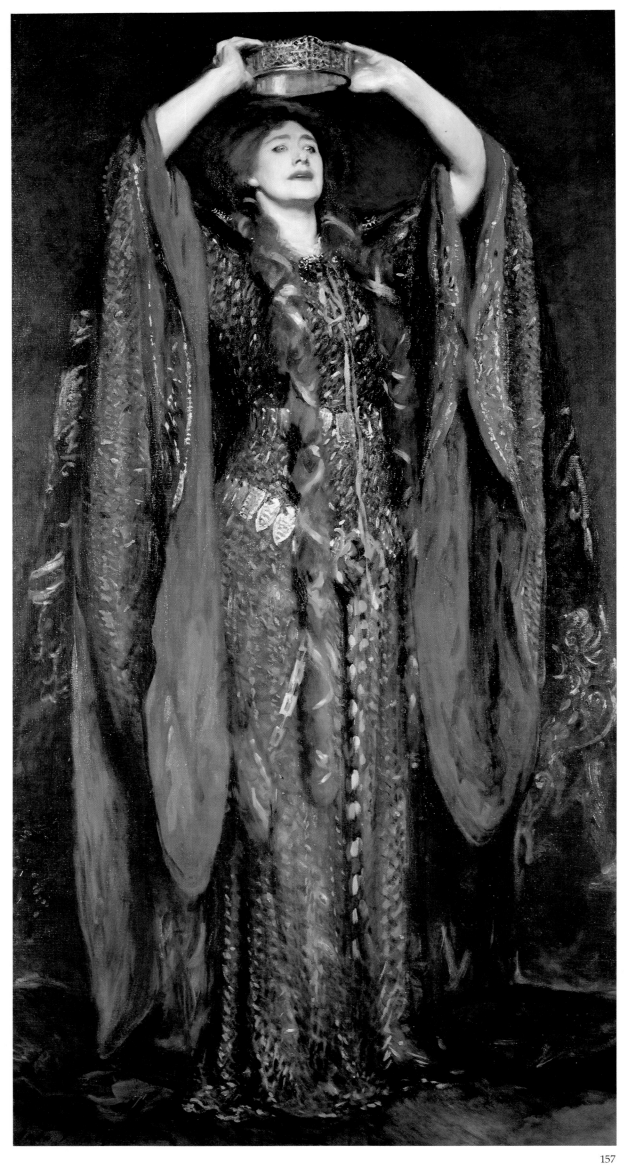

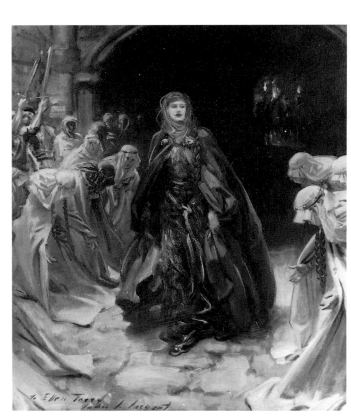

157 158

159

157. *Miss Ellen Terry as Lady Macbeth*, 1889. Oil on canvas, 87 x 45 inches. National Portrait Gallery, London.

158. *Ellen Terry as Lady Macbeth Leaving the Keep to Meet Duncan*, 1888. Oil on canvas (grisaille sketch), 33½ x 28 inches. National Portrait Gallery, London.

159. *W. Graham Robertson*, 1894. Oil on canvas, 90¾ x 46¾ inches. The Tate Gallery, London.

blend nicely with *The Daughters of Edward D. Boit* (plate 107) of six years earlier. When he veered in the direction of Monet, Sargent let his colors get thick, opaque; for *Mrs. Boit*, he thinned them once again. The mother is made of the same translucent glazes as her daughters. In both paintings, figures and objects appear against luminous, dark backgrounds. Light, when it strikes, sets off a brilliant shimmer. Sargent's touch is more economical in 1888 than in '82—and it was even more so in his formal portraits of later years. As paint marks grow fewer, Sargent's forms owe more and more of their coherence to his command of tonal contrast. Thus he continues to refine—and, on occasion, over-refine—the lessons he learned from Carolus-Duran, from Manet, and from the master of them both, Velázquez. *The Daughters of Edward D. Boit* draws on *Las Meniñas*; Sargent's portrait of the mother shows the exuberance, in pose as well as treatment, that Frans Hals nearly always reserved for men.

Mrs. Gardner wanted nothing so nicely calculated. She fancied herself wicked and, by the standards of her time, she was. Having taken a lover or two, she hoped Sargent's portrait of her would be as shocking to Boston as *Madame X* had been to Paris. The painting (plate 161) turned out to be, instead, a bit peculiar. Mrs. Gardner stands facing full front, her hands held much as Mme. Poirson held hers in 1885 (plate 129). Two ropes of pearls at her waist repeat the curve of her arms, and the same curve reappears in the flounces of her dress. These patterns echo through the backdrop: a red and black brocade arranged to provide Mrs. Gardner with an exotic halo. The picture seems loaded with pretensions to symbolic import, as if this Boston patron wished to offer herself up to worship as a Madonna—or Venus—of the arts.

Mrs. Gardner was an infuriatingly skittish sitter. After eight false starts, Sargent arranged her in a simple pose, raked her with dramatic lighting, and restrained his brushwork almost as much as he had done for Mme. Gautreau. He showed the same restraint later on, whenever the occasion required it—passages of the extravagant Wertheimer portraits (plates 254, 255, 257) are similarly subdued. Sargent always adjusted his style to the project at hand. Once mastered, a resource never grew obsolete: some of his very last portraits show glazed backgrounds and tonal transitions across forehead and cheek that arrive directly from the late 1870s, when Sargent was still the protégé of Carolus-Duran.

On January 30, 1888, St. Botolph's Club in Boston put on a large show of Sargent's work. This was not his first appearance at St. Botolph's; the month before, his picture of Robert Louis Stevenson had

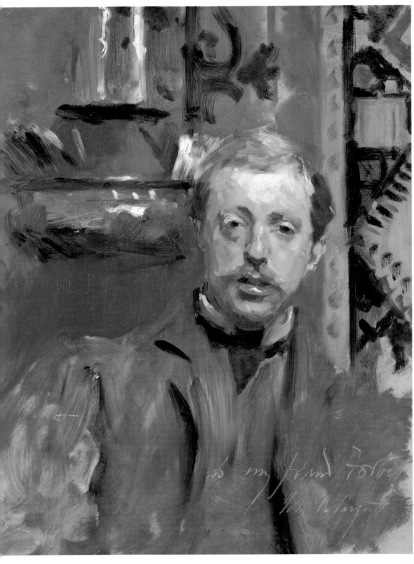

160

appeared in a group exhibition. "Greta," the New York *Art Amateur*'s Boston correspondent, had reported on this "odd sketch," "full of character and life, say those who know him [Stevenson]." Greta reported on the opening of the one-man show as being as much a social as an artistic event. "Boston propriety," she wrote, "fairly jumped at the first sight" of these canvases,

and on second thoughts did not know whether it ought to feel really shocked or only amused. It is still undecided, I think, whether it was insulted or delighted. Mr. Sargent, everyone knows, is a distinguished painter, even in Paris, and has two or three times produced the most talked-about picture in the Paris Salon. But it does not follow that Boston, which prides itself on an art-culture very different from that of the contemporary Salon, dating indeed from Athens and Flaxman's Outlines, will think the more of him for that. [Sargent] is the member of one of the most distinguished of old Boston families, but he has had the temerity to absent himself from his native country from the day he was born up to within two months of this exhibition. The first impression of many a well-bred Boston lady was that she had fallen into the brilliant but doubtful society one becomes familiar with in Paris or Rome, and I should not be surprised if some of our matrons were still inwardly blushing.[106]

Greta teases Boston for the benefit of a New York audience. Few Bostonians were quite as proper, as earnestly Athenian in their cultural yearnings, as she makes out. Still, she gets close to the source of Sargent's early difficulties—and later triumphs—with her remark that "the spirit and the style of the painter were so audacious, reckless and unconventional!" "He actually presented people in attitudes and costumes that were never seen in serious, costly portraits before, and the painting was done in an irreverently rapid, off-hand, dashing manner of clever brushwork." Greta complains that Sargent's paintings lack "deep, sweet, harmonious tone." By daylight, "the cleverest" of them look "harsh, almost chalky"—a complaint lodged for a quarter of a century against Manet and all those painters who learned from his "brutal" manner of moving from one tone to the next. Greta had kept up with the art magazines of London and Paris.

She looks at *El Jaleo* (plate 99) with "a quickening of the pulse." As for *The Daughters of Edward D. Boit*—"who would dare to deny to that picture the highest qualities of truest art?" Of course, it was the formal portraits that "caused the hubbub. One must admit that the young portraitist took some liberties!" Sargent has transformed one "sweet

160. *Charles Stuart Forbes*, c. 1889. Oil on canvas, 29 x 24½ inches. The Virginia Steele Scott Foundation, Pasadena, California.

161. *Isabella Stewart Gardner*, 1888. Oil on canvas, 74¾ x 31½ inches. Isabella Stewart Gardner Museum, Boston.

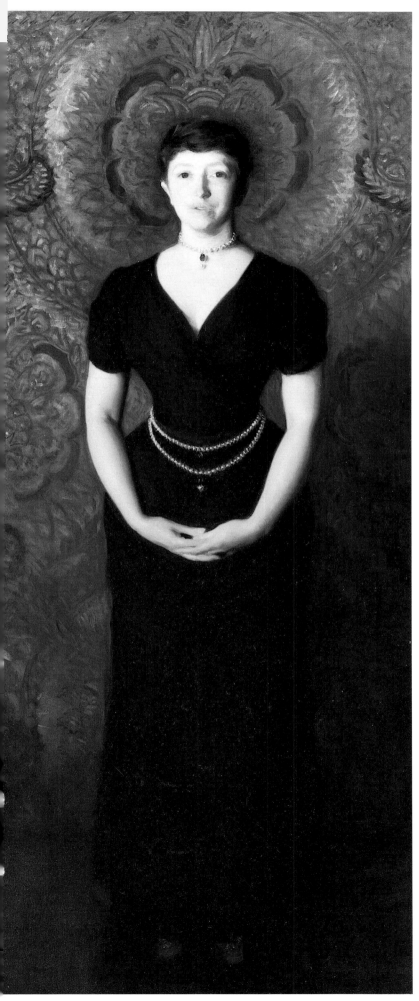

and unpretentious'' (and unidentified) lady into ''a tall, imperious personage quite different from the original, but twice as picturesque.'' *Mrs. Edward D. Boit* is suspiciously ''high-colored.'' Greta refers to Mrs. Gardner only as ''the most dashing of fashion's local cynosures.'' With ''her head enclosed as by an aureole,'' she seems to give ''testimony to her devotion to the fashionable Hindoo cult. The mystic smile—if smile it be—upon the quivering lips of this portrait was the prime *tour de force* of the whole exhibition, and the discussion is still hot as to what that smile signified or what it concealed.''[107]

Greta's determinedly light tone leads her straight to the crux of Sargent's success, which never was a weighty affair of sheer formal excellence, as even his staunchest admirers were ready to admit. Still, as Greta senses, he had an astounding power to adapt radical styles to the conservative traditions of official portraiture. Wielding this power, Sargent produced ''the picture of the year'' in city after city, at one crowded exhibition after the next. Avant-gardists very early judged this use of the new as a betrayal of their struggle to purify the forms and purposes of art.

The success of the St. Botolph's show suggests that Boston had been waiting for someone like Sargent to resolve—or at least finesse—troubling questions about tradition and the new, the academy and Impressionism, even the ungraspable matter of Europe's relation to America. Prodded by satirical impulses, Greta pictures the Boston spirit as Neoclassical, dedicated to fragile refinements of John Flaxman's togaed and helmeted figures. Boston was the hometown of the American Renaissance, that self-conscious attempt to find a New World counterpart to the classicism of Athens, Rome, and Florence. Yet Bostonians launched themselves on other aesthetic currents, too, as indeed all the major cities of America did.

Impressionism, like Barbizon painting before it, was more widely popular in the United States than in France or England. Few Americans interested in the arts cared much about the classicizing ideals of academic practice. Presented with challenges to the academy, most responded with a certain innocence and, often enough, deep enthusiasm. There was an audience in Boston and New York receptive to the claim that Jean Baptiste Corot, Jean François Millet, and, later, Monet offered images of directly apprehended truth. Those who doubted the French painters were usually convinced by the Ruskinian truths of Burne-Jones and the Pre-Raphaelites. Of course, only genteel truthtelling could count on acceptance—critics and collectors demanded that

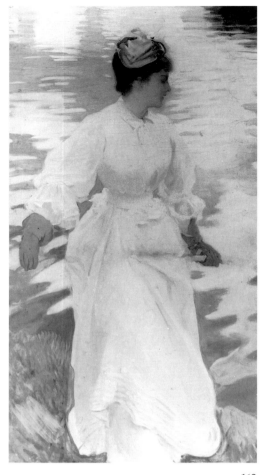

162

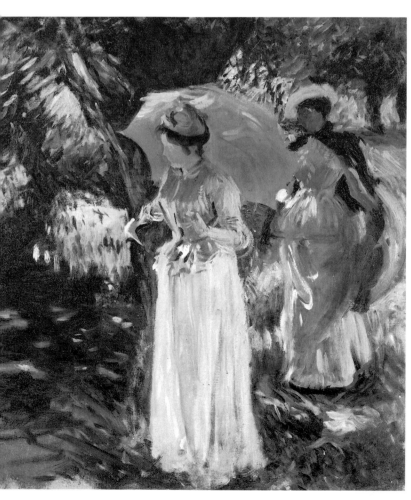

163

even the most spontaneous seeming landscape be refined. Thus there developed a market in Boston for the exceedingly cautious Barbizon style of William Morris Hunt. After Barbizon came Impressionism, as in France. By the end of the century there were any number of East Coast painters working in ways derived from Monet and company—Theodore Robinson, Thomas Wilmer Dewing, and Frederick Childe Hassam among them. With the exception of Hassam and a very few others, none of these painters was really an Impressionist, though that was the label they enjoyed. In Boston and New York, this was a helpful tag, signifying a devotion to up-to-date truthfulness of a kind that never got in the way of comforting pictorial refinement. In America the line between radical possibilities and long certified beauty was always blurred. This worked in Sargent's favor.

Back in New York after his Boston triumph, Sargent painted portraits of Mrs. Adrian Iselin (plate 8) and Mrs. Lucius Shepard, a member of the Vanderbilt family. In May he sailed for London. On arriving, Sargent found that his father had suffered a stroke that winter in Nice. The artist arranged for his family to settle in Calcot, a village near Broadway. Soon afterward, he joined them there, going down to London only on occasion. Sargent had several seasons to wait before he found a London clientele to match the one he had gathered around himself in Boston. *Carnation, Lily, Lily, Rose* had made him famous, but his portraits had gotten him the reputation of pushing acute observation to the point of bluntness. W. Graham Robertson, a friend of his, recalled the talk in London:"'It is positively dangerous to sit to Sargent. It's taking your face in your hands,' said one timid aspirant; and many stood shivering on the brink waiting for more adventurous spirits to take the plunge."[108]

Commissions were scarce throughout 1888. Sargent had time for a presentation piece of George Henschel, the fashionable conductor, and he began work on a painting of Ellen Terry in her current role: Lady Macbeth (plate 157). A subject as blatantly dramatic as *El Jaleo*, Ellen Terry presented the further advantage of posing in a costume by Mrs. Alice Comyns Carr, wife of the Grosvenor Gallery's director. Sargent spent much of the summer with his family, and of course he continued to sketch in oils along the River Avon. His sisters appear often in these paintings. Vernon Lee, who visited the Sargents now and again, recalled "the loving tenderness with which, the day's work over, John would lead his father from the dinner table and sit alone with him till it was time to be put to bed. 'I am going to sit and smoke,' the old man

162. *Fishing*, 1889. Oil on canvas, 72¾ x 38½ inches. The Tate Gallery, London.

163. *Two Girls with Parasols at Fladbury*, 1889. Oil on canvas, 29½ x 25 inches. The Metropolitan Museum of Art, New York. Gift of Mrs. Francis Ormond, 1950.

164. *Paul Helleu Sketching with His Wife*, 1889. Oil on canvas, 26⅛ x 32⅛ inches. The Brooklyn Museum. Museum Collection Fund.

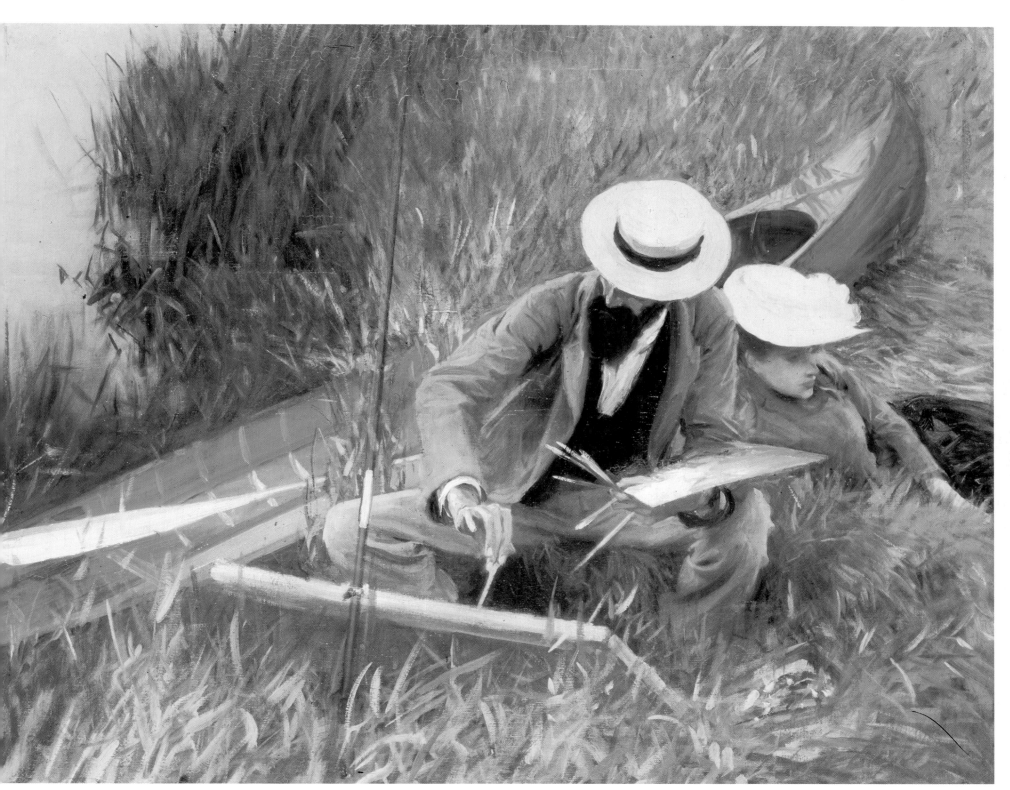

164

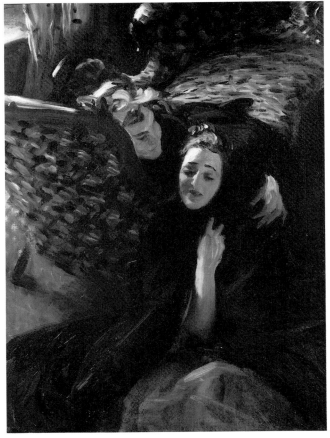

165

repeated evening after evening, 'with my son John.'"[109] Dr. Sargent died on April 25, 1889.

That spring the New Gallery, which was the Grosvenor in a later incarnation, showed Sargent's picture of Ellen Terry as Lady Macbeth. The actress said in her diary that she thought it "quite magnificent. The green and blue of the dress is splendid, and the expression as Lady Macbeth holds the crown over her head is quite wonderful." The *Athenaeum* said just the opposite:

> This startling piece has more of the *Lyceum* spectacle about it than of Shakespeare or Lady Macbeth. While its vigor is not to be denied, its taste and the genuineness of its inspiration are on a par with each other. The lady raises the crown to her brow with passion which would be quite admissible in the portrait of a fine actress in such a character, if the sensational elements in her acting and the coarseness of her surroundings—down to the blue and green of her robes, layers of stage paint on her face, lips contorted to move the pit, eyes shining in the footlights' glare—had not been dwelt upon in a way at which the visitor will shudder. This is painting for the pit.[110]

Speaking on behalf of herself and her stardom, Ellen Terry had taken immediate liking to this painting. Speaking in righteous defense of all that is fitting and proper and uncontaminated by fashion, the *Athenaeum*'s critic once again recoiled. In the generality of its praise, the *Magazine of Art* was nearly as uncritical as Ellen Terry: "No portrait has been exhibited for some years which excels this in grandeur of pose, fineness of modeling, and magnificence of colour."[111]

Only the *Saturday Review* had anything specific to say about the tactics Sargent employed in this painting. After pointing out that *Miss Ellen Terry as Lady Macbeth* "enjoys the distinction . . . of being the best-hated picture of the year," the *Saturday Review*'s critic goes on to make some unusually acute points about Sargent's command of artifice. "There is no attempt to idealize the subject, no thought of giving us Lady Macbeth herself; it is strictly and limitedly Miss Ellen Terry in that particular part, made as real underneath her stage artificiality as the painter knows how to make her. In fact, it is a *tour de force* of realism applied to the artificial, the actress caught and fixed, not as the individuality assumed [i.e., Lady Macbeth], but herself seen through and outside of the assumption."[112] "Realism applied to the artificial"—if the critic had gone on to acknowledge that realist devices are as artificial in their way

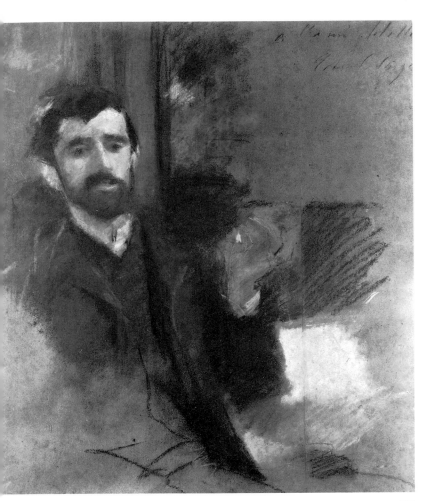

166

118

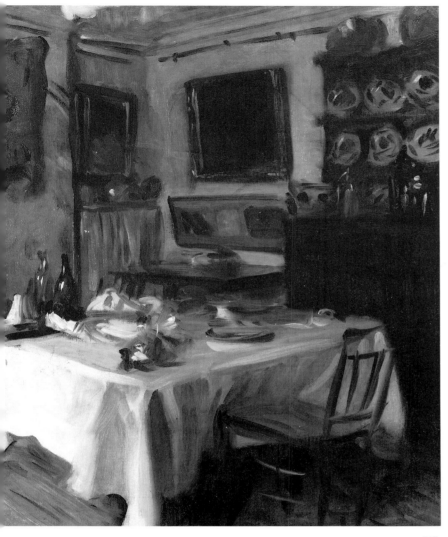

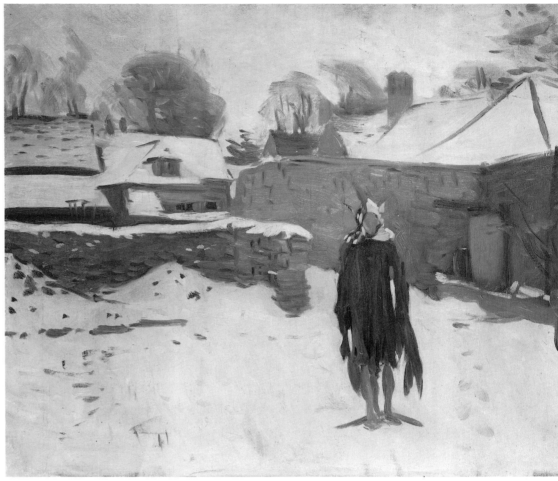

167 168

165. *Flora Priestly and Violet Sargent*, 1889. Oil on canvas, 22 x 16½ inches. The Ormond Family.

166. *Portrait of Paul Helleu*, c. 1889(?). Pastel on paper, 19½ x 17⅝ inches. Fogg Art Museum, Harvard University, Cambridge, Massachusetts. Annie Swan Coburn Bequest.

167. *My Dining Room*, c. 1889. Oil on canvas, 29 x 23¾ inches. Smith College Museum of Art, Northampton, Massachusetts. Purchased with funds given by Mrs. Henry T. Curtiss (Mina Kirstein '18) in memory of William Allan Neilson.

168. *Mannikin in the Snow*, 1889. Oil on canvas, 25 x 30 inches. The Metropolitan Museum of Art, New York. Gift of Mrs. Francis Ormond, 1950.

as the actress's make-up, he would have given a full account of the Terry painting.

Sargent was always aware that art is artifice, whatever else it might be. That awareness shows in the speed with which he mastered the techniques of painting, and in his predilection for theatrical subjects. Even when Sargent confined a portrait to the narrow terrain of dullness and propriety—as he did more and more often toward the end of his career—he refused to mitigate the sheer paintedness of an image's surface. Thus he was always called tasteless by those, like the *Athenaeum*'s critic, who expected art to be more diffident about its physical presence, to appeal more humbly to social and intellectual ideals. Sargent's portraiture served those who had the most to gain from the belief that the social order is itself an artifice, and so is best elaborated in a spirit of alert and lively elegance. The artist tired of his sitters' most wearisome pretensions, and eventually he fled portrait painting for murals and the open air. Still, if his world was artifice, it was also— and with the help of its artificiality—the guardian of all he valued. Manet challenged the premises of his own art, and thereby offered a symbolic challenge to the society that provided him with an audience. Sargent

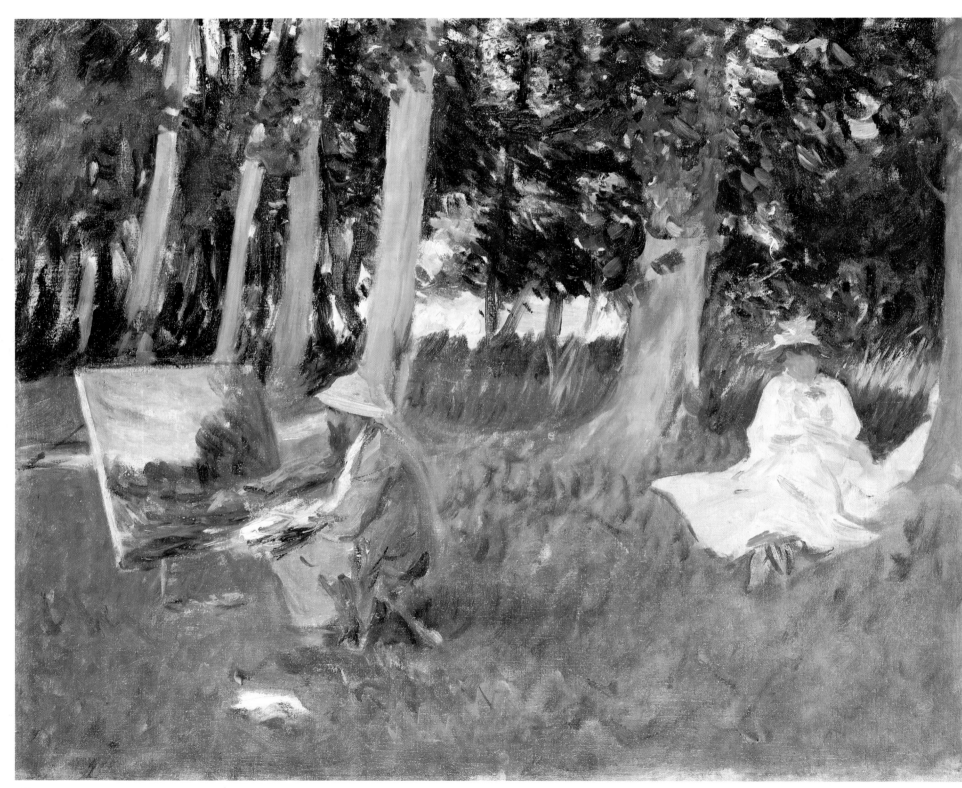

169

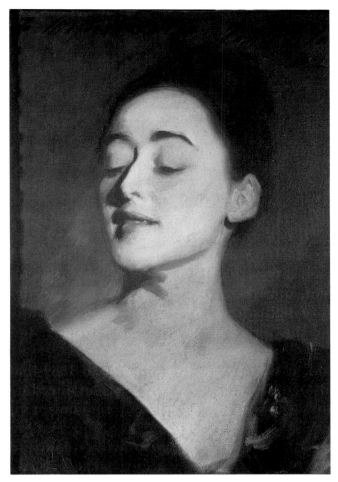

170

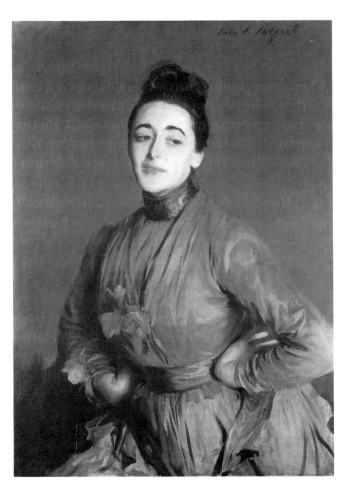

171

did neither. Early on, his masterly play with the possibilities of style led conservatives to accuse him of avant-garde impertinence. This was misguided. Sargent commanded style and history and social nuance in order to refurbish these things, not to question them.

In June of 1889 Sargent showed six paintings in the American section of the Exposition Universelle at Paris. The French government awarded him a medal and made him a *chevalier* of the Légion d'Honneur. One of the spectacles on view at the exposition was the Spanish dancer La Carmencita. Sargent watched her perform and, the following year, he painted her. He found other dancers there as well—a troupe of them from Java. Numerous drawings, watercolors, oil sketches, and finished paintings followed (plate 172), which are as tentative as *La Carmencita* is certain. The costumes, and especially the gestures, of the Javanese may have interrupted his fluency. Yet he found the subject difficult to abandon. Sargent was, said Vernon Lee, "attracted by the bizarre and outlandish." His tastes in literature ran to Leconte de Lisle, a late Romantic visionary of exotica, and to the rest of the Parnassians. His murals for the Boston Public Library are liveliest when they treat such pagan deities as Astarte and Moloch. Usually, though, he veils the bizarre, dimming its effects until they read as theatrical.

Throughout 1889 Sargent and Monet worked together raising money for the purchase of Manet's *L'Olympia*. Manet had died six years before. The fund was to go to his widow, and the painting would be presented to the Louvre. Nearly all the Impressionists contributed, as did Carolus-Duran, the dealer Paul Durand-Ruel, the novelist J. K. Huysmans, and the critic Antonin Proust. Monet was the leader of this project; Sargent was one of several others especially active in encouraging contributions. Among his friends, Paul Helleu, Carroll Beckwith, and Gustav Natorp all gave as much as they could. Sargent and Rodin each gave 1,000 francs, and the total grew to nearly 20,000. Painters and writers who could agree on nothing else insisted on the importance of *L'Olympia*. The fund for its purchase united the factions and peripheries of the avant-garde, but only for a very short moment.

Sargent spent part of August at Fladbury Rectory, near Broadway, where his mother and sisters had settled. This summer, as last, Vernon Lee visited. Abbey was at work nearby, and Paul Helleu, a friend of Sargent's since their days together at Carolus-Duran's atelier, arrived with his new wife, Alice Louise. Sargent painted Helleu several times (plates 164,166). His picture of the newlyweds, the husband intently working, the wife a bit glum, is one of the best-known examples of

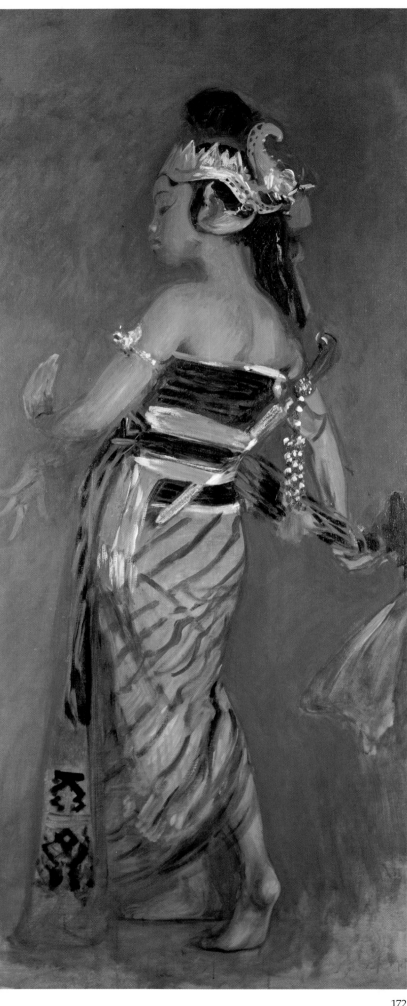

172

122

172. *A Javanese Dancer*, 1889. Oil on canvas, 68½ x 30 inches. The Ormond Family.

173. *La Carmencita*, 1890. Oil on canvas, 90 x 54½ inches. Jeu de Paume, Paris.

174. Edouard Manet. *Lola de Valence*, 1862. Oil on canvas, 48½ x 36¼ inches. Jeu de Paume, Paris.

175. William Merritt Chase. *Carmencita*, c. 1890. Oil on canvas, 70 x 40⅛ inches. The Metropolitan Museum of Art, New York. Gift of Sir William Van Horne, 1906.

"American Impressionism." It is not, however, an Impressionist canvas. Rather, it is a rendering of figures in a landscape so brightly lit, so dazzlingly accented by the red canoe, that its tonal structure is difficult to see. That structure is solid, nonetheless—especially in the two figures, where the transition of lights and darks is as orderly as any Sargent constructed under the direct influence of Velázquez and Manet.

According to John Rewald, it was during the summer of 1889 that Sargent and Monet painted together at Giverny. There is an anecdote of Monet's that suggests that Sargent found genuine Impressionism incomprehensible—that he threw up his hands in the face of its extremism. When he came to Giverny, said Monet, "I gave him my colors and he wanted black, and I told him, 'But I haven't any.' 'Then I can't paint,' he cried, and added, 'How do you do it!'"[113] One needs black in order to model form, and Sargent needed to model in order to paint.

In the fall Sargent traveled to Kent, where he stayed with the Harrisons and painted his striking portrait of Elsie Palmer (plate 235), the daughter of an American general. There must also have been at least one trip, late in the fall, to Broadway—*Mannikin in the Snow* (plate 168) is Sargent's fast, extremely contrasty sketch of a figure in Edwin Austin Abbey's garden. (Abbey had transformed the scarecrow into a troubadour, a personage proper to the Cotswold Picturesque.) That December, Sargent and his sister Violet sailed to America. She traveled on to Boston, while Sargent stayed behind to see his friend Carroll Beckwith, who celebrated the occasion with a party. La Carmencita danced. Though she was in the midst of an American tour, Sargent somehow induced her to pose for him (plate 173). This subject carries over from *El Jaleo*, and so does the dancer's theatrical flair. Lit from below, as if by spotlights, she stares out of the frame with a hauteur very close to arrogance. La Carmencita's pose is an energized version of Lola de Valence's, in Manet's painting of 1862 (plate 174). Historians have suggested that Manet borrowed the stiffness of his image from souvenir posters. Sargent offers no such comment on the conventions of high and low art; without a moment's hesitation he spirits his subject away to the upper reaches of style. W. Graham Robertson remembered the dancer's performances: "She postured and paced, she ogled, she flashed her eyes and her teeth."[114] In Sargent's painting the treatment of her dress, intricately embroidered and flashing with highlights, is a bravura flourish in support of an elegant pose and a dignified stare. In fact, every flourish in the painting joins in that support, fully and

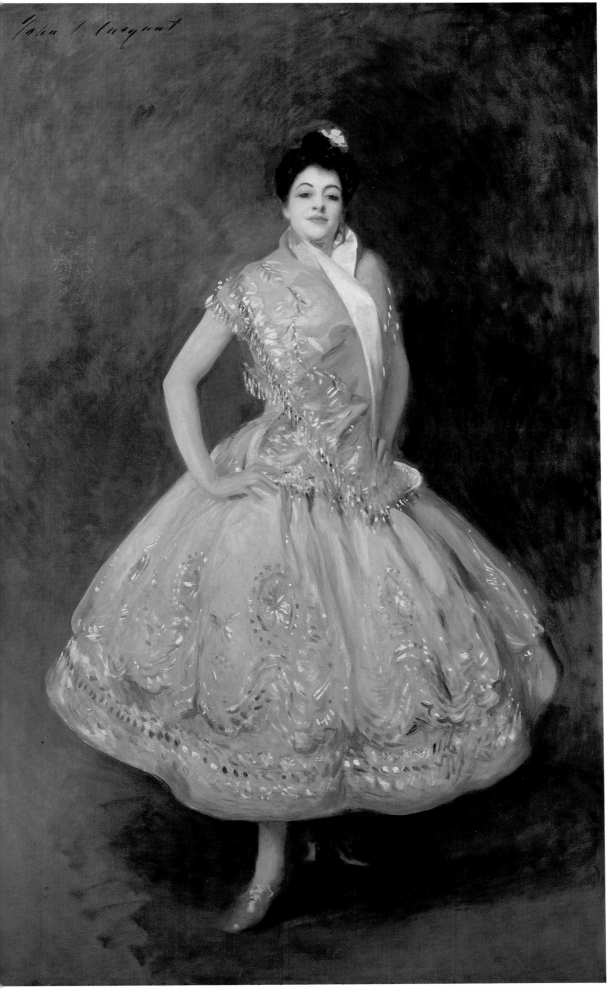

173

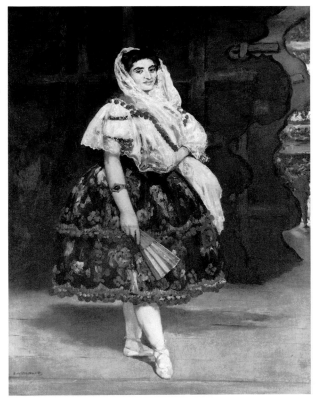

174

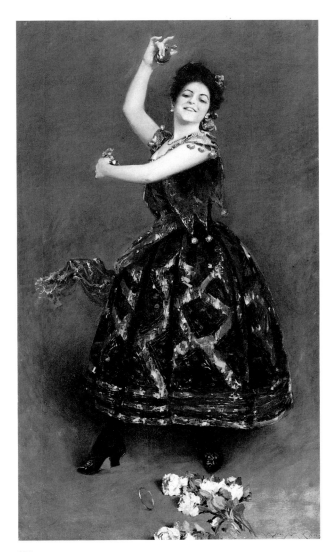

175

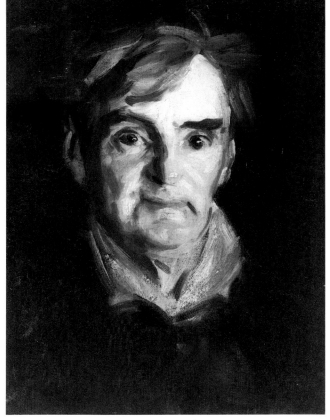

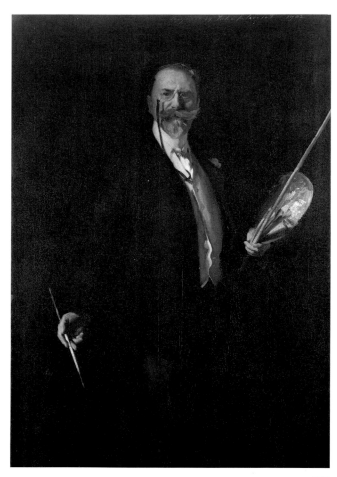

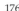

immediately. By contrast, Manet's *Lola de Valence* draws the eye into a labyrinthine series of considerations, doubts, and reconsiderations of painting's very means.

There was another party in New York, this time at the studio of William Merritt Chase, where La Carmencita danced again. Mrs. Gardner made an appearance and later saw Sargent's half-finished portrait of the dancer. She did not, as Sargent hoped she might, decide to buy it. Chase nonetheless started on his own version of the subject (plate 175). During this stay Sargent painted still more actors—Lawrence Barrett, Edwin Booth, and Joseph Jefferson (plate 176). These are intimate, informal paintings, not commissioned. In Sargent's treatment of Jefferson, painterly spontaneity—or signs of it—nearly smother the image of the actor as an inspired personality. It is as though Sargent felt his performance at the easel must equal any to be seen on stage.

Late in his second portrait-painting excursion to America, Sargent painted Mrs. Edward Davis and her son—members of a genteel family from Worcester, Massachusetts (plate 178). Mariana Griswold van Rensselaer praised the painting as "masterly," going on to say that

some observers used to deny that Mr. Sargent was a great portrait painter, while acknowledging him a master of the brush. They said he was not a master of the art of reading character; that he painted the merely superficial aspect of his models, and when he tried to do more than this, gave a distorted or overcharged account of the facts that lay beneath the surface. They said that he always succeeded with children because in childhood character scarcely exists, because the charm and even the individuality of the child are essentially superficial, and that his least successful portraits of women were those where some marked peculiarity of type or expression had given him the chance to exaggerate. And they sometimes added that were the fine costumes of his models exchanged for simpler clothes, much of the interest of his pictures would disappear.

With none of these ideas did we agree. We felt that his children's faces were not lacking in character, but were especially remarkable because childish character is so subtly revealed; that what seemed "exaggeration" would not have seemed so but for the public's sad familiarity with women's portraits from which all expression has been wiped in the interest of a smooth, inane prettiness; and that no matter how brilliant were the costumes Mr. Sargent portrayed, he always places his heads pre-eminent in interest. But we also feel there was a force, a virility, in Mr. Sargent's

176. *Joseph Jefferson*, 1890. Oil on canvas, 21 x 15 inches. The Ormond Family.

177. *William Merritt Chase*, 1902. Oil on canvas, 62½ x 41⅜ inches. The Metropolitan Museum of Art, New York. Gift of the pupils of William M. Chase, 1905.

178. *Mrs. Edward L. Davis and Her Son, Livingston*, 1890. Oil on canvas, 86¼ x 44¾ inches. Los Angeles County Museum of Art. Frances and Armand Hammer Purchase Fund.

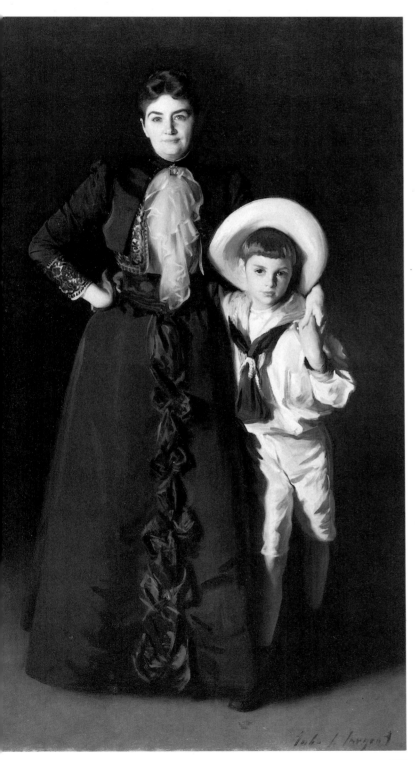

perception of character which might find fullest expression were he to paint forcible masculine heads.[115]

The critic praises Sargent's recent portrait of the Honorable Thomas B. Reed, ex-Speaker of the House of Representatives. Van Rensselaer has difficulty claiming much for the Reed portrait. It is routine, a pretext for her measured, even stately reply to the charges of Sargent's detractors. As usual in disagreements over an artist's worth, the argument comes down to a series of contradictions. Is it said that Sargent is superficial? Well, then, van Rensselaer will claim the opposite. The points she makes are not as important as the tone in which she makes them. Her article demonstrates the possibility of considering Sargent with the utmost seriousness, not only as a brushhandler but as a reader of "character and soul." Growing more and more common in the 1890s, this attitude toward Sargent was standard by the turn of the century. Sargent was deeply relieved when he encountered it in van Rensselaer's article, which must have been in December of 1891 or sometime during the following year. He wrote her to say:

I am sure you must be the author of an article that has been sent me from N.Y. in which Mrs. Davis' picture receives very high praise, because it seems to have touched a sentiment in the writer like what you expressed about the Goelet baby, and very few writers give me credit for insides, so to speak. I am of course grateful to you for writing, but especially for feeling the way you do, for it would seem that sometimes at any rate for you, I hit the mark.

Please believe me,
Yours sincerely,
John S. Sargent.

I feel as if I ought to have written a much longer letter to give you any idea of how much pleasure and what kind of pleasure you have given me.[116]

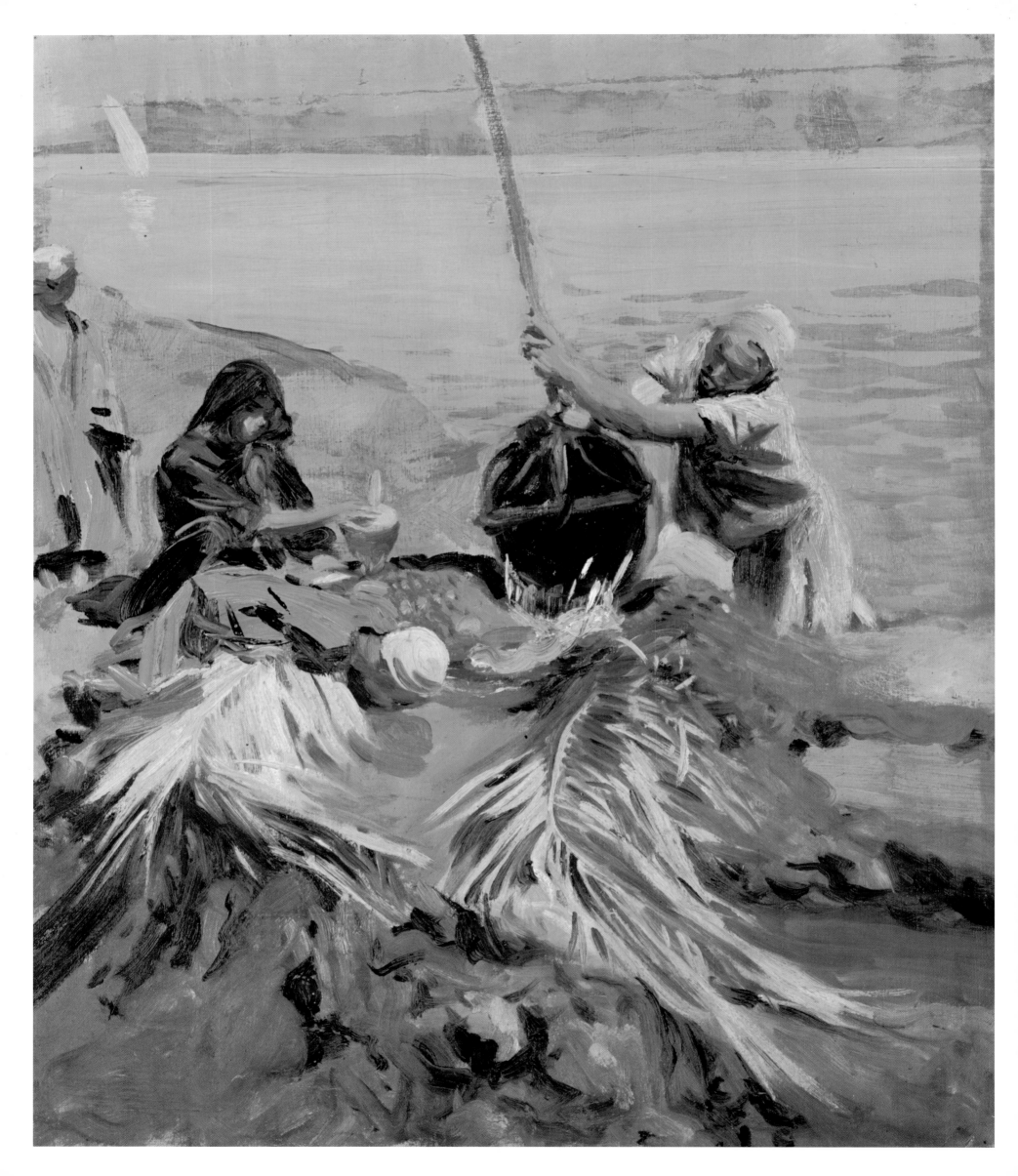

VII. *Patriarchs and Pagans– The Boston Murals*

179. *Egyptians Raising Water from the Nile*, 1890–91. Oil on canvas, 25 x 21 inches. The Metropolitan Museum of Art, New York. Gift of Mrs. Francis Ormond, 1950.

W
HEN SARGENT PAINTED *Mrs. Edward L. Davis and Her Son, Livingston* (plate 178) he had already been in America for nearly a year. Commissions arranged for him by Stanford White put him in a position to find others on his own, and he was constantly busy. White admired him personally, yet that explains just a part—perhaps a small part—of the architect's efforts on his behalf. White had big plans for Sargent's talents. The firm of McKim, Mead and White was in the midst of building the Boston Public Library, a monument to the aspirations of the American Renaissance. It wasn't enough for the firm's library to suggest a Renaissance palazzo, the Colosseum in Rome, and the Bibliothèque Sainte-Geneviève in Paris. The American Renaissance was an attempt to unite all the visual arts, and so the library also had to be embellished, not merely brought to a climax of architectural reference. There would be bronze doors by Daniel Chester French, statuary by Frederick MacMonnies and Louis Saint-Gaudens; Louis's younger brother Augustus was to collaborate with Kenyon Cox on a seal for the building's façade. And on the interior walls there would be cycles of mural decoration. White wanted Sargent to execute one of these cycles, hence the need to sustain his career until the trustees of the library approved a commission. They accepted Sargent in the spring of 1890, along with his friend Edwin Austin Abbey.

Murals need themes. Edwin Blashfield, another painter of the American Renaissance, said that "besides having pattern, color, style, the decoration in a building which belongs to the public must speak to the people—to the man in the street. It must embody thought and intelligence."[117] Blashfield wrote this in 1913, when American Renaissance ideals had begun to drift into oblivion. Its murals, its allegorical statues, its emblematic embellishments never did speak very clearly to the man in the street. The American Renaissance was a nationalist, even a chauvinist movement, but never a popular one. It was a cultural power play, an attempt to appropriate the classical and European past as a refined backdrop for the economic elite of New York, Boston, and a few other cities. By the time the American Renaissance reached the statehouses of Midwestern capitals, the movement was dead. Only three decades

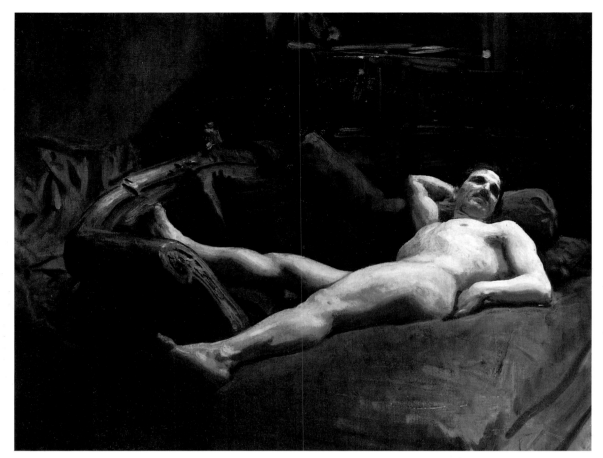

180

181

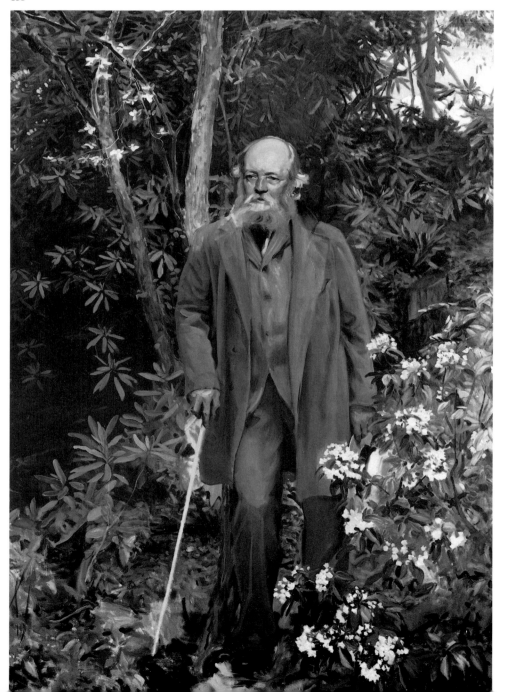

180. *Male Model Resting*, 1890s. Oil on canvas, 22 x 28 inches. The Forbes Magazine Collection, New York.

181. *Frederick Law Olmsted*, 1895. Oil on canvas, 92 x 62 inches. Biltmore Estate, Asheville, North Carolina.

182. *Nude Egyptian Girl*, 1891. Oil on canvas, 73 x 23 inches. The Art Institute of Chicago. Anonymous loan.

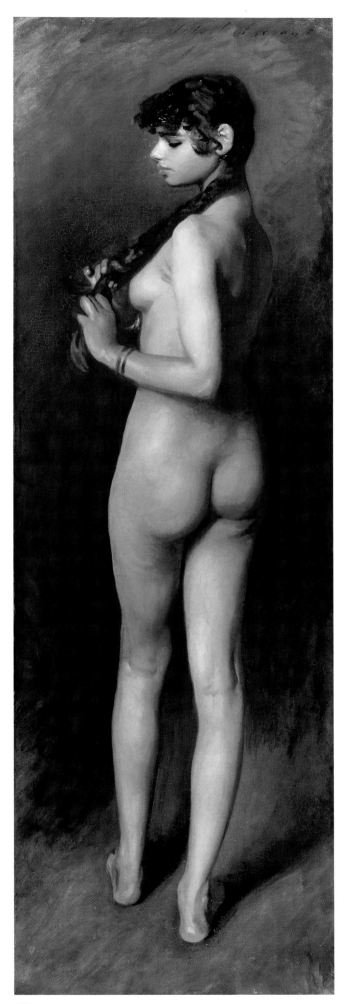

182

before, in the 1890s, it had seemed unstoppable. At that time the only difficulty seemed to be finding a subject on which to drape all this civic-minded yearning for refinement.

Abbey chose his easily—*The Quest of the Holy Grail*. Sargent thought at first that he might do a series of murals on themes from Spanish literature. He knew the subject, having made himself familiar with all the major European literatures, and each of his Spanish-flavored subject-paintings had been a success. His sources would be impressive, while his images could be as theatrical as he liked. Then he found another source, the Bible. Cervantes and the rest of the Spanish masters were august, but Scripture was even more so. And scriptural subjects would permit him, now and then, to transform the theatrical into the bizarre. Sargent decided to paint *The History of Religion*.

He and Violet left New York for Marseilles in 1890. Meeting the rest of his family there, Sargent sailed for Egypt with his mother and sisters. As usual, he sketched at every stopping-off point on the way—along the Nile, at Luxor, at the Santa Sophia in Constantinople, among the ruins of ancient Greece. His *Nude Egyptian Girl* (plate 182) is a full-length, comparatively finished canvas—"A superb studio study of the nude, masterly alike in strength, truth, and grace of drawing," said the *Magazine of Art*.[118] Most of the images Sargent painted in the Eastern Mediterranean were set aside in the form of sketches or absorbed into his tableau of Jehovah's struggle with pagan gods—see the lunette on the north wall of the Boston Public Library (plate 200). The artist had come to Egypt and Jerusalem, Constantinople and Athens, to gather, on the original sites, some impression of Western spirituality's most distant origins. This was an archeological expedition, guided by visionary impulses. Sanction for the project came first of all from the Parnassian and Symbolist poets for which, according to Vernon Lee, Sargent always had a taste. They believed that each epoch of the past had an aura perceptible to a refined imagination, much as the peculiar quality of a painter's style is visible to a sophisticated eye.

Since it was built from fragments of the past, tastefully arranged, the American Renaissance offered its own rationale for Sargent's trip—the need for a firsthand, perhaps even scientific examination of his sources. Sargent's colleague Abbey later said, "I feel it my duty as well as my pleasure to be guilty of as few historical inaccuracies as this antiquarian age permits."[119] And so Sargent's pagan gods, his Moloch, Osiris, and Isis; and his ancient tyrants, the Pharoah and the king of Assyria, appear on the north wall in punctiliously Egyptian and Assyrian detail.

183

It is, of course, historically inaccurate to mix these two styles with the Michelangelesque agonies of the children of Israel. Yet the American Renaissance had a rationale for this eclecticism. In 1897 Charles McKim said to Edith Wharton that "the designer should not be too slavish. By conscientious study of the best examples . . . it is possible to conceive a perfect result suggestive of a particular period . . . but inspired by the study of them all."[120] With enough study of the past, one earned a license to embroider and refine as freely as a Huysmans hero sequestered in a Symbolist sanctuary with a few books, exotic flowers, and his imagination. The difference was that each Symbolist dandy provided himself with his own prime audience, while the muralist in the American Renaissance tradition claimed to address the multitudes.

Sargent needed a public version of a style he had developed for the delectation of an elite. Fortunately, he had already taken a number of steps in that direction. In 1882 *El Jaleo* (plate 99) had pushed tonal play to theatrical extremes, and the painting had turned heads. Five years later, so did *Carnation, Lily, Lily, Rose* (plate 139), which absorbed all the richness and ambiguity of his color into a unified, deeply affecting mood. *Lady with a Rose* (plate 90), *Miss Ellen Terry as Macbeth* (plate 157), all of Sargent's popular paintings put his virtuosity at the service of a highly focused impact. Yet in murals the focus had to be still sharper, the effects more immediately accessible, according to the promoters of the American Renaissance. Sargent gravitated toward those precedents

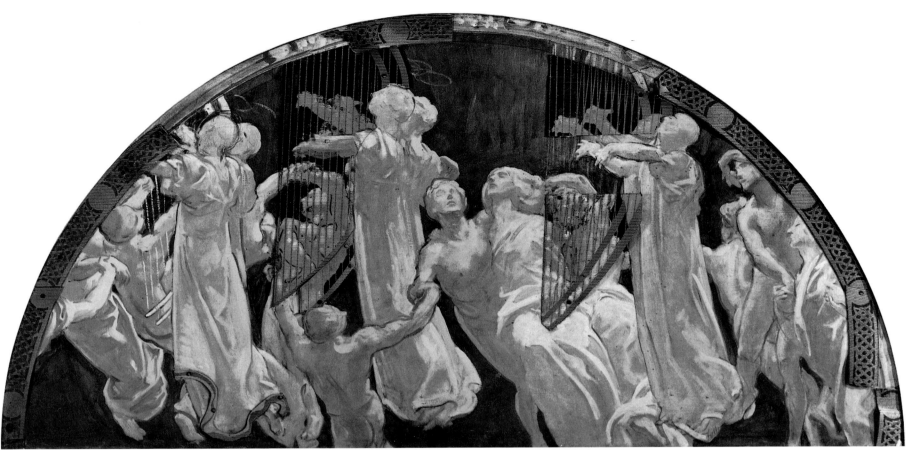

184

185

186. *Study for "Hell,"* c. 1903–9. Oil on canvas with applied cloth and gilding, 33¼ x 66¼ inches. Smith College Museum of Art, Northampton, Massachusetts. Gift of Mrs. Dwight W. Morrow (Elizabeth Cutter '96), 1932.

187. *Hell*, 1895–1916. Oil on canvas. West wall. Courtesy of the Trustees of the Boston Public Library.

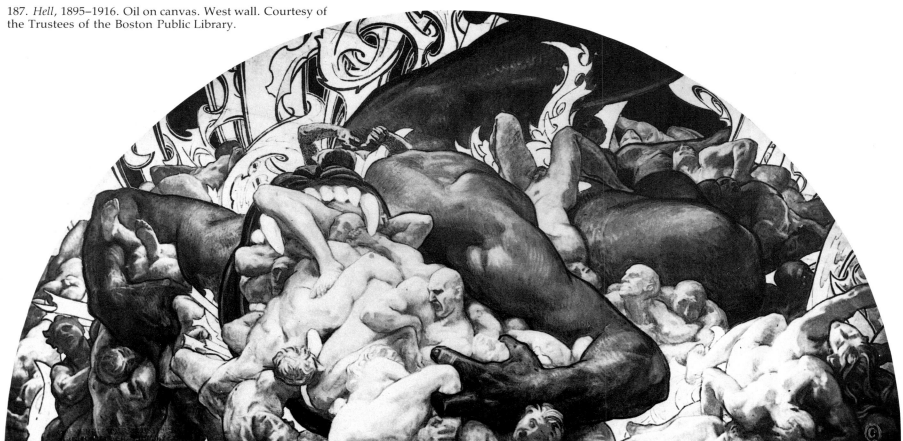

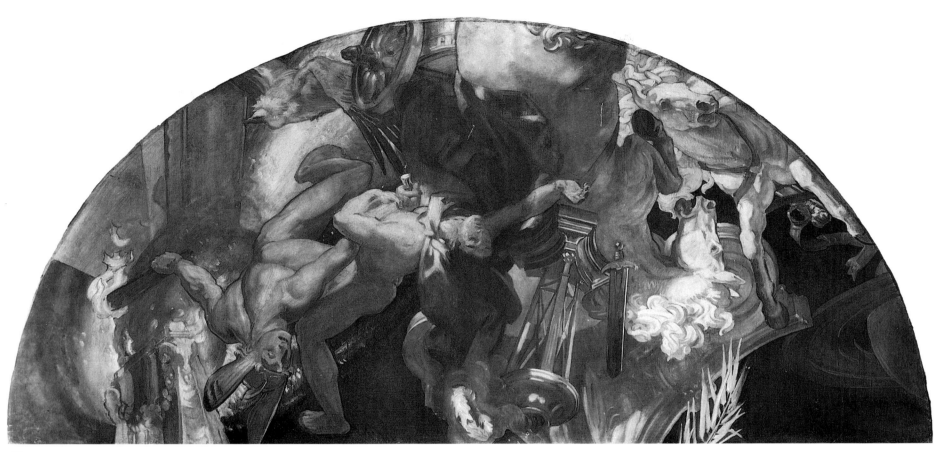

188

188. *Study for "Gog and Magog,"* c. 1903–9. Oil on canvas, 33⅛ x 66¾ inches. Fogg Art Museum, Harvard University, Cambridge, Massachusetts.

189. *Gog and Magog*, 1895–1916. Oil on canvas. East wall. Courtesy of the Trustees of the Boston Public Library.

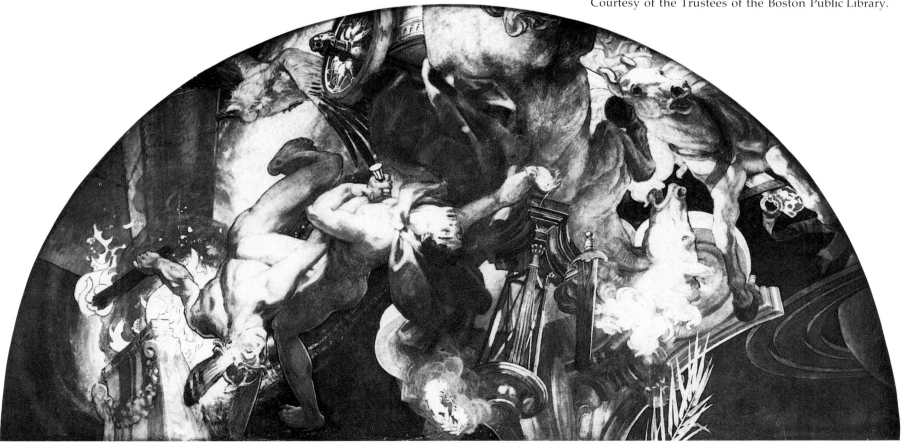

189

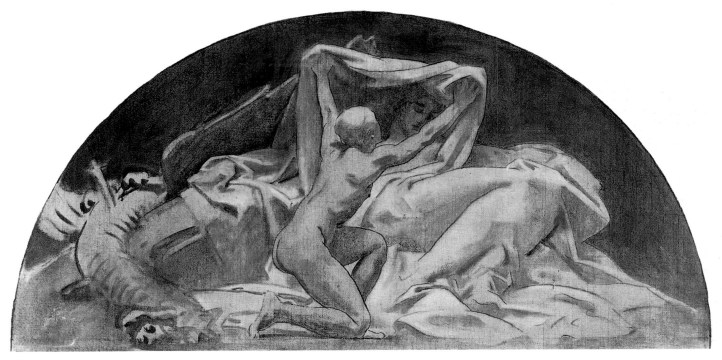

190

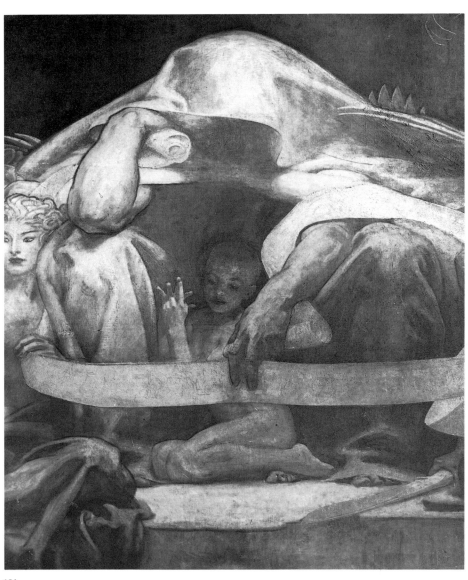

191

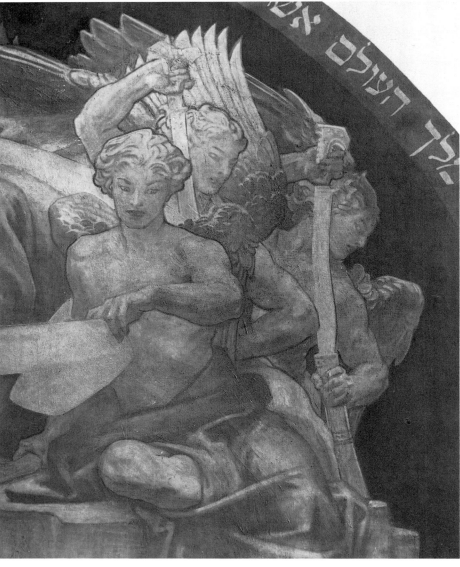

192

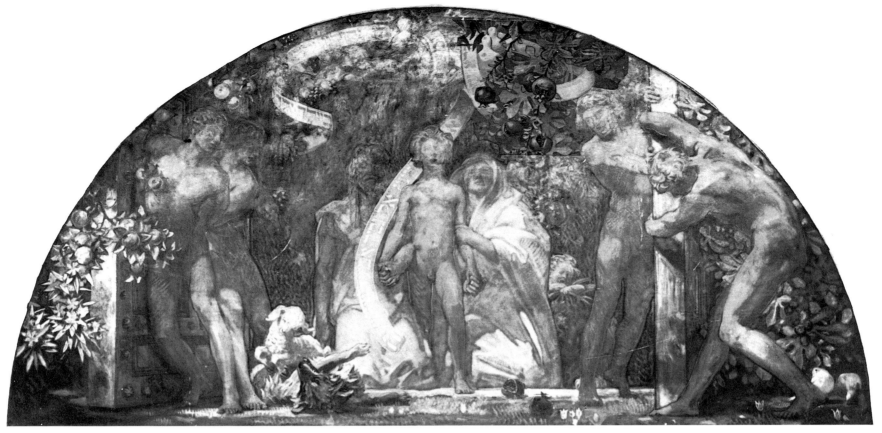

193

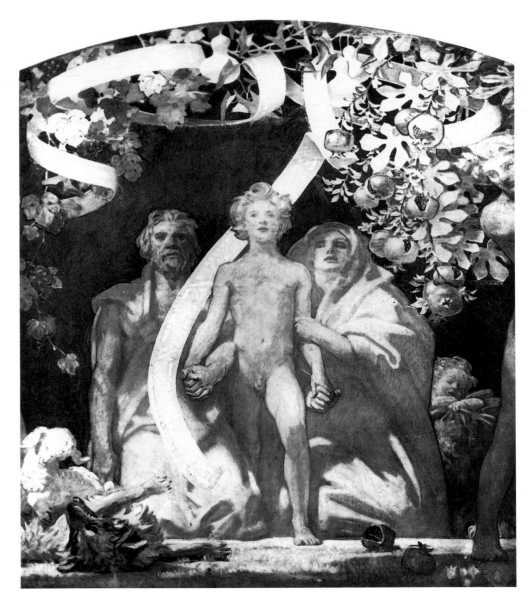

190. *Study for "Gog and Magog,"* c. 1903–9. Oil on canvas, 33⅛ x 66¾ inches. Fogg Art Museum, Harvard University, Cambridge, Massachusetts.

191. *The Law*, 1895–1916, center detail. Oil on canvas. East wall. Courtesy of the Trustees of the Boston Public Library.

192. *The Law*, 1895–1916, side detail. Oil on canvas. East wall. Courtesy of the Trustees of the Boston Public Library.

193. *The Messianic Era*, 1895–1916. Oil on canvas. East wall. Courtesy of the Trustees of the Boston Public Library.

194. *The Messianic Era*, 1895–1916, center detail. Oil on canvas. East wall. Courtesy of the Trustees of the Boston Public Library.

194

195

196

that, it was thought, would guide the civic-minded artist to a genuinely public style: he returned to the lessons of his old drawing teacher, Adolphe Yvon, and the Ecole des Beaux-Arts. In 1907 the critic Charles H. Caffin gave an American summary of the Beaux-Arts program. It is "based upon the preeminence of line over color, drawing over painting. Such an out-and-out doctrinaire as Ingres asserted that 'Form is everything, colour nothing.' Whether the doctrine is applied to landscape or figure painting, it implies the superiority of art over nature, and the need of modifying the forms of nature that they may be made to emulate the perfection of classical models."[121]

Timeless ideals tend to squelch panache, and so discourage play with the fashions of the moment—never mind that the American Renaissance was itself a fashion, one that sank quickly under the weight of its own earnestness. While it lived, the movement required artists to cultivate a solemn reverence for order, refinement, and the monuments of art history. The library project led Sargent on a long search in the realms of the universal, habitat of the archetype. As he progressed with

136

197

SARGENT'S SCULPTURE, THE CRUCIFIXION

THE original design for the piece of sculpture by the painter John S. Sargent, called "Crucifixion," is now in this country. The bronze group is 20½ by 29½ inches, and so, considerably smaller than the work, as it now appears, forming an essential part of the artist's decorations in the Boston Public Library. It was made in the late nineties.

The Sargent contributions to the building form an organic whole. They express, taken all together, a philosophical idea. The aim of the painter has been to show the development of a religious idea, which was also a social or legal idea. The prophets are quite inconclusive in themselves, either individually or collectively. Without the key furnished by the sculpture they might be regarded simply as expressing what a man of imagination thought that these poetseers looked like. But once the symbolism of the details of "the crucifixion" is understood it will be seen at a glance that Isaiah and Jeremiah and the rest are hardly even links in a chain. They are rather explanatory spectators, like the chorus in a Greek play.

THE figure on the cross, with a foot on the serpent, is bound to Adam and Eve, who hold chalices in their hands. These chalices symbolize the means by which the supreme act of expiation is to be commemorated through the ages.

So, in the summary supplied by the sculpture, it becomes clear that the whole religious development, set forth by the artist, depends on one idea, that of expiation. This was the theory, taken from the Roman Law, that St. Paul contributed to the church—a theory that entirely altered the attitude of the world towards Christianity. St. Paul was the Aristotle of the church, just as St. John was its Plato. That St. Paul insisted on the idea of expiation, because it was the only way he could make the citizens of Rome understand the meaning of the crucifixion, had the effect of making Christianity logical, and started it on its career of expansion. Without that lucidity and clearness it might have continued to be the creed of a small and obscure sect that would have had but little effect on civilization.

THE decorations of Mr. Sargent, together with the sculpture that binds them together, make up a very elaborate and complicated whole. It is the biggest "subject" ever tackled by an American sculptor. Some spectators will be content to look at the individual figures without bothering about their relation to the rest. Any such lazy and careless way of judging the work involves an injustice to the artist, who has a right to have his whole conception carefully considered and respected.

Mr. Sargent is now, admittedly, the most conspicuous figure in American art. This sculpture by him is only another link in the evidence of his extraordinary versatility. Since his determination to paint no more portraits he has devoted himself (1) To making portrait heads—in crayon, pencil, and charcoal, (2) To water colors, and (3) To landscapes in oil. It was while Mr. Sargent was in pursuit of stimulating and novel subjects in oils that our photographer luckily chanced to come up with him—in September—at Yoho, the heart of the Canadian Rockies.

198

195. *The Church: Tabernacle of the Eucharist*, 1895–1916. Oil on canvas. West ceiling. Courtesy of the Trustees of the Boston Public Library.

196. *The Synagogue: Ark of the Covenant*, 1895–1916. Oil on canvas. East ceiling. Courtesy of the Trustees of the Boston Public Library.

197. *Head of Christ*, c. 1897. Oil on canvas, 28¼ x 18 inches. Museum of Fine Arts, Boston. Gift of Mrs. Francis Ormond.

198. "Sargent's Sculpture, The Crucifixion," *Vanity Fair*, November 1916.

199. *The Dogma of Redemption* (Trinity, Crucifixion, frieze of angels), 1895–1916. Oil on canvas. South wall. Courtesy of the Trustees of the Boston Public Library.

199

200

201 202

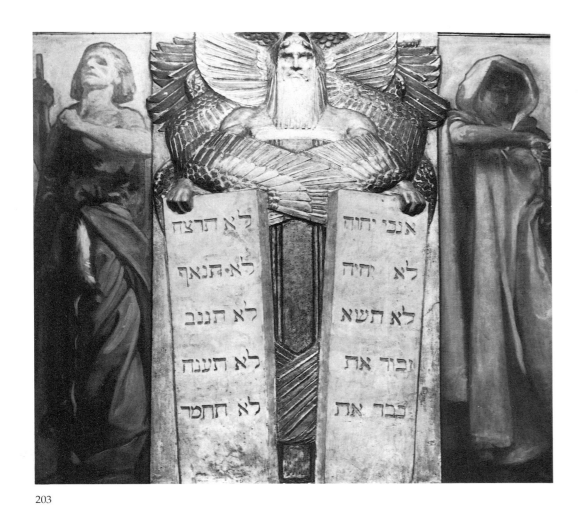

203

200. *The Children of Israel beneath the Yoke of Their Oppressors*, 1895–1916. Oil on canvas. North wall. Courtesy of the Trustees of the Boston Public Library.

201. *Frieze of the Prophets* (Zephaniah, Joel, Obadiah, Hosea), 1895–1916. Oil on canvas. Northwest wall. Courtesy of the Trustees of the Boston Public Library.

202. *Frieze of the Prophets* (Amos, Nahum, Ezekial, Daniel). North wall.

203. *Frieze of the Prophets* (Elijah, Moses, Joshua). North wall.

204. *Frieze of the Prophets* (Jeremiah, Jonah, Isaiah, Habakkuk). North wall.

205. *Frieze of the Prophets* (Micah, Haggai, Malachi, Zechariah). Northeast wall.

204 205

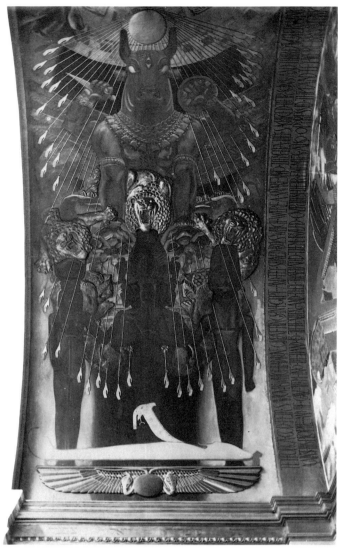

206

the cycle, he rendered his figures ever less earthy, giving them the bland suppleness that the late nineteenth century required of figures undraped for public display. To us, these images look caught in their time. To Sargent, they were approaches to eternity.

In early studies for Sargent's mural projects, tone flickers over shape, blending suggestions of light with hints about texture—as in his Santa Sophia pictures of 1889. Subsequent reworkings are neater: outlines clarify themselves, colors are more carefully confined. A separate hue, flattened out by a single tone, fills the black-line contour of a limb or a pagan symbol. Moloch and Astarte and the other monstrous deities in the north wall portion of the cycle are severe, encrusted patterns of form. In contrast, Sargent signifies the humanity of the children of Israel by modeling their bodies in an academic manner. They are familiar flesh and blood, rendered according to the long-standard Beaux-Arts style. After all those years, Sargent's imagery finally offered the conservative eye a proper degree of finish.

In 1891 Edwin Austin Abbey settled with his wife and family into Morgan House, at Fairford, a small town near Cambridge. He designed a utilitarian iron structure and had it built on the grounds as a studio. When Sargent returned to England that fall, he moved his gear into one side of the building. While Abbey pursued his *Quest*, Sargent hired models and sketched them in charcoal. (One of these, Nicola d'Inverno, came to the studio in 1893 and stayed on as Sargent's valet for many years.) When sufficient figure studies had accumulated, Sargent worked them up into compositional studies in oil. He built a model of the library's third-floor landing and tried out one large scheme after another. It was the beginning of a project that would go on for twenty-five years.

Sargent persuaded McKim and White that Puvis de Chavannes ought to do a series of murals for the library. And, with trepidation, he also arranged for the architects to meet Whistler on one of their trips to London. "He'll be silent as the grave," said Sargent, "or outrageously vituperative, or the most charming dinner companion you've ever met."[122] Whistler decided to be charming and, when a mural commission was offered, enthusiastic. At a second dinner, he made a sketch for an immense peacock but nothing came of it. Meanwhile, Sargent kept hard at work.

A letter from Abbey to McKim suggests that Sargent worked on the murals even when he was back in London. "I went into his studio a day or two before I sailed [for Italy]," said Abbey,

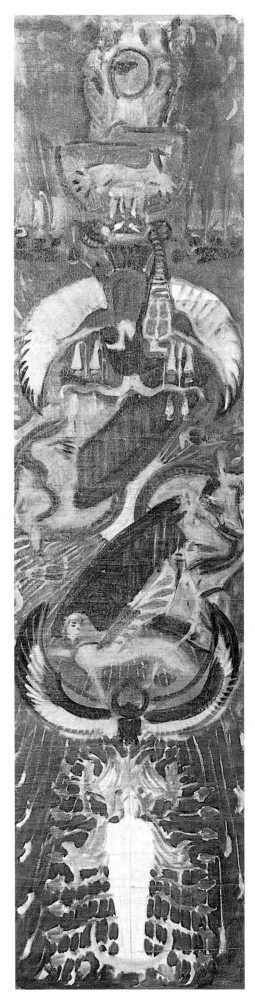

and saw stacks of sketches of nude people—Saints, I dare say, most of them, although from my cursory observation of them they seemed a bit earthy. You will certainly get a great thing from him, he can do *anything*, and don't know himself what he can do. He is latent with all manner of possibilities, and the Boston people need not be afraid that he will be eccentric or impressionistic, or anything that is not perfectly serious and non-experimental. . . .[123]

Sargent was able to send the north wall decorations to the Royal Academy in the spring of 1894, where they were displayed much as they would be in America. Some viewers took these exotic images for an attempt to redecorate the galleries of Burlington House. Critics were cautious. The *Saturday Review* concluded, "We are too much startled to comprehend at once how the realistic painter of so many mundane portraits has suddenly become the illustrator of Ezekial. Much study should be given to these extraordinary figures before a final verdict is submitted. It is enough to say that of their originality and solemn impressiveness there can be no question."[124] A letter from Sargent to his friend Lady Lewis suggests that the audience was caught up in the puzzle of deciphering his emblems and effigies. "You seem to me," he wrote, "really to like my decoration and not to look upon it as a hopeless conundrum as most people do. I was delighted to find that you got some pleasure out of it through your eyes and were not fidgetting about the obscurity of those old symbols. What a tiresome thing a perfectly clear symbol would be."[125]

Sargent traveled to the United States in 1895 to oversee the installation of the north end murals at the library, a trip that also took him to George Vanderbilt's Biltmore, a five-million-dollar French Renaissance mansion in Asheville, North Carolina. The architect Richard Morris Hunt, the landscape designer Frederick Law Olmsted, and the owner were all present during Sargent's visit, and he made a portrait of each (plate 181). Despite the distance between his civic and his elitist styles, they seem to have supported each other—at least in America. Those who wanted to give their public selves the "snap," the "*sprezzatura*," of Sargent's portrait manner drew a vague comfort from the respectability of his mural projects, every stage of which attracted a ponderous flood of high-minded praise. At the same time, Sargent was notable among American muralists as a painter who brought an impressive private reputation to public buildings.

In 1916 he wrote to Evan Charteris about his progress on the west wall of the Boston Public Library, where a winged, haloed figure repre-

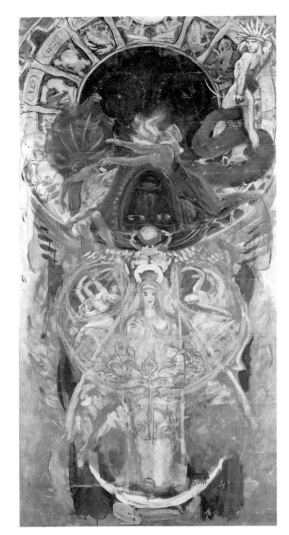

208

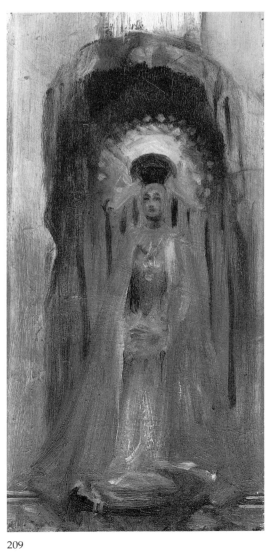

209

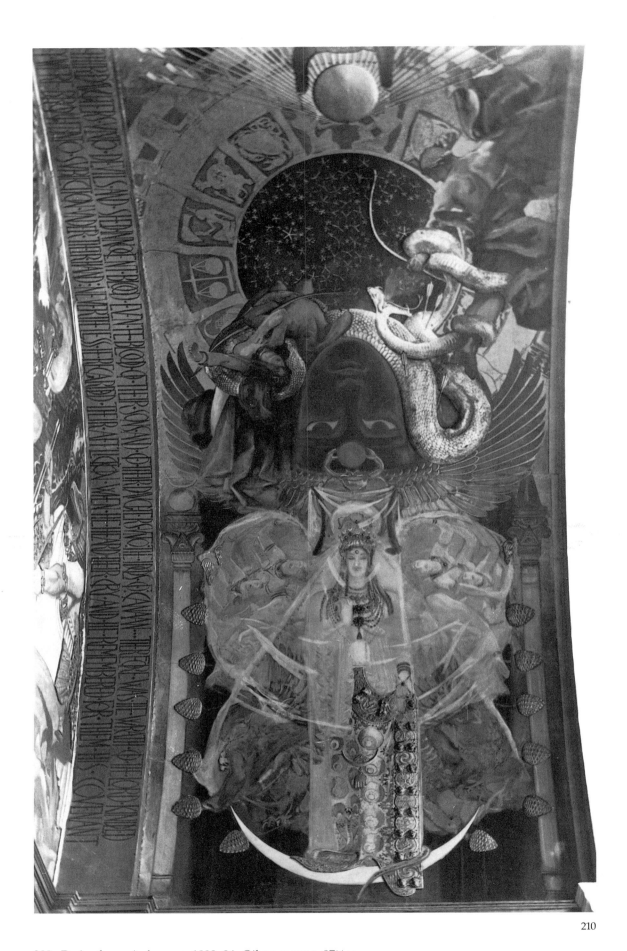

210

208. *Design for an Archway*, c. 1890–94. Oil on canvas, 87¼ x 51¼. Yale University Art Gallery, New Haven, Connecticut. Edwin Austin Abbey Memorial Collection.

209. *A Spanish Madonna*, c. 1895. Oil on wood, 13½ x 6 inches. Isabella Stewart Gardner Museum, Boston.

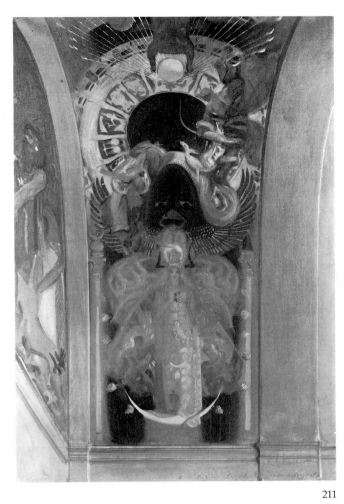

211

212

senting *Judgment* (plate 183) is flanked by *Hell* (plate 187) and *The Passing of Souls into Heaven* (plate 184). "I left Boston a week ago," he writes from the Rocky Mountains,

> the work that I had personally to do with my own hands being accomplished—now the plasterers, painters and gilders will do the rest, which will take another month or more, and, in September I will return and put my painting up. I tried one temporarily, the big green Devil [*Hell*], and he looked well as far as one can judge, from the scaffolding which is on the level of the cornice. The whole architectural and ornamental scheme seems to work out on the large scale, and it has been a great satisfaction not to have to make any changes. Whether or not it is another of the palpable signs that I am getting old, I am rather revelling in the appearance this white elephant of mine is taking on of amounting to something, after all these years.[126]

For Sargent, as for Christian theologians over the centuries, the Old Testament is reflected and consummated by the New. The Hebrew prophets and oppressed Israelites at the north end of the landing are answered to the south by the Trinity, the Crucifixion, and a frieze of angels (plate 199). *Hell* on the west wall is directly across from the plummeting *Gog and Magog* (plates 188, 189) on the east. Christian *Judgment* faces Jewish *Law* (plate 191), while *The Messianic Era* (plates 193, 194) of the Old Testament looks across to *The Passing of Souls into Heaven*. The final additions to the scheme were allegorical figures of *The Synagogue* (plate 196) and *The Church* (plate 195), which appear on the ceiling as pendants to *Gog and Magog* and *The Messianic Era*. Throughout the cycle, large formal currents flow through limbs left naked and through the drapery that covers the rest. These effects show Sargent's familiar elegance, though the relentless decorum of his civic hand often gives his figures the look of flesh and cloth carved in stone—or cast in plaster from Neoclassical statuary. The atmosphere is thick with reverence for certified masters—no one in particular, all of them in concert—in other words, precisely what the American Renaissance called for.

One of the movement's chief tenets was the unity of the arts, so Sargent felt called upon to design the moldings and frames that surround his painted panels. He raised haloes and the gilded hems of robes into low relief. Then, in the *Crucifixion* (plate 198) that appears between the Trinity and the angel frieze of the south wall, he essayed a three-dimensional image—Sargent's major foray into sculpture. When Whistler saw this work at the Royal Academy exhibition of 1901, he

143

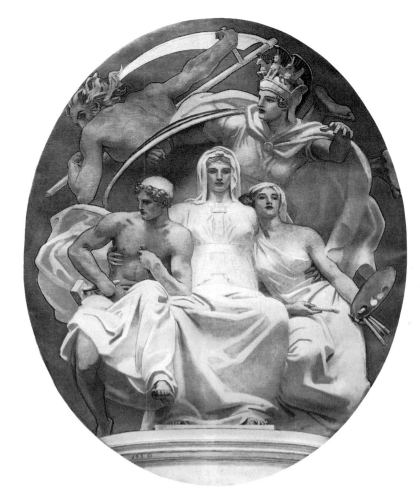

213

214

wrote Sargent to say how good he thought it was—the first and only time the older artist offered his compatriot unqualified praise. H. Hamilton Fyfe found the *Crucifixion* "all the more striking for being Mr. Sargent's." This critic allowed that while Sargent's paintings "do offer us ideas, they do not offer us the noblest ideas that must animate the work of a great painter."[127] Fyfe, a stolid conservative, saw Sargent's portraiture as a series of worldly accommodations to a wealthy clientele. Whistler, from his bitterly maintained outpost at the fringes of the avant-garde, took the same view.[128] Yet conservative and radical alike were impressed by what Fyfe called the "force and truth and beauty" of Sargent's *Crucifixion*.

Elsewhere in the hall, Sargent offered flourishes of historical reference to suit nearly every high-minded taste. *Gog and Magog* and *Hell* are particularly Michelangelesque. The allegorical figure of *The Synagogue* also draws from the Sistine Chapel repertoire, and perhaps shows a touch of Salvator Rosa's wildness. The lunette of heaven's gate surrounded by angels pays cautious, generalizing homage to Tiepolo, the Pre-Raphaelites, and even to the murals of Puvis de Chavannes on the floor below. There is much medievalism in the south end of the cycle. Some of this is Spanish-flavored, though Charles H. Caffin praised *The Blessed Trinity* for its Byzantine "flatness of treatment . . . general simplicity of design and occasional elaboration of parts"[129]—effects that Sargent had learned from the mosaics of Constantinople. Yet the *Frieze of the Prophets* (plates 201–5) and the *Pagan Deities* (plates 206, 210) of

144

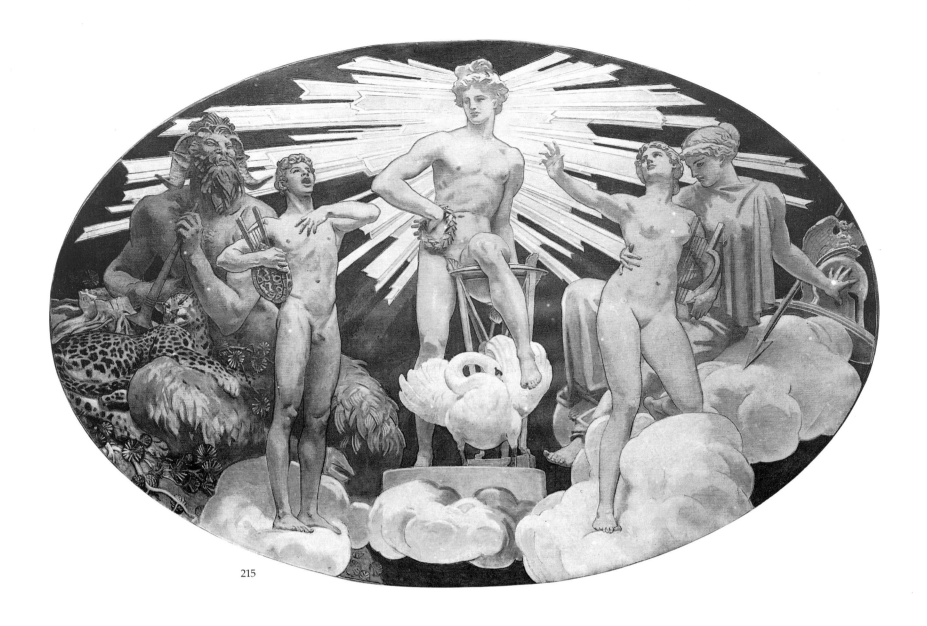

215

the north end impressed Caffin most. In fact, these images were nearly everyone's favorites, for Sargent managed to smuggle into their academic propriety the flavor, at least, of an adventurous contemporary style—Symbolism.

The presiding pagan is the goddess Astarte, who appears on the vaulted ceiling above the lunette. As the figure sweeps upward on the right, it is met by that of "Neith, mother of the Universe," arching across from the other side of the vault. The two goddesses look down, their heads oriented in opposite directions. It is difficult at first to see which lush accouterments, which emblematic flourishes, belong to whom. Caffin feels sympathy for the question "'What is it all about?'" Answers appear, as he says, in "the printed explanation." This pamphlet "is invaluable, especially when the visitor proceeds to examine . . . the ceiling space. How tired his neck becomes, and possibly his brain, by the alternate reference to the book and to the ceiling! He experiences quite a relief when his eyes come down to a lower level and are greeted by a row of stately figures, prophets of the Old Testament, as he sees by the name written under each."[130]

Sargent's literary intricacies presented a problem to which Vernon Lee proposed a solution. These *Pagan Deities*, she said in 1897, appeal less to the mind than to the imagination, which has no use for "dry

213. Sargent murals in the rotunda. Photographed December 1921. Museum of Fine Arts, Boston.

214. *Painting and Sculpture Protected from the Ravages of Time by Minerva*, 1916–21. Oil on canvas. Rotunda. Museum of Fine Arts, Boston. Francis Bartlett Donation of 1912.

215. *Classical and Romantic Art*, 1916–21. Oil on canvas. Rotunda. Museum of Fine Arts, Boston. Francis Bartlett Donation of 1912.

145

216

217

definitions." It "makes at once for the complex . . . impression of the whole"—but this is nothing like Monet's plein-air impressions. Rather, it is a "vision" of the kind we see when revery or a work of art like "Sargent's strange, painted Theogony" carries us deep into the past. Lee has taken up, for the moment, a version of the Symbolist aesthetic practiced by Gustave Moreau, J. K. Huysmans, and many, many others. History, she says, is a "realm of fancy" to be elaborated by modern minds, as medieval ones once embroidered their theologies. So there is no need for the library's detailed pamphlet; it is enough to let the imagination drift free.

Lee's reading is justified. The voluptuous fussiness, the exotic and elusive themes, the air of lurid drama at the north end of the Sargent Hall overpower the decorous rendering of the children of Israel, and launch the artist, briefly, on Symbolist currents. Sargent's Astarte is a femme fatale, one of that immense flock of Salomés, remorseful Eves, and Lorelei that crowded fin-de-siècle art and literature. The closest cousin of Sargent's figure is Flaubert's "Tanit," the ominously female principle who animates the mock-historical action of *Salammbô*, his novel of ancient Carthage. Vernon Lee rather willfully enters into the Symbolist spirit, as she describes the Boston *Astarte*:

> She is, so to speak, the main smoke wreath of unseen fires, and the strange winged creatures surrounding her as a cocoon, whirling in slow crab movements, are the minor smoke spirals; they form wings to her head and wings to her garment, vague whirling night creatures, arms only and legs, round the long erect goddess, swathed chrysalis-like in her blue veil, and they seem in a way to be evoking, nay, *weaving* her into

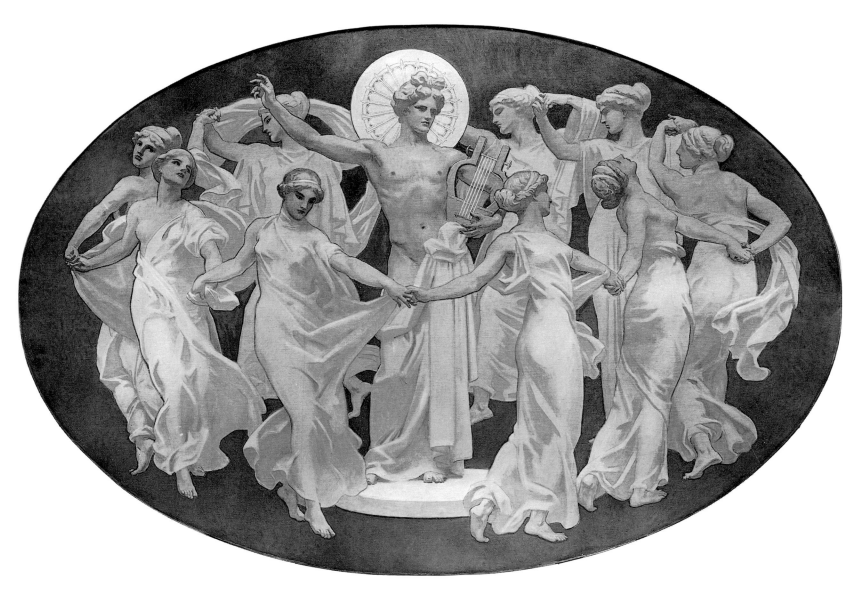

218

216. *Apollo and Daphne*, 1916–19. Oil on canvas, 32½ x 28⅞ inches. The Corcoran Gallery of Art, Washington, D.C. Gift of Emily Sargent and Violet Sargent Ormond.

217. *Studies of the Head of Apollo for "Apollo and the Muses,"* 1916–21. Charcoal on paper, 17½ x 23½ inches. The Corcoran Gallery of Art, Washington, D.C. Gift of Emily Sargent and Violet Sargent Ormond.

218. *Apollo and the Muses*, 1916–21. Oil on canvas. Rotunda. Museum of Fine Arts, Boston. Francis Bartlett Donation of 1912.

existence, a moon wraith swaying over the sea, a mystic opium vision; the night, muffled, expectant, so lucid and yet so vague, full of possible dangers.[131]

Sargent's subsequent murals suppressed all such hints of Symbolist exotica. Archetypes in that style have inward natures, like idols erected for ceremonies of private obsession. The American Renaissance required clear forms whose large meanings were readily available in official pamphlets. Sargent's civic style supplied such largeness and clarity with ever-increasing efficiency. As a result, his themes began to lose focus. In May 1916 the trustees of the Boston Museum of Fine Arts invited Sargent to design a cycle of decorations for the museum's newly built rotunda. He accepted the commission, perhaps glad of a second chance to attack the problems of public art. The literary puzzles of the library panels had distracted some viewers from their visual properties. The Sargent Hall had an atmosphere of difficulty, heightened by somber passages of color and occasional luridness, even violence, in the treatment of details. If these were problems, Sargent corrected them in the figures of Apollo, Minerva, and other beneficent presences with which he filled the rotunda of the Boston Museum. As Preserved Smith wrote in 1922, a year after these murals were unveiled:

219

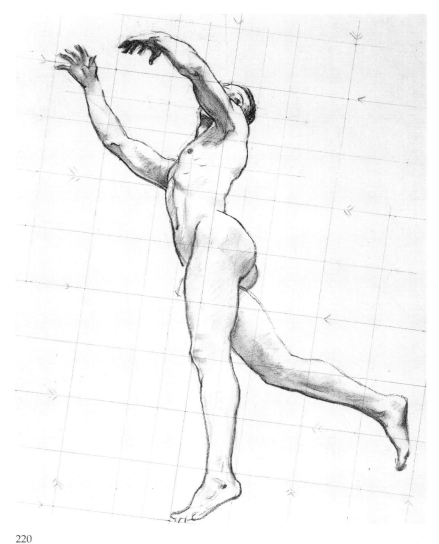

220

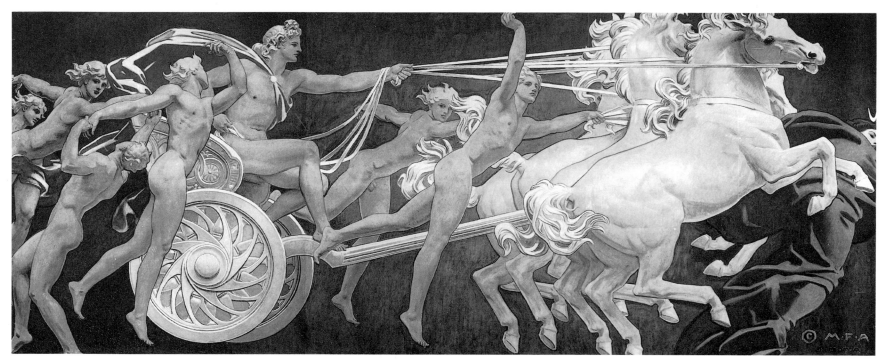

221

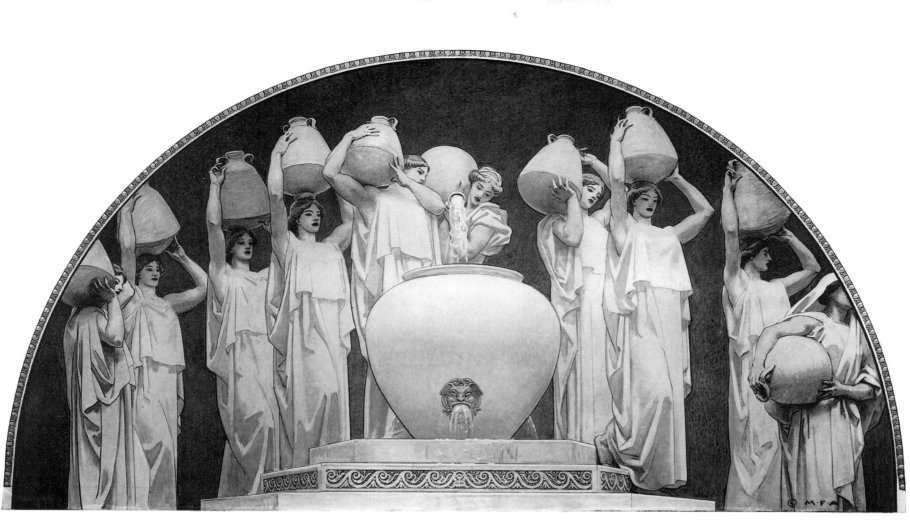

222

219. Sargent murals over the stairway. Photographed November 1926. Museum of Fine Arts, Boston.

220. *Study for "Apollo in His Chariot with the Hours,"* 1921–25. Pencil and charcoal on paper, 24⅞ x 19⅛ inches. Museum of Fine Arts, Boston. Gift of Miss Emily Sargent and Mrs. Francis Ormond.

221. *Apollo in His Chariot with the Hours*, 1921–25. Oil on canvas. Stairway. Museum of Fine Arts, Boston. Francis Bartlett Donation of 1912.

222. *The Danaides*, 1921–25. Oil on canvas. Stairway. Museum of Fine Arts, Boston. Francis Bartlett Donation of 1912.

223. *The Sphinx and Chimera*, 1916–21. Oil on canvas. Rotunda. Museum of Fine Arts, Boston. Francis Bartlett Donation of 1912.

223

224

225

226

227

228

224. *Study for "Science,"* 1921–25. Oil on canvas, 13⅝ x 7½ inches. The Metropolitan Museum of Art, New York. Gift of Mrs. Francis Ormond, 1950.

225. *Science,* 1921–25. Oil on canvas. Stairway. Museum of Fine Arts, Boston. Francis Bartlett Donation of 1912.

226. *Hercules and the Hydra,* 1921–25. Oil on canvas. Stairway. Museum of Fine Arts, Boston. Francis Bartlett Donation of 1912.

227. *Study for "Philosophy,"* 1921–25. Charcoal on paper, 22¼ x 16¾ inches. The Corcoran Gallery of Art, Washington, D.C. Gift of Emily Sargent and Violet Sargent Ormond.

228. *Philosophy,* 1921–25. Oil on canvas. Stairway. Museum of Fine Arts, Boston. Francis Bartlett Donation of 1912.

All the canvases are in the same key of blue and gold, giving the effect to the spectator from below of looking up into the sky, a heaven shot through with sunbeams and peopled with radiant images of gods and goddesses, and other immortal creatures of the imagination. The unity of tones and the similarity of the subjects, all drawn from classical myth, constitute the bond that makes all the pictures one. For they tell no connected story; they have no message save that of the glory of art and the compulsion of beauty. Interpret each and every detail as subtly as we may, our first impression is likely to be our last one—that it is good to live in a world of ideas where such beauty is possible, where men can dream such dreams and create such speaking symbols of their aspiration. Next to beauty, joy is the dominant idea. The world has escaped the horror of the great war, and peace comes again, and with peace her natural handmaidens, the pleasant things of the spirit.[132]

The critic enters so fully into the spirit of Sargent's high-minded allegory that he puts allegorical figures of his own on parade.

In one of the rotunda murals, nine muses pursue a gracefully elliptical orbit around Apollo, who stands at the center of the oval-shaped canvas (plate 218). The god of clarity and light reappears in a panel facing this one. In the second painting, he stands between the figures

151

230

of Classical and Romantic Art, both of them rendered—as are all the figures of this cycle—in a staid and academic version of nineteenth-century Neoclassicism (plate 215). A rather prim Pan appears at the shoulder of Romantic art, while Minerva attends the spirit of Classicism. The latter goddess serves in another of the rotunda's major panels, this time protecting the figures of Painting and Sculpture from the ravages of Time (plate 214). Facing this group is a painting of the earthbound sphinx receiving a chaste kiss from a winged chimera, whose pinions, arms, and legs are arranged to provide visual echoes of the mural's oval frame (plate 223).

As Smith says, the "story" told by these paintings is not important. Their gods and goddesses fill the elegant space of the rotunda with an atmosphere of reverence for the ancient past and respect for early twentieth-century properties. Most commentators were gratified by the results. Among the exceptions was Bernard Berenson, who judged the entire cycle "very lady-like."[133] The trustees of the museum were so pleased that they commissioned another set of murals in November

229. *Perseus on Pegasus Slaying Medusa*, 1921–25. Oil on canvas. Stairway. Museum of Fine Arts, Boston. Francis Bartlett Donation of 1912.

230. *Sketch for ''The Judgment of Paris,''* 1916–21. Oil on canvas, 30¼ x 26 inches. Museum of Fine Arts, Boston. Gift of Mrs. Francis Ormond.

153

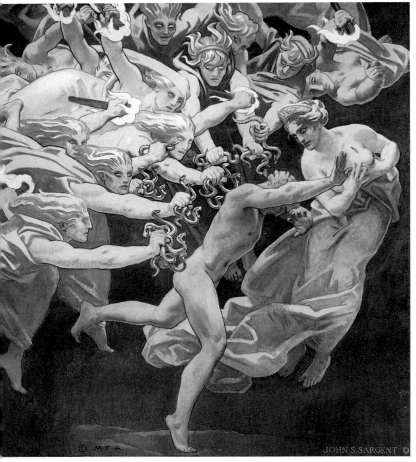

231

1921, only a month after the first was unveiled. These appear in the vault above the museum's main stairway and on the ceilings above the corridors that run alongside the stairs on the second floor (plate 219). Ascending and looking upward, one sees *The Winds*, a subject that inspired Sargent to enliven his American Renaissance style with some rococo flourishes of cloud and scattered petals. The familiar stiffness reappears in another of the vault panels—Apollo once again, this time in a chariot attended by the Hours (plate 221).

Having reached the top of the stairs, one turns and looks backward to the wall above the stairwell. Here the vaguely Athenian figures of Philosophy (plates 227, 228) and Science (plates 224, 225) flank a tableau called the *Unveiling of Truth*, which shows a kneeling, half-draped figure removing a vast expanse of drapery from Truth's hidden form. Above this three-part allegory of cooperation in the search for enlightenment Sargent set an immense lunette—*The Danaides* (plate 222). There are ten of these togaed women. In Greek myth, there were fifty, all daughters of Danaos, who had ordered them to kill their husbands. As punishment for obeying, the Danaides were condemned to fill a bottomless jar from broken pitchers. Sargent arranged them in a line, moving up to a massive vessel and away from it. There is a rhythm here but little life; no aura of this dreadful myth animates the panel. Dutiful commentators were inspired to explain the procession as an allegory of the endless search for knowledge.

Perseus appears in a painting above one of the second-floor corridors (plate 229); in another, Hercules slays the Hydra (plate 226). Atlas holds up the weight of the world (plates 232, 233), Orestes flees the Maenads (plate 231), and there is still more from Greek mythology. In these corridor paintings, color is not so blandly pretty as it is in the rotunda and in the stairwell—Sargent darkens blue toward slatiness, and the bland ocher of the oval panels takes on a weighty, claylike cast. There are echoes here of the mysteries that fill the library murals, and Sargent shows ingenuity in fitting his subjects into their square panels. Still, even his frantic Orestes is a frozen, storybook figure. Sargent's murals in the Museum of Fine Arts might be called public art for public art's sake, an exercise in civic virtue with nothing much to offer the ordinary citizen, save the assurance that academic archetypes are somehow good for him.

Perhaps the grand archetype guiding all of Sargent's mural projects was the image of America, an abstract emblem of home. He tried until the end of his life to adjust his art to the sensibilities of those who had

231. *Orestes*, 1921–25. Oil on canvas. Stairway. Museum of Fine Arts, Boston. Francis Bartlett Donation of 1912.

232. *Sketch for "Atlas and the Hesperides,"* 1921–25. Oil on canvas, 34 x 34 inches. Museum of Fine Arts, Boston. Gift of Mrs. Francis Ormond.

233. *Atlas and the Hesperides*, 1921–25. Oil on canvas. Stairway. Museum of Fine Arts, Boston. Francis Bartlett Donation of 1912.

154

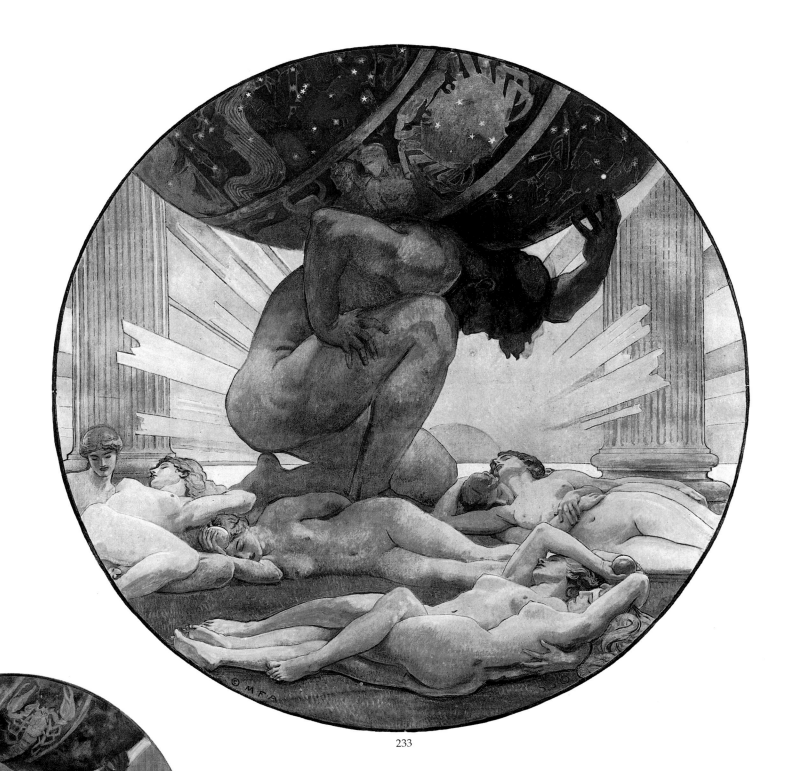

233

232

always lived there, remote from the complexities of Europe—Edwin Blashfield's "man in the street." There is nothing to suggest that Sargent considered this attempt a failure. Still, he generated his most powerful energies when he rendered types who move easily from nation to nation, culture to culture. As he later wearied of cosmopolitan portraiture, his strength shifted to landscapes, those images in which *he* is the dominant type, though unseen—the celebrated, widely traveled John Singer Sargent, whose hand formulates the very premises of the world we share through the faculty of vision. It is in those late works that Sargent came closest to the Romantic faith that to see with an artist's eye is to create art and reality at once.

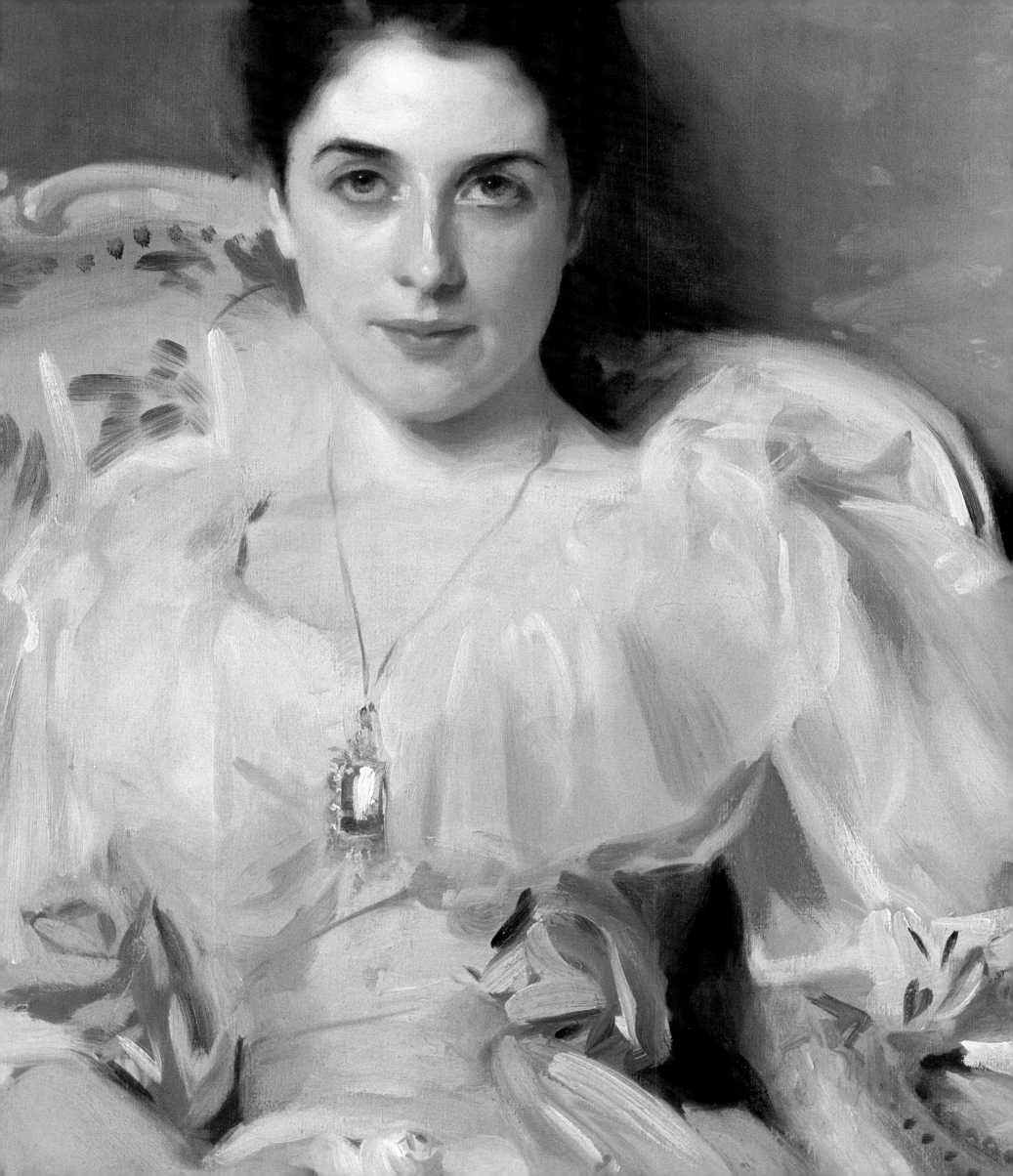

VIII. *Master of the Modern Portrait*

ALTHOUGH THE MURALS TOOK UP VAST AMOUNTS OF SARGENT'S time, he continued to paint and exhibit portraits throughout the 1890s. In the spring of 1891 he showed his portrait of Miss Elsie Palmer (plate 235) at the New Gallery. The *Athenaeum*'s critic called the treatment of the sitter's drapery "a triumph" but disliked everything else about the painting, from Sargent's draftsmanship to the unsmiling eyes and lips of Miss Palmer's "mask-like face."[134] The *Magazine of Art* was less set on upholding the proprieties of formal portraiture. Its critic, too, thought *Miss Elsie Palmer* odd, yet he was willing to allow that the painting was wonderful in its way. Its subject "gazes straight out of the canvas at the spectator, with an extraordinary, almost crazy, intensity of life in her wide-open brown eyes. Even here [Sargent's] perverse joy in mystifying the Philistines is not wholly absent; the irresistible force and fascination of this singular embodiment of youthful vitality cannot be gainsaid."[135]

Sargent had his greatest success that year with *La Carmencita* (plate 173), which he showed at the Royal Academy. The indefatigable *Athenaeum* went on the offensive once again, with a barrage of particulars designed to show that the artist lacked "culture in that antique sense of the word which demands first of all things the harmonizing of pure lines."[136] *La Carmencita* was nonetheless so striking that even the *Athenaeum* couldn't deny that "Mr. Sargent's idiosyncracies . . . are original, vigorous, and often beautiful." It was getting difficult for guardians of taste to hold the line against Sargent's popularity, borne along as it was on a surge of raves. *La Carmencita*, "one is half inclined to say, is not a picture; it is the living being itself, and when the music strikes up she will bound away in the dance,"[137] said the London *Times*. In *Black & White*, Walter Armstrong said the painting "is in some ways the best thing in the whole exhibition."[138] The Louvre bought *La Carmencita* and hung it in the Palais du Luxembourg.

Sargent later said that he was sorry it represented him there. Asked why, he answered, "After all, it is little more than a sketch." [139] He could afford to be modest about a work that had nearly been swamped by approval, some of it directed at his brilliant sketchiness. He could also afford to send nothing to the Royal Academy in 1892. In any case, he

234. *Lady Agnew*, detail. See plate 239.

157

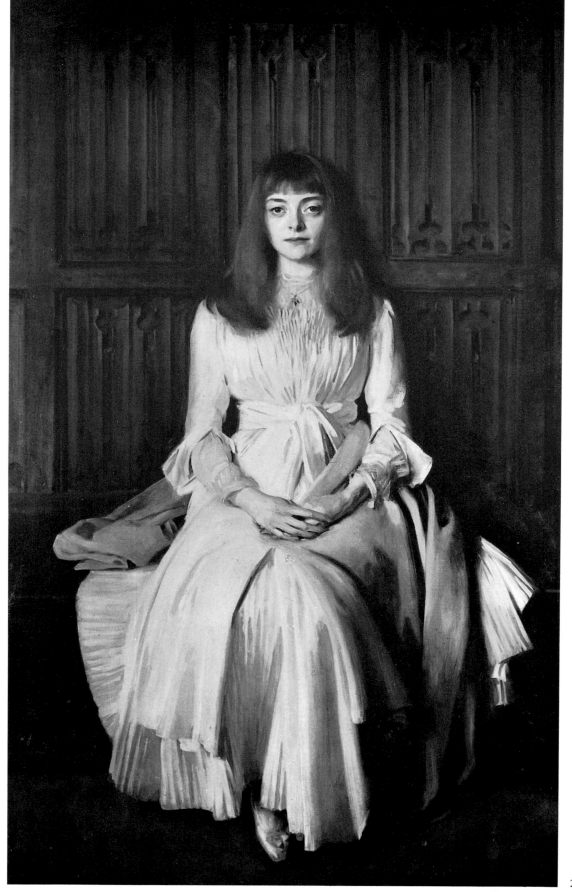

236

235

237

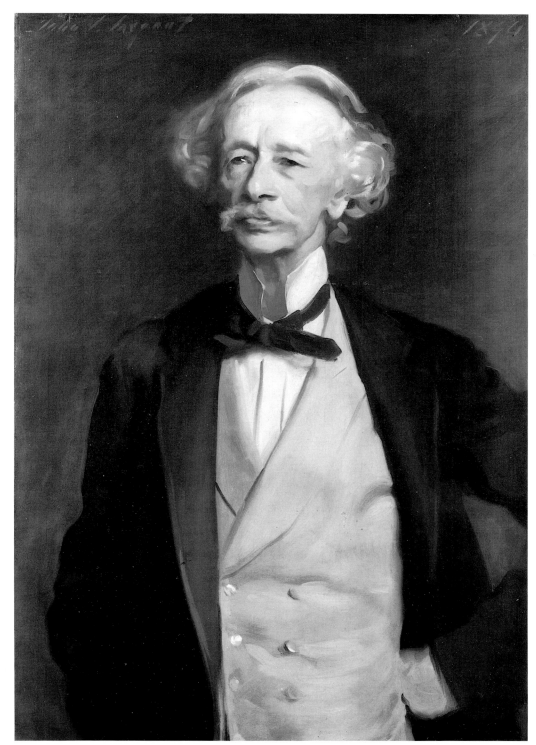

238

235. *Miss Elsie Palmer*, 1889–90. Oil on canvas, 75 x 45 inches. Colorado Springs Fine Arts Center.

236. *Miss Helen Sears*, 1895. Oil on canvas, 65¾ x 35¾ inches. Museum of Fine Arts, Boston. Gift of Mrs. J. D. Cameron Bradley.

237. *Coventry Patmore*, 1894. Oil on canvas, 18½ x 13 inches. The Ormond Family.

238. *Coventry Patmore*, 1894. Oil on canvas, 36 x 24 inches. National Portrait Gallery, London.

had produced nothing suitable, having been too busy with the Boston mural project.

Late in 1892 Sargent began a portrait of Lady Agnew, the wife of a Scottish peer (plate 239). When the painting appeared at the Royal Academy the next spring, the *Times* called it "a masterpiece . . . not only a triumph of *technique* but the finest example of portraiture in the literal sense of the word, that has been seen here in a long while. . . ."[140] Sargent presents his subject in a white gown with a pale lavender sash. In shadow, her dress picks up greenish hues from the backdrop; her flesh tints show through the sleeves. Broad, confident brushstrokes draw these colors across a minutely gradated range of tones, producing an effect so elegantly assured that it is almost offhand—this is an aris-

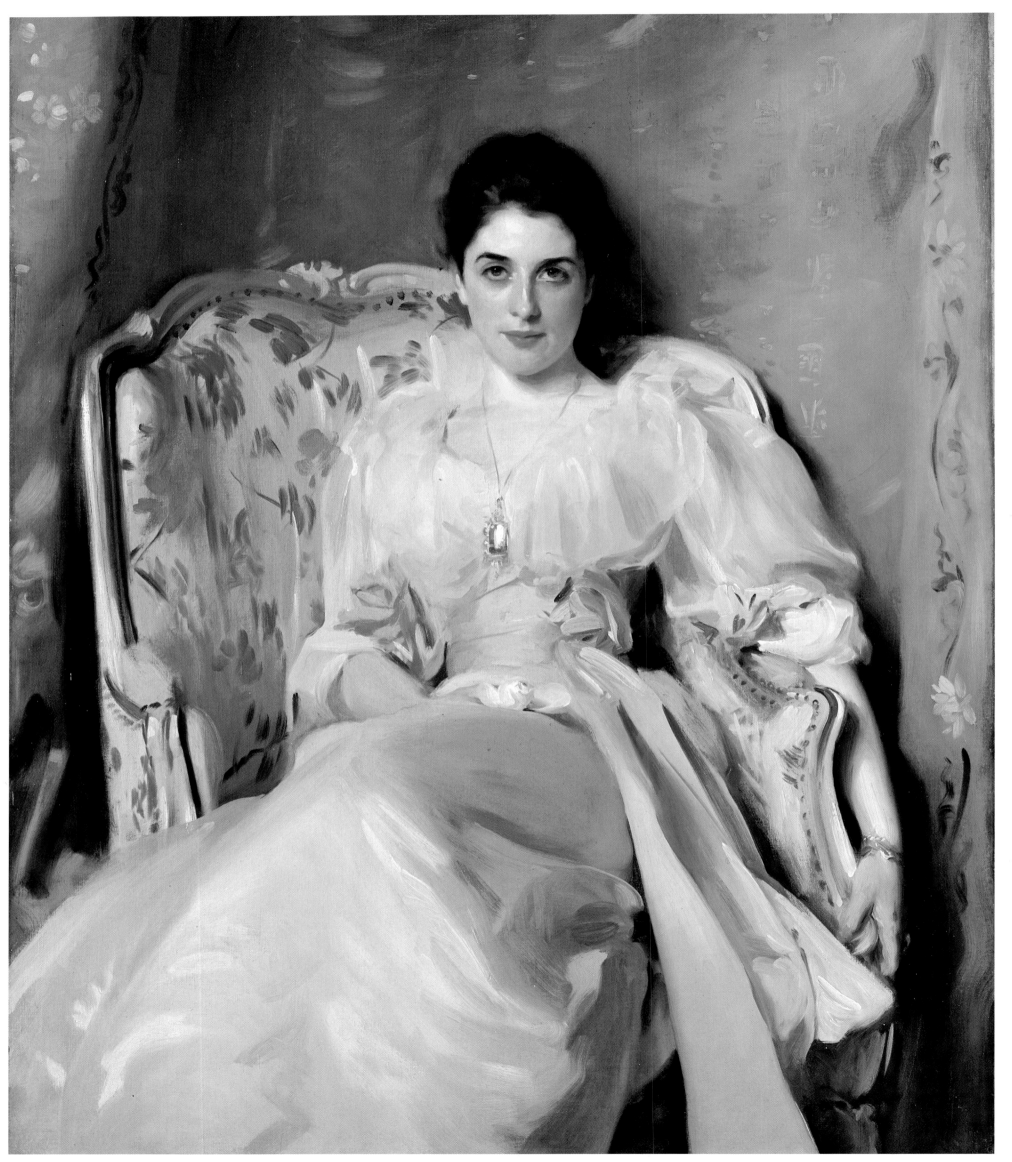

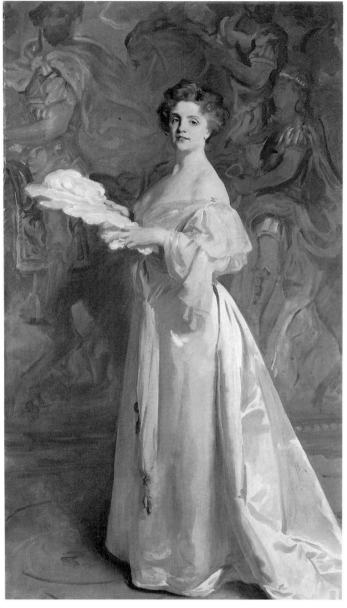

240

241

239. *Lady Agnew*, c. 1892–93. Oil on canvas, 49½ x 39½ inches. National Gallery of Scotland, Edinburgh.

240. *Ada Rehan*, 1894. Oil on canvas, 93 x 50⅛ inches. The Metropolitan Museum of Art, New York. Bequest of Catherine Lasell Whitin in memory of Ada Rehan, 1940.

241. *Eleonora Duse*, c. 1893. Oil on canvas, 23 x 19 inches. Mr. and Mrs. Paul Amir, Beverly Hills, California.

tocratic type. Not that Lady Agnew was born to a noble family—in fact, she was not—but Sargent's manner asserts a claim to nobility on her behalf. He supports this claim by giving her a dress cut from patterns to be found in the portraits of Lawrence and Reynolds.

Lady Agnew's personality engages in endlessly elusive play against her social type. Sargent has made her face almost schematic, yet within that regularity there are slight departures, nuances whose faintness blends nicely with the sitter's languid pose. Lady Agnew's face seems all possibility, and consciously so. The moment the right side of her lips looks slightly drawn back, as if in doubt or weariness, the left side seems about to smile. And, as if to insist on her control of this ambivalence, her eyes are oddly calm. Of course it is Sargent who commands these meanings. The economy of his style generates the subtlety of the types he presents—or invents. When he elides the transition from one tone, one color, one facial feature to the next, he invites us to reinvent

161

243

these types for ourselves, much as Henry James's narrative voice entangles us in a labyrinth of alternative meanings, then leaves us there to chart them for ourselves.

Edmund Gosse suggested to Coventry Patmore, a poet well known in Victorian times, that he sit to Sargent. Patmore was willing. He told Gosse that he thought Sargent "to be the greatest, not only of living English portrait painters, but of all English portrait painters."[141] When they saw the result (plate 238), Patmore's friends felt that Sargent had missed the poet's character altogether. Basil Champneys took the portrait as a caricature, perhaps of an overseer on a Southern plantation. Gosse himself said, "It is necessary to insist that [Patmore] was not always thus ragged and vulturine, not always such a miraculous portent of gnarled mandible and shaken plumage."[142] The more intimately one shared the assumptions of Sargent's style and milieu, the more one was at liberty to disagree with the use to which he had put them.

From a distance matters seem clearer, character less nuanced. By 1895, when *Coventry Patmore* was shown at the Royal Academy, Sargent could count on reviews as favorable as, ten years before, they had been bad. As their approval approached unanimity, critics talked in more and more general terms. It was as if Sargent's command of social and psychological types had turned into a fact of nature, a resource to be celebrated, not a set of dubious devices to be enumerated and condemned, as critics had earlier done with *The Misses Vickers* (plate 145). The *Magazine of Art* said: "Undoubtedly the most electrifying portrait in the Academy—we nearly said the most masterful painting—is Mr. Sargent's kit-kat [narrow canvas] of Mr. Patmore . . . not only the head, but the figure and garments have been rendered with an almost unsurpassable skill, and contain passages which would not do discredit to a great master."[143]

In 1894 Sargent was at work on his *Frieze of the Prophets* (plates 201-5), which runs along the lower edge of the north wall lunette in the Boston Public Library. The prophet Ezekial, he thought, would benefit from Patmore's craggy profile, and so a type ended up amid the archetypes of the library murals. Sargent tried, now and then, to bring these two sides of his art together. Usually he kept them apart, for their distance from each other is what gave them their value, perhaps their meaning. His painterly manner thrived in an atmosphere dedicated to the worldly refinement of seeing and feeling. The style of Sargent's murals makes sense only given the assumption that there are universals to which anyone can respond, with a little instruction. This posits an

egalitarian world, while the world of the artist's fashionable portraits was elitist. His murals were for America. The rest of his art was for that international zone of high style and comfortably refined sensibility to which he belonged, and where he never felt entirely at home.

Eleonora Duse arrived in London in 1893. Sargent saw her in *Feodora* and, once again bowled over by a star performance, immediately wanted to paint the actress's portrait. As Charteris recalls: ''He used to tell of Duse that she consented to give one sitting. She arrived at midday and at five minutes to one rose from her chair, saying, 'Je vous souhaite de vivre mille ans et d'avoir gloire et beaucoup d'enfants, mais au revoir,' and he never saw her again.''[144]

Usually the process took longer, and Sargent's portrait manner is hardly ever as elliptical as in this painting of Duse (plate 241). Under pressure from her impatience, he has left much of the tragedienne's appearance—and character—to be guessed from oblique hints. Yet Sargent always challenged the eye this way, as critics had begun to acknowledge with remarks about proper viewing distances. One must make the effort, they often said, to find the vantage from which the suggestions made by Sargent's separate brushstrokes coalesce into larger meanings. All fluent, painterly styles require this search, and Sargent underwent a corollary process as he worked—the easel was placed near the sitter, so that he could stand back and view object and image at once. This arrangement necessitated a great deal of to-ing and fro-ing, for Sargent often progressed one brushstroke at a time. When he saw what to do next, the knowledge would so agitate him that he charged the canvas, muttering furiously.[145]

He always tried for the quick ease of the Duse portrait, though he knew it couldn't always be counted on to appear. Charteris quotes an unnamed subject whose sister ''remembers seeing Mr. Sargent paint my scarf with one sweep of his brush.'' Such sweeps often went awry and had to be painted over or even scraped down. Sargent imposed a heavy burden on himself in his struggle for nonchalance, and of course this was hard on his sitters too. In 1894 he was commissioned to paint a full-length portrait of yet another actress, Ada Rehan (plate 240). She had been ill and thought it might be tiring to pose. Sargent wrote: ''I should argue, with more truth than seems likely, that a great many people find it rather a rest to than otherwise, and also that some of my best results have happened to be obtained with a few sittings . . . (Lady Agnew was done in six sittings), but I always admit beforehand that it may take me much longer—Will you give me a chance?''[146] She did,

244

244. Sir Joshua Reynolds. *Lady Elizabeth Delmé and Her Children*, 1777. Oil on canvas, 94 x 58⅛ inches. National Gallery of Art, Washington, D.C. Andrew Mellon Collection.

245. *Mrs. Carl Meyer and Her Children*, 1896. Oil on canvas, 79½ x 53½ inches. Sir Anthony Meyer, Bt., Sunningdale, Berkshire.

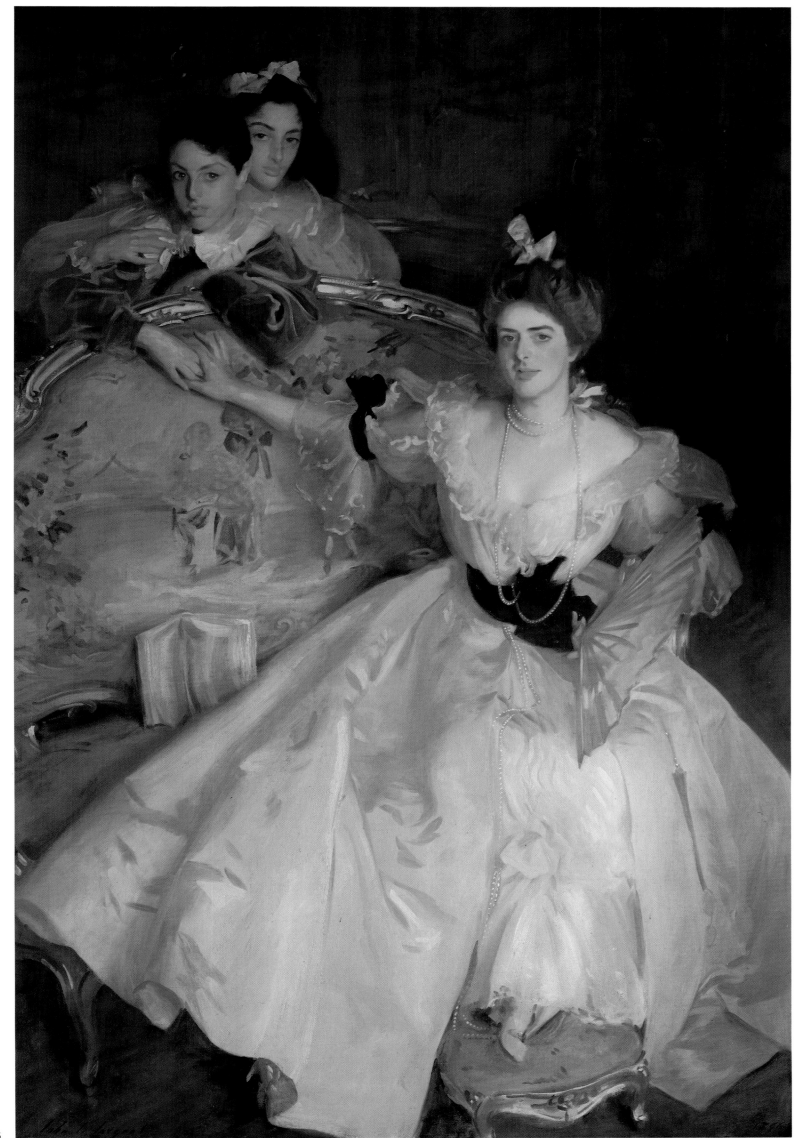

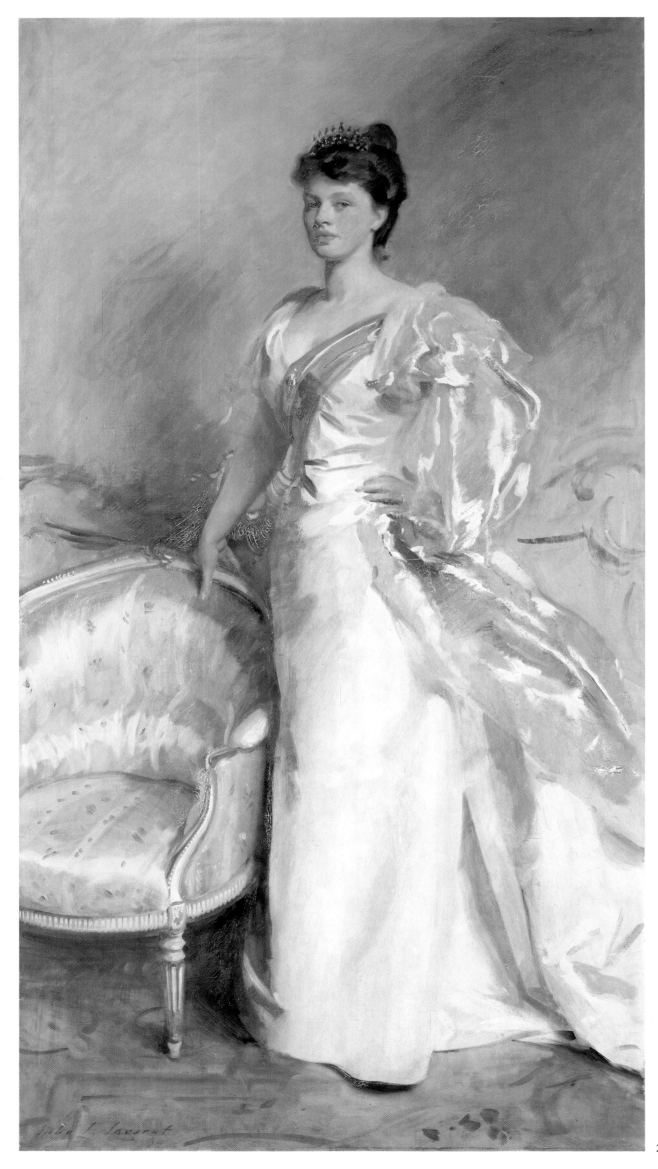

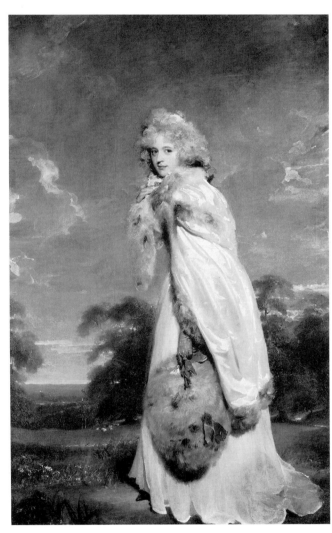

247

246. *Mrs. George Swinton*, 1896–97. Oil on canvas, 90 x 49 inches. The Art Institute of Chicago. Wirt D. Walker Collection.

247. Sir Thomas Lawrence. *Elizabeth Farren, Countess of Derby*, 1790. Oil on canvas, 94 x 57½ inches. The Metropolitan Museum of Art, New York. Bequest of Edward S. Harkness, 1940.

in the spring of that year. He was still at work on the picture on August 18, when he wrote to Isabella Stewart Gardner about a carpet she had lent him for the background: "It did not answer in Miss Rehan's picture—she became a mere understudy and the carpet played the principal part, so it had to be taken out."[147]

The following March, when Sargent finally thought the portrait done, a tapestry with cloaked and mounted horsemen had taken the place of Mrs. Gardner's carpet. Sargent treats these figures with a summary broadness, to indicate their place in the background of the portrait. Ada Rehan's face stands out in sharp focus and yet the flat patterns of the tapestry are powerfully present. Sargent has given them at least as much care as the folds and highlights of the actress's dress. Decoration struggles with reportage in this painting, perhaps a sign of how deeply Sargent's imagination was entangled in the Boston Public Library murals, with their intertwined figures of Astarte, Moloch, and Thammuz. Sargent was working frantically to finish the north wall designs by the end of 1894. He succeeded, but this had interfered with the Rehan portrait. Further, there had been the difficulty in choosing a backdrop. Luckily, Ada Rehan had found the task of posing quite bearable, even enjoyable.

In 1902 the Duchess of Portland had a very different experience. After several weeks of sittings at the duchess's house, Sargent found he couldn't make her image "live." She came downstairs one morning to find a fresh canvas on Sargent's easel and the old one lying in a corner, slashed. "She was so overcome with fatigue," her husband recalled, ". . . that she burst into tears; but Sargent reassured her by saying, 'I know you so well now that, if only you will let me try again, I am quite sure I can paint something "alive." . . .' He then altered her pose. . . . The picture simply flowed along, and in very short time was completed."[148] Sargent needed several chances to arrive at that spontaneity which, with extraordinary concentration, he had displayed in his first and last session with Eleonora Duse.

With the large matters of a portrait's mass, tone, and color settled, Sargent would attend carefully to detail—touches calculated to answer the demand for "finish" with an air of offhand elegance. Of his portrait *Mr. and Mrs. Isaac Newton Phelps Stokes* (plate 242), the husband later wrote that Sargent "was particularly well satisfied with the 'spiral' stroke with which he produced the diamond in Edith's engagement-ring, and cautioned me, if the picture were ever varnished, to be sure that the protruding whisp of paint was not injured. Alas! it has been."[149]

167

Prior to that last touch, Sargent had painted nine heads of Edith Stokes. Eight were scraped down to the canvas. Mr. Stokes appears in the painting only because the great dane expected to pose was not available; Sargent substituted husband for dog in three sittings. When he showed the portrait at the Society of American Artists, the *New York Times* called it one of the "stars" of the show.[150] The *Critic* said it "might stand alone as a sample of the painter's brushwork."[151]

Sargent had been elected an associate of the Royal Academy in 1894. Full membership followed just three years later. London's *Art Journal* approved: "The rise of Mr. Sargent is one of the meteoric incidents in art, and it is sufficient at this stage merely to state that his portraits this year will increase his great fame and clinch his recognized position as one of the chief portrait painters of the end of this century."[152]

Among Sargent's canvases at the 1897 exhibition of the Royal Academy was *Mrs. Carl Meyer and Her Children* (plate 245), in which diagonals and tilted perspectives create such a flurry that the artist's drift toward the monumental is almost obscured. Eighteenth-century English portraiture had treated such subjects more calmly. In *Lady Elizabeth Delmé and Her Children*, 1777 (plate 244), Joshua Reynolds suggests that the authority of strong horizontals and verticals—tree trunk and balustrade—can be softened by maternal form. Lady Delmé sits very straight, but her drapery and arms give her a pyramidal and sheltering presence. Two centuries later, Mrs. Meyer manages a slight—though obviously warm—contact with her offspring in a world in which even youngsters must stay alert. There is no question here of the mother as an island of calm in a predictable world. Sargent has torn down this genre of portraiture and rebuilt it along lines adapted to the quick pace, the sudden social and economic surprises, of late nineteenth-century England. He has also preserved enough from earlier times to please even the *Athenaeum*, which revised its policy on Sargent's treatment of flowers. "A capital and thoroughly modern piece is the life-size, whole-length, bright and brilliant portrait of Mrs. C. Meyer, which is Mr. J. S. Sargent's masterpiece this year; an excellent likeness and most charming as a painting. Its strongest point perhaps is the treatment of the rich, pure and delicate bloom of the carnations, which, however, are, as is not seldom the case with the painter, rather artificial and a little feverish."[153]

In an article for *Harper's Weekly*, Henry James said that the Meyer portrait is "far higher a triumph of painting than anything else" at the exhibition:

248. *Mrs. Fiske Warren and Her Daughter Rachel,* 1903. Oil on canvas, 60 x 40¼ inches. Museum of Fine Arts, Boston. Gift of Mrs. Rachel Warren Barton and Emily L. Ainsley Fund.

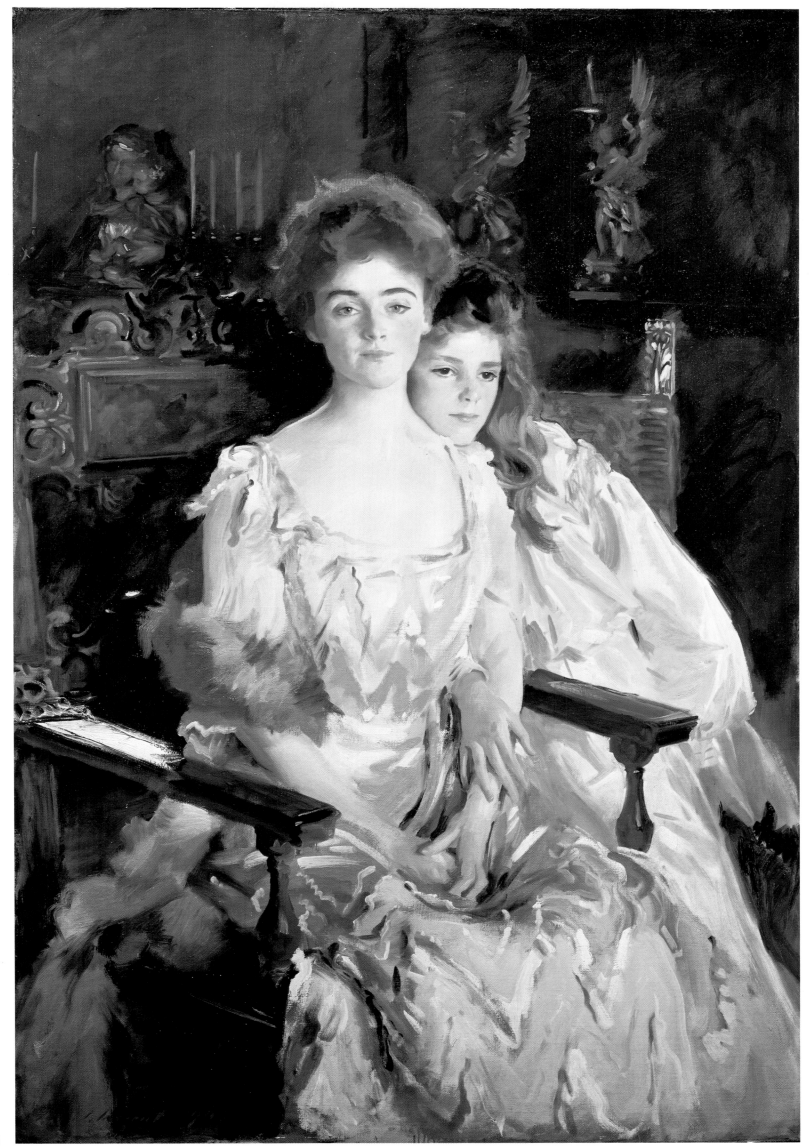

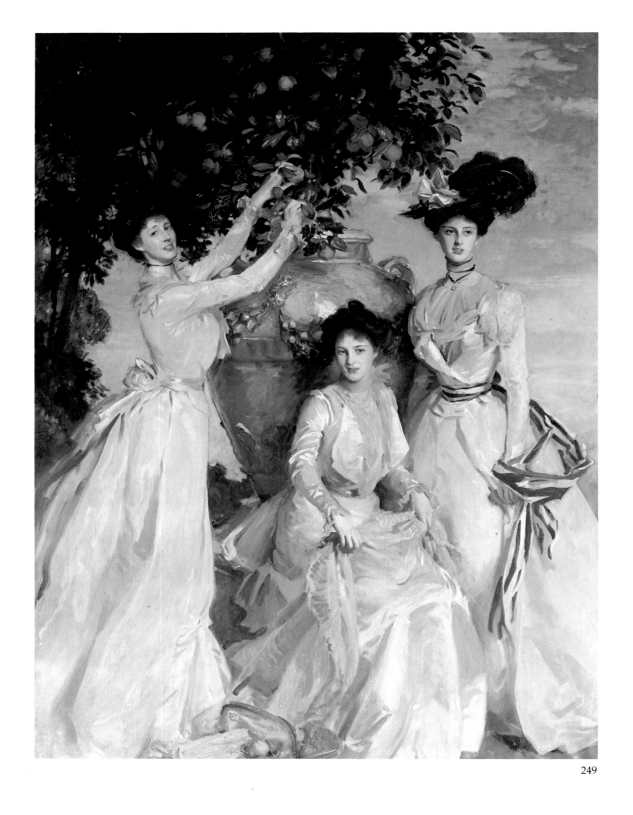

249

249. *The Acheson Sisters*, 1902. Oil on canvas, 106 x 78 inches. Devonshire Collection, Chatsworth, Bakewell, England. Reproduced by Permission of the Chatsworth Settlement Trustees.

250. *Lord Ribbesdale*, 1902. Oil on canvas, 101¾ x 56½ inches. The Tate Gallery, London.

. . . a picture of knock-down insolence of characterization, a wonderful rendering of life, of manners, of aspects, of types, of textures, of everything. It is the old story; he expresses himself as no one else scarce begins to do in the language of the art he practices. The complete acquisition of this language seems to so few, as it happens, a needful precaution! Beside him, at any rate, his competitors appear to stammer; and his accent is not to be caught, his progress, thank heaven, not to be analysed.[154]

In the 1880s English critics had condemned Sargent for technical facility unguided by taste. James now feels he can claim that the painter's command over "the language of the art he practices" is the first step toward paintings whose high taste is guaranteed by their accuracy —their "wonderful rendering of life, of manners . . . of everything." In

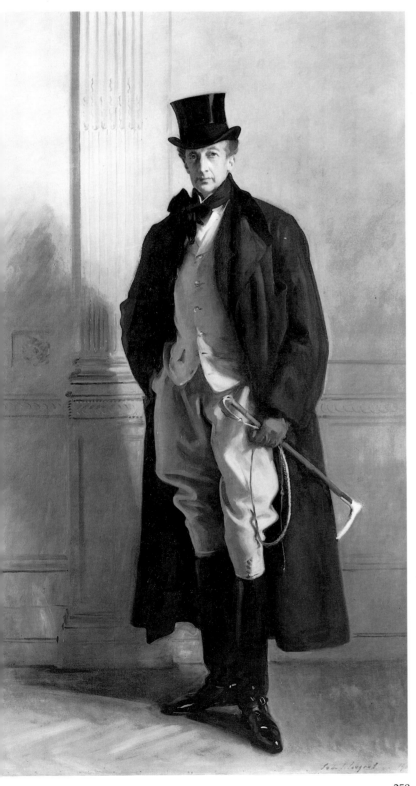

"The Art of Fiction," James calls painting "the sister art" of the novel, that literary form that he believes is dedicated more completely than any other to the struggle to "try and catch the colour of life itself." In 1897 he praises Sargent in terms appropriate to the greatest novelist—terms, in other words, that James surely thought applicable to himself. Never did he feel closer to his favorite artist, yet one must be as cautious here as everywhere else in traversing the terrain of Henry James's peculiar sensibility.

Early in 1888 James wrote to Thomas Bailey Aldrich: "Yes, I have always thought Sargent a great painter. He would be greater still if he had one or two things he isn't—but he will do." James rendered this private judgment half a year after the raves of his first Sargent article in *Harper's Weekly*—that celebration of a young artist who "sees deep into his subject, undergoes it, absorbs it, discovers in it new things that were not on the surface, becomes patient with it, and almost reverent, and, in short, enlarges and humanizes the technical problem."[155] In 1887, as in 1897, James marked Sargent as one of those delicate, powerful imaginations "upon whom nothing is lost," to draw once again on the language of "The Art of Fiction." Sargent's art is capable of "an immense and exquisite correspondence with life"—that is, "beauty and truth"—thanks to the technical flair with which he transports experience from "the chamber of consciousness" to his canvases.

What are those "one or two things" Sargent lacks? Had he obtained them by the time of the Meyer portrait? James never says. These questions can only be resolved by comparing James's beauties and truths with Sargent's. No doubt the novelist's are larger—or at least more disquieting. As critics have complained, James manipulates the narrator's point of view with a finesse that sometimes leads to utter confusion. James's art posits an ultimate, unresolvable ambiguity in the commerce of one individual, one imagination, with another. Sargent is much more straightforward when he narrates, so to speak, the occasion of a sitting. Yet, to quote Henri Houssaye's comments about Sargent in 1882, nothing is simple here. Sargent offers what might be called Jamesian perplexities—the play of social type against personality, of the sitter's inner nature against fashion's constantly shifting ideals. "Women don't ask you to make them beautiful," he said, "but you can feel them wanting you to do so all the time."[156] On the evidence of his best portraits, Sargent felt these pressures in the endlessly delicate, persistently tangled terms of the international society in which he moved. Yet he was not addicted to such ambiguity, as was James. All

252

251

251, 252. *Preliminary Studies of "The Wyndham Sisters"* (from a sketchbook, pp. 10v, 11), c. late 1890s. Pencil on paper, 9 x 11⅝ inches. Fogg Art Museum, Harvard University, Cambridge, Massachusetts. Gift of Mrs. Francis Ormond.

253. *The Wyndham Sisters: Lady Elcho, Mrs. Adeane, and Mrs. Tennant*, 1899. Oil on canvas, 115 x 84⅛ inches. The Metropolitan Museum of Art, New York. Catherine Lorillard Wolfe Collection, 1927.

through the 1890s he worked away at the grand themes of the Boston Public Library murals. And the time was coming when he would try to give up portraiture altogether.

In the spring of 1897, when *Mrs. Carl Meyer and Her Children* was dominating the Royal Academy exhibition, Sargent's *Mrs. George Swinton* (plate 246) was doing the same at the New Gallery. H.S. of the *Spectator* was enchanted by the "art of suggestion" Sargent had put to work in Mrs. Swinton's drapery: "One wonders if anyone else could have painted the left arm—or rather left it out—with such complete feeling of the solid structure beneath the loose scarf. . . ."[157] Sargent's command of translucence is sure, yet no surer than it had been in 1883, when he painted the candlelight caught in Mme. Gautreau's chiffon. The artist is making familiar, virtuoso use of the lessons in tone and observation that he had learned from Manet and Monet. Yet the scale has changed. This is in part a physical matter—brushstrokes are now larger in proportion to the entire surface. Sargent has aggrandized his touch remarkably, and there are other aggrandizements as well. H.S. hints at these when he says, "Even if there is nothing new in the arrangements of the figure and the accessories, still the fact that no one else can paint these things in a manner even approaching to Mr. Sargent makes one glad to see them again, when painted with such convincing mastery."[158] As the critic points out, Sargent himself had made Mrs. Swinton's setting and pose familiar. Yet there was another source which had made these devices more familiar still—formal British portraiture as practiced in Georgian and Regency times.

If Sargent's picture of the Meyers plays variations on themes from Joshua Reynolds, then *Mrs. George Swinton* updates Thomas Lawrence's images of gracefully standing women. Mrs. Swinton's poise is touched with anxiety, which is in turn veiled by a hint of standoffishness. Possessed of a secure if not exalted place in English society, she seems to feel—consciously or unconsciously—some doubts about her fitness to play the role of a Regency belle. As for Sargent, his way with satin recalls Lawrence's blithe and frothy manner, inflected with remembrances of avant-garde Paris. This blend of the hallowed and the radical, the English and the Continental, produces an elegant edginess —stylish signs of an impatience that in *Mrs. Fiske Warren and Her Daughter Rachel* (plate 248) produces zigzags of the most perfunctory sort. In 1902 Sargent had painted a triple portrait of the Acheson sisters (plate 249), giving the one on the right the pose of Reynolds's *Marchioness of Tavistock* (1761–62).

172

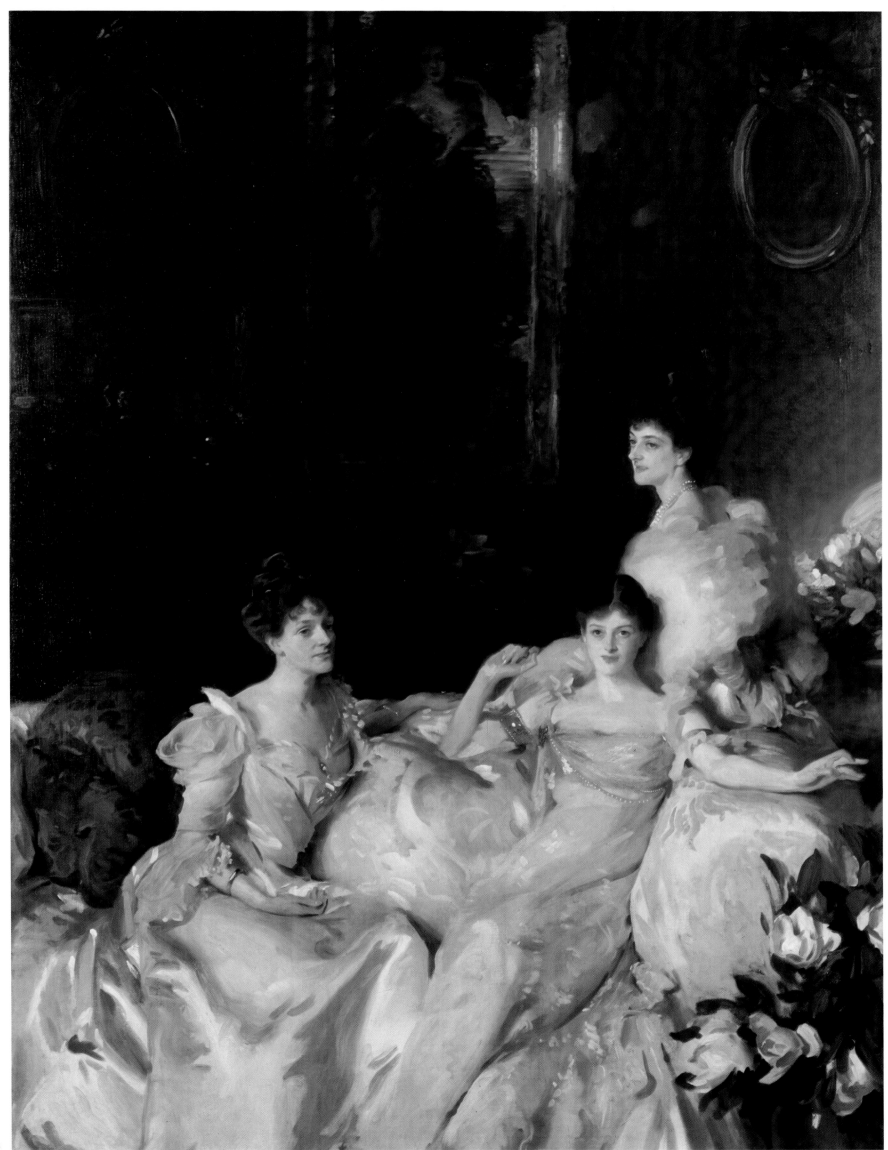

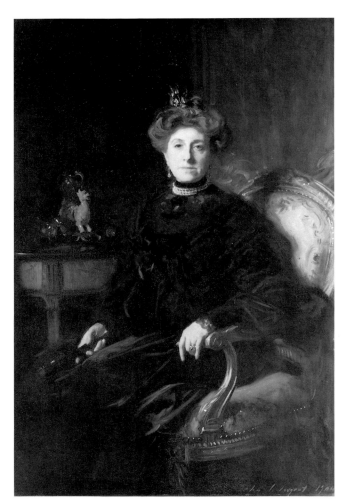

254

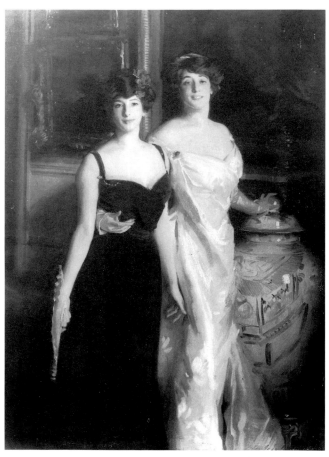

255

Even if Sargent's most enthusiastic admirers didn't always notice such allusions, they were willing to place him among the major figures of the past. In 1911 Robert Ross claimed that Sargent's portrait of Asher Wertheimer, 1898 (plate 257), "is surely one of the great portraits of the world, the only modern picture which challenges the Doria Velasquez at Rome—Innocent X."[159] Others had a more complex view of Sargent's modernity. Writing in the *Magazine of Art*, Marion Hepworth Dixon says that "the case of the masters is the case of Mr. Sargent, if I may put so youthful an Academician in line with his spiritual forebears." This critic senses that life has changed, and art with it—a modern master doesn't belong to quite the same species as an old master. On Sargent's portraits of the "vulturine" Coventry Patmore and the willowy W. Graham Robertson (plate 159), Dixon says:

Without the smallest accent of exaggeration—indeed with a reticence which seems to make us hold our breath and listen—we have two men presented to us, so diverse, so opposite, and yet so typical of our present civilization, that both the strength and weakness of that civilization seem mirrored in Mr. Sargent's creations. An even more strenuous grip of subject and material is seen in the study of Mr. Wertheimer. Fastidious, swift, and incisive, the artist shows himself in these canvases so capable of subtle distinctions, that, in Henry James's admirable phrase, "perception" seems "a kind of execution."[160]

The phrase is from James's 1887 article on Sargent. Dixon's use of it signals his acceptance of the idea, fully elaborated by James, that art is less a matter of sustaining traditions than of pursuing one's freedom "to represent life." Old masters might help the novice learn how to do this, but of course, "One writes the novel, one paints the picture, of one's language and one's time." Thus one is modern, by James's reckoning. And Dixon, guided by the novelist's spirit, sees something particularly modern in Sargent's treatment of women. "Ladies," he says, "no longer play at being goddesses; they have, possibly, even a sense of remoteness from the gods." Thanks to the "perplexities and anxieties" of the age, the genre of formal portraiture generates a peculiar tension in nineteenth-century women. They don't want to dress up as Hebe or the Tragic Muse, yet, like Mrs. Swinton, they don't feel quite adequate merely as themselves in expensive gowns. These qualms and all they imply about the vexed state of social legitimacy provided Sargent with much of his subject matter. The outlook for long-held values is uncertain, says Dixon, and thus "every man and woman bears something of

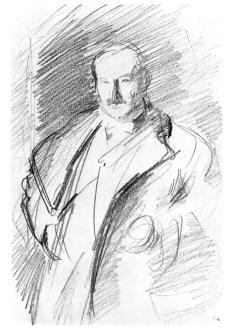

256

257

256. *Asher Wertheimer*, 1898. Pencil on paper, 9⅜ x 6 inches. Fogg Art Museum, Harvard University, Cambridge, Massachusetts. Gift of Mrs. Francis Ormond.

257. *Asher Wertheimer*, 1898. Oil on canvas, 58 x 38½ inches. The Tate Gallery, London.

the uneasy presage in his or her face. And this clearly Mr. Sargent has realized. A student of character, he remains a modern of moderns.''

In the avant-garde an artist was modern by virtue of subjecting his means—the forms and devices of his art—to the pressures of up-to-date ideas. Modernity of subject followed. In that aesthetic of which James and Sargent were primary practitioners, modernity of subject came first. Insofar as some contemporary theme "permeates and penetrates" a work, the results will inevitably belong to one's own time. As for such avant-garde painters as the Impressionists, James considered them "cynics," and their methods full of "latent dangers" for the young Sargent.[161]

In 1885 Vernon Lee registered doubts about Sargent's sensitivity to the era's anxieties. Of *The Misses Vickers*, she wrote, "I fear John is getting rather into a way of painting people too *tense*. They look as if they were in a state of *crispation de nerfs*. . . ."[162] As the years passed, others showed an eye for the tenseness in Sargent's art. Dixon is caught up first of all in the play of his pigments, the shifts from thick to thin, from elegant hesitation to sweeping certainty—"accent or emphasis is as much a pre-occupation with him as his colour scheme." Thus "the actual nervous grip of his tools is as engrossing as the technical problem of his values." As Dixon moves from an appreciation of Sargent's technique to a sense of the way he inflects it, he comes close to defining Sargent's modernity as a realm of deliberate inconclusiveness. Reynolds and Romney clothed their female sitters in the costume and character of myth. That is charming, even persuasive, but "it is useless to suppose that the tense, 'prickly,' and complex women of our present era could be summarized" that way. Sargent's "nervous grip" provides as certain a hold on such subjects as one could hope for.

Throughout, Dixon shows a pride in modern complexity. Robert Clermont Witt is even prouder of his era's frankness. Writing about *La Carmencita* in 1903, he says, "The brushmarks are there for all to see just as the painter dashed them on with swift, nervous certainty."[163] Is "nervous certainty" oxymoronic? If so, Witt parades the contradiction in his phrase, all the better to celebrate Sargent's power to resolve it. This artist is the master of modern unease, whether it appears in his touch or in his subjects. A year after *La Carmencita* was painted, it inspired another paradoxical flourish—the notion of poetic realism. Writing in the *Academy*, Claude Phillips said that the painting of the Spanish dancer has "sprung from the artificial soil of the expiring century, a veritable 'Fleur du Mal,' such as would have delighted Bau-

258

259

258. *Study of a Nude Model*, after 1900. Watercolor on paper, 18½ x 21½ inches. National Museum of Wales, Cardiff.

259. *In Switzerland*, 1908. Watercolor on paper, 10 x 12⅝ inches. The Brooklyn Museum. Special Subscription Fund.

260. *Padre Sebastiano*, c. 1904–6. Oil on canvas, 22¼ x 28 inches. The Metropolitan Museum of Art, New York. Rogers Fund, 1911.

261. *Spanish Fountain*, c. 1902–3. Watercolor and pencil on paper, 20⅞ x 13⁹⁄₁₆ inches. The Metropolitan Museum of Art, New York. Joseph Pulitzer Bequest, 1915.

delaire himself; but it would be impossible to give more spontaneous or more passionate expression to a conception which, in its mingled strangeness and naturalistic truth, expresses the very poetry of modern realism."[164] Symbolist artifice, direct expression, the truth of naturalism —Sargent resolves them all. Other critics, closer than Phillips to the clashes of opposed aesthetics (and closer, perhaps, to Baudelaire) were not so sure.

When *Madame X* (plate 120) was on view at the Salon, Toulouse-Lautrec had posed a rhetorical question to Sargent, in a letter to a friend: "Are you anxious to make sales, Monsieur Sargent? Certainly you mop the canvas in a marvelous manner, but international art will hardly be revivified by contact with that overwrought brush of yours."[165] One of Sargent's close London friends, the painter William Rothenstein, recalled that in the 1890s he had been "touched by Sargent's generous enthusiasm for Manet and Monet, for Rodin and Whistler; for . . . I had heard Degas and Whistler speak disparagingly of Sargent, as a skilful portrait painter who differed little from the better Salon painters then in fashion. With the exception of Rodin, I never heard anyone in Paris acknowledge the worth of Sargent's performance."[166] In the fall of 1891, Lucien Pissarro was setting himself up for a London career, with the guidance of his father Camille, a veteran of Impressionism's early skirmishes with official taste. Evidently Sargent helped the son find a studio. "Soon you will be settled," Camille Pissarro writes his son: "What you say about Sargent doesn't surprise me; Monet had told me that he is very kind. As for his painting, that, of course, we can't approve of; he is not an enthusiast, but an adroit performer. . . ."[167]

An enthusiast, in Pissarro's view, is one who joins with Prudhon in the belief that the "love of nature is linked with revolution, and consequently with the artistic ideal." This had nothing to do with virtuosity. Pissarro once wrote to his dealer, Paul Durand-Ruel: "As for execution, we regard it as inconsequential, of very little importance: art has noth-

260

261

ing to do with it; originality consists only in the quality of drawing and the vision particular to each artist.''[168] In Pissarro's view, Sargent's adroitness shows too much respect for conventional expectations about the look of art. This unadventurousness serves the status quo, all the moment's entrenched conventions—aesthetic, social, and economic. Sargent was not a revolutionary.

Neither was Mary Cassatt, yet her art and her way of life made her acceptable to Edgar Degas, that pillar of the avant-garde's elitist establishment. Late in her life, Cassatt condemned Sargent—as well as Henry James, Cecilia Beaux, and Edith Wharton—for having given themselves over to ''high society.''[169] As the English critic and painter Roger Fry put it, Sargent's portraiture is ''art applied to social requirements and social ambitions.'' The Wertheimer paintings represent ''a social transaction quite analogous to the transactions between a man and his lawyer. A rich man has need of a lawyer's professional skill to enable him to secure the transmission of his wealth to posterity, and a rich man, if he have the intelligence of Sir Asher Wertheimer, and the luck to meet Sargent, can, by the latter's professional skill, transmit his fame to posterity.''[170]

Though he refuses to launch a personal attack on Sargent, Fry is the bitterest of the painter's avant-garde opponents. Parisians could dismiss Sargent as an Anglo-American phenomenon on the periphery of radical developments. Fry must live with the memory of having once greeted Sargent as a painter dedicated to ''the discoveries of pure art.''[171] How, he asks himself in 1926, could he have been so mistaken? ''That Sargent was taken for an artist,'' says Fry,

will perhaps seem incredible to the rising generation, but I can testify to the fact, for I remember well his exhibiting at the New English Art Club two sketches of Javanese dancers. . . . The New English was then the home of whatever serious art England possessed, the home of real artists like Steer and Sickert, and I remember the buzz of excitement at the *maîtrise* of these two figures, though I remember, too, George Moore's warning note: ''No artist, but a prince of the *atelier*.'' Then came ''Carnation, Lily, Lily, Rose,'' which seemed a new revelation of what colour could be and what painting might attempt, and of how it could be at once decorative and realistic. When I look now at the thin and tortured shapes those lily petals make on the lifeless green background, I realize that what thrilled us all then was the fact that this picture was the first feeble echo which came across the channel of what Monet and his friends had been doing with a far different intensity for ten years or more. This new

262

color was only a vulgarisation of the new harmonies of the Impressionists. . . .[172]

For Fry, Sargent is no modernist at all, but a traitor to all of modernism's possibilities. Toward the end of his long indictment, Fry says that Sargent has ascended to a false Parnassus. "A number of very celebrated artists sit there, and Sargent takes his place on it, how far below Sir Thomas Lawrence time alone will decide."[173]

For all its differences, the avant-garde was united, from the 1880s to the 1920s, in the judgment that Sargent lacked something basic to genuine modernity—he updated the past with flair, but he never challenged it. As William Rothenstein generously put the matter: "We all acknowledged [Sargent's] immense accomplishment as a painter to be far beyond anything of which we were capable. But the disparity between his gifts and our own we were inclined to discount, by thinking we had qualities that somehow placed us among the essential artists, while he, in spite of his great gifts, remained outside the charmed circle."[174] R. A. M. Stevenson had anticipated this attitude in 1887. Avant-gardists, he said, were opportunists (cousins to Henry James's "cynics"), who sought only to shock. Sargent, by contrast, had studied painting's heritage, mastered it, and now was able to express himself in a genuinely modern fashion.[175]

There is no hope of reconciling these opposed notions of modernity. For R. A. M. Stevenson, the avant-garde is a rabble of pretenders who generate fads for their own dubious, too worldly purposes. Sargent, on the other hand, possesses a timeless body of knowledge—"painting itself"—which he employs with taste and inspiration for the benefit of his era's most refined audiences. Roger Fry judges Sargent to be the worldling. In the matter of art and timelessness, Fry accepts Cézanne's claim that painting "should enable us to see nature as eternal." Dedicated to absolutes, the avant-garde challenged things as they were. In the name of different absolutes, the pro-Sargent camp celebrated that same status quo. Not surprisingly, the celebration found a much larger audience than the challenge. And for those exceedingly cautious viewers who sensed the Parisian sources of Sargent's style, there were writers like A. L. Baldry to assure them that this "militant leader of the modern art world" wears "the mantle of Velasquez."[176] As "the chief exponent of the great technical truths that have been handed down to us from the mightiest of the old masters," Sargent has the "right to be ranked among the best of the modern masters who are keeping art alive."

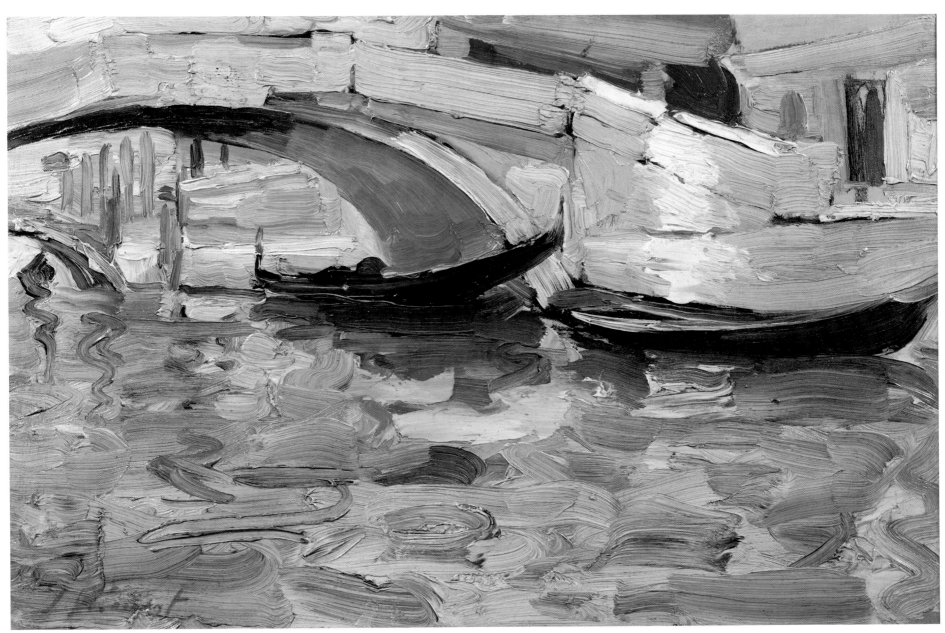

263

262. *Gourds*, c. 1905–8. Watercolor on paper, 13¹³⁄₁₆ x 19¹¹⁄₁₆ inches. The Brooklyn Museum. Special Subscription Fund.

263. *Gondolas*, 1899 (1905?). Oil on artist's board mounted on panel, 13¼ x 19⅛ inches. Private Collection.

When H.S. of the *Spectator* reviewed Sargent's portrait of the Wyndham sisters (plate 253), in 1900, he recycled terms of praise from his comments made earlier that year about a van Dyck exhibition.[177] Of *The Wyndham Sisters*, the London *Times* was "inclined to say that it is the greatest picture that has appeared for many years on the walls of the Royal Academy."[178] The *New York Tribune* said that the sitters' "faces reveal refinement of nature, high-bred distinction of manner, and individual peculiarities and traits."[179] By the turn of the century, praise for Sargent had become a constant din. As its volume rose and its terms became less and less precise, doubts about his sort of modernity were drowned out. For all but the most radical sensibilities in London and Paris, Sargent had defined the look of the modern individual. His types had become archetypes, social icons with much more authority than his mural figures possessed. And as Sargent stood beside these portrait images, he rose to their stature—and higher, perhaps, than some of them. In the friendly regions of English and American society, Sargent was no longer merely the highest type of modern painter. He was Art itself, or at least the artist in archetypal form.

IX. *"Sargentolatry" and a Reluctant Idol*

SARGENT DIED IN LONDON ON APRIL 14, 1925. Immediately, the press in England and America was filled with eulogies. There was a memorial service at Westminster Abbey and a number of memorial exhibitions. The same year, Christie's auctioned off much of the work Sargent had left in his studio, as well as the paintings and drawings by others that he had begun to accumulate in his student days. It was a newsworthy occasion, for Sargent was a celebrity at the very least, and even something of a legend. At any rate, the inaccuracies that clustered around him late in life, and soon after his death, are of the sort inspired by figures who loom large on the horizon.

In 1930 a writer named Grace Irwin published a book called *Trail-Blazers of American Art.* She included Sargent, inevitably, despite her title's image of aesthetic pioneers at large in a New World wilderness. Irwin calls Gilbert Stuart "America's First Great Portrait Painter." Sargent is the "Greatest," and, furthermore, he

> was a success in London from the first. The English liked this cultured, fine-looking artist who had a fine reserve and dignity. The aristocracy came flocking to his studio to be painted. . . . In America he painted the portraits of two Presidents, Theodore Roosevelt and Woodrow Wilson, and the presidents of several universities, besides a long list of notables in many walks of life—poets, actors, and actresses, statesmen, and those socially prominent.[180]

None of this is wrong, save the claim that Sargent was successful in England from the outset. And Vernon Lee might have resisted the judgment on Sargent's looks; on one occasion, she wrote of him as "ugly." Irwin could have defended these mistakes, or refused to recognize them, on the grounds that of course an American artist as important as Sargent was successful the moment he set up shop in the English-speaking world. And never mind that the aristocrats he painted were often those who had decided, for one reason or another, to enter into competition with the merely fashionable. Nowhere in Irwin's remarks is there any room for a consideration of Sargent's own—and deeply vexed—attitudes toward portraiture. In her view, he produced stunning, authoritative images of important people much as Nature

264. *Artist in His Studio*, detail. See plate 265.

181

265

265. *Artist in His Studio*, c. 1903. Oil on canvas, 28½ x 28¼ inches. Museum of Fine Arts, Boston. Charles Henry Hayden Fund.

266. *Venetian Doorway*, after 1900. Watercolor and pencil on paper, 21 x 14¼ inches. The Metropolitan Museum of Art, New York. Gift of Mrs. Francis Ormond.

267. *Edward Robinson*, 1903. Oil on canvas, 56½ x 36¼ inches. The Metropolitan Museum of Art, New York. Gift of Mrs. Edward Robinson, 1931.

produces sunsets. Some are more impressive than others, but all of them are splendid.

This reverence for Sargent goes even farther with anecdotes of a kind that had appeared very early in Western culture—the story, for instance, of Parrhasius's curtain, which he had painted so skillfully that his rival, Zeuxis, asked him to lift it from the canvas. In Sargent's day, the Duke of Portland recollected that a friend once "happened to look through the window" of his house, "tapped on the glass and called my wife's name. Later in the day she met my wife and asked her, 'why were you so haughty this morning, and wouldn't answer when I tapped on the window?'"[181] Sargent was very pleased when he heard this—for of course it was his portrait of the duchess that had fooled the

266

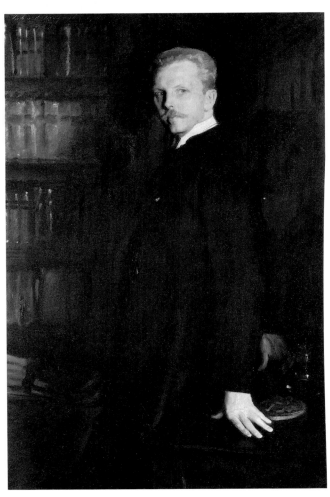

267

woman at the window. This is alleged to have happened during the early 1900s. In the previous decade a London *Times* reviewer had said, hyperbolically, that *La Carmencita* looked ready to spring to life. Here, that magical illusion has happened, if only for a moment. Audiences completely convinced by an artist's style are always tempted to explain its authority by an appeal to supernatural powers. Sargent's worldliness prevented this from happening very often in his case, though there are other instances of it.[182] For the most part, the uncritical enthusiasm for his art took the form of raves, ever more enthusiastic and unfocused as the years went by.

Some stood apart from the spectacle of Sargent's career and were amused, particularly if they had illustrious careers of their own. In April of 1914 Max Beerbohm writes about seeing Henry James—"he has become one of the stock ornaments at dinner tables, uniform with Sargent, Claude Phillips, etc. . . ."[183] Others, like Roger Fry, granted Sargent his place in fashionable society, yet were galled by the fear that his grand manner stood in the way of more radical styles. Walter Sickert, a colleague of Sargent's from the early days of the New English Art Club, had a broader, more political view than Fry's. Writing in 1910 for a socialist journal, the *New Age*, Sickert poses a rhetorical question to young, struggling painters: "Doesn't it seem very hard that because Mr. Sargent has a knack of hitting off the kind of showy and brilliant likeness that is in demand, and the opportunity of so displaying it in Picadilly [at the Royal Academy's Burlington House] as to afford the noblest and the richest arrivists just the sort of discreet and flaring advertisement they crave for (oh so ardently!), you should get as many tens as he does thousands for his paintings?"[184] If this does seem unfair, he continues, perhaps young artists should protest. They might even consider going on strike. Sickert mocks this policy, talk of which was in the air. Serious art is a form of work, he believes, and the workman should pursue his task. That is the way to a solid reward and eventual justice. In the meantime, the meretriciousness of Sargent's portraiture should not inspire any bitterness toward the man himself.

Sickert appears to have felt genuine good will toward Sargent and on occasion managed to praise his art, if only faintly. His fellow painter possesses, after all, "an eye for character. He has a great gift for placing his shapes where he wishes, safely and firmly. The color is quelconque [indifferent], and the quality of execution is slippery, and has no beauty or distinction of its own. The paintings might be described as able black-and-white sketches on a large scale, in adequate colours."[185]

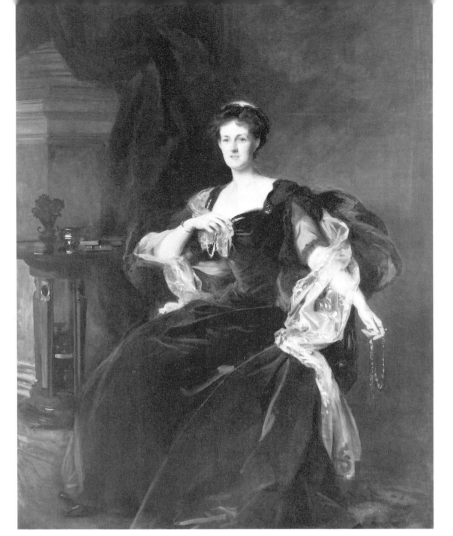

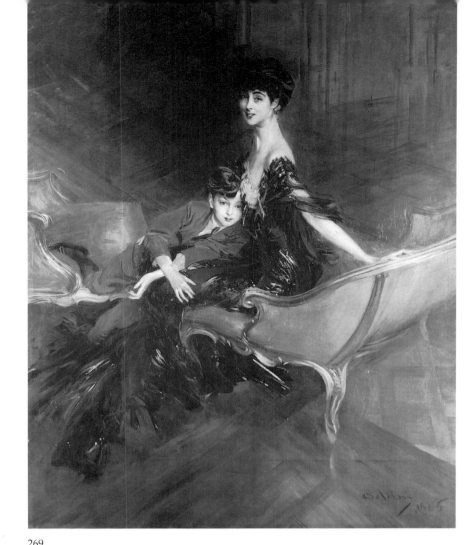

268

269

With these remarks Sickert insinuates a claim for his own mastery of the Impressionist palette. Sargent, he implies, understands nothing so advanced. Instead of building images from color, he assembles them from tones of light and dark, then applies his hues like a skin. This conservative practice is all very well, but aesthetic—and ultimately social—injustice is done when "Sargent's painting is accepted . . . as the standard of art, the ne plus ultra and high-water mark of modernity. Let us try to arrive at a reasonable and just estimate, devoid alike of detraction and a hysterical abasement."[186]

This is more than an avant-gardist's complaint about Sargent's blend of Impressionism and the old masters. Sickert objects to a phenomenon that leads, at extremes, to legend-making and the ascription of magical properties. He calls it "Sargentolatry"—Sargent worship—and sees it chiefly in the "prostration" of critics.

> Where there is real poverty of thought, and absence of knowledge, the first necessity is to find an idol before which to assume the favourite attitude which the French call flat-belly. Flat-belly the critics have been before [Sargent's] successes; faithfully flat-belly before his failures. . . . The only person who has resolutely abstained from any complicity in the Sargent boom has been Mr. Sargent himself.[187]

It is true that Sargent took a deprecating attitude toward his own work. One of his earliest biographers, W. H. Downes, asked him if "Darnation, Silly, Silly, Pose" was Whistler's nickname for *Carnation, Lily*. Sargent let on that it was his own. He considered his watercolors

270

268. *The Countess of Lathom*, 1904. Oil on canvas, 89¾ x 78¾ inches. The Chrysler Museum, Norfolk, Virginia. Gift of Walter P. Chrysler, Jr.

269. Giovanni Boldini. *Consuelo, Duchess of Marlborough, and Her Son, Lord Ivor Spencer-Churchill*, 1906. Oil on canvas, 87¼ x 67 inches. The Metropolitan Museum of Art, New York. Gift of Consuelo Vanderbilt Balsan, 1946.

270. *The Duchess of Marlborough*, after 1905. Pencil on paper, 11¼ x 7⅞ inches. The Metropolitan Museum of Art, New York. Gift of Mrs. Francis Ormond and Miss Emily Sargent, 1931.

unfit to be sold. When pressed for one, he would ask an absurdly low price and tag the work with a joke title—"Dried Seaweed," "Triple Bosh," "Troglodytes of the Cordilleras." Once, on a visit to the Metropolitan Museum of Art in New York, Sargent, his sister Emily, and the architect Bosworth Wells were standing in front of Henry G. Marquand's portrait. Boswell said to Miss Sargent, "'If your brother had never painted any other picture than this, he would go down to posterity as the greatest portrait painter of his time.' Overhearing this, Sargent pointed to the pink skin drawn over the skull of the aged financier and mumbled disdainfully, 'Chicken—chicken! I can never think of anything else, when I look at this portrait, but plucked fowl in the markets!'"[188]

Yet even as Sargent grew bored with portraiture, he found ways to make it grander. Having referred directly to Reynolds in his *Acheson Sisters*, he drew on the seventeenth century for the *Marlborough Family*, 1905—the duchess wears a dress copied from one of the van Dyck portraits at Blenheim. James Lomax and Richard Ormond see van Dyck's "heroic conception of the figure" in Sargent's portrait of Sir Frank Swettenham (plate 273).[189] This is surely correct, though the tension between image and precedent is even greater here than in *Mrs. George Swinton* (plate 246). Van Dyck celebrated not only Charles I and his court, but also that theory of divine right by which the king claimed his authority. In that milieu, van Dyck found it legitimate to endow his double portrait of the writers Thomas Killigrew and Thomas Carew, 1638, with a degree of melancholy refinement only a touch less elevated than the king's. After all, their poems and masques, like the work of van Dyck himself, were dedicated to Charles's glorification. By contrast, Sir Frank Swettenham, governor of the Malay States, served an empire that justified itself only by economic need and military power. He wielded a thoroughly secular authority, and so when Sargent introduces him into a painting whose style is touched by the exalted religiosity of King Charles's court, Sir Frank looks somewhat ill at ease.

In 1905 the American muralist Kenyon Cox retold an anecdote of the time Sargent "had painted a portrait in which he was thought to have brought out the inner nature of his sitter, and to have 'seen through the veil' of the external man. When asked about it, he is said to have expressed some annoyance at the idea, and to have remarked: 'If there were a veil, I should paint the veil; I can paint only what I see.'"[190] Despite this denial of any psychological acumen, many of Sargent's formal portraits are filled with sharp insights about character and soci-

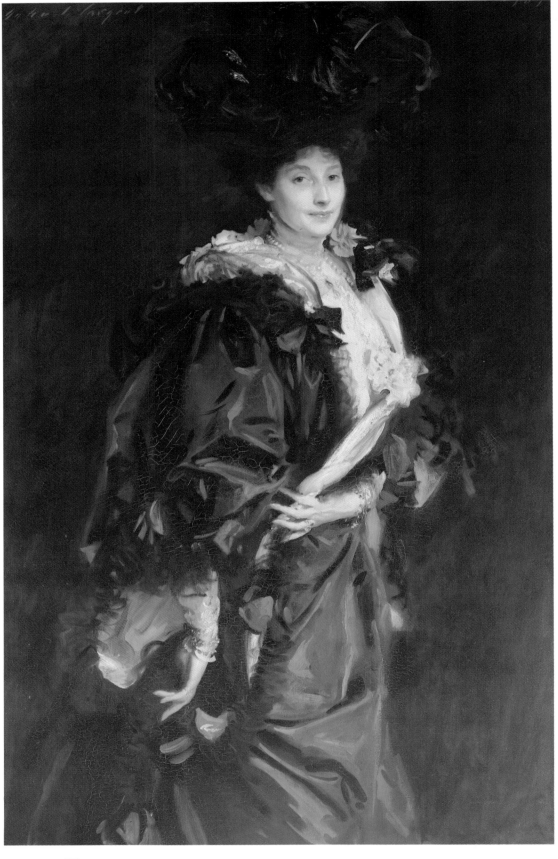

271

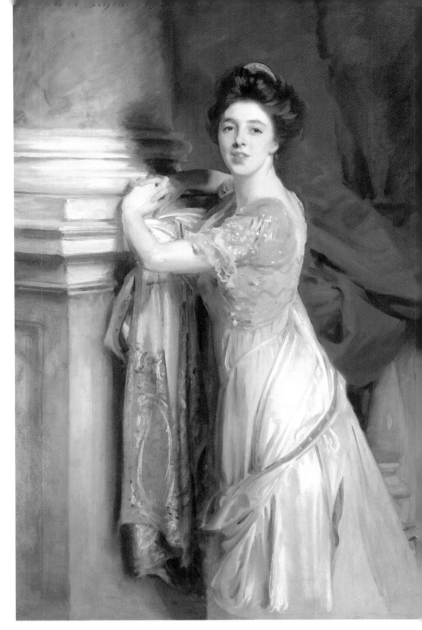

272

271. *Lady Sassoon*, 1907. Oil on canvas, 62 x 41 inches. The Marchioness of Cholmondeley.

272. *Izme Vickers*, 1907. Oil on canvas, 57½ x 37½ inches. Coe Kerr Gallery, New York.

273. *Sir Frank Swettenham*, 1904. Oil on canvas, 67¼ x 47½ inches. National Portrait Gallery, London.

186

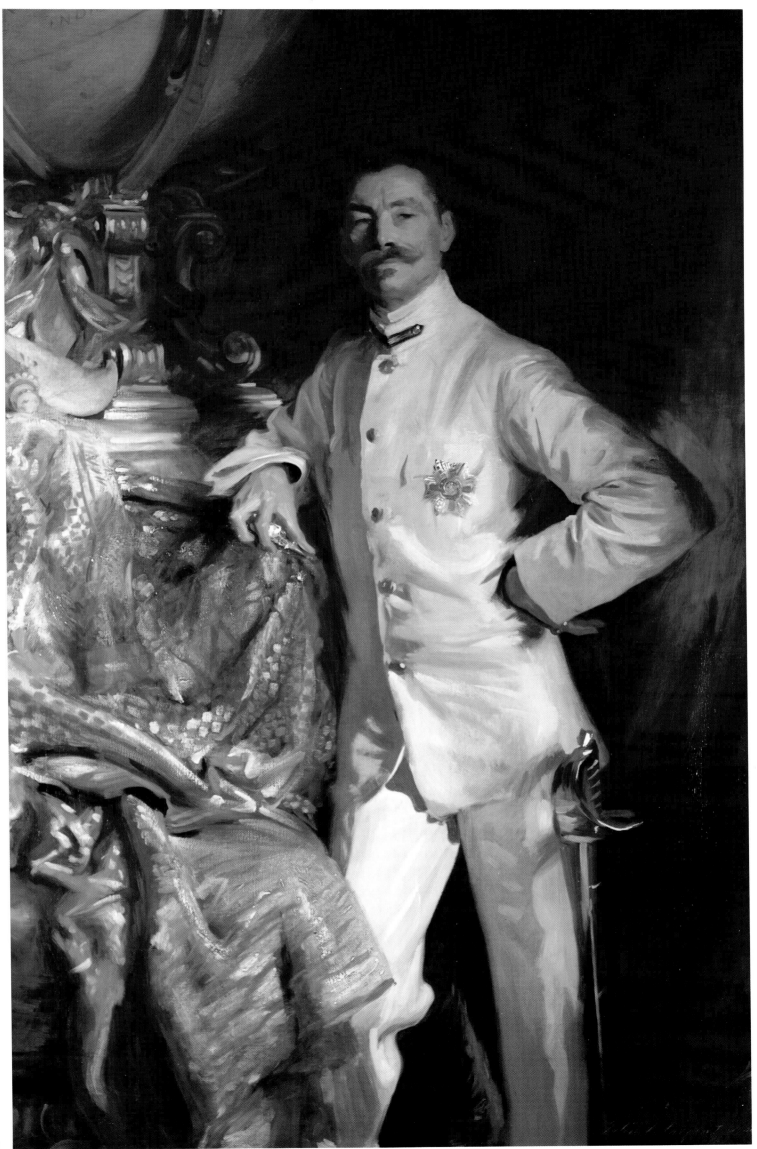

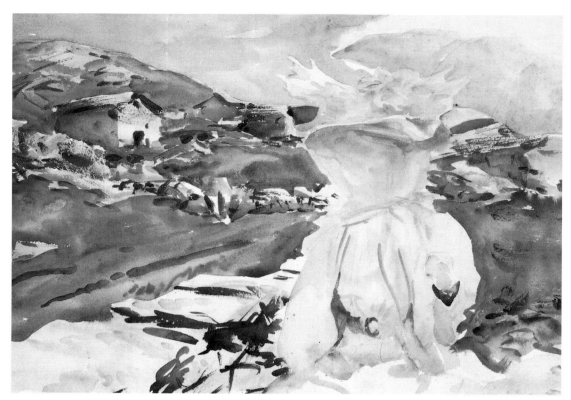

274

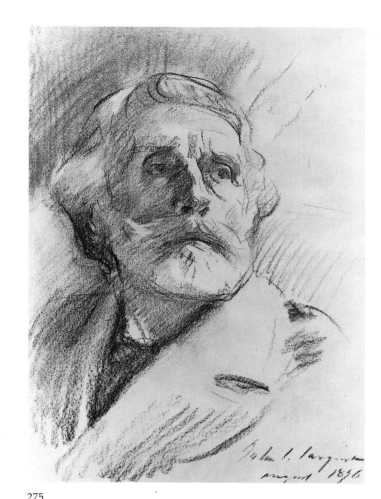

275

ety, which he might have censored had he recognized how much they revealed. Although critics occasionally noted in Sargent's likenesses an acuteness approaching caricature, the painter's most fervent admirers maintained a resolutely one-sided view of his art, refusing to see in his formal portraits anything but grandeur and elegance and privilege deserved. Rodin called him "the van Dyck of our times," and many accepted that label with no hesitation. "Sargentolatry" was a widespread and highly respectable cult.

Yet Sargent's doubts about his studio practice continued to grow, feeding his annoyance with the vanity of clients. He got into the habit of saying that a portrait is "a likeness in which there is something wrong about the mouth."[191] A sitter once complained about his rendering of her nose. "Oh," he said, "a trifle like that you can alter yourself when you get home!"[192] In 1902 Sargent went sketching in Norway, then in Spain, where he returned the following year. Lasting three to four months, these trips were first of all a way of avoiding would-be clients. In 1906 he wrote to a friend: "I have now got a bomb-proof shelter to which I retire when I sniff the coming portrait or its trajectory."[193] The continent of Europe was his shelter. But when he returned to London from the Simplon Pass and a stopover in Italy or Majorca, the rush of clients would be fiercer than ever.

In the first years of this century, Sargent's presence in Tite Street gave a glow of celebrity to that corner of Chelsea. Writing in the *Pall Mall Magazine*, Cecil Chard went on at length about the neighborhood where the painter kept his studio. "At one end of the vista, rather grey

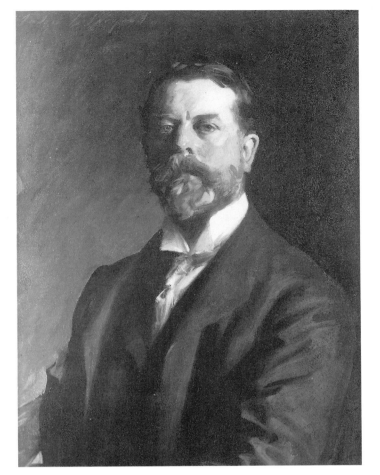

276

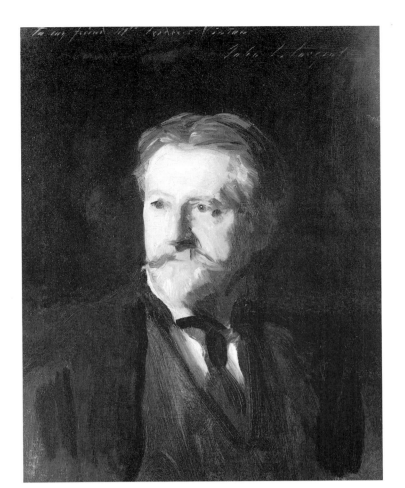

277

274. *In the Simplon Pass*, c. 1910. Watercolor on paper, 14⅛ x 20⅝ inches. The Brooklyn Museum. Gift of the Roebling Society.

275. *George Meredith*, 1896. Charcoal on paper, 13 x 9 inches. Fitzwilliam Museum, Cambridge, England.

276. *Self-Portrait*, 1907. Oil on canvas, 30 x 25 inches. Galleria degli Uffizi, Florence.

277. *Frederic Porter Vinton*, 1903. Oil on canvas, 25½ x 19¼ inches. Museum of Art, Rhode Island School of Design, Providence.

and hazy, the river gleams, and behind the quiet houses, each with its individual aspect of reserve, tower ancient elms that suggest hidden gardens."[194] Eventually Chard turns from cataloging the details of Tite Street to the "solid, polished, dark-green door" of the artist's own house, which is "greyish-red brick with a high Dutch roof." Of this door, he says, "It has been plaintively asserted that it is harder to pass than the shining gates of Buckingham Palace or any other Palace." Commentary of this sort suggests that Sargent had moved—rather, had been promoted against his will—from the rank of painter to the status of public figure. He responded by withdrawing to an ever smaller group of family and particular friends.

In the 1890s Sargent had begun to make charcoal sketches, some full-length figures but mostly heads. In the following decade he found that he could occasionally get out of a promise to execute an oil portrait sometime in the future by offering to do something in charcoal right away. Soon, as Lomax and Ormond point out, "A Sargent drawing became an important status symbol. 'How do you like your Sargent drawing?' was the conversational gambit of one distinguished diplomat to ladies he had never met before, and he claimed that it was successful nine times out of ten."[195] Sargent's work in charcoal gives the best evidence that he kept an eye on fashion—and on the mannerisms of fashion plates.

In January of 1905 he began an oil painting of Lady Sackville-West, the mother of the writer Vita Sackville-West. According to her diary, the painting was still not finished a month and a half later. First Sargent

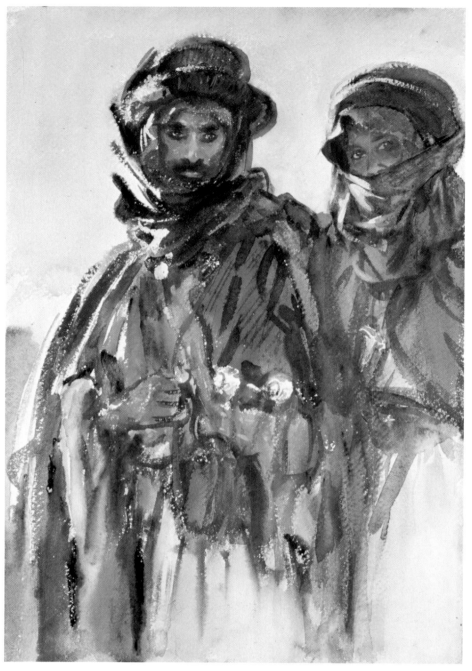

278

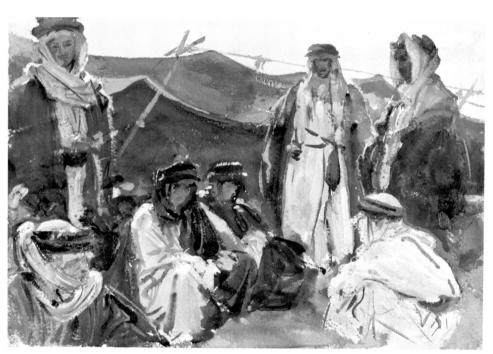

279

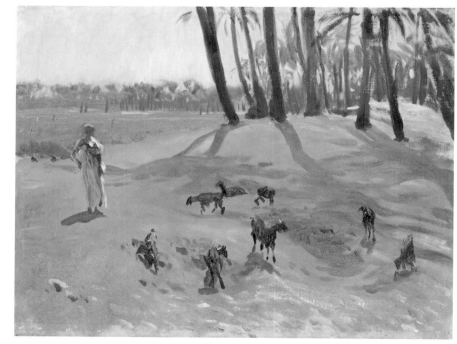

280

281

278. *Bedouins*, 1905–6. Watercolor on paper, 17⅝ x 11¹³⁄₁₆ inches. The Brooklyn Museum. Special Subscription Fund.

279. *Bedouin Camp*, 1905–6. Watercolor on paper, 9⅞ x 13⅞ inches. The Brooklyn Museum. Special Subscription Fund.

280. *Landscape with Goatherd*, 1905. Oil on canvas, 24¼ x 31⅞ inches. The Metropolitan Museum of Art, New York. Gift of Mrs. Francis Ormond, 1950.

281. *Arab Stable*, 1905–6. Watercolor on paper, 10⅞ x 14⅜ inches. The Brooklyn Museum. Special Subscription Fund.

said his work "was not good enough to sign." Next, Lady Sackville-West writes, he painted "a horrid face and was not at all pleased when I told him I did not like it at all! But he wrote afterwards that he would do a drawing of me for Vita's birthday, for nothing! as *amende honorable*."[196] This substitute for oil on canvas (plate 283) took an hour to do, and its subject found it "charming." Sargent made another effort at painting Lady Sackville-West, but, after half a dozen attempts, the project was abandoned.

Sargent made a self-portrait in 1907, after which he said: "I have long been sick and tired of portrait painting, and when I was painting my own 'mug,' I firmly decided to devote myself to other branches of art as soon as possible."[197] Of course, when he said this Sargent had been working on the library murals for over a decade, and not a single year of his adult life went by without long sessions of plein-air sketching. He

191

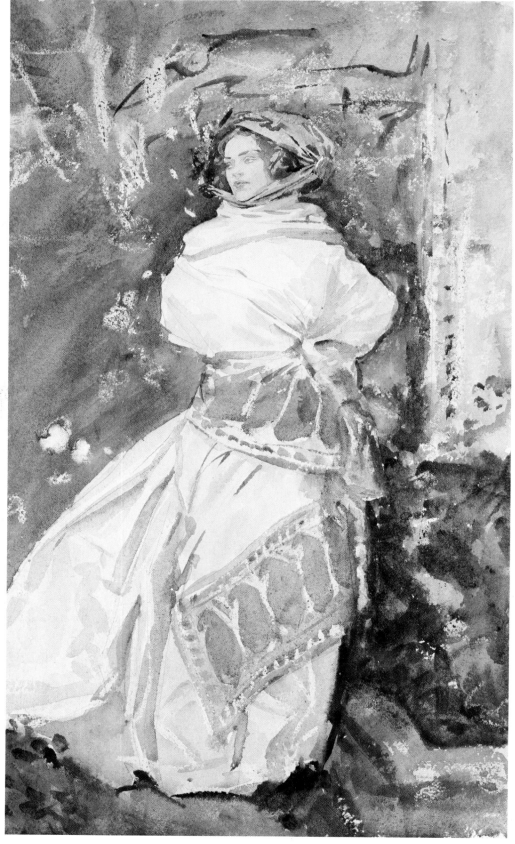

282

283

284

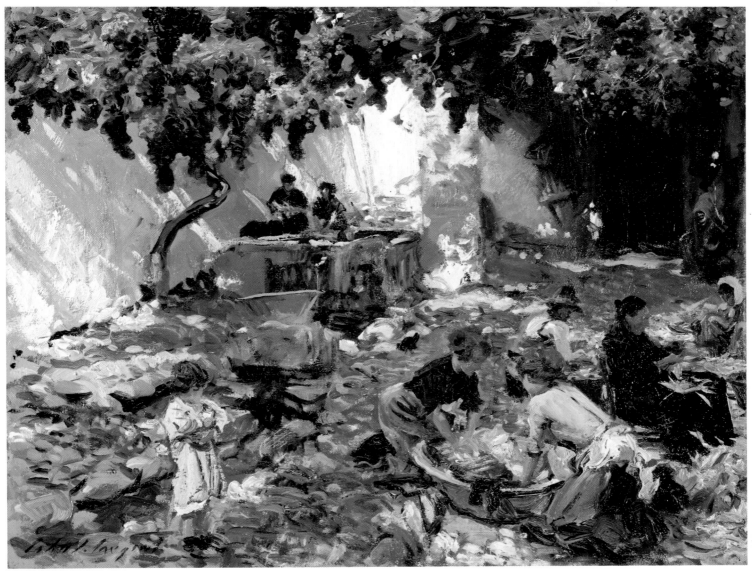

285

282. *The Cashmere Shawl* (Rose-Marie Ormond), 1911. Watercolor on paper, 19¾ x 11¾ inches. Museum of Fine Arts, Boston. Charles Henry Hayden Fund.

283. *Mrs. Sackville-West* (later Lady Sackville), 1905. Charcoal on paper, 24 x 18 inches. Nigel Nicolson.

284. *Lady Helen Vincent* (later Viscountess d'Abernon), c. 1905. Charcoal on paper, 24 x 18 inches. York City Art Gallery, England.

285. *Women at Work*, c. 1910. Oil on canvas, 22 x 28 inches. Private Collection.

286. *Granada*, 1912. Watercolor on paper, 20 x 15⅝ inches. The Metropolitan Museum of Art, New York. Gift of Mrs. Francis Ormond, 1950.

286

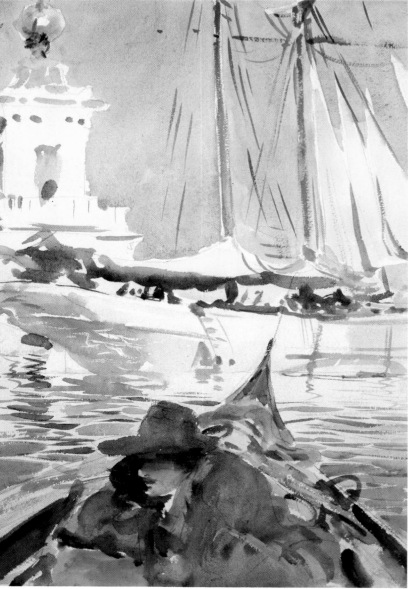

287

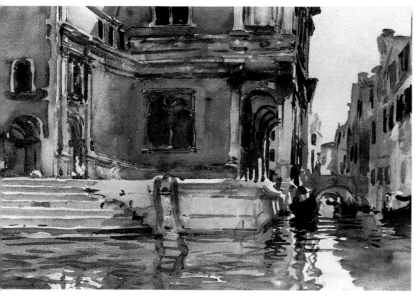

288

287. *The Dogana*, c. 1904–8. Watercolor on paper, 14 x 10 inches. The Ormond Family.

288. *Scuola di San Rocco*, c. 1907–8. Watercolor on paper, 13¾ x 19½ inches. The Ormond Family.

289. *Henry James*, 1913. Oil on canvas, 33½ x 26½ inches. National Portrait Gallery, London.

290. *Theodore Roosevelt*, 1903. Oil on canvas, 58½ x 40½ inches. White House Collection, Washington, D.C.

had hardly neglected other branches of art. Nor did he manage to give up portraiture, though there were other resolutions to do so, like this one from a letter to Ralph Curtis: "No more paughtraits whether refreshed or not. I abhor and abjure them and hope never to do another especially of the Upper Classes. I have weakly compromised and lately done a lot of mugs in coke and charcoal and am sick of that too, though occasionally the brief operation has been painless. I am winding up my worldly affairs in that line and now I shall be able to paint nothing but Jehovah in Fulham Road."[198] Jehovah is the figure veiled by the wings of cherubim in the north wall lunette at the Boston Public Library. The Old Testament demands that his face be hidden, though Sargent, when questioned on the point, said it was because he had "given up painting portraits."

In the winter of 1905 Sargent returned to the Middle East to get "new fuel" for the library murals. He was near Jerusalem, in January 1906, when the news of his mother's death reached him. He telegraphed his sisters, asking that they delay the funeral until his arrival in London. They did. Soon afterward, Sargent wrote to his friend Elizabeth Lewis: "Everything is dreadful except that her friends were good and that death itself came unsuspected and unrecognized."[199] Sargent drew closer than ever to the small band at the center of his private existence—his sister Emily; Henry Tonks, professor of fine art at London's University College; Wilfred de Glehn, a painter, and his wife, Jane; and Philip Wilson Steer, like Sargent a cofounder of the New English Art Club. During their summer travels, John and Emily were usually joined by their sister, Violet Ormond, and her daughters. The de Glehns often came along, as did Mr. and Mrs. Adrian Stokes, both painters.

When Sargent extricated himself from murals and landscapes for a serious effort in portraiture, it was often for one of his close friends— *Mrs. Huth Jackson*, 1907, for instance, and *The Marchioness of Cholmondeley*, 1913. On occasion Sargent let a sense of duty persuade him to return to portraiture. He painted *Theodore Roosevelt* in 1903 (plate 290); *Woodrow Wilson* fourteen years later; and in 1908 was prevailed upon, by means still mysterious, to paint an elaborately dignified portrait of the Tory prime minister, A. J. Balfour.

When, in 1913, Sargent was asked to do a portrait of Henry James (plate 289), both motives—deep friendship and respect for a major personage—were called into play. The James portrait began as Edith Wharton's idea; she wanted it done in time for his seventieth birthday. When James heard of her successful attempts to raise a fund for the

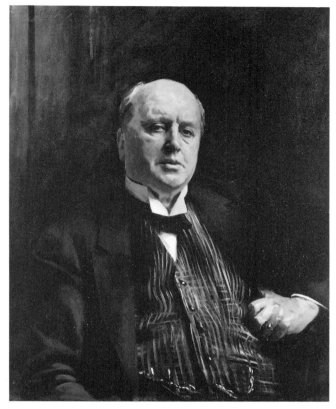

289

290

project, he forbade it. Then his English friends set about the same purpose, and this time he relented. Sargent accepted no money for the commission, which freed the English fund to go for other gifts.

With "some seven or eight" sittings over and only a few more to come, James described his effigy to Lizzie Boott:

> One is almost full-face, with one's left arm over the corner of one's chair-back and the hand brought round so that the thumb is caught in the arm-hole of one's waistcoat, and said hand therefore, with the fingers a bit folded, entirely visible and "treated." . . . The portrait comes down to just where my watch-chain (such as it is, poor thing!) is hung across the waistcoat: which later, in itself, is found to be splendidly (poor thing that it also be) and most interestingly treated. Sargent *can* make such things so interesting—such things as my coat-lappet and shoulder and sleeve too![200]

James had suggested in "The Art of Fiction" that novelists and painters are kin. If so, to sit for the illustrious Sargent was for James to face art's nearest counterpart to himself. That may be why he begins his description with a stately flurry of distancing devices—all those impersonal pronouns and detached references to thumb and hand. Next comes the mock-deprecation of watch-chain and waistcoat, then the close focus on Sargent's way with details of tailoring. James seems discomfitted by undergoing the same sort of scrutiny that he directed at others as a matter of course. He does get around to saying that "what is most interesting, every one is agreed, is the mouth—than which even [Sargent] has never painted a more living and, as I am told, 'expressive'! In fact, I can quite see that myself. . . ."[201] When the picture was done, James wrote to Mrs. Alfred Sutro:

> . . . it is nothing less evidently, than a very fine thing indeed, Sargent at his very best and poor H.J. not at his worst; in short a living breathing likeness and a masterpiece of painting. I am really quite ashamed to admire it so much and so loudly—it's so much as if I were calling attention to my own fine points. I don't, alas, exhibit a "point" in it, but am all large and luscious rotundity. . . . I am sorry to have ceased to sit, in spite of the repeated big holes it made in my precious mornings: J.S.S. being so genial and delightful a *nature de grand maître* to have to do with, and his beautiful high cool studio, opening upon a balcony that overhangs a charming Chelsea green garden, adding a charm to everything.[202]

When the portrait was shown at the Royal Academy in 1914, it was slashed by a suffragette.[203]

195

X. *The End of an Era*

WAR BROKE OUT IN AUGUST OF 1914, and its horror soon carried James far from his delighted, exquisitely inflected encounter with Sargent's eye. As news from the front arrived in England, James immersed himself in it. The result was "a nightmare from which there is no waking save to sleep." James had often written of evil. His relentlessly meandering stories of social and psychological entanglement offer a counterpart of sorts to Joseph Conrad's tales of political and economic corruption. Each prophesies the West's collapse into militarized chaos—or so it seems from our viewpoint now. Yet the war took James by surprise. As he wrote to a friend that August: "Black and hideous to me is the tragedy that gathers and I'm sick beyond cure to have lived on to see it. You and I, the ornaments of our generation, should have been spared this wreck of our belief that through the long years we had seen civilization grow and the worst become possible."[204] However we interpret the James of the major novels, he saw himself as an optimist—and now he despaired of civilization.

Sargent was in the Austrian Tyrol when hostilities began. Local authorities impounded his paintings and those of his companions, the Stokeses. Their friend Colonel Armstrong was placed under arrest. Armstrong was not jailed, but the entire party was refused permission to leave for England. They found lodging in the town of Colfuschg, settled in, and continued to paint. The region was filled with Austrian troops, some of them drunk and disorderly. According to Adrian Stokes: "Sargent's equanimity was disturbed by none of these things. He never grumbled, he never complained, but went out to work with what materials had been left him. . . . He seemed to regard the whole affair merely as an example of human folly."[205] During a stay at St. Lorenzen, another mountain village, the Stokeses received permission to leave. Sargent arrived in London only in December, after a trip to Vienna, where he managed to obtain a passport. The war changed from a mere inconvenience to a cause for sorrow when the husband of his niece Rose-Marie, and later Rose-Marie herself, were killed in France.

In May 1918 the prime minister, Lloyd George, formally requested that Sargent travel to the front as an official war artist. His assignment

291. *The Hermit (Il solitario)*, detail. See plate 316.

197

292

293

292. *Trout Stream in the Tyrol*, 1914. Oil on canvas, 22 x 28 inches. The Fine Arts Museums of San Francisco. Gift of the Isabella M. Cowell Estate.

293. *Graveyard in the Tyrol*, 1914. Watercolor on paper, 13⅝ x 20⅞ inches. British Museum, London.

294. *Rose-Marie Ormond*, 1912. Oil on canvas, 31½ x 23 inches. The Ormond Family.

295. *Tyrolese Crucifix*, c. 1911. Watercolor on paper, 20⅞ x 15½ inches. The Metropolitan Museum of Art, New York. Pulitzer Fund, 1915.

296. *Tyrolese Interior*, 1915. Oil on canvas, 28⅛ x 22 inches. The Metropolitan Museum of Art, New York. George A. Hearn Fund, 1915.

294

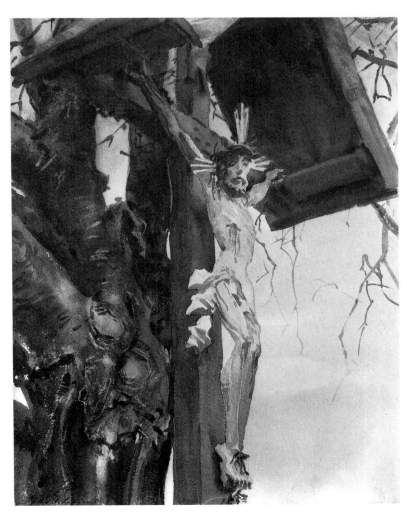

295

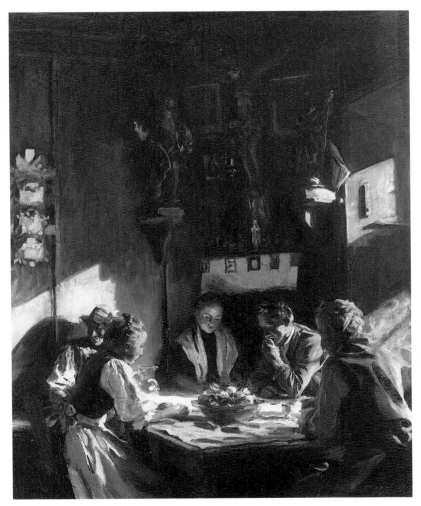

296

199

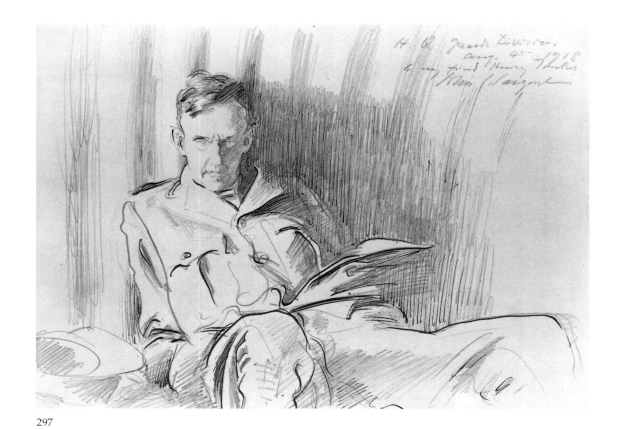

297

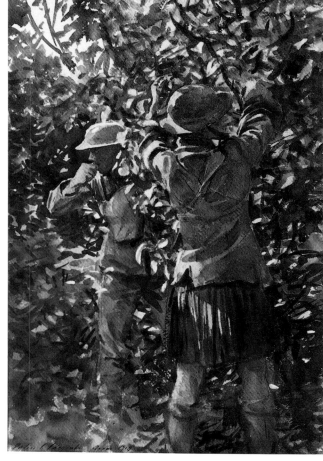

298

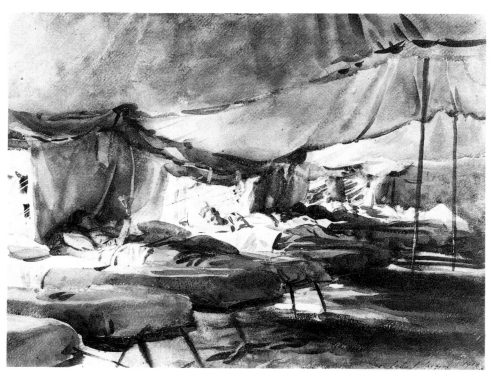

299

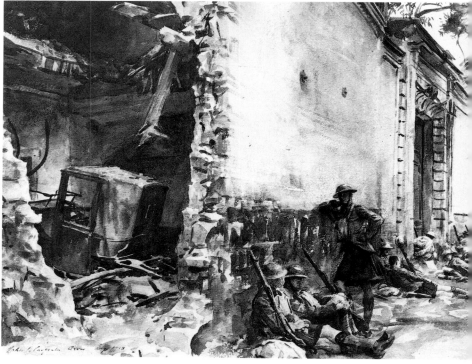

300

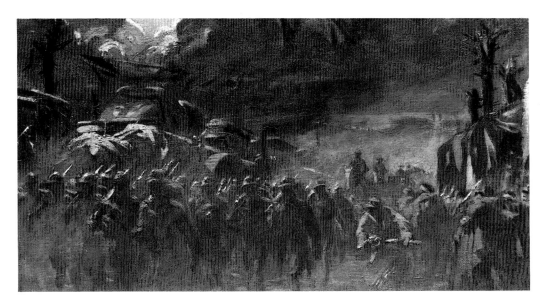

301

was to paint a large canvas memorializing the joint efforts of English and American troops. In June he set out for the western front with his friend, the artist and teacher Henry Tonks, who had volunteered for a similar assignment. They messed with General Geoffrey Fielding, commander of a British army division stationed twenty-five miles south of Arras. Fielding recalled that Sargent "was a delightful companion, and we all loved him. He used to talk the whole time, and there was always some competition to sit next to him. He took an enormous interest in everything going on, he discussed music, painting and every imaginable subject."[206] According to his friend Tonks,

> Sargent entered completely into the spirit of his surroundings. I don't think he ever grasped much about the military campaign in actual being, which is curious as he had in his library and had read with deep interest many books on the Napoleonic campaigns. I could never make him understand differences of rank, no not the most commonplace, so I gave up trying. Things which seemed the commonplaces of war surprised him as when he said to General Fielding one Sunday when the Band was playing "I suppose there is no fighting on Sundays." Sometimes I used to wonder if he knew how dangerous a shell might be, as he never showed the least sign of fear, he was merely annoyed if they burst near enough to shake him.[207]

297. *Henry Tonks*, 1918. Pencil and ink on paper, 9¾ x 14⅝ inches. Fitzwilliam Museum, Cambridge, England.

298. *"Thou Shalt Not Steal,"* 1918. Watercolor on paper, 21 x 13¼ inches. Imperial War Museum, London.

299. *The Interior of a Hospital Tent*, 1918. Watercolor on paper, 15½ x 20¾ inches. Imperial War Museum, London.

300. *A Street in Arras*, 1918. Watercolor on paper, 15½ x 20¾ inches. Imperial War Museum, London.

301. *The Road*, 1918. Oil on canvas, 15 x 29¼ inches. Museum of Fine Arts, Boston. Charles Henry Hayden Fund.

Protected from the sun by a large white umbrella, Sargent worked in much the same manner as he did in the Alps or on the canals of Venice. He made watercolors and oil sketches of soldiers stealing fruit (plate 298), soldiers in a hospital tent (plate 299), soldiers being led to a dressing station after an attack of poison gas. This last subject stayed with him. "The Ministery of War expects an epic," Sargent wrote to Evan Charteris, "and how can one do an epic without masses of men?"[208] He mentions several crowded frontline scenes, then comes back to "a harrowing sight, a field full of gassed and blindfolded men." By the

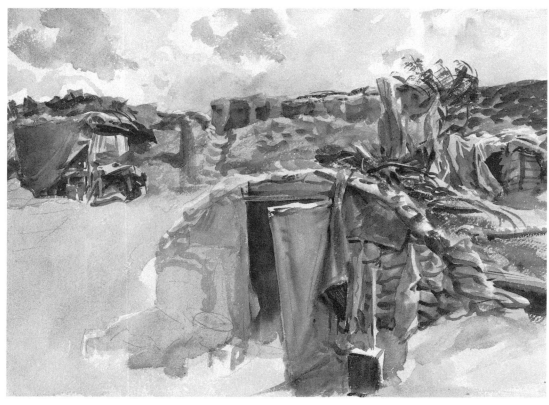

302

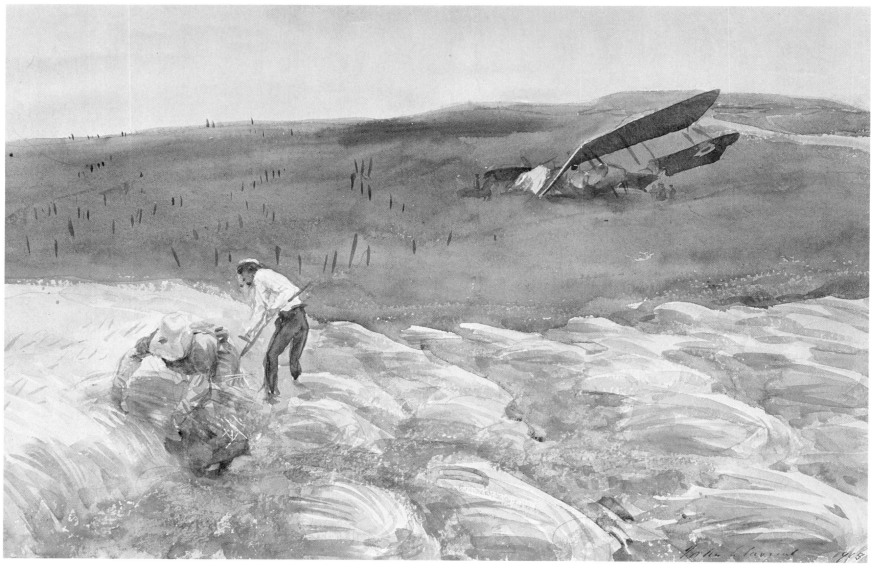

303

end of 1918 Sargent had turned this subject into a twenty-foot long painting, *Gassed* (plate 305).

Sargent brought to this large painting much of his experience with murals. At the Boston Public Library, a frieze of angels runs beneath *The Three Persons of the Blessed Trinity* (plate 199). There are eight of them, tightly confined within a long, narrow space. In *The Passing of Souls into Heaven* (plate 184), a line of similarly draped figures drifts more freely within the shape of the lunette. The *Frieze of the Prophets* (plates 201–5) is most to the point, however, for here Sargent gives pictorial life to a tight array of figures by means of gestures linking each to each—as in the line of wounded soldiers that stumbles from left to right in *Gassed*. Of all his mural subjects, the *Frieze of the Prophets* is the most fluently painted—in other words, it gives the strongest hints of those loose, elliptical sketches from which Sargent developed the image. In *Gassed*, too, the style of his sketches shows through—spikier now, less lush and graceful. Along the base of the painting there is a heap of those too wounded even to stumble, and another line of victims approaches from the far right-hand distance. Thus Sargent evokes the zone of trenches—"the farther forward one goes," he had written, "the more scattered and meagre everything is."[209] It is utterly desolate here, very far forward indeed. And yet it is nowhere, as well—an imaginary space, like that of a decorative frieze. Just as Sargent's Hebrew prophets stand as emblems outside the rules of ordinary perspective, so these soldiers wander in some unimaginable place—a place their cruel wounds, their blindness, permits them to see. The work touches on nightmare (there were reports of viewers fainting at the sight of this picture), yet the composition is put at a distance by the idealism that persists from its origin in the murals.

Sargent took up friezelike compositions in other major projects, but more and more dispiritedly. As Claude Phillips says of *Some General Officers of the Great War* (plate 307):

> We stand before this immense canvas wholly disconcerted by its pale, anaemic aspect, by the absence of vigor and accent that it betrays. There is nothing here of a living rhythm, no serious attempt at a caesura of the almost unbroken line of great military personages who, impassive—we had almost said disdainful—stand side by side yet isolated from one another, and from the spectator.[210]

Sargent's murals at the Widener Library of Harvard University show the forced enthusiasm—and even the facial types—of wartime propa-

302. *Dugout*, 1918. Watercolor on paper, 15⅜ x 20⅞ inches. The Metropolitan Museum of Art, New York. Gift of Mrs. Francis Ormond.

303. *Crashed Aeroplane*, 1918. Watercolor, pencil, and gouache on paper, 13½ x 21 inches. Imperial War Museum, London.

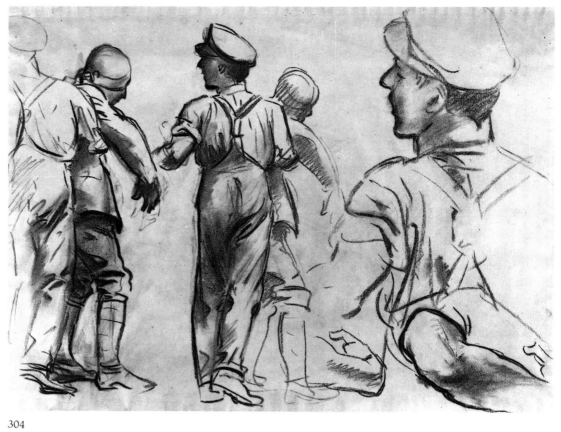

304

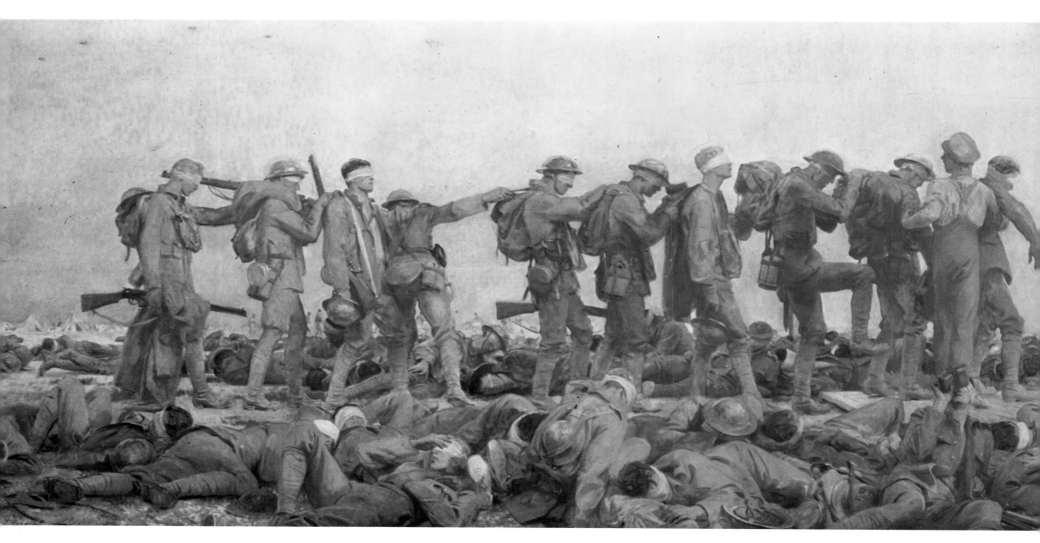

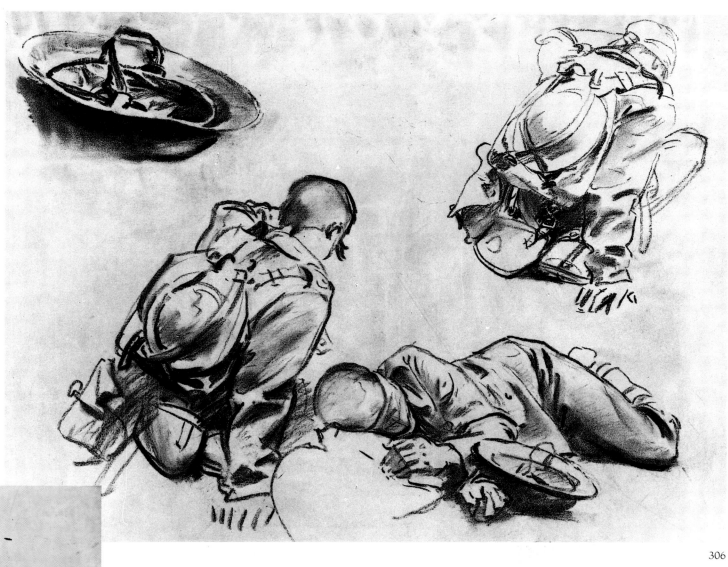

305

306

304. *Study for "Gassed,"* 1918–19. Charcoal on paper, 18½ x 24½ inches. The Ormond Family, on loan to the Imperial War Museum, London.

305. *Gassed*, 1918–19. Oil on canvas, 90½ x 240 inches. Imperial War Museum, London.

306. *Study for "Gassed,"* 1918–19. Charcoal on paper, 18¾ x 24½ inches. The Ormond Family, on loan to the Imperial War Museum, London.

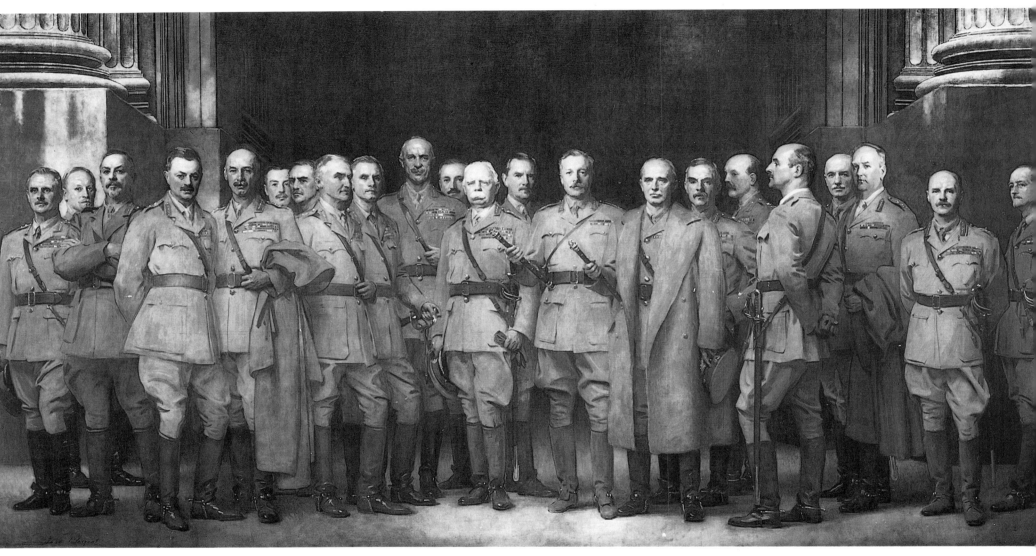

307

307. *Some General Officers of the Great War*, 1920–22. Oil on canvas, 118 x 208 inches. National Portrait Gallery, London.

308. *Death and Victory*, 1922. Oil on canvas. Stairway. Widener Library, Harvard University, Cambridge, Massachusetts.

309. *The Coming of the Americans to Europe*, 1922. Oil on canvas. Stairway. Widener Library, Harvard University, Cambridge, Massachusetts.

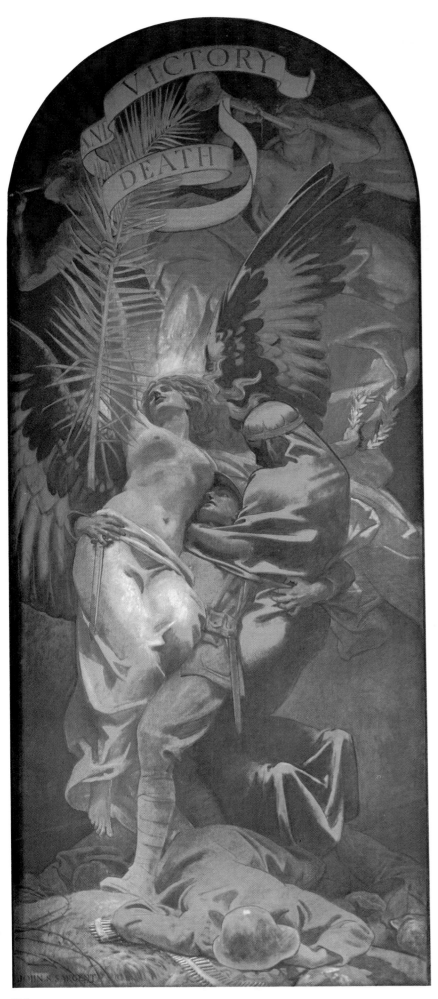

308

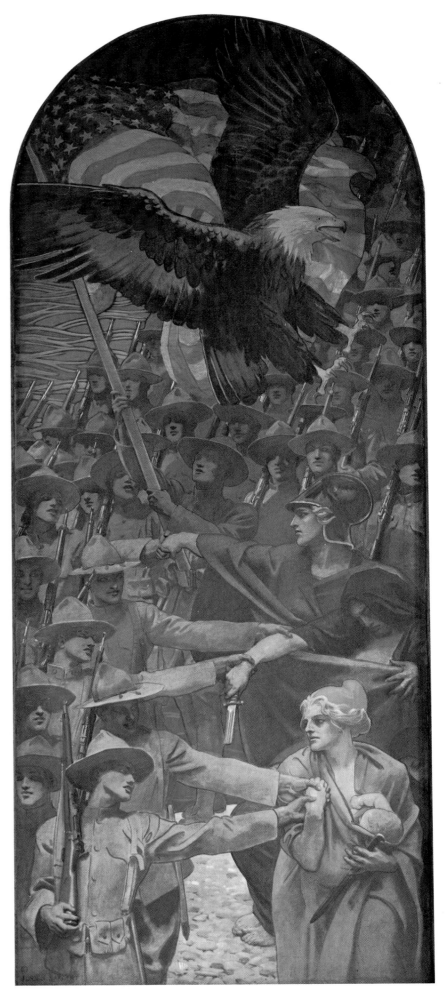

309

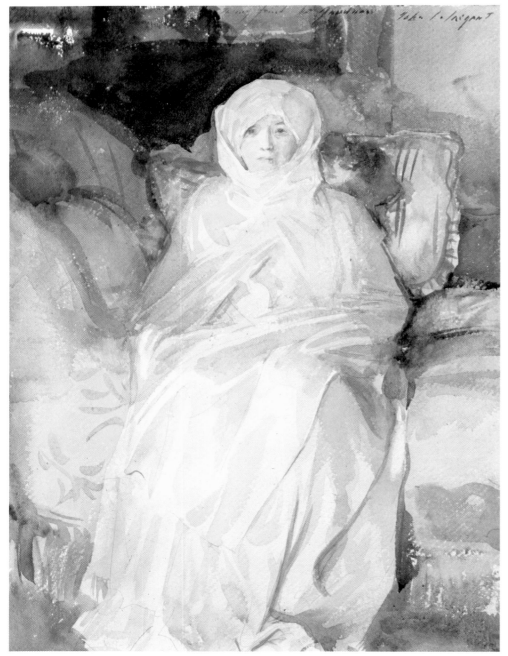

310

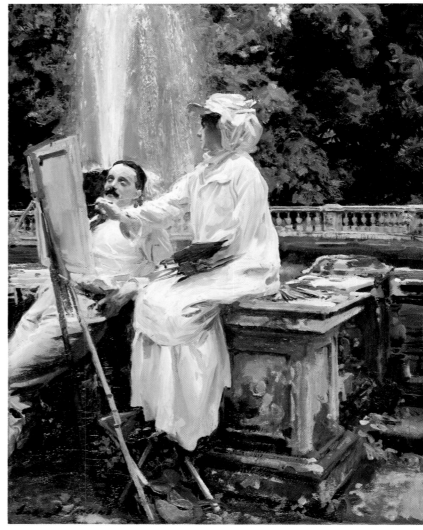

311

208

312

ganda. *The Coming of the Americans to Europe* (plate 309), unveiled in 1922, is filled with a company of doughboys in casual formation. As they stride into the foreground of the picture, several of them reach out to allegorical figures of the European allies. Michelangelo painted the distant ancestors of these robed presences, as of so many others in Sargent's mural cycles. But the soldiers, like the eagle poised above the scene, look as if they've just arrived from a tour of duty on a recruiting poster. Here Sargent blends the high-art mannerisms of the American Renaissance with the archetypes of popular culture. Then, in the left-hand Widener mural, he revives the Symbolist atmosphere that permeates the early stages of his Boston Public Library murals.

Death and Victory (plate 308) shows a stricken doughboy falling backward into the strained embrace of two figures—one a togaed female, the other a hooded, vaguely Middle Eastern male. She, of course, is Victory, and very much a femme fatale. He is Death, appropriately faceless and mysterious, and grimly attentive to the young soldier. Reminiscences of Astarte, Moloch, and the other pagan deities are faint but definite. Sargent has tried to engage the feelings in war's awesomeness, but in the attempt he has let his imagination get overwrought. At the same time, the properties of his American Renaissance style generalize his forms to an extreme degree. The result is a quasi-academic, quasi-Symbolist cartoon of patriotism and sacrifice. Sargent appears to have lost control, to have slipped into bathos.

By contrast, his late watercolor sketch of Isabella Stewart Gardner (plate 310) is all the more striking. Painted three years before *Death and Victory*, it is a flurry of whites and near whites laid down with even greater delicacy and confidence than the bright tones of *Fumée d'Ambre Gris*, 1880. Sargent may have meandered in his late murals and formal portraits, often losing ground, but in his landscapes and informal portraits he continued to advance. Comparatively few of his plein-air paintings were exhibited during Sargent's lifetime. Critics usually approved of them, given the opportunity, but the artist tended to stuff them away in drawers and racks. He did these paintings for himself, not for clients or the public. Over the seasons, they came to look like Sargent's way of mediating between himself and the world—to be in a place fully meant transposing it into paint.

Others appear in these images—the de Glehns, the Stokeses, Sargent's sisters, and Violet's daughters, Reine and Rose-Marie. Often they sleep or read. In *The Brook* (plate 313), painted at Purtud around 1907, Reine looks to the right, while Rose-Marie stares languidly out at

310. *Isabella Stewart Gardner*, 1922. Watercolor on paper, 16¾ x 12½ inches. Isabella Stewart Gardner Museum, Boston.

311. *The Fountain, Villa Torlonia, Frascati, Italy*, 1907. Oil on canvas, 28½ x 22 inches. The Art Institute of Chicago. Friends of American Art Gift.

312. *Figure and Pool*, 1917. Watercolor on paper, 13¾ x 21 inches. The Metropolitan Museum of Art, New York. Gift of Mrs. Francis Ormond, 1950.

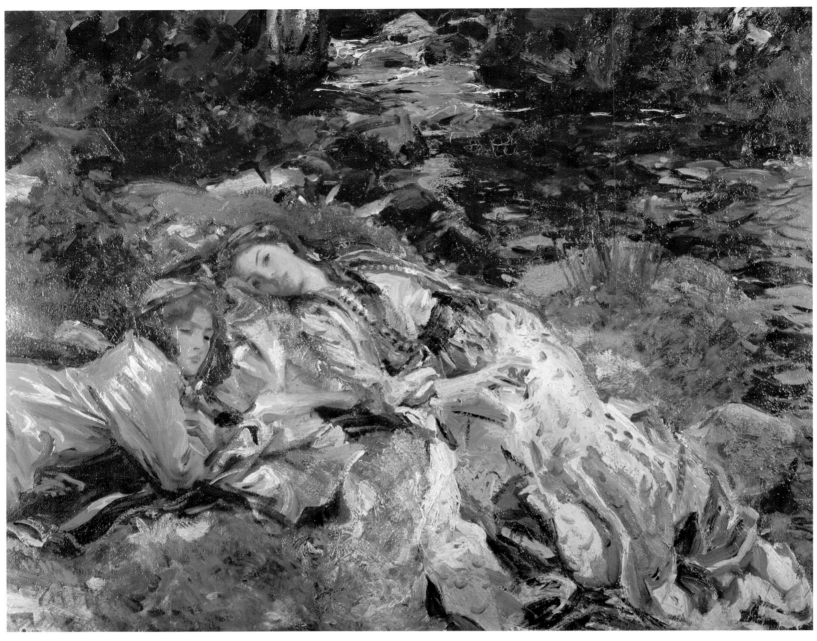

313

314

315

316

317

313. *The Brook*, c. 1907. Oil on canvas, 21 x 27½ inches. The Ormond Family.

314. *The Pink Dress*, 1912. Oil on canvas, 21¼ x 26 inches. The Ormond Family.

315. *Palmettos, Florida*, 1917. Watercolor on paper, 13½ x 20⅝ inches. The Metropolitan Museum of Art, New York. Gift of Mrs. Francis Ormond, 1950.

316. *The Hermit (Il solitario)*, 1908. Oil on canvas, 37¾ x 38 inches. The Metropolitan Museum of Art, New York. Rogers Fund, 1911.

317. *A Tramp*, after 1900. Watercolor on paper, 19¹¹⁄₁₆ x 13¹³⁄₁₆ inches. The Brooklyn Museum.

the viewer. They are aware of being seen, yet this doesn't pull them out of their immersion in the landscape where they lie. Sargent has not divided his image into sitters and backdrop. This is less an outdoor portrait than a web of landscape textures. The two girls are granted touches of personality, yet this serves, like their Turkish costumes, to blend them all the more fully into the sparkling mood of the scene.

The Hermit (plate 316), another painting from the Purtud summers, buries the human presence even more deeply in the play of light and color. Originally called *Il solitario*, its English title disturbed Sargent in one respect. "I wish," he said, "there were another simple word that did not bring with it any Christian association, and that rather suggested quietness or pantheism."[211] Sargent wanted his painting to be read as an image of the self given over completely to the natural world. The hermit is the sole human to be seen, but he is not alone. There are the deer and the exuberance of vegetable life. It would go too far to claim this as a covert self-portrait, yet during the last twenty years of his life Sargent, too, spent much of the day in the solitude of painting. The

318

320

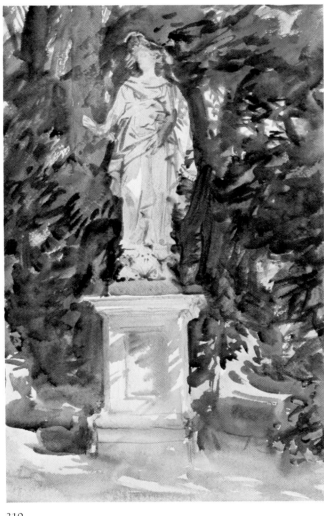

319

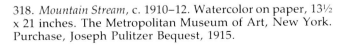

318. *Mountain Stream*, c. 1910–12. Watercolor on paper, 13½ x 21 inches. The Metropolitan Museum of Art, New York. Purchase, Joseph Pulitzer Bequest, 1915.

319. *Boboli*, 1907. Watercolor on paper, 18⅛ x 11⁷⁄₁₆ inches. The Brooklyn Museum.

320. *In the Generalife*, 1912. Watercolor on paper, 14¾ x 17⅞ inches. The Metropolitan Museum of Art, New York. Purchase, Joseph Pulitzer Bequest, 1915.

others who surrounded him, family and close friends, he came to treat more and more as aspects of landscape.

Manierre Dawson, an American painter with avant-garde ambitions, watched Sargent at work during this period. "Above all," he said, Sargent's "painting looks masterfully easy. But I notice one thing," he went on. "At the start of a painting he is very careful and then as it develops he lays on the paint with more freedom. When about done he looks at it with piercing eyes and making a stroke here and there, gives the whole a look of spontaneous dash. Although nine-tenths of the work is very careful indeed, there is a look of bold virtuosity when the work is done."[212] Dawson describes a solid tonal structure, of the kind Sargent mastered very early, overlaid by accents of high-keyed and fully saturated color. As at Broadway, Sargent continued later on to adapt Impressionism to his style of tonal painting. Between the late 1880s and the first years of this century, the pigment thickened in his formal portraiture. It did the same in his plein-air sketches, some of which are quite heavily laden. In his late watercolors, the broadness of his touch takes the place of piled-up paint.

When Sargent switched from oils to watercolors, he forced himself to compress his method drastically. This did not change his style so much as force it to further extremes of elegance. Watercolors are transparent, so it isn't possible to build a tonal structure with them, then lay down signs of spontaneity on top of it. Sargent's underlying structure had to be as sparkling, as freely brushed, as all his subsequent effects. Very often he managed this. *In the Generalife*, 1912 (plate 320), looks a bit

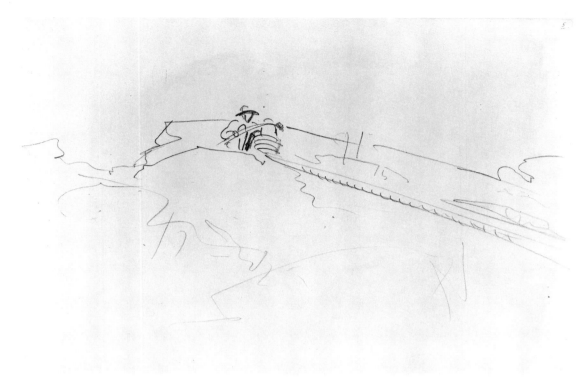

321

322

murky toward the right-hand side, but this is rare. More often, a complex texture sustains its brightness across the entire surface—as in *Mountain Stream* (plate 318). And *Boboli* (plate 319), from around 1907, makes a virtue of its muddy colors. Enough of their once bright constituents can be intuited for these dark passages to be read as luminous shadows.

During the autumn of 1911 Sargent set up his easel and umbrella at the quarries of Carrara. Working in oils and watercolors, he also filled a

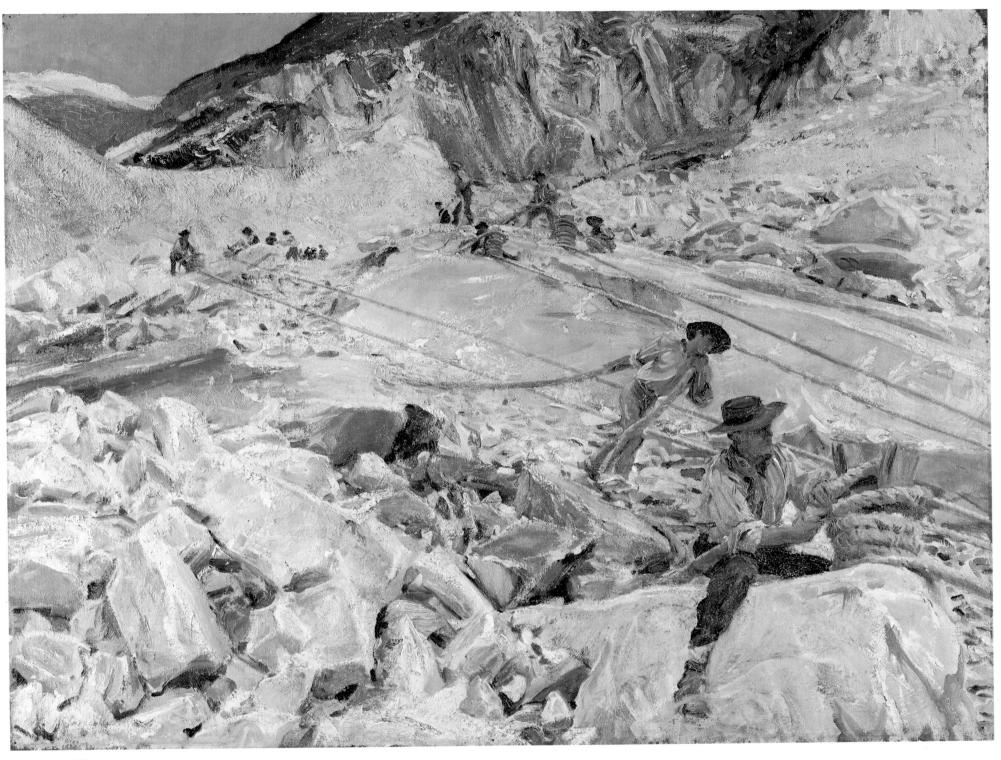

323

sketchbook with notes on rock formations, workmen's poses, and the apparatus used in quarrying. A friend of his once recalled how little "luxury or magnificence" the artist required on an expedition of this kind. At Carrara, Sargent "slept for weeks in a hut so completely devoid of all ordinary comforts that his companions, far younger men, fled after a few days, unable to stand the Spartan rigors tolerated by their senior with such serene indifference."[213] Sargent appreciated comfort, but even in the most trying circumstances, his complaints were

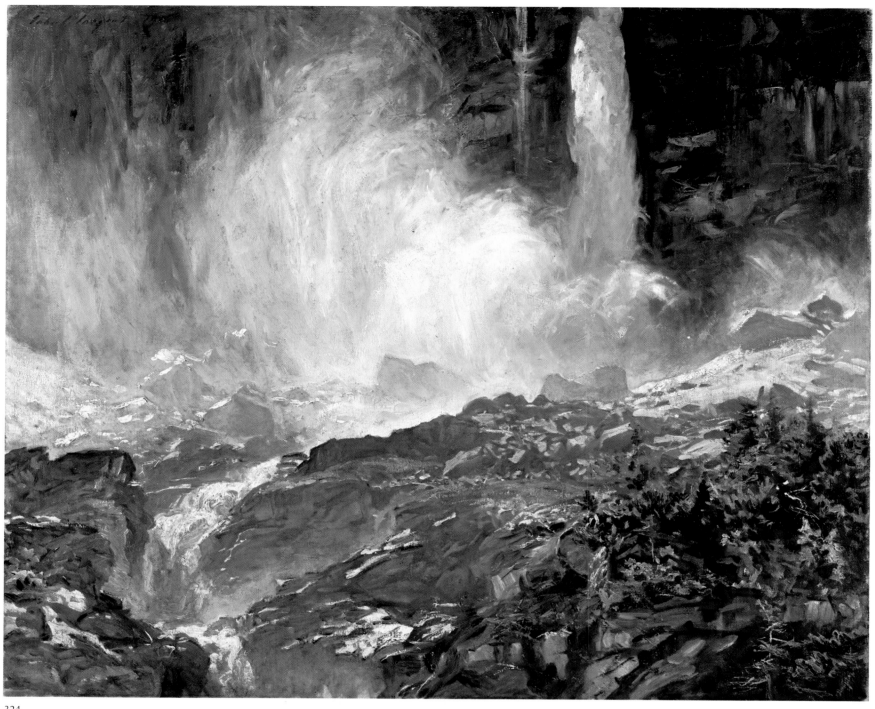

324

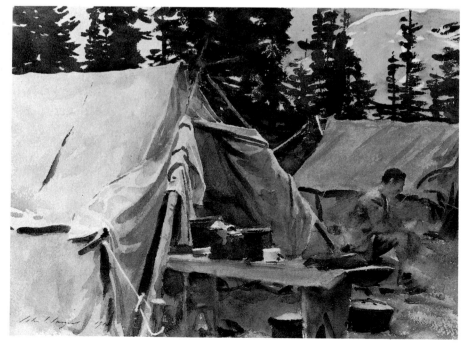

325

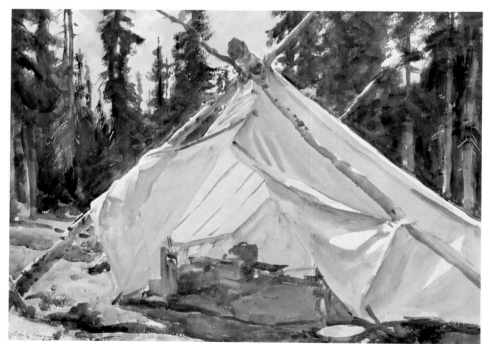

326

324. *Yoho Falls*, 1916. Oil on canvas, 37 x 44½ inches. Isabella Stewart Gardner Museum, Boston.

325. *Camp at Lake O'Hara*, 1916. Watercolor on paper, 15¾ x 21 inches. The Metropolitan Museum of Art, New York. Gift of Mrs. David Hecht, in memory of her son Victor D. Hecht, 1932.

326. *A Tent in the Rockies*, 1916. Watercolor on paper, 15½ x 21 inches. Isabella Stewart Gardner Museum, Boston.

327. *The Master and His Pupils*, 1914. Oil on canvas, 22 x 28 inches. Museum of Fine Arts, Boston. Charles Henry Hayden Fund.

330

328. *Statue of Perseus by Night*, c. 1907. Oil on canvas, 50¾ x 36⅜ inches. Santa Barbara Museum of Art, California. Gift of Mrs. Sterling Morton to the Preston Morton Collection.

329. *Cellini's "Perseus,"* n.d. Watercolor on paper, 14⅜ x 8¹⁵⁄₁₆ inches. National Gallery of Art, Washington, D.C. Gallatin Collection.

330. *Mountain Fire*, 1903–8. Watercolor on paper, 13¾ x 19¾ inches. The Brooklyn Museum. Special Subscription Fund.

329

good-humored. He visited the Rocky Mountains of British Columbia in the summer of 1916, a season of bad weather, as this letter to his cousin Mary Hale makes clear:

Dear Cousin Mary,

At the risk of importuning you with this persistent letter writing, here I go again. As I told you in my first letter or my last it was raining or snowing, my tent flooded, mushrooms sprouting in my boots, porcupines taking shelter in my clothes, canned food always fried in a black frying pan getting on my nerves, and a fine waterfall which was the attraction to the place pounding and thundering all night. I stood it for three weeks and yesterday came away with a repulsive picture. Now the weather has changed for the better and I am off again to try the simple life (ach pfui) in tents on the top of another valley, this time with a gridiron instead of a frying pan and a perforated India rubber mat to stand on. It takes time to learn how to be really happy.[214]

The pictures from Sargent's Carrara expedition are unusual in one respect—they lead the eye far into the background. Of course, the deep interiors, the narrow streets and canals of his Venetian paintings do the same, yet these city scenes usually bring vision to a halt against a far wall or a distant façade. At Carrara, nothing stood between Sargent's eye and the mountainous horizon. Space is potentially limitless here, as in any landscape, a condition that most of his outdoor imagery ignores. *Mountain Fire* (plate 330), painted some time in the century's first decade, drew Sargent's attention into the distances, though he focused chiefly on middle-ground effects of smoke and flame. There are few skies in any of his landscapes. Once when a friend asked him to paint a

331

333

favorite vista, he said, "I can't paint *vedutas*. I can paint objects; I can't paint *vedutas*."[215]

Sargent's watercolor of Benvenuto Cellini's *Perseus* (plate 329) sets this heroic figure afloat against a blank expanse, like an Apollo or a muse in the Boston Museum murals. Another *Perseus* (plate 328), rendered in oils, shows the statue from the side. This viewpoint permits Sargent to play human form off against the architectural details of the Loggia dei Lanzi, Florence, where Cellini's figure stands. It is night in Sargent's painting, a time of deep shadows and bright highlights on bronze surfaces, which leaves the figure and its setting all the more effectively joined.[216]

When Sargent said he could only paint objects, he might have added that his greatest power was to enmesh them in their immediate surroundings. That is why he had so little interest in vistas. In the art he made for himself, Sargent drew the visible close around him. Thus the prow of his own gondola often appears in his Venetian watercolors. At Purtud, especially, his landscapes are expanses of enveloping texture, woven from phenomenally acute perceptions of tone and color. Even in the Rocky Mountains, the scale of his pictures is often that of a drawing-room scene. Thus, little separates indoor from outdoor images done in Sargent's private style.

Although landscapes dominate the work of his late career, that period is best summed up by *Repose* of 1911 (plate 332), a sketch of the artist's niece Rose-Marie Ormond on a sofa. In Manet's *Repose* (plate 333), Berthe Morisot looks out with intense alertness, undercutting the restfulness of her pose. Further ironies lead the eye into Manet's play with tone, with space, with the ambiance of the setting. Sargent, by contrast, presents a young woman as withdrawn into her mood as he is into the act of painting her. Artist and subject seem present to each other on terms completely resolved by the setting they share. As Rose-Marie rests, Sargent offers an exemplary performance in his late style. The full repertoire of his brushstrokes appears in her satin skirt. The flow of tones creates a space as richly inflected and as intimate as a glade at Purtud. Tonal accents, though sparse, imply an entire palette. Sargent's command of his private style is so sure that he feels free to draw on the grandeurs of his formal manner. The resulting image presents all the crucial points in his lifelong argument that art can be a homeland as comforting as any other.

331. *Bridge of Sighs*, c. 1907. Watercolor on paper, 9⅞ x 13¾ inches. The Brooklyn Museum. Special Subscription Fund.

332. *Repose*, 1911. Oil on canvas, 25⅛ x 30 inches. National Gallery of Art, Washington, D.C. Gift of Curt H. Reisinger.

333. Edouard Manet. *Repose*, c. 1869–72. Oil on canvas, 58¼ x 43¾ inches. Museum of Art, Rhode Island School of Design, Providence. Bequest of Mrs. Edith Stuyvesant Vanderbilt Gerry.

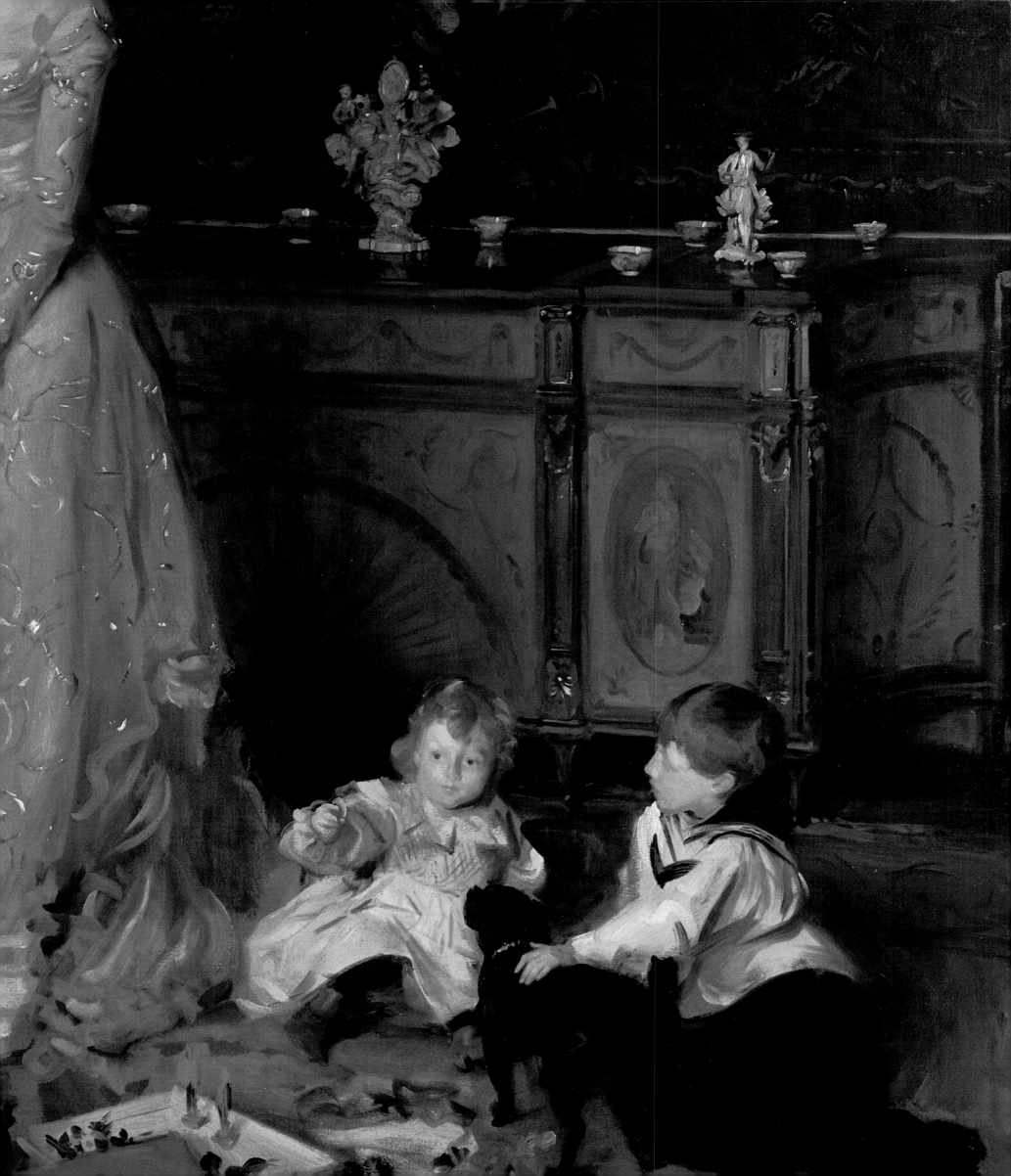

EPILOGUE: *The Sitwell Portrait*

Uring World War II, Sir Osbert Sitwell retired to Renishaw, his family's house in Derbyshire, to compose *Left Hand, Right Hand!*, a volume of memoirs.[217] Sitwell was then in his fifties. Though not as horrified as Henry James had been at the outbreak of the First World War, he was troubled enough to feel that the time had come to record what he knew of a way of life that was on the verge of profound change, no matter how the current conflict was resolved.

A long section of the memoir details the roundabout process by which Sir George Sitwell, Osbert's father, decided that Sargent should be commissioned to paint the family portrait (plate 336). What it comes down to is this: no other painter in England could be expected to carry out a creditable performance. And the picture had to be creditable, at the very least. Sir George wanted this portrait to be a pendant to the Sitwell group that John Singleton Copley had painted in 1787 (plate 335). Though the Sitwells greatly prized this earlier painting, critics had been dubious when Copley showed it at the Royal Academy. The previous year his entry had been *The Daughters of King George II*, which was disliked for its rococo flurries. Copley overadjusted in the Sitwell group, producing an orderly arrangement of Francis Hart Sitwell's children at play in a severely Neoclassical drawing room. The *Morning Post* denounced its "meretricious glare."[218] A century and a half later, Sir Osbert Sitwell calls it "sound in workmanship" and "true in color." Sargent was more impressed by the canvas. Since his picture was to be the same size and proportions as Copley's, he traveled to Renishaw for a look at it. On first sight he said, "I can never equal that." Sitwell felt that he never did.

The painter refused, in those days, to work on portraits outside his Tite Street studio. There were some exceptions, but this was not one of them. The Sitwells therefore had to ship to London all the family possessions they wanted to appear as props in the painting. Several of these were cumbersome, including a Louis XIV tapestry and a Chippendale commode. Yet the effort was worthwhile, Sir George thought, for this was an important event in the family's history. It even justified the expense of taking up lodging in London for the several months the multiple portrait would require.

334. *The Sitwell Family*, detail. See plate 336.

335

335. John Singleton Copley. *The Sitwell Children*, 1787. Oil on canvas, 61½ x 71 inches. Renishaw Hall, Derbyshire, England.

"I think Sargent must have liked children," says Osbert, who was eight years old at the time. Or "perhaps he only found them a pleasant change from the usual, more sophisticated occupants of his studio, public monuments of men, proconsuls and generals, grave and portentous mouths through whom spake spirits, the infinite army of the banal dead, or fashionable beauties, with psyches that resembled air balloons, inflated, light and highly coloured." Sitwell's satire of Sargent's clientele, mild and deft as it is, hints at a stubborn loyalty to traditions that the writer feels have been swamped by a froth of worldliness. Though his voice is aristocratic, what he says has similarities to Walter Sickert's left-leaning remarks about the "arrivists" among Sargent's sitters. Both Sickert and Sitwell felt dubious about a style of portraiture that, as they saw it, promoted cosmopolitan flair at the expense of stauncher virtues. According to Sitwell, the newly rich loved Sargent because "he showed them to be rich: looking at his portraits, they

understood at last *how* rich they really were. . . ." But this, in his view, has nothing to do with the Sitwell family, firmly rooted in the soil of Derbyshire for seven centuries. For Sir Osbert, the Sargent group is important chiefly for having produced a scene in the drama of his childhood.

In an attempt to quiet Osbert's brother, the two-year-old Sacheverell, Sargent would recite a limerick about "a Young Lady of Spain/Who often was sick in a train." This worked for short spells, though the painter eventually replaced the boy with a dummy, calling him in only when it came time to finish off details of the face. The rest of the family posed in shifts, according to a strict schedule. Sargent had the Sitwells at his disposal, though Osbert's father was inclined to treat the artist as a servant. This seemed natural to Sir George, who was an educated gentleman with firm opinions about art. He had, as well, problematic feelings about his daughter, Edith. Blithely aristocratic attitudes came together with fatherly vexations at a sitting where, as Osbert remembers it, Sir George

> pointed out to the painter that my sister's nose deviated slightly from the perpendicular, and hoped he would emphasize the flaw. This request much incensed Sargent, obviously a very kind and considerate man; and he showed plainly that he regarded this as no way in which to speak of her personal aspect in front of a very shy and supersensitive child of eleven. Perhaps, too, he may have already divined in her face and physique the germ of a remarkable and distinguished appearance which later was to appeal particularly to painters. At any rate, he made her nose straight in his canvas and my father's nose crooked, and absolutely refused to alter either of them, whatever my father might say. [219]

Sargent resisted the servant's role, very likely because it never occurred to him that Sir George expected him to play it.

When the portrait was done, Sargent put it on display in his studio. The most elderly and hidebound of the Sitwell family wondered why riding clothes and an evening gown would appear in the same picture. Why did Osbert's mother wear a hat with a transparent brim? Above all, they were nonplussed by the decision to call in an American painter. Sir Osbert, of course, has a full appreciation of the fact that Copley, author of the first Sitwell group, was a colonial American. So was Benjamin West, Copley's mentor and Joshua Reynolds's successor as president of the Royal Academy. Sargent belonged to an Anglo-American tradition that Sir Osbert is determined to admire. Yet he finds the

225

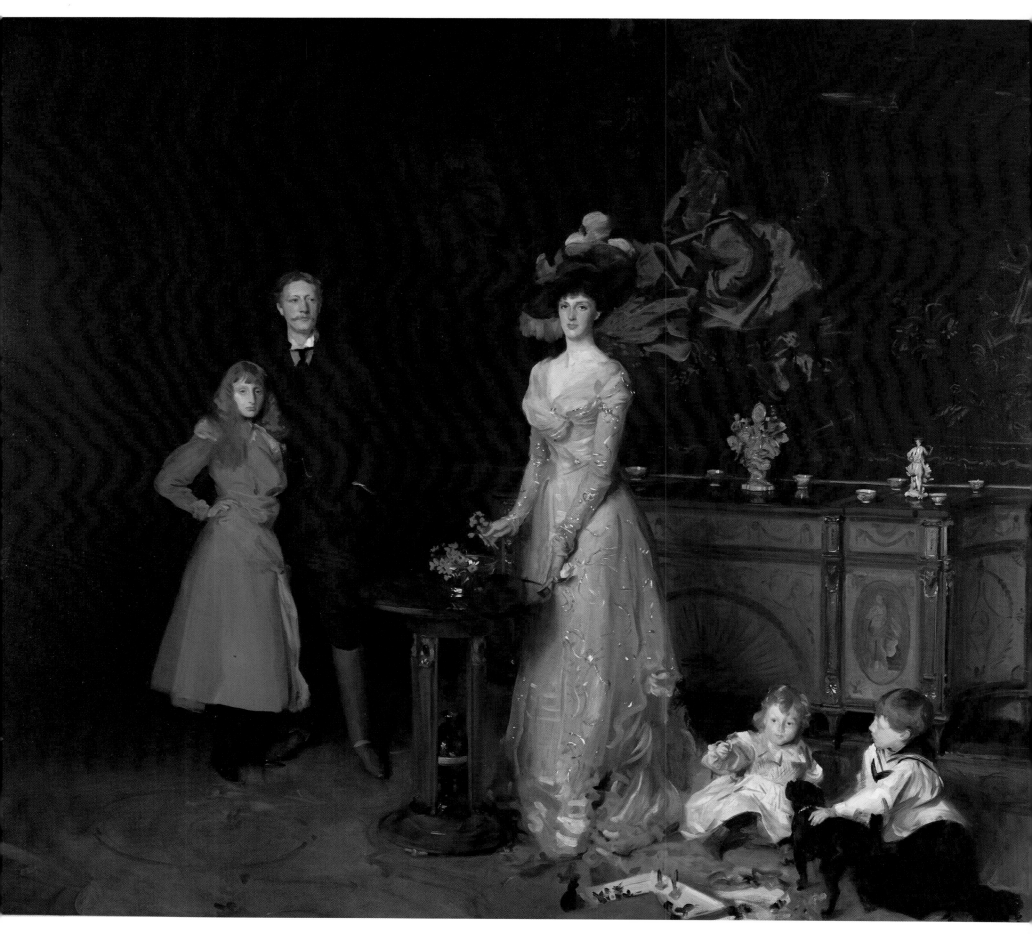

going difficult, for Sargent is, after all, "the painter of Pêche Melba, the artist who exalted this dish to the rank of an ideal."

In 1945 Osbert and Edith posed for the photographer Bill Brandt beneath the Sargent family portrait. The canvas makes an awkward backdrop, for the break between the grown-up Sitwells and their images as late Victorian children is distressingly sharp. All has changed, from clothes to the way of arranging a public expression on one's face. Brandt's photograph makes it look doubtful that the relentless sweep of nostalgia in *Left Hand, Right Hand!* has succeeded in bearing Sir Osbert back into the past. It is as if the Sargent picture can only be remembered, not seen first hand, though it hangs on the wall behind him. The portrait's meanings rest in part on assumptions of Anglo-American community, which, like all such assumptions, were growing doubtful in 1945. In fact, the cultural bonds between England and America had begun to fray at the time of Sargent's death. He was the last painter who counted as a major presence in the art worlds of both London and New York.

No portraitist would ever again have Sargent's success in adapting conventions designed for royalty to images of fashion and recent wealth. Further, Sargent was the last artist with a command of those pre-modern conventions to have links with the avant-garde. His virtuosity was a unifying force, and his paintings convinced many in his time that culture could be made whole. From the outset of his career to its end, however, modernism gathered strength. Since modernist culture enforces specialization, Sargent's syntheses fell into neglect soon after he died. The unity of his art, his grand sweep of form and feeling to decisive conclusions, looks innocent of our century's harshest pressures, no matter how complex, how "tense" in overtone his most ambitious portraiture might be. Like Henry James, Sargent seems not to have noticed that the avant-garde, as well as mass culture, was undermining those traditions of high art to which he was dedicated. Some critics, even in his own time, argued that he saw signs of these shifts and fissures but chose, out of fear, to ignore them or, with cynical calculation, to exploit them. As we've seen, Sargent was often anxious about the sensibilities of others, yet he was never fearful. He was a master of the politics of style, but never a cynic. No matter how complex, Sargent's stance was always straightforward as he labored to refine the present and revivify the past. He believed wholeheartedly that past and present could be joined, that art could be one with itself, and that life, too, could enter into the accord.

336. *The Sitwell Family*, 1900. Oil on canvas, 67 x 76 inches. Renishaw Hall, Derbyshire, England.

Notes

1. Henry James, *The Painter's Eye: Notes and Essays on the Pictorial Arts*, pp. 218–19.

2. Henry James, *Henry James Letters: 1883–1895*, ed. Leon Edel, vol. 3, p. 32.

3. Ibid., p. 43.

4. James Lomax and Richard Ormond, *John Singer Sargent and the Edwardian Age*, pp. 82–83.

5. Evan Charteris, *John Sargent*, p. 145.

6. Ibid.

7. Cecil Chard, "John S. Sargent, R.A.: The Work of a Great Portrait Painter," p. 647.

8. William Blake, *Complete Writings*, ed. Geoffrey Keynes (London: Oxford University Press, 1969), p. 456.

9. Violet Paget (Vernon Lee), "J.S.S.: In Memoriam," p. 254.

10. E. R. and J. Pennell, *The Whistler Journal*, p. 34.

11. Charles Merrill Mount, *John Singer Sargent: A Biography*. Mount includes among Sargent's possible lovers women as disparate as Mrs. Charles Hunter, the wife of a mining tycoon (p. 217 ff.), and La Carmencita (p. 165 ff.).

12. Trevor J. Fairbrother, "A Private Album: John Singer Sargent's Drawings of Nude Male Models," pp. 70–79.

13. Paget (Lee), "In Memoriam," p. 238.

14. Charteris, *Sargent*, p. 98.

15. Ibid., p. 12.

16. Ibid., p. 4.

17. Ibid., p. 5.

18. Mount, *Sargent*, p. 26.

19. Henry James, "The Pupil," p. 145.

20. Ibid., p. 169.

21. Charteris, *Sargent*, p. 4.

22. Ibid., pp. 19–20.

23. William A. Coffin, "Sargent and His Painting, with Special Reference to His Decorations in the Boston Public Library," p. 172.

24. Hamilton Minchin, "Some Early Recollections of Sargent," p. 736.

25. Coffin, "Sargent and His Painting," p. 172.

26. R. A. M. Stevenson, "J. S. Sargent," p. 66.

27. R. A. M. Stevenson, *Velazquez*, p. 147.

28. Charteris, *Sargent*, p. 22.

29. Emily Sargent to Vernon Lee, September 1877, in Richard Ormond, "John Singer Sargent and Vernon Lee," p. 162.

30. Charles Merrill Mount, "Carolus-Duran and the Development of Sargent," p. 386.

31. Dorothy Weir Young, *The Life and Letters of J. Alden Weir* (New Haven: Yale University Press, 1960), p. 50.

32. Charteris, *Sargent*, p. 47.

33. Charles Merrill Mount, "New Discoveries Illumine Sargent's Paris Career," p. 304.

34. Nelson C. White, *Abbott H. Thayer: Painter and Naturalist* (Hartford: Connecticut Printers, 1951), p. 159.

35. "The Royal Academy Exhibition," *Magazine of Art*, 1902, p. 358.

36. Charteris, *Sargent*, p. 50.

37. Ibid., p. 49.

38. Mount, *Sargent*, pp. 66–67.

39. Ibid., p. 68.

40. Charteris, *Sargent*, p. 55.

41. Violet Paget (Vernon Lee), *Letters*, ed. Irene Cooper Willis (privately printed, 1937); cited in Lomax and Ormond, *Edwardian Age*, p. 26.

42. Paget (Lee), "In Memoriam," p. 251. When the American-born painter Abbott H. Thayer saw Sargent's *Mrs. Fiske Warren and Her Daughter Rachel* (plate 248), he said that Sargent "knows more about values than any living painter." (White, *Thayer*, p. 231.) Thayer was especially qualified to make this judgment, having made a close study of the way birds employ contrasts of light and dark tones to camouflage themselves in foliage. At the outbreak of World War I, Thayer became obsessed with persuading the American and British military to apply the system of camouflage he had developed from his ornithological observations. On February 10, 1915, Thayer wrote to Col. Bernard James of the British War Office, recommending that his camouflage patterns be deployed at the front and suggesting that the War Office "secure John Sargent for that job or an equal valuist if there is one." (White, *Thayer*, p. 158.) Though Thayer's system was not adopted until the next world war, his view of Sargent's style is convincing. The web of light and texture in Sargent's landscapes owes much to a play of tone that recalls not only military camouflage but also the patterns by which birds and other creatures blend into their surroundings. See especially *The Brook* (plate 313).

43. Cited in Charteris, *Sargent*, p. 57.

44. James, *Painter's Eye*, pp. 220–21.

45. Olivier Merson, "Le Salon de 1882," p. 330.

46. "The Salon from an Englishman's Point of View," p. 217.

47. Victor Champier, "The Salon from a Frenchman's Point of View," p. 271.

48. Antonin Proust, "Le Salon de 1882," p. 551.

49. Anne Coffin Hanson, *Manet and the Modern Tradition* (New Haven and London: Yale University Press, 1979), p. 182.

50. George Heard Hamilton, *Manet and His Critics* (New York: W. W. Norton & Company, 1969), p. 134.

51. Ibid., p. 255.

52. Paget (Lee), *Letters*; cited in Lomax and Ormond, *Edwardian Age*, p. 30.

53. John Singer Sargent to Mrs. Daniel Sargent Curtis (December 4, 1882), Curtis family collection; cited in Richard Ormond, *John Singer Sargent: Paintings, Drawings, Watercolors*, p. 30.

54. Arthur Baignères, "Première exposition de la Société des Peintres et Sculpteurs," p. 190.

55. Henri Houssaye, "Le Salon de 1883," p. 616.

56. William H. Gerdts, "The Square Format and Proto-Modernism in American Painting," pp. 70–75.

57. Baignères, "Première exposition," p. 189.

58. Frederick A. Sweet, *Miss Mary Cassatt: Impressionist from Pennsylvania* (Norman: University of Oklahoma Press, 1966), pp. 151, 196.

59. Charteris, *Sargent*, p. 59.

60. Ibid.

61. Ibid.

62. Mount, "Carolus-Duran," p. 398.

63. Charteris, *Sargent*, pp. 59–60.

64. Ibid., p. 61.

65. Ibid., pp. 61–62.

66. Louis de Fourcaud, "Le Salon de 1884," p. 483.

67. Henri Houssaye, "Le Salon de 1884," p. 589.

68. Charteris, *Sargent*, fn., p. 62.

69. Ibid., p. 62.

70. André Michel, "Le Salon de 1884," p. 14.

71. Fourcaud, "Le Salon de 1884," pp. 483–84.

72. John Singer Sargent to Vernon Lee, 1884; cited in Ormond, *Colby*, p. 175.

73. "The Exhibition at the Royal Academy," p. 242.

74. "Fine Arts: The Royal Academy," 1884, p. 798.

75. "The Salon. II," p. 427.

76. William Sharp, "The Paris Salon," pp. 179–80.

77. Charteris, *Sargent*, p. 66.

78. "The Salon, Paris," p. 702.

79. Edmund Gosse, in Henry James, *The Letters of Henry James*, ed. Percy Lubbock, vol. 1, p. 88.

80. Charteris, *Sargent*, p. 78.

81. Ibid., p. 77.

82. Ibid.

83. Ibid., pp. 74–75.

84. Paget (Lee), *Letters*; cited in Lomax and Ormond, *Edwardian Age*, p. 36.

85. Ormond, *Sargent*, p. 39.

86. Charteris, *Sargent*, p. 80.

87. "The Salon, Paris," p. 702.

88. Charteris, *Sargent*, p. 75.

89. James, *Letters*, ed. Leon Edel, vol. 3, pp. 117–18.

90. "Art: Royal Academy," 1886, p. 580.

91. Ibid.

92. "Fine Arts: The Royal Academy," 1886, p. 786.

93. Ibid.

94. Charteris, *Sargent*, p. 95.

95. Ibid.

96. "The New English Art Club," pp. 158–59.

97. "Art: Royal Academy," 1887, p. 591.

98. "Fine Arts: The Royal Academy," 1887, p. 580.

99. "Art Chronicle," May 1887, p. 104.

100. "Art Chronicle," June 1887, p. 125.

101. Claude Phillips, cited in William Howe Downes, *John S. Sargent: His Life and Work*, p. 140.

102. "The Royal Academy Exhibition," p. 248.

103. Ibid., p. 247.

104. "Current Art—IV," p. 383.

105. Lomax and Ormond state that Sargent painted with Monet at Giverny in 1887 (*Edwardian Age*, p. 37). Charteris puts the date in 1888 (*Sargent*, p. 133). According to Mount (*Sargent*, p. 153) and John Rewald (*The History of Impressionism*, p. 551), Sargent joined Monet at Giverny in the summer of 1889. In any case, Sargent was always a fervent admirer of the older artist. Daniel Wildenstein (*Claude Monet: Biographie et catalogue raisonné*, 3 vols. [Lausanne and Paris: Bibliothèque des Arts, 1974–79]) records Sargent as the purchaser of four of Monet's canvases: *Maison de Jardinier*, 1884 (Wildenstein, *Monet*, vol. 2, p. 118); *Bennecourt*, 1887 (*Monet*, vol. 3, p. 88); *Paysage avec figures*, 1888 (*Monet*, vol. 3, p. 114); and *Vaques à La Manneport* (*Monet*, vol. 2, p. 178). The last of these paintings was auctioned at the Sargent sale (London, July 27, 1925) under the title *A Rock at Tréport*. This seems to be the painting to which Sargent refers in a letter he wrote (in French) to Monet sometime before departing for the United States on September 17, 1887. As translated in Charteris, *Sargent*, p. 97, the letter reads as follows:

> My dear Monet,
> It is with great difficulty that I tear myself away from your delicious painting for which "you do not share my admiration" (what a joke!) to tell you how much I admire it. I could spend hour after hour in front of this canvas in a state of voluptuous stupefaction—or enchantment, if you prefer. I am stunned to have such a source of pleasure in my possession. . . .

106. Greta, "Art in Boston: The Sargent Portrait Exhibition, etc.," p. 110.

107. Ibid.

108. W. Graham Robertson, *Life Was Worth Living*, p. 233.

109. Charteris, *Sargent*, p. 246.

110. "The New Gallery: Second and Concluding Note," p. 669.

111. "Current Art: The New Gallery," p. 290.

112. Downes, *Sargent*, p. 152.

113. René Gimpel, *Diary of an Art Dealer* (New York: Farrar, Straus and Giroux, 1966), p. 75.

114. Robertson, *Life Was Worth Living*, p. 245.

115. Mariana Griswold van Rensselaer, "Another Portrait by Sargent," p. 1012.

116. Charteris, *Sargent*, pp. 109–10.

117. Edwin H. Blashfield, *Mural Painting in America*, pp. 175–76.

118. Downes, *Sargent*, p. 166.

119. E. V. Lucas, *Edwin Austin Abbey, Royal Academician: The Record of His Life and Work*, vol. 2, p. 381.

120. Charles F. McKim, "Memoranda to Mrs. Wharton," c. February 2, 1897, McKim Collection, Library of Congress, Washington, D.C.; cited in Richard Guy Wilson, et al., *The American Renaissance: 1876–1917*, p. 61.

121. Charles H. Caffin, *The Story of American Painting*, p. 123.

122. Stanley Weintraub, *Whistler: A Biography* (New York: Weybright and Talley, 1974), p. 372.

123. Mount, *Sargent*, pp. 179–80.

124. "The Royal Academy," p. 494.

125. Charteris, *Sargent*, p. 144.

126. Ibid., p. 207.

127. H. Hamilton Fyfe, "Mr. Sargent at the Royal Academy," p. 1024.

128. E. R. and J. Pennell, *Whistler Journal*, p. 35.

129. Charles H. Caffin, *How To Study Pictures*, p. 450.

130. Ibid., p. 428.

131. Violet Paget (Vernon Lee), "Imagination in Modern Art: Random Notes on Whistler, Sargent and Besnard," p. 516.

132. Preserved Smith, "Sargent's New Mural Decorations," p. 381.

133. Ormond, *Sargent*, p. 94.

134. "The New Gallery," *Athenaeum*, 1891, p. 610.

135. "The New Gallery," *Magazine of Art*, 1891, pp. 261–62.

136. "The Royal Academy (First Notice)," p. 577.

137. Downes, *Sargent*, p. 161.

138. Walter Armstrong, "The Royal Academy," p. 461.

139. Charteris, *Sargent*, p. 113.

140. Lomax and Ormond, *Edwardian Age*, p. 56.

141. Charteris, *Sargent*, p. 153.

142. Ibid.

143. "The Royal Academy Exhibition.—II," p. 281.

144. Charteris, *Sargent*, p. 158.

145. Lady Diana Cooper reported that Sargent's mutterings were strange and incomprehensible. (Lomax and Ormond, *Edwardian Age*, p. 87.) The Duke of Portland found them strange, too, but identifiable as "Spanish oaths." (John Portland, *Men, Women, and Things*, p. 219.) Richard Ormond says the painter "rushed bull-like at his canvas, spluttering and gasping, and muttering imprecations and incantations to himself in the throes of creation. 'Demons!,' repeated several times, was a favorite expression." (*Sargent*, p. 56.) Joseph Pulitzer's secretary, Norman G. Thwaites, reported no odd noises during Pulitzer's sessions with Sargent, though he did write that the painter "worked at a great pace, advancing upon his canvas and retiring much in the manner of a boxer sparring for an opening. Always he smoked cigarettes without a pause. . . . (Norman G. Thwaites, *Velvet and Vinegar* [London: Grayson & Grayson, 1932], p. 55.) Charteris describes a sitting of 1902 during which the painter was heard to say to himself: "'Gainsborough would have done it! . . . Gainsborough would have done it!'" (*Sargent*, p. 158.) I. N. P. Stokes thought he heard "'pish-tash; pish-tash!'" each time Sargent touched the canvas with his brush. (Isaac Newton Phelps Stokes, *Random Recollections of a Happy Life*, p. 115.) Sargent's varied mutterings suggest that the act of putting paint on canvas was somehow not entirely satisfying in itself. Every brushstroke required verbal accompaniment, sometimes a nonsense phrase, sometimes not. In any case, the atmosphere of ritual necessity was strong.

146. John Singer Sargent to Ada Rehan [1894], Folger Shakespeare Library, Washington, D.C.

147. John Singer Sargent to Isabella Stewart Gardner, August 18 [1894], Isabella Stewart Gardner Museum, Boston, microfilm 408, Archives of American Art.

148. Portland, *Men, Women, and Things*, pp. 219–20.

149. Doreen Bolger Burke, *American Paintings in the Metropolitan Museum of Art*, ed. Kathleen Lurhs (New York: Metropolitan Museum of Art, 1980), vol. 3, p. 248.

150. Ibid., p. 250.

151. "The Society of American Artists' Exhibition," p. 220.

152. Ormond, *Sargent*, p. 53.

153. "The Royal Academy: Fifth Notice," p. 846.

154. James, *The Painter's Eye*, p. 257. In this same passage James says that Mrs. Meyer's "type is markedly Jewish" and that her children have "shy olive faces, Jewish to a quaint orientalism, faces quite to peep out of the lattice or the curtains of closed seraglio or palanquin." James may or may not be permitting himself a hint of anti-Semitism here. In Sargent's time, remarks about social, cultural, and racial "types" were not considered outside the limits of polite commentary on art.

Mariana Griswold van Rensselaer, an extremely proper and determinedly tolerant critic, said that Sargent was "impartial, catholic. Whoever was visibly of one country or another so reappears on Sargent's canvas—his aristocratic Englishwomen, his Jews, as in the Wertheimer pictures, his Spanish Carmencita, his Parisian Madame Gautreau, and his Americans of many kinds including . . . our naively theatric, pseudo-Gallic painter Chase." What, she goes on, would Sargent's Spanish contemporary Ignacio "Zuloaga have made of a Miss Burckhardt or a John Rockefeller or a Miss Thomas of Bryn Mawr? What would an ingrained Englishman Sir Joshua have done with a Betty or an Asher Wertheimer?" (Mariana Griswold van Rensselaer, "John Singer Sargent: 1856–1925," pp. xviii–xix.)

These comments are intended to be liberal, though they may betray a condescending attitude toward nearly everyone outside Mrs. van Rensselaer's immediate circle. Henry Adams, by contrast, was consciously a bigot and took no pains to hide the fact. In 1895 he wrote: "But now we all go to the Royal Academy to see Sargent's portrait of Mrs. Mayer [sic] and her two children. Mrs. Mayer is a sprightly Jewess, who did us the favor of standing under her portrait on the private opening day to show us she was as good as her picture. The art of portrait-painting of Jewesses and their children may be varied but cannot be further perfected." (Henry Adams, *Henry Adams and His Friends: A Collection of His Unpublished Letters*, edited, with a biographical introduction, by Harold Dean Cater [Boston: Houghton Mifflin Company, 1947], p. 404.) *The Spectator's* reviewer said that the Meyer portrait shows its subjects "all dressed in great splendor and with an air of *haute finance* . . . Even Mr. Sargent's skill has not succeeded in making attractive these over-civilised European Orientals. We feel these people must go to bed in satin and live on ices and wafer bisquits." ("The Academy—II," p. 731.)

Sargent's own attitudes were quite different. According to the painter William Rothenstein, "In London [Sargent's] warmest admirers were the wealthy Jews. But it would be a mistake to suppose

that Sargent preferred the aristocratic to the Jewish type, that he painted Jews because they happened to be his chief clients. On the contrary, he admired, and thoroughly enjoyed painting, the energetic features of the men and the exotic beauty of the women of the Semitic race. He urged me to paint Jews, as being at once the most interesting models and the most reliable patrons. (William Rothenstein, *Men and Memories*, vol. 1 of 3 [London: Faber and Faber, 1931], p. 195.)

155. Ibid., p. 228.

156. Ormond, *Sargent*, p. 56.

157. H.S., "Art: The New Gallery," p. 625.

158. Ibid.

159. Robert Ross, "The Wertheimer Sargents," p. 7.

160. Marion Hepworth Dixon, "Mr. John S. Sargent as a Portrait Painter," p. 119.

161. James, *The Painter's Eye*, pp. 115, 223.

162. Lomax and Ormond, *Edwardian Age*, p. 35.

163. Robert Clermont Witt, *How to Look at Pictures*, p. 147.

164. Claude Phillips, "Fine Art: The Royal Academy," p. 471.

165. R. H. Wilenski, *Modern French Painters: 1863–1903*, vol. 1 of 2 (New York: Vintage Books, 1960), p. 160.

166. Rothenstein, *Men and Memories*, vol. 1, p. 194.

167. Camille Pissarro, *Letters to His Son Lucien*, ed. John Rewald with Lucien Pissarro (New York: Pantheon Books, 1943), p. 183.

168. Camille Pissarro, "Letters to Durand-Ruel," in *Impressionism and Post-Impressionism 1874–1904*, ed. Linda Nochlin (Englewood Cliffs, N.J.: Prentice-Hall, 1966), p. 55.

169. Sweet, *Mary Cassatt*, p. 196.

170. Roger Fry, "J. S. Sargent," in *Transformations*, p. 178.

171. Ibid., p. 181.

172. Ibid., pp. 169–70.

173. Ibid., p. 180.

174. Rothenstein, *Men and Memories*, vol. 1, p. 190.

175. Stevenson, "Sargent," pp. 66–68.

176. A. L. Baldry, "The Art of J. S. Sargent, R.A.: Part I," p. 9.

177. H.S. "The Vandyck Exhibition at the Academy," *Spectator* 84, no. 3732 (January 6, 1900): 18–19; H.S. "Art: The Academy.—I," May 5, 1900, pp. 631–32.

178. Downes, *Sargent*, p. 189.

179. Ibid.

180. Grace Irwin, *Trail-Blazers of American Art*, p. 186.

181. Portland, *Men, Women, and Things*, p. 220.

182. For Cecil Chard, Sargent's portrait subjects are more alive than the gallery-goers who come to look at them. Compared to Sargent's "powerful and stirring representations drawn from every class of modern society," he wrote, "the living people who pass before [these paintings] are shadowy and unreal." (Cecil Chard, "John S. Sargent, R.A.: The Work of a Great Portrait Painter," p. 651.) For Chard, Sargent's "exaggeration of vitality" was so great that it drained the life from its admirers, a vampirish effect to which the writer did not object. H.S. was more alarmed, saying in 1899 that "The power wielded by the painter of this portrait [Sargent's *Lady Faudell-Phillips*] has something terrible about it." (H.S., "The Academy—I." [May 6, 1899], p. 641.) In 1906 Christian Brinton claimed that the magical vitality of Sargent's images was unprecedented. Velázquez's portrait subjects are stationary, as are the liveliest of Gainsborough's, "but here in Sargent's portraits are women about to start suddenly from their chairs and men on the very point of speaking." *La Carmencita*'s "yellow skirt still swirls with elastic movement." (Christian Brinton, "Sargent and His Art," p. 281.) This is hyperbole in the service of an eager desire to believe that the greatest art is nothing more or less than life in a heightened condition, and that Sargent had the supernatural secret of such greatness. Sargent knew very well that painting depends not on magic but on a cluster of pictorial conventions. Part of his disgust with portrait painting must surely have originated in his impatience with those whose refusal to see his art as the product of an ordinary aesthetic intention rendered them incapable of distinguishing his ambitious from his perfunctory efforts. Nothing bores an artist more thoroughly than an audience that accepts nearly anything he does.

183. Max Beerbohm, *Max Beerbohm's Letters to Reggie Turner*, ed. Rupert Hart-Davis (Philadelphia and New York: J. P. Lippincott Company, 1965), p. 232.

184. Walter Sickert, "Encouragement for Art," p. 4.

185. Walter Sickert, "Sargentolatry," p. 57.

186. Ibid.

187. Ibid., p. 56.

188. Martin Birnbaum, *John Singer Sargent: A Conversation Piece*, pp. 41–42.

189. Lomax and Ormond, *Edwardian Age*, p. 67.

190. Kenyon Cox, *Old Masters and New: Essays in Art Criticism*, p. 264.

191. Charteris, *Sargent*, p. 157.

192. Minchin, "Some Early Recollections," p. 739.

193. Charteris, *Sargent*, p. 172.

194. Chard, "John S. Sargent," p. 643.

195. Lomax and Ormond, *Edwardian Age*, p. 71.

196. Ibid., pp. 77–78.

197. Frederick W. Coburn, "The Sargent Decorations in the Boston Public Library," p. 136.

198. Charteris, *Sargent*, p. 155.

199. Ibid., p. 172.

200. James, *Letters*, ed. Lubbock, vol. 2, p. 316.

201. Ibid.

202. Ibid., p. 318.

203. On May 4, 1914, the portrait of Henry James was attacked by a scissors-wielding suffragette. Though the canvas was immediately repaired, traces of the damage are still visible. James became the target of this assault not for his writing but because Sargent's picture of him presented such an overbearing image of male authority. See "Suffragette Butchery of Art," *Literary Digest* 48 (June 13, 1914): 1434.

204. Leon Edel, *Henry James: The Master: 1901–1916* (New York: Avon Books, 1978), p. 512.

205. Adrian Stokes, "John Singer Sargent, R.A., R.W.S.," p. 58.

206. Charteris, *Sargent*, p. 211.

207. Ibid.

208. Ibid., p. 214.

209. Ibid.

210. Downes, *Sargent*, p. 256.

211. John Singer Sargent to Edward Robinson, March 16, 1911, copy in Metropolitan Museum of Art Archives, New York.

212. Manierre Dawson Journal, September 26, 1910, 64, Archives of American Art, New York.

213. Memories of Sargent by a Friend," p. 446.

214. Charteris, *Sargent*, pp. 204–5.

215. Donelson F. Hoopes, *Sargent Watercolors*, p. 42.

216. Commenting on Sargent's late plein-air paintings, Evan Charteris says that "olive and ilex, fountain and statue, sunlight and shade, rocks and running water were to him just problems of form and color, opportunities for the exercise of his supreme craftsmanship rather than settings for moods induced by association or reflection." (*Sargent*, p. 171.) This inaccurately ascribes to Sargent a detachment more characteristic of painters in the modernist tradition, though Charteris's misinterpretation is understandable. For the most part, Sargent's landscapes convey no mood in particular, rather a general feeling of serene attentiveness. Immersed in pleasant surroundings, Sargent seems to have taken no note of literary associations, engaged in no meditative reflections. There appear to be two exceptions to this, both provided by the statuary Charteris lists among Sargent's favorite subjects. The first of these is a statue of Daphne in the gardens of the Villa Colodi, near Lucci. The second is Cellini's figure of Perseus holding aloft the head of Medusa, which stands in the courtyard of the Loggia dei Lanzi, Florence (plates 328 and 329). A second watercolor of this *Perseus* is reproduced in *The Sargent Exhibition: 1926*, p. 106; see also *Perseus on Pegasus Slaying Medusa* (plate 229), one of the stairwell decorations at the Boston Museum of Fine Arts. A watercolor of the Daphne statue is reproduced in *The Sargent Exhibition*, p. 62, and in Rensselaer, *Memorial Exhibition*, watercolors: fig. 14. The daughter of a river god, Daphne fled the loving pursuit of Apollo. When she saw that he was overtaking her, Daphne prayed to Zeus to be turned into a laurel tree. Zeus granted her wish, thus providing Western art with an abiding image of the self united with the natural world. The myth's fascination for Sargent might have been manifold, for he could see himself as Zeus, capable of blending human forms with those of foliage and river bank; as Apollo (the god who dominates the rotunda murals), whose pursuit of open-air subjects precipitates such a blending; and, insofar as Sargent identified himself with the unities effected by his art, he could also imagine his own presence as Daphne-like, joined seamlessly to landscape. Sargent's interest in Perseus, slayer of Medusa, might have been that of a portrait painter who had come to feel that the gaze of his sitters, like that of the snake-haired monster, was lethal. Moreover, Sargent's life was powerfully affected by his mother and his sister Emily. A lifelong bachelor, he may have admired Perseus's decisive way with strong females.

217. Osbert Sitwell, *Left Hand, Right Hand!*, pp. 246–92.

218. *Morning Post*, London, May 16, 1786; cited by Jules David Prown, *John Singleton Copley in England: 1774–1815*, vol. 2 of 2 (Cambridge: Harvard University Press for the National Gallery of Art, Washington, D.C., 1966), p. 319.

219. Sitwell, *Left Hand, Right Hand!*, p. 266.

Selected Writings on Sargent

SARGENTOLATRY

By Walter Sickert

I DOUBT if anyone can be as much surprised and amused as Mr. Sargent himself—I have no authority for saying so—at the prostration before him and all his works that has been the attitude of the English press for the last decade or so. Where there is real poverty of thought, and absence of knowledge, the first necessity is to find an idol before which to assume the favourite attitude that the French call flat-belly. Flat-belly the critics have been before his successes; faithfully flat-belly before his failures. Flat-belly before the ability of his paintings; equally and imperturbably flat-belly before his very nugatory life-sized heads in black-and-white. He tried to elude them. Turning, in a holiday mood, from his portrait clientèle, he exercised his great facility in some landscape sketches. In these his firm and certain mise-en-place served him well, but the absence of any delicate or interesting colour-sense became more obvious than it is in the portraits. Not a bit of use! He was at once hailed as the heaven-born landscape-painter. "Blinding light" is the consecrated phrase. Some painters are said to have "painted" a picture or "exhibited" a picture. Not so Mr. Sargent. He "vouchsafes" a picture, a word hitherto confined to the deity.

Directly it was discovered that he was the North Pole towards which the critical needles must all point, other societies determined that the Royal Academy should not keep him to themselves. I think I can even remember seeing a poster in the street issued by an exhibiting society worded: "Works by Mr. John Sargent and others." Whether a few other names were added I forget, but the gravamen of the poster was as I say. The New English Art Club, with the eye for the main chance that generally distinguishes the founders of a new religion, clung firmly to the skirts of the frock-coat from which virtue was understood to issue. Virtue was to some extent its own

reward. Visitors would hurry in, ask the secretary which were Mr. Sargent's pictures, and, having inspected them, go out again at once. The attitude of the Press was generally thus: "We know all about Impressionism, or whatever you like to call the beastly thing, that these people practise. It is an unpleasant and not very reputable thing, anyhow. But, of course, when Mr. Sargent condescends, in his moments of recreation, between the serious and respectable labours of painting proper expensive portraits, to dally with anything so trivial, it becomes supreme, etc."

This brief résumé reads like a farcical account, but anyone who has watched these things will acknowledge that it is a moderate and fair statement of the facts. It errs, if anything, on the side of understatement, as all accounts of a boom of snobisme must do. (For readers who have not been out of England it may be necessary to explain that "le snobisme" is not the French equivalent for the English word "snobbishness." "Le snobisme" does not carry with it any suggestion of social subservience, but means abject subjection to a name, or a supposed authority.)

The only person who has resolutely abstained from any complicity in the Sargent boom has been Mr. Sargent himself. If sense and modesty could disarm criticism, Mr. Sargent would be immune. But alas! nothing disarms me.

I need not labour the truth, with which I have already dealt, that the work of the modern fashionable portrait-painter has to be considered as, in a sense, a collaboration, a compromise between what the painter would like to do, and what his employer will put up with. Mr. Sargent, who has an acute sense of, and keen delight in, character, has no wish to compromise more than he need. But the ineluctable laws that rule the relations of employer and employed are there for him as for others. Where he has found himself before a

man of esprit—I have one specially in my mind, and his daughter—he has let himself go, and given of his best, with charming and piquant results. And in the degree to which he lets himself go, a shrewd spectator may measure the painter's estimate of his sitter's wit.

It is a pitiful thing, and one of the best proofs to the nullity of art-criticism in this country, that Sargent's painting is accepted, as it is, as the standard of art, the ne plus ultra and high-water mark of modernity. Let us try to arrive at a reasonable and just estimate, devoid alike of detraction and of hysterical abasement.

I have said that he has the supreme virtue in a portrait painter of an eye for character. He has a great gift for placing his shapes where he wishes, safely and firmly. The colour is quelconque, and the quality of execution is slippery, and has no beauty or distinction of its own. The paintings might be described as able black-and-white sketches on a large scale, in adequate colours. The problem of turning out satisfactory likenesses with a certain brilliant allure, and the little touch of piquant provocation that respectable women are always so anxious to secure, has seldom been solved by an abler hand or a juster eye. And really of the landscape sketches, which my critical colleagues believe to be epoch-making, not much more can be said. Some of the figures in these landscapes have a prettiness quite worthy to illustrate a feuilleton. Practice for a quarter of a century in portrait-painting, with the triple problem of likeness, rapidity, and the sitter's taste to solve is not likely—and even critics who are ignorant of art, might guess at the inherent improbability—is not likely to be the best preparation for the production of epoch-making landscape.

Let any of my readers go, without prejudice, straight from a Sargent landscape to the

Pissarro of the Louvre in the Grafton Gallery, and compare the weight of the two productions. Compare the degree of passion, of power, of observation, of delicacy. Enumerate the facts of structure contained in the one and the other. Notice the degree in which, in each, the various colours on the canvas are differentiated from the state in which they are supplied by the colourman. You won't find a painter who needs to be told this, Mr. Sargent least of all. But then, if I am right, I herewith convict almost the whole critical Press of this country for ten years either of elementary ignorance, or laziness and indifference, or of craven abjection to a social and commercial success.

I resent this attitude for two reasons. Because it means that for many years much patient merit must have been overlooked and slighted. This attitude has some of the effects of a panic. Gentle and charming people are hustled. It has some of the effect of the entrance into a private party, where many interesting and well-bred people are assembled, of an actress who is the vogue. I resent it because in this Academy, for instance, Mr. Fowler's picture (237) is not hung on the line, and has not been properly considered. Mr. Davis's landscape (17) is overlooked. Mr. Leslie, Mr. Stanhope Forbes, Mr. Hughes Stanton, and Mr. Alfred East are all somewhat brushed aside.

But I resent it most of all for myself. Gross and continued negligence in the critical world is just like negligence in the material world. Someone, who loathes the job, is at last compelled to get up and put things straight. To deal with the accumulated prostration that cumbers the ground of serious criticism, my lazy and ignorant critical colleagues have put me in the odious and tiresome position of appearing to attack an artist who has constantly given me real pleasure. I find myself forced to write grudgingly of a man whose great and rare qualities I cordially envy. I am, however, somewhat consoled by the fact that one little article, with only a week of life in it, is a very feeble dart to set against a decade of the heaviest artillery of unbroken adulation.

I would be glad if I could achieve one result. I have noticed that critics who have mostly no knowledge of art are rightly careful to read anything that painters write. To these I would make one general suggestion. Let them turn over a new leaf, and try this system in future. When they approach an exhibition, let them see what they can find to say of all the pictures signed by names of which they have never heard. Let them leave out, for a change, all mention of the well-known names—and mine among them.

From *The New Age,* May 19, 1910.

MEMORIES OF SARGENT

By A Friend

THERE are many who have written of Mr. Sargent as an artist—many who will continue to write of him in time to come. But of his personality, at once so genial and so dominant, so humorous and so austere, who can write as he painted—with such careful mastery, with an economy of statement that fastened, in a flash of deliberation, with swift certainty, upon the essential characteristics! How can one hold fast an impression that must fade; or retain the memory of lineaments stamped with his individual temperament, but which were, at the same time, so extraordinary and impenetrable a disguise!

The simplicity of his address, the complete absence of affectations of any description, the graciousness of his manner, could not blind the sensitive to the distinction that was his, almost in spite of himself. He wanted none of it. Not for a moment did he wish for or exact from his friends anything but the spontaneous cordialities and kindnesses of ordinary intercourse. Reticent himself, he cordially detested every form of publicity. Nothing irritated him more than any exaggeration of deference or respect. Flattery he cut short with impatience, with inward—sometimes with audible—groans. Even appreciation he faced "as one meets a cooling breeze, enjoyed but not detained." It is questionable even whether he enjoyed it; for he exercised his critical faculties upon his own works and, keeping his indulgence for others, never learned how to spare himself. He knew, none better, just when and where he had succeeded in capturing the fleeting grace, the imperceptibly delicate transition, the vital quality he sought for. He knew, also, beyond argument, where he had failed; and this certainty of judgment made him almost terrifyingly independent of comment, appreciative or the reverse.

Intellectual independence was perhaps the keynote of his mental attitude: he made his own discoveries, accepting nothing at second hand. That independence was the background for his reserve, a reserve inviolable to the most intimate of his friends. The most unqualified admiration, the deepest affection, which he so frequently inspired, as never without a compelling restraint, even a secret chastening sense of awe from which there was no escape.

On the last night of his life, an old friend, leaving after dinner, said half-laughingly to his sister, referring to her long acquaintance with the family: "Do you know, I am still a little terrified of your brother! This is not a case of perfect love casting out fear."

Yet how tinged with a kind of "deep-toned gayety" was his ordinary conversation! Mrs. Meynell once wrote of "the deep-toned gayety" of his Spanish paintings, and the phrase is singularly descriptive, both picturesque and just.

This habitual good temper—not free from flashes of impatience or nervous irritability in moments of strain or fatigue—was a kind of spiritual courage, the courage of the explorer, the mental adventurer, interested in every variety of the human problem. His keen enjoyment of a fine gesture was as characteristic as his zest for the bizarre, the original, anything odd, funny, or ridiculous in the spoken or written word. Humor played over his whole conception of life, in Carlyle's definition, "like sunlight on the deep sea."

His independence was not only mental. His enjoyment of life required so few of the ordinary creature-comforts. The simplicity of his habits and of his tastes, at once fastidious and austere, remained singularly free from any inclination toward luxury or magnificence, which he nevertheless painted with such delight, whether expressed in splendid architecture, or in interiors where fine proportions were accentuated by the surface beauty of lovely materials, over which his brush lingered. During one holiday before the war, while painting at the Carrara marble

quarries, he slept for weeks in a hut so completely devoid of all ordinary comforts that his companions, far younger men, fled after a few days, unable to stand the Spartan rigors tolerated by their senior with such serene indifference.

All his life he remained the student, absorbed in his work, steeping himself in it, attempting always some new development, some fresh experiment. During the last few months he had found extraordinary pleasure in sculpture, and small sculptured groups remain to show this tireless exploration of another field. One of the latest was an attempt to render in the mass the subject of his decoration for the Harvard war memorial: A dying soldier with Love wresting Victory from Death.

To his indefatigable energy, a holiday meant simply a change from the work of the moment to work of another description. The brilliant sparkle of his water colors conveys perfectly the relaxed tension of his holiday mood; yet even in these gay records how disciplined was the eye that chose a subject, how controlled the hand that held the dripping brush, dipped, it seemed, in dazzling light!

In former years, at the height of his popularity as a portrait-painter, it was not unusual for him to undertake three sittings a day. Involuntarily he measured the capacity for work of any student or fellow artist by the amplitude of his own insatiable appetite for it. He could never get enough.

Upon one occasion a discussion was going on in his presence about a painter who had failed to fulfill the extraordinary promise of his youth. Mr. Sargent was appealed to in the end for some explanation of that disappointing lapse in continuity. "Perhaps," he replied, after a moment's hesitation, "he finds his happiness in too many other things."

The absurdity that he ever deliberately sought for and accentuated the less pleasing qualities in his sitters could be refuted by innumerable canvases. Take just one instance, the very beautiful and dignified portrait of the late Mrs. Wertheimer, whose family, it was reported, were startled to discover the exquisite quality this intimate rendition so clearly revealed. Mr. Sargent himself dismissed this silliest of legends with dry unconcern: "I chronicle," he declared, "I do not judge."

Like many men of generous physical proportions, Mr. Sargent was instinctively kind. Charles Furse loved to relate how, when engaged on one of his decorations, at a distance of several hours from London, he wrote to his friend begging for a few lines of advice, confessing that he was "stuck," and enclosing, with a small diagram of the space to be covered, a careful analysis of his difficulties. On the following morning, before an answer could be expected, he was at the scaffolding, working hard, when a head appeared at the top of the ladder. Without an instant's hesitation, canceling all his other engagements, Mr. Sargent had taken an early train from London, so that there might be, for Charles Furse, to whom he was warmly attached, the smallest loss of time.

When Robert Brough was mortally injured in the terrible accident to the Scotch express, the news reached London late in the evening. A few friends met at a studio, in the early hours of the morning after, to discuss what could be done for him, whether one of their number should not go at once to Sheffield to stand by him, and to do what was possible. It was decided to consult John Sargent, and a deputation went at once to rouse him, even though it was only a little after seven o'clock in the morning. At the door in Tite Street they were met by his servant leaving the house with a sheaf of telegrams. "Mr. Sargent heard of Mr. Brough's accident last night," he said, "and took the six o'clock train for Sheffield this morning." The sight of his great friend was Robert Brough's last personal triumph, for he sank within an hour into the unconsciousness that prefaced the end.

Too much stress is laid upon Mr. Sargent's shyness, his capacity for silence. He was the most amusing of companions, the most entertaining of hosts. When he was interested in a subject under discussion he spoke freely, vehemently even, with great felicity of phrase, often with a witty and clear decisiveness.

At this moment it is difficult to remember the world's loss in the overwhelming personal loss. His whole life, as well as his work, bore silent testimony to the faith that was in him. He loved Plato's definition of Beauty as "the Splendor of the True." To that splendor he contributed, with the scrupulous yet generous spontaneity of his work, with the broad-mindedness, the indulgence, the toleration, and the sincerity of his character. He leaves, as an inheritance for the artists of all time, the unstained record of a noble and laborious life.

From *The Living Age*, May 30, 1925.

THE SARGENT I KNEW

By Mary Newbold Patterson Hale

Author's Note.—This aspect of John Singer Sargent to one of his cousins may, I hope, have some worth. Our mothers were first cousins; his mother was an only child, my mother had no married brothers and sisters, so that the Sargents and ourselves have no first cousins on our mother's side. In the years between 1916 and 1925, when Sargent frequented Boston, it was my happy chance to be constantly with him—in his daily life and work, in his studio, on the scaffolding of Library or Museum, with books and plays, friends and music. . . .

JOHN SINGER SARGENT was born at Florence, January 12, 1856, the second child of FitzWilliam and Mary Newbold Singer Sargent, childless for two years since the death of their first-born. Of the younger children only two sisters, of whom one married, lived to grow up and make the close knit devoted family of his later years.

Sargent's own contribution to the history of his schooldays was that his fondness for drawing in his schoolbooks made his teachers and parents despair of his learning what was printed in them. That what he drew was lively and true may be seen by the pencil drawings which his father enclosed in letters to the Sargent grandparents and the Newbold great-aunts and cousins. A score of these were exhibited in Boston a few months after his death, and all of the original drawings convey some idea or aspect important in the child's mind. The copies of birds, boats, and flowers are done with conscientious fi-

delity, and were probably taken from a book of which he writes to his grandmother Sargent, telling her (July 11, 1864) what good models he finds in it, and that he and his sisters have lessons in writing, arithmetic, and geography with his father.

He recognized beauty as beauty at an early age; indeed, no one who knew him could believe he had ever been unaware of it. He said his first distinct memory was of a porphyry cobblestone in the gutter of the Via Tornabuoni in Florence of a colour so lovely that he thought of it continually, and begged his nurse to take him to see it on their daily walks.

He must have been what our nurse called "a biddable child," for there floated down to the far end of his generation a long list of the things "your cousin John Sargent would never have done," coupled with a mythical belief that he arose at dawn and practised for hours on a piano which he probably built and assuredly tuned. He preferred porridge to all other food for his hard-earned breakfast, and his favourite pastimes were playing scales and brushing his teeth. His sisters, too, were rare and perfectional beings, although they never attained such heights as he did in our mythology.

The interchange of letters, fifty or sixty years ago, in our wide family circle was full and free, and Mrs. Sargent came of a tribe of punctilious and voluminous scribes. Letters and the not infrequent meetings when the Philadelphia cousins were in Italy and France made John, Emily, and Violet Sargent vivid and real to their unseen cousins in America. "Emily is a dear little girl," writes one of the cousins to my mother from Paris in the autumn of 1865. "The children have beautiful manners, and Johnny seems artistic." Why did we not hate these paragons?

It was in May, 1865, that John Sargent wrote to his grandmother Sargent that his father was expecting to go to America the following week, and that they would miss him very much "because he always does everything for us, and I do not know what we shall do without him."

Mrs. Sargent, herself a clever painter in water colours, used to go sketching with her son, she the teacher in those days, with a spirited decision and quick choice which were characteristic. She ruled that no matter how many sketches were begun each day *one* must be finished. "Sargent works with vehemence and accuracy," said John Briggs Potter, and this maternal dictum was told him in response. "That," said Mr. Potter, "was the beginning of it."

John Sargent's first languages were Italian and English, and he seems early to have known German, for he writes in 1864 that they are hoping their mother will find them a

German nurse, that they may not forget their German. His speech was accurate, having a delightful and easy correctness, free from any suspicion of pedantry. His vocabulary was large, and he rarely used a word from a language other than the one he was speaking. He was as clear verbally as he was mentally, and would describe intricate objects or compositions in a most understandable way.

A Musical Genius Spoiled

If, as Mark Twain says, a child's first duty is to choose his parents carefully, John Sargent discharged that duty faithfully, and began his years of student life in France with the fullest equipment in their power to give. At twenty he went to Paris to work in the studio of Carolus-Duran. His piano teacher solemnly protested against this decision, and warned Dr. and Mrs. Sargent that they were robbing the world of a great pianist.

His rapid rise to fame was not because of his great talent alone; he would have come less quickly to the front had it not been seconded by an indomitable habit of work, unceasing, unremitting, which resulted in a deftness almost magical, and a power of swift completion which gave his canvases the look of having burst into bloom all at one moment.

In the summer of 1876 Mrs. Sargent came to America with her son and elder daughter, their first visit to this side of the Atlantic, when Sargent declared and registered his American citizenship. His cousins remembered him that summer as much for his delightful music as for his continual sketching, and a passionate Italian love song, the words composed of the names of patent medicines. Music was his constant delight and he never lost his facility, although long ago he gave up all semblance of practising. He read music quickly and accurately, had a strong sense of rhythm, a first-rate musical memory, and a catholic taste down to Debussy. There he stopped, saying, "It is not music, it is massage."

Sargent enjoyed playing duets, always playing the bass, with the same concentration with which he read or painted or played chess, giving himself entirely to the present interest. He read widely in several languages, and had a clear memory of what he read, with a quick sense of the relation of one thing to another, and the development of thought and principles from one age to another. He was very fond of memoirs, and would read all the available ones of any period with a keen appetite; also a few romances, with a keen eye for the construction of the plot and the reality of the characters, and always travels and history.

He wrote his own letters, scouting the idea of a secretary, and his handwriting was very difficult to decipher. One day a lady brought

me a letter over which she had puzzled for three days. She could make out that it was something about her portrait, but that was all. It was a six-page letter giving the full details of the shipping of her portrait from London, name of the agent, and the steamer by which it was to be sent, dates, etc., and all a Rosetta stone to her! Every morning he attacked his letters, opening all in familiar handwritings, answered all he could, and shoved aside the remainder, which was sometimes forgotten, so that terrible accumulations gathered for a day of reckoning in spite of his honourable intentions. A single letter, or even a brace, was sure to be answered promptly, but a great mass of papers seemed to swamp him and render him helpless. All sorts of people wrote to him on all sorts of subjects, some of them probably autograph hunters, and many of these letters he would answer, until time and endurance were exhausted, when he would stop, for a long time, but not for ever.

Once a lady wrote begging him to sign the portrait he had painted of Abraham Lincoln, as she felt it would add greatly to the value of the picture, which she proposed bringing to Boston for his signature. Sargent wrote a civil reply, pointing out that as he was born in 1856 he had not begun to paint portraits professionally before the President was assassinated. He was very patient under such attacks, though his paraphrase of Meredith was a cry from the heart:—

"So hard it seems that one must read
Because another needs must write!"

Sargent's second visit to America was in the 'eighties. He was no longer the student of the 'seventies or the rising painter, but the risen. Carolus-Duran had chosen Sargent to paint his portrait, an honour which he followed by the compliment of becoming jealous as Sargent's fame grew. That portrait, and *El Jaleo*, had brought Sargent to the front, and were the prelude to years of portrait painting and the first part of the mural decorations in the Boston Public Library. Several visits to America were made in the 'eighties and 'nineties, and the first series of visits closed in 1903.

The child of the nursery myth and the fading letters was father to the man we knew. His ceaseless industry was rooted in the habits formed in childhood; his consideration for others, the outgrowth of the courteous daily life of a family whose father "does everything for all of us." The ready give and take of Sargent's talk was in part the echo of what he had heard in his early days, to which his own wit and love of the ludicrous added much. He was a remarkable mimic, and with all his wit, mimicry, and common sense never said unkind things. Meanness and unfairness he would denounce, but the ordinary unkind

and derogatory speech or comment was alien to him, kindly, courteous, helpful, truly interested in the work of any other painter, sculptor, or musician, always encouraging and giving time and thought to other people's tangles.

Much has been written and more has been said about the "psychology" in Sargent's portraits. His are the portraits of a painter whose hand accurately recorded what was before his eyes, fixing on the canvas for all time what was there in the flesh, which usually expresses what spirit, if any, is behind it. Ninety-nine men use their eyes so little that when the hundredth records a less incomplete vision, the ninety and nine rise up and accuse him of extra ocular powers, as if some inner eye had ranged a hidden field. Sargent painted the people he saw, and his amazing skill enabled him to put their exteriors on the canvas as he saw them, not as he divined or inferred their inner selves to be. He saw more and recorded more fully than other painters, just as he saw and noticed more things in a strange room than most people do.

Sargent was not always fortunate in his sitters, and it should be remembered that at the time that he was painting some uninspiring portraits, he was also giving us such canvases as Miss Elizabeth Chanler (Mrs. John Jay Chapman), the Hon. Laura Lister, Miss Beatrice Goelet, Lady Victoria Stanley, and Mr. and Mrs. Field—this last a presentation of enduring love, confidence, and protection which blinds one to its technical perfections. The beautiful relation of the couple is given to us by the same co-ordination of eye and hand that put upon canvas less charming and interesting people. It is a notable contradiction and a flight into the realm of the unlikely to suppose that one whose kindly use was not to speak in disparagement of others, should choose to paint the less lovely aspect of a sitter, leaving a belittling and enduring statement in paint. Sargent saw this or that; he knew what he saw and his hand painted it surely.

Painted Diaries

In the years between the two series of American visits Sargent's life was busy and full as ever. It was impossible for him to accept all the commissions that came to him, and he tried to withdraw completely from painting portraits, although he had to go on with many already promised to clear the ground for the future. Honours were heaped upon him; in the catalogue of The Memorial Exhibition is a list of thirty decorations and degrees bestowed upon him in America, Belgium, Germany, France, and England.

The work for the Boston Library was always on hand; holidays in Switzerland were filled with the outdoor painting begun in childhood, holidays when Miss Sargent and Mrs. Ormond and her children were with Sargent, as his many water colours show. Other travellers wrote their diaries; he painted his, and his sisters, his nieces and nephews, Miss Wedgewood, the Misses Barnard, Mr. and Mrs. de Glehn, Mr. Harrison are all on its pages. Palestine, the Dolomites, Corfu, Italy, Spain, Portugal, Turkey, Norway, Greece, Egypt, France, and the Balearic Islands are on record. Fortunately, museums and private collections are rich in oil and water colours of his many travels, for his industry and love of his work were equal, and the sum of it all would be astounding if we could ever come at it.

To see one of Sargent's water colours in the making always reminded me of the first chapter of Genesis, when the evening and the morning were the first day, order developed from chaos, and one thing after another was created of its kind. Having chosen his subject and settled himself with sunshade, hat, and paraphernalia all to his liking, he would make moan over the difficulty of the subject and say, "I can't do it," or "It's unpaintable," and finally, "Well, let's have a whack at it."

Perfect absorption would follow, and after what looked like a shorthand formula in pencil was on the block, the most risky and adventurous technique would come into play, great washes of colours would go on the paper with large brushes or sponges, and mutterings of "Demons! Demons!" or "The devil's own!" would be heard at intervals.

All the time the picture was growing surely, swiftly; he worked through to the end, only stopping when it was a subject where light and tide changed before he could get it all in, and two "goes" were necessary. Change of light Sargent could understand and condone, but change of tide affronted him. When he was painting the *Schooner Catherine* and got the row-boats where he wanted them in the foreground, he was most resentful when the tide changed their position. He kept us hauling the "bestial boats" into place, and was afraid that we could not get them back in place the second day, as of course we did.

Sargent's private life was simple; his house, 31, Tite Street, Chelsea, adjoining the flat next door which had been his first dwelling and studio in London, was filled with beautiful things which he enjoyed and lived with, but no habit or material thing had dominion over him, and all the comforts and conveniences of modern life were used as a means to free him from petty cares and distractions from his work. He usually lunched with his sister, Miss Emily Sargent, seeing her and Mrs. Ormond almost every day.

He was a much-sought guest and a charming one, as well as a delightful host. The stage was one of his interests, and here, too, he was catholic, enjoying all good acting from Duse to Dan Leno, the opera, Spanish and Russian dancing, tumblers, acrobats, music hall artistes, Charley Chaplin, and such films as the delightful "Thief of Bagdad."

This catholicity was possible to one of his sincerity; he detested sentimentality and airs, which he classified as "flip-flap"; but for true feeling he had a deep and sensitive respect. One phase of his sincerity was the open way in which he met people, and one often hears, "I met him only once, but I feel as if I really knew him."

Portraits of Sargent

There are few portraits of John Sargent; he disliked being drawn or painted or modelled. A long series of photographs begins with a little boy of perhaps seven, and closes a year before his death. St. Gaudens made a portrait medallion of him in 1889-90, he painted his own portrait twice—once for the Uffizi and again for the National Academy of Design. The most characteristic likeness is in Herkomer's group of Royal Academicians, hanging in the Tate Gallery. Mr. Raymond Crosby's delightful portrait drawing is Sargent himself, his head bent over book, music, or chess board. It shows the profile well remembered by all who played duets with him, and I especially prize it as my first recollection of him is playing duets when I was a very small child.

In 1916 Sargent came to America, after an absence of thirteen years, to instal the last portion of his decorations in the Boston Public Library. He was lame, for a big packing case had fallen on him in his studio as he was seeing the decorations off. A small bone in one foot had been broken and he had been in bed for a fortnight, delaying his journey.

He pitched into his work here at once, despite his temporary ailment, gathered up the threads of old friendships and made new ones, finished his Library work and accepted a commission to decorate the dome of the Boston Museum of Fine Arts, painted two portraits of Mr. Rockefeller and a portrait of President Wilson. He travelled to the Canadian Rockies in summer and Florida in winter, and Fenway Court, the Fogg Museum, and the Worcester Museum are the richer because of those journeys. "Rockerfellering" at Ormond was mitigated by the sea bathing, for Sargent was a strong swimmer and delighted in the exercise. Miami held him because of the beauties of Viscaya.

"It is very hard to leave this place," he wrote me. "There is so much to paint, not here, but at my host's brother's villa. It combines Venice and Frascati and Aranjuez, and all that one is likely never to see again. Hence this linger-longering."

In the spring of 1918 he returned to England at the worst phase of the submarine attacks. He had planned the changes in the dome of the Boston Art Museum to be finished in London.

Sargent detested the packing which these moves entailed and was bothered by the disposition of the hoards of possessions of one sort or other, which gathered about him as by atomic attraction. He lived at the Copley Plaza in Boston, and opposite his rooms on the Trinity Place side of the hotel was a large open space where the School of Technology had stood, scattered over with heaps of bricks and rubbish of the demolished buildings. This, Sargent was inspired to think, was the best place to deposit packages of old clothes or what not, so he tied up newspaper parcels and placed them amidst the rubbish, one or two at a time, under cover of night, looking out of the tail of his eye the next morning as he passed by to his studio to see if the packages were gone. The first deposit lingered a day or two, and he was beginning to despair, but on the third day it was gone! Thus encouraged he made daily contributions to the comfort of the great unknown and unwashed until all the things he did not want had passed from his possession.

At the Front in France

Two months he was in France, painting at the front for the British Government, and on his return to London finished his picture, *Gassed*, exhibited in the Royal Academy of 1919, and came to Boston that spring, staying until the autumn of 1920. He made numbers of black and white portrait drawings, "mugs," he called them, the only portraits he would make, although a second portrait of Lady Rocksavage, now Lady Cholmondeley, one of Sir Philip Sassoon, and the portrait of Dr. Lawrence Lowell, president of Harvard, are among the latest fortunate exceptions to his rule.

Several times Sargent went back and forth between London and Boston. Miss Sargent often came with him, and the spring of 1925 found them in London, preparing to sail together on Saturday, the 18th of April, for Boston.

The dome was long since finished, and the last decorations for the staircase leading to it were either safely in Boston or on the water. Two portraits, Lady Curzon and Mr. George Macmillan, had been sent to the Royal Academy, and on Tuesday, the 14th of April, Sargent made a portrait drawing of Princess Mary. His work was done.

The next day his packing was to begin, a really dreadful undertaking, for he did it himself with thought and care, doing and undoing, dreading and hating it, and enjoying his victories over the pure cussedness of inanimate objects. He dined with his sisters, who had gathered together some of their intimates for a farewell. He was in high spirits, "genial and wonderful," one of the guests wrote, "never in better form, and waved good night to us as he walked away from Emily's." A shower came on, and Mr. Nelson-Ward overtook him in a taxi and made him drive the short distance to Tite Street. "Au revoir in six months," said Sargent at his own door. His servants heard him moving about for a while; after a little the house fell quiet.

And then the end came, "on a midnight without pain," we may believe. In the morning he was found, sitting up on his pillows, the reading lamp still burning, an open volume of Voltaire fallen from his hand. Death had found him—conscious, active, ready; calmly he answered the summons and was gone from us for ever.

What is John Sargent's greatest legacy to those who come after him? His friends, left poor indeed by his going from the world he so enriched, might say it is the example of what one man may be to another, be he kith or kin, in the sureness of honour, loyalty, and kindliness which John Sargent had in so great a measure that his genius seemed the lesser part of him in comparison. The world inherits his paintings, full of colour and beauty, holding the rapture of sunshine and running water, the wonder and glow of youth, the calm authority and wisdom of riper years. Under this accomplishment lies the foundation of single-minded devotion to a definite end. Some of us still believe that the function of art is the perpetuation of beauty, and the work that Sargent has left us testifies to that faith. The servant of beauty, from the early days when the colour of the porphyry stone enthralled him, John Sargent worked to perpetuate beauty with all the might that was in him to the last day of his life, and bequeaths to the world his formula.

From *The World Today*, November 1927.

OF JOHN SARGENT

By W. Graham Robertson

IN 1894 I blossomed into a Notable Personage myself: it was a second-hand notability, a reflected aureole but distinctly noticeable. I dined out in it for a couple of seasons, and even now it sheds an occasional glimmer upon an otherwise unillumined name. More or less by accident, I became the subject of one of John Sargent's most famous pictures.

Sargent was still a young man (nobody was very old in the early 'nineties), and Tite Street, Chelsea, did not as yet show the unending procession on its way to his studio that thronged it in later days, but several distinguished clients had already passed that way and, as Oscar Wilde observed to me, "The street that on a wet and dreary morning has vouchsafed the vision of Lady Macbeth in full regalia magnificently seated in a four-wheeler can never again be as other streets: it must always be full of wonderful possibilities."

Sargent's fame was approaching its zenith, though sitters were still a little coy: his portraits were not always quite what the subjects expected—they could not feel comfortably certain of what they were going to get.

"It is positively dangerous to sit to Sargent. It's taking your face in your hands," said a timid aspirant; and many stood shivering on the brink waiting for more adventurous spirits to make the plunge.

This was Sargent's great period, when he was not so overtasked with commissions and was able to concentrate upon the work in hand.

I had long wanted a portrait of my mother and was lucky in persuading him to undertake it, though it was perhaps not a complete success. My mother was a bad sitter, she was shy and very loath, as she expressed it, to 'sit still and be stared at.'

Sargent could not reproduce her real self because during the sittings he never saw it, although afterwards they became good

friends. Still, the portrait was a fine piece of work and a brilliant superficial likeness.

I was often commandeered to attend the séances, as my mother required support and considered that the casual woman friend worried the artist, in which opinion she was not far wrong.

Ada Rehan was sitting to Sargent at the same time, a large portrait of her having been commissioned by an American adorer, one Mrs. Whiting of Whitingsville, Mass. I remember the imposing name, as it seemed to fascinate Sargent, who became haunted by it and would chant it rhythmically as a kind of litany the while he painted, the 'Mass.' in very deep tones coming as a final Amen, in which I reverently joined.

Miss Rehan was another shy and reluctant sitter and, between the two, the poor artist must have had uphill work. Each, I think, found a certain comfort in the other's discomfort; they were comrades in misfortune and even shared certain studio ''properties,'' Sargent borrowing from my mother her white feather fan for Ada to hold outspread while she glanced at the spectator over her shoulder.

The comic relief of the sittings was supplied by my dog, Mouton, who, well stricken in years and almost toothless, claimed rather unusual privileges and was always allowed one bite by Sargent, whom he unaccountably disliked, before work began.

''He has bitten me now,'' Sargent would remark mildly, ''so we can go ahead.''

Miss Rehan's sittings had been interrupted by a few final rehearsals of ''Twelfth Night'' before its production in London, but at last the evening arrived. I was ''in front'' with a friend, J.J. Shannon, then Sargent's most formidable rival among portrait painters, and had sent round a line to the Leading Lady asking to see her when all was over.

Almost from the start her Viola had enchanted the audience, but in the midst of her triumph, and success in a great Shakespearean rôle in Shakespeare's country meant very much to her, she found time to scribble a note and to send it to me.

Yes, come by all means. I have something particular to tell you about Sargent—something he said of you—you must hear it and, I hope, act upon it. Shall I tell you before your friend?—you must bring him. This evening is so nice—it has unnerved me a little.
Affectionately, ADA REHAN

I felt puzzled and intrigued. What could Sargent have said of me, Sargent who so very seldom said anything of anybody? It was quite exciting. We presented ourselves in due course and found Viola rather overwhelmed by her great ovation, but still eager to impart news.

''Well, he's very anxious to paint you.''
''Me?''
''Yes. He wants you to sit to him?''

''Wants *me*? But good gracious, why?''

''I don't know,'' said Ada, a little tactlessly. ''He says you are so paintable: that the lines of your long overcoat and—and the dog—and—I can't quite remember *what* he said, but he was tremendously enthusiastic.''

I did not wonder that Miss Rehan's memory had failed, but I was well able to supply the missing words. Sargent, I felt sure, had delivered himself thus—''You know—there's a certain sort of—er—er—that is to say a kind of —er—er—in fact a—er—er____'' and so on and so on. He had not the gift of tongues, but that mattered little; he was so well able to express himself otherwise.

No one had ever wanted to paint me before. Portions of me had been borrowed from time to time; hands pretty frequently by Albert Moore, hands again by Poynter, quite a good deal by Walter Crane for immortals of uncertain shape and sex, but I myself, proper (I use the word in its heraldic sense), had never been in request. Even now, as far as I could gather, the dog and the overcoat seemed to be regarded as my strong points; nevertheless, I felt very proud and—well, Sargent soon had three large canvases on hand instead of two.

Being but an amateur model, I was easily entrapped into a trying pose, turning as if to walk away, with a general twist of the whole body and all the weight on one foot. Professional models will always try to poise the weight equally on both feet and will go to any lengths of duplicity to gain this end.

I managed pretty well on the whole, but the sittings cleared up a point which had long puzzled me: why did models occasionally faint during a long pose without mentioning that they felt tired and wanted a rest? One day the answer came to me quite suddenly.

I had been standing for over an hour and saw no reason why I should not go on for another hour, when I became aware of what seemed a cold wind blowing in my face accompanied by a curious ''going'' at the knees.

I tried to ask for a rest, but found that my lips were frozen stiff and refused to move. Hundreds of years passed—I suppose about twenty seconds.

Sargent glanced at me.

''What a horrid light there is just now,'' he remarked. ''A sort of green____'' He looked more steadily. ''Why, it's *you*!'' he cried, and seizing me by the collar, rushed me into the street, where he propped me up against the door-post. It was a pity that Oscar Wilde opposite was not looking out of the window: the ''wonderful possibilities of Tite Street'' were yet unexhausted.

After the picture was well advanced it was laid by for a short time while the artist took a holiday in Paris, and when I started sittings again I found him much perturbed.

''I say,'' he began, ''did you ever see Whistler's portrait of Comte Robert de Montesquiou?''

''No,'' said I. ''They never would let me see it while it was being painted. Why?''

''Well, I'd never seen it either,'' said Sargent, ''until I came across it just now in the Champs de Mars. It's just like this! Everybody will say that I've copied it.''

My old friend Robert de Montesquiou had been sitting to Whistler while Sargent's portrait of me was in progress, but had shrouded the fact in all the romantic secrecy that his soul loved.

He was in England incognito (I cannot imagine why) and took much delight in gliding down unfrequented ways and adopting strange aliases; visiting me by stealth after dusk with an agreeable suggestion of dark lanterns and disguise cloaks, though, as he was almost unknown in London, he might have walked at noon down Piccadilly accompanied by a brass band without anyone being much the wiser.

Whistler, who also loved to play at secrets, was equally clandestine, I, dutifully acting under orders, dissembled energetically, and Montesquiou was so wrapped about in thick mystery that no intelligent acquaintance within the three miles radius could possibly have failed to notice him.

And now the mystic portrait was on view in Paris, and Sargent had found it just like mine and feared that critics would agree with him.

And in truth a few people did make the remark, though there was really but little resemblance. Both canvases showed a tall, thin figure in black against a dark background, but the likeness ceased there and, as a picture, the Sargent was by far the finer. The Whistler was not of his best—the blacks were black, not the lovely vaporous dimness of the ''Rosa Corder''; the portrait was quite worthy neither of the painter nor the model, for the delicate moulding of Robert de Montesquiou's features was hardly suggested; but Whistler was not then quite equal to the physical exertion of dealing with so large a canvas. He had started two portraits of Comte Robert, working upon them alternately, but as far as I know only one survived: it was the last large picture that he ever completed.

The Sargent, on the other hand, was of the artist's best period and he was painting something that he had ''seen'' pictorially and for some unknown reason had wished to perpetuate. Why a very thin boy (I then looked no more) in a very tight coat should have struck him as a subject worthy of treatment I never discovered, but he evidently had the finished picture in his mind from the first and started it almost exactly upon its final lines.

It was hot summer weather and I feebly rebelled against the thick overcoat.

"But the coat is the picture," said Sargent. "You must wear it."

"Then I can't wear anything else," I cried in despair, and with the sacrifice of most of my wardrobe I became thinner and thinner, much to the satisfaction of the artist, who used to pull and drag the unfortunate coat more and more closely round me until it might have been draping a lamp-post.

Even before the picture was finished its fame began to grow, and friends took to dropping in, anxious for a sight of it. Sargent's old friend, Henry James, whom I had known before very slightly, came several times and expressed high approbation.

The Henry James of those days was strangely unlike the remarkable-looking man of almost twenty years later, who was then himself painted by Sargent.

In the 'nineties he was in appearance almost remarkably unremarkable; his face might have been anybody's face; it was as though, when looking round for a face, he had been able to find nothing to his taste and had been obliged to put up with a ready-made "stock" article until something more suitable could be made to order expressly for him.

This special and only genuine Henry James's face was not "delivered" until he was a comparatively old man, so that for the greater part of his life he went about in disguise.

My mother, who was devoted to his works, used to be especially annoyed by this elusive personality.

"I always want so much to talk with him," she complained, "yet when I meet him I never can remember who he is."

Perhaps to make up for this indistinguishable presence he cultivated impressiveness of manner and great preciosity of speech.

He had a way of leaving a dinner-party early with an air of preoccupation that was very intriguing.

"He always does it," untruthfully exclaimed a deserted and slightly piqued hostess. "It is to convey the suggestion that he has an appointment with a Russian princess."

In later life both the impressive manner and fastidious speech became intensified: what he said was always interesting, but he took so long to say it that one felt a growing conviction that he was not for a moment, but for all time. With him it was a moral obligation to find the *mot juste*, and if it had got mislaid or was far to seek, the world had to stand still until it turned up.

Sometimes when it arrived it was delightfully unexpected. I remember in later years walking with him round my little Surrey garden and manoeuvering him to a spot where a

rather wonderful view suddenly revealed itself.

"My dear boy," exclaimed Henry James, grasping my arm. "How—er—how____" I waited breathless: the *mot juste* was on its way; at least I should hear the perfect and final summing up of my countryside's loveliness. "How—er—how____" still said Mr. James, until at long last the golden sentence sprang complete from his lips. "My dear boy, how awfully jolly!"

I also recall his telling of a tale about an American business man who had bought a large picture.

"And when he got it home," continued Mr. James, "he did not know what—er—what____"

"What to do with it," prompted some impatient and irreverent person.

Henry James silently rejected the suggestion. "He did not know what—er—what—well, in point of fact, the *hell* to do with it."

When, quite towards the end of his life, his new face was evolved, it was a very wonderful one and well worth waiting for. Sargent's painting of it is fine, but lacks a certain something.

"It is the sort of portrait one would paint of Henry James if one had sat opposite to him twice in a bus," said a disappointed admirer, and the statement, though untrue, had some grains of truth in it.

Yet this should not have been so. Sargent and Henry James were real friends, they understood each other perfectly and their points of view were in many ways identical.

Renegade Americans both, each did his best to love his country and failed far more signally than does the average Englishman: they were *plus Anglais que les Anglais* with an added fastidiousness, a mental remoteness that was not English.

Both were fond of society, though neither seemed altogether at one with it: Henry James, an artist in words, liked to talk and in order to talk there must be someone to talk to, but Sargent talked little and with an effort; why he "went everywhere" night after night often puzzled me.

I saw a good deal of Henry James at about this time, then we lost sight of each other for many years. When I next met him, almost unrecognisable in his new face, he seemed much aged and broken. His ever troublesome nerves had now made him more dependent upon companionship; some of the mystery and remoteness had disappeared.

His final nationalisation as an Englishman came as a surprise to many. His liaison with Britannia was then such an old story, both had completely lived down any scandal, and that he should wish at the eleventh hour to make an honest woman of her seemed almost unnecessary.

His portrait by Sargent, one of the few men who really knew him, should have supplied a clue to the true Henry James that no one else could have found: perhaps the artist intentionally withheld it.

Another friend who volunteered to "come and sit with me while I was being painted" (how painters of portraits have learned to dread that offer) was Sarah Bernhardt.

She wished to see what Sargent was "making of me" and proposed her chaperonage at an early stage of the portrait's evolution.

I had misgivings; I could not see Madame Sarah sitting quietly in a corner while I basked in the limelight.

"But it will bore you," I ventured.

"No," said Madame Sarah. "I want to see the picture and I'm coming. You must call for me and take me with you."

"But the sitting is early: you will never get up in time and you'll never be ready."

"I shall get up and I shall be ready. I am coming," said Sarah with finality; so of course she came.

If the sun had risen in the west that morning it would have surprised me less than the sight of Madame Sarah ready and waiting when I called for her at an early hour, waiting in a neat, business-like walking-dress with a small black hat. She might have been going to shop at Whitely's with a string bag.

Sargent, who disliked the flamboyant type of actress, was completely won over and surveyed the little dark figure with approbation.

"I never saw that she was beautiful before," he whispered to me. "Look at her now."

Sarah was leaning forward, getting a view of the picture in a little hanging mirror: she was poised, the tips of the fingers against the wall, the head thrown back, the delicate profile in relief against a black screen.

I believe that Sargent only narrowly escaped asking to paint her then and there, but that he did escape was perhaps fortunate. They were not sympathetic; Sargent as a painter of Facts was unrivalled, but Sarah Bernhardt was embodied Fantasy and was only well and truly seen through the golden mist of dreams. Dreams were not in Sargent's line.

The Ellen Terry portrait, imaginative and dramatic, was a splendid exception to this rule; here, I think, the magnificent pomp of colour had fired the artist's fancy, but in the head of Henry Irving, painted in the same year, he had again shown his limitations.

He had painted the great actor with the flame of his genius blown out and had shown that the marvellous face, had it belonged to someone else, might not have been marvellous at all.

Here was a face that might look drearily at us out of a ticket office or haughtily take our

order for fancy trouserings; it might bend over a ledger with a pen behind its ear or stare in listless apathy at small children in a Board School, but never could it blaze like a beacon or lower like a thundercloud, never could it have held crowds spellbound and swayed them with a glance. It was not Henry Irving, but the dreadful thing about it was that it *might* have been, and the sitter, probably recognising this, actively hated it.

He hid it away for some time, but one morning when it shyly peeped from the boot cupboard or crept from under the bed, he took a breakfast knife and_____ There is now no portrait of Irving by Sargent. . . .

His destruction of the Sargent portrait was of course regarded as a great crime, and it was perhaps as well that Sarah Bernhardt was not exposed to a like temptation.

I wonder whether, having us both before him in his studio, Sargent noticed that, all unlikely as it sounds, there was then a vague resemblance between Madame Sarah and myself.

She had apparently realised it before I did. I had paid a sudden visit to Paris without advising her of my advent and had, as usual, gone on my first evening to see her play. When I went round to her dressing-room after the fall of the curtain I found her expecting me.

"But I never told you that I was coming."

"No," said she, "but when I was on the stage one of the actors (he's new and does not know my friends) whispered to me, 'Your son is in the audience, Madame Sarah'; and when I said, 'But you have never seen Maurice,' he told me that he recognised him from his likeness to me. Now Maurice is not in the least like me, so I felt sure that it must be you."

"But I am not like you," I said, all incredulous.

"Look," said Sarah, and leading me to the mirror she put her face beside mine.

It could not be denied that there was a certain sort of something, as Sargent would have said, a blurred travesty of her clear-cut face; but, had I been Madame Sarah, I should not have mentioned it. That she should contrive to resemble the Mona Lisa of Leonardo and the Primavera of Botticelli and also to be rather like me was perhaps one of her most amazing feats.

My face acquired for me a spurious interest for some time after—which reminds me that while I was sitting to Sargent I made a joke.

I know it was a joke because several people laughed at it and it gained me quite a little reputation, but it must have been very subtle as I have never been able to grasp the point myself.

Sargent had asked me why I had not painted myself and I replied, "Because I am not my style." That was the joke.

Sargent didn't see it until three days afterwards, when he suddenly burst out laughing at a dinner at Sir George Lewis's. That was the birth of the joke *as* a joke. It had a great success; it went the round of the studios, it was translated into French by Mr. George Moore and the translation revised and re-edited by Walter Sickert. When the latter repeated it to me in its final form I almost saw it, but the illumination was only momentary.

I can't see that joke yet; in fact, I don't believe that it is a joke.

Sometimes Sargent would give studio parties at which the originals of the various portraits would perforce prowl suspiciously round each other, perforce paying tribute to rival charms, yet each comfortably confident that he (or perhaps in this case mostly she) was sole possessor of the elusive quality—the "certain sort of a something"—that drew out the greatest powers of the painter.

Once we were summoned to meet and admire Carmencita, the dancer, whose portrait had been one of the first of Sargent's sensational successes. This was to be an unusually large gathering and the artist was rather puzzled by questions of space: the dancer and her guitar players required about half the studio for their evolutions; there was not much room for an audience. Sargent was the kindliest of men; unless really roused, it was very difficult for him to say No: the invitation list presented a troublesome problem.

"I suppose I must ask So-and-So," said Sargent dismally.

"Why should you?" I demanded.

"Oh, well, you know—I suppose—I ought to."

"But do you want to?"

"No," said Sargent with unusual firmness.

"Then don't."

"All right," said Sargent bravely, as he scratched out the name. "I won't. I'm—I'm damned if I do."

Nevertheless, when I arrived at the party, the first person I met was So-and-So.

The scene in the dimly lit studio was a Sargent picture or an etching by Goya, the dancer, short-skirted and tinsel-decked, against a huge black screen, the *guitaristi*, black against black, their white shirts gleaming. And then Carmencita danced. She postured and paced, she ogled, she flashed her eyes and her teeth, she was industriously Spanish in the Parisian and American manner, she looked beautiful and tawdry, but she was not a great dancer—it was all a little disappointing. Then she retired, to reappear in a dress of dead white falling to her feet, with a

long, heavy train; she wore no jewels, only one dark red rose behind the ear. And she sang the wild, crooning "Paloma," and as she sang she circled with splendid arm movements, the feet hardly stirring, the white train sweeping and swinging round her. This was better—this was different. This was not Carmencita of the Halls, but the real dancer of Old Spain.

Then Sargent came to her whispering a request. She looked angry, then sullen, shaking her head violently. He persisted, and opening a great cupboard in the wall, held out to her a beautiful white shawl with long fringes.

She still hesitated, pouting, then snatched the shawl, threw it over her shoulders, flicking him in the face with the fringe with the impudent gesture of a gamin, and slowly crouched down upon a low stool, her face now grave, her hands in her lap. From the *guitaristi* behind her came a low thrumming, a mere murmur, and softly, under her breath, Carmencita began to sing.

Old folk songs she sang, mournful, haunting, with long cadences and strange intervals, and as she sang she clapped her hands, softly swaying to the rhythm. And her beauty changed, the tawdriness fell away, she became ageless and eternal like the still figures of Egyptian sculpture.

She was one with the "spinsters and the knitters in the sun" who crooned and swayed thus while the Moors were building the Alhambra, nay, perhaps when Nimrod was building Nineveh.

Sargent told me afterwards that she had held out long against the performance. It was low, she declared; the common people sang these songs at street corners—they were not for Carmencita of Broadway and the Boulevards; what would his fine ladies and gentlemen think of her if she thus forgot herself?

But those whispered lilts laid a spell upon her audience, and the name of Carmencita now brings me no vision of a pirouetting dancer, but memory of a quiet, shrouded figure with darkly dreaming eyes and hands rhythmically clapping.

I wonder that Sargent had not chosen to paint her thus rather than in her short-skirted finery; I suppose it was because he had already used the white satin and long train *motif* in one of his best early pictures, *El Jaleo.*

From *Life Was Worth Living*, copyright 1931, by W. Graham Robertson. Reprinted by permission of Hamish Hamilton, Ltd., London, and Harper & Row, Publishers, Inc., New York.

241

Chronology

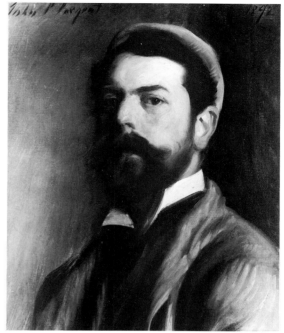

1856
January 12—John Singer Sargent born at the Casa Arretini in Florence. His father, FitzWilliam Sargent (1820–1889), graduated in medicine from the University of Pennsylvania. He pursued a successful medical career in Philadelphia until 1854, when he and his wife, Mary Newbold Singer Sargent (dies 1906), took up permanent residence in Europe. Mrs. Sargent was the daughter of a prosperous Philadelphia fur merchant.

1857
Sister Emily born (dies 1936).

1865
Sargents travel to Pau, Biarritz, London, and Paris. At Paris zoo, John makes drawings of animals.

1866–67
Winter—Sargent family lives in Nice. John and Emily become friends with Violet Paget, later known as Vernon Lee; they spend afternoons painting together.

1867–68
Winter—Sargents return to Nice. Lee recalls Sargent in this period as "already a painter."

1868
Studies with the German-American landscapist, Carl Welsch; also receives lessons in portraiture from the English artist Joseph Farquarson. Spring —family travels to Spain. Summer—family visits Switzerland.

1868–69
Winter—Sargent and Paget families live in Rome. Mrs. Sargent entertains artists of the city's American colony. John continues studies with Welsch.

1869
Summer—family visits the ruins of Pompeii; travels to Naples, Sorrento, Capri, Munich, and Carlsbad.

1870
Sister Violet born in Florence (dies 1955). Sargent enrolls in the Accademia delle Belle Arti, Florence. Summer—tours the Tyrol with Welsch.

1870–71
Winter—family lives in Dresden.

1872
Summer—Sargents visit Switzerland and the Tyrol.

1874
February—family lodged on the Grand Canal, Venice. Spring—Sargents go to Florence, then back to Venice, and on to Paris, where John enrolls at the atelier of Emile Carolus-Duran. Summer— family visits seashore at Benzeval, Brittany. Returns to Paris to prepare for entrance exams to life classes at the Ecole des Beaux-Arts. September 26– October 18—takes exams and passes. Meets the American artist J. Alden Weir. October 21— Carolus-Duran's classes begin. John's work routine includes a full day at Carolus's atelier, two hours at Adolphe Yvon's life classes at the Ecole des Beaux-Arts, then two more hours at the studio of Léon Bonnat. Colleagues include Carroll Beckwith, Will H. Low, R. A. M. Stevenson, and Robert Louis Stevenson.

1875
January—annual dinner for Carolus-Duran, after which he takes Sargent and two other students on a trip to Nice. June–September—Sargent joins family at St. Enogat, Brittany.

1876
April—visits Claude Monet exhibition at the Durand-Ruel gallery, Paris, possibly with Paul Helleu. May have met Monet. May 15—in order to retain American citizenship, visits the United States with Mrs. Sargent and Emily. September— family returns to Paris. Sargent continues studies at the atelier of Carolus-Duran. May have met Auguste Rodin and Monet during this period, as well as the painters Albert Besnard and Albert Belleroche.

1877
May—sends *Miss Fanny Watts* to the Paris Salon. Paints Carolus-Duran's portrait. Summer—visits Cancale, Brittany. August–September—takes walking tour of Switzerland with Beckwith, then joins the Sargent family at Bex, Switzerland. Fall— attends Carolus's atelier. Also works at a studio rented by Beckwith, 73b rue Notre Dame des Champs; eventually takes over payments for rent and heat. With Carroll Beckwith, assists Carolus-Duran on his decoration for the Palais du Luxembourg, *The Triumph of Maria de Medici*.

1878
May—*The Oyster Gatherers of Cancale* wins an honorable mention at the Paris Salon. Spends less time at Carolus's atelier, more at the rue Notre Dame des Champs studio. Meets Augustus Saint-Gaudens in Paris. Joins with him, Beckwith, and oth-

ers in founding the Society of American Artists, New York, in opposition to the National Academy of Design. Exhibits at the Society's first annual show. Summer—Beckwith in the United States; Sargent works alone in their Paris studio. Late summer–fall—visits Naples and Capri. Back in Paris, visits Carolus's atelier only intermittently.

1879
Version of *Capri* sold to an American collector. May—second version of the painting, plus *Carolus-Duran*, exhibited at the Salon. Exhibits for the first time at the National Academy of Design, New York. Continues to exhibit at the Society of American Artists. Begins to attend musical and literary salons in Paris. Paints *Edouard Pailleron*. Summer— executes portrait commissions for Kieffer and de Cévrieux families. August—travels to the Savoy estate of the Paillerons; paints several portraits of family members.

1879–80
Winter—travels to Spain and Morocco. Copies works by Velázquez in the Prado, Madrid.

1880
Travels to the Netherlands with Ralph Curtis and other artists. Copies works by Frans Hals. May— shows *Fumée d'Ambre Gris* and *Mme. Pailleron* at the Salon. Summer—visits family in Venice; sets up studio at the Palazzo Rezzonico, where he meets Giovanni Boldini and James Abbott McNeill Whistler. Fall—returns to Paris, works on portraits of Dr. Pozzi and the Pailleron children. Meets Henry James and Oscar Wilde during the early 1880s.

1881
May—wins a second-class medal at the Salon for *Mme. Subercaseaux*. Summer—visits England; sees his family off to the United States; executes portraits.

1882
May—exhibits *El Jaleo* and *Lady with a Rose (Charlotte Louise Burckhardt)* at the Salon; both paintings receive widespread attention in the press. Shows

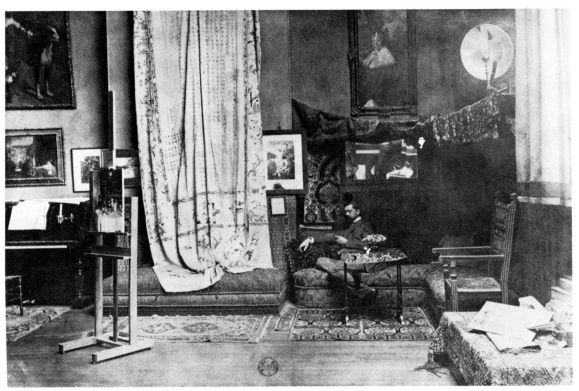

Sargent in his studio, 41 boulevard Berthier, Paris, 1885.

paintings of Venetian scenes at the Grosvenor Gallery, London; exhibits at the Royal Academy for the first time. August—visits the Curtis family, Palazzo Barbaro, Venice. Paints *Mrs. Daniel Sargent Curtis* and more Venetian scenes. Fall—travels to Florence, Siena, and Rome.

1883

February—visits Nice. Spring—persuades Virginie Avegno Gautreau to pose; begins *Mrs. Henry White*. May—exhibits *The Daughters of Edward D. Boit* at the Salon. Summer—visits the Gautreau estate in Brittany. July 14—returns to Paris; makes a short trip to the Netherlands with Paul Helleu and Albert Belleroche. Returns to the Gautreau estate. Berthe Morisot attempts to enlist his support for the Impressionist movement. October—travels to Italy, then returns to Paris with half-finished portrait of Mme. Gautreau.

1883–84

Winter—moves to a new studio, at 41 boulevard Berthier. Visits Florence and Rome; stops off at Nice to see his family. On friendly terms during this period with Edgar Degas, Auguste Renoir, Alfred Sisley, Camille Pissarro, and, particularly, Claude Monet.

1884

May—exhibits the Gautreau portrait (*Madame X*) at the Salon; scandal erupts. *Mrs. Henry White* on view at the Royal Academy, London. *Doctor Pozzi at Home* included in an exhibition of Les XX, Brussels. June—travels to London, then visits the Albert Vickers family in Sussex; paints *Mrs. Albert Vickers* and several informal studies. July—paints *The Misses Vickers*, daughters of Colonel Thomas Vickers, at Sheffield. November—paints Robert

Louis Stevenson's portrait, at Bournemouth. Returns to Paris after Christmas.

1885

Commissioned by his landlord, Paul Poirson, to paint a portrait of his daughter, Suzanne, and another of his wife. Paints a double portrait of Charlotte Louise Burckhardt and her mother. May—exhibits *The Misses Vickers* and *Mrs. Albert Vickers* at the Salon. Returns to London; takes a lease at 13 (later 33) Tite Street, Chelsea, Whistler's old studio. Meets Edwin Austin Abbey. Takes a trip with Abbey on the Thames, then settles in at Broadway, a village on the River Avon. Other artists and writers in the Broadway colony include Abbey, Francis Davis Millet, Edwin Blashfield, Alfred Parsons, Frederick Barnard, Edmund Gosse, and Henry James. Begins *Carnation, Lily, Lily, Rose*. Exhibits with Monet and other Impressionists at the Galerie Georges-Petit, Paris. October—travels from Broadway to Bournemouth to paint a portrait of Mr. and Mrs. Robert Louis Stevenson. November—returns to London.

1886

Spring—shows *Mrs. Albert Vickers, The Misses Vickers*, and *Mrs. Robert Harrison* at the Royal Academy; shows the portrait of Charlotte Louise and Mrs. Burckhardt at the Grosvenor Gallery, London, and at the Paris Salon. Decides not to exhibit again with the Impressionists at the Galerie Georges-Petit. Helps found the New English Art Club, London. Gives up his boulevard Berthier studio; Giovanni Boldini takes it over. Summer—visits family at Gossensass, Switzerland; returns to Broadway to finish *Carnation, Lily, Lily, Rose*. October—returns to London; executes portrait commissions.

1887

Receives letter from Henry G. Marquand requesting a portrait of his wife, to be painted at Newport, Rhode Island. Spring—exhibits *Carnation, Lily, Lily, Rose* and *Mrs. William Playfair* at the Royal Academy; exhibits *Robert Louis Stevenson and His Wife* at the New English Art Club. Summer—may have painted with Monet at Giverny, or in the summer of 1889. September 17—sails for the United States; paints numerous portraits in Newport, Boston, and New York. Meets the architect Stanford White.

1888

January—major exhibition of paintings held at St. Botolph's Club, Boston. May—returns to England to find his father ill; settles his family at Calcot, near Broadway, where he spends the summer.

1889

April 25—Dr. Sargent dies. Sargent shows *Miss Ellen Terry as Lady Macbeth* at the New Gallery, London. Paintings included in the American section of the Exposition Universelle, Paris; made a *chevalier* of the Légion d'Honneur. Sees Javanese dancers and La Carmencita at the exposition. Works with Monet to raise money for the purchase of Manet's *Olympia*, the painting to go to the Louvre and the funds to be donated to Manet's widow. Summer—spends part of August at Fladbury Rectory, near Broadway, with his family; visited by Paul Helleu and his wife. Fall—visits the Harrisons in Kent; returns to Broadway. December—sails with his sister Violet for the United States; begins a series of portrait commissions.

1890

Paints *La Carmencita* in New York. With Stanford White's help, receives commission for Boston Public Library murals. Paints *Mrs. Edward L. Davis and Her Son, Livingston*. Autumn—returns with Violet from America; meets Mrs. Sargent and Emily at Marseilles, then travels with his mother and sisters to the Middle East. Visits Egypt and Palestine.

1891

Visits Turkey and Greece. Exhibits *La Carmencita* at the Royal Academy. Summer—visits the Villa Ormond, San Remo, Italy; Violet marries Francis Ormond. Settles his mother and sister Emily at 10 Carlisle Mansions, Cheyne Walk, Chelsea, London. November—shares a studio with Abbey at Fairford, Gloucestershire, near Cambridge. Begins library murals; spends a portion of every year here until 1894, when the first section of the cycle, the north wall, is finished. Angelo Colarossi and Nicola D'Inverno become regular models. Elected associate of the National Academy of Design, New York.

1892

Works on murals; exhibits no new paintings in London.

1892–93

Winter—travels to Tunis.

1893

Exhibits *Lady Agnew* at the Royal Academy. Exhibits paintings at the Columbian Exposition, Chi-

cago, and at the Pennsylvania Academy of the Fine Arts.

1894

Elected associate of the Royal Academy; shows first section of the Boston murals at the Royal Academy exhibition. Awarded the Temple Gold Medal, Pennsylvania Academy of the Fine Arts. Paints *W. Graham Robertson*.

1895

January—attends opening night of Henry James's play, *Guy Domville*; outraged by the public's rejection. Exhibits *Coventry Patmore* at the Royal Academy. Travels to Boston for first stage of mural installation. May—visits George Vanderbilt's Biltmore, in Asheville, North Carolina. Edward Robinson raises a fund for the continuation of the mural cycle. Leases space at 12–14 Fulham Road in order to continue the project in London.

1897

January–February—travels to Sicily and Florence. Spring—exhibits *Mrs. Carl Meyer and Her Children* at the Royal Academy. Elected a full member of the Royal Academy and of the National Academy of Design. Begins the first of three years teaching at the Royal Academy School, London. Made an *officier* of the French Légion d'Honneur.

1898

Paints *Asher Wertheimer*, the first of a series of portraits of the Wertheimer family. Summer—travels to Northern Italy; studies early Christian mosaics at Ravenna.

1899

Major exhibition held at Copley Hall, Boston. His death erroneously reported in American newspapers; sends a telegram to Mrs. Gardner: "Alive and kicking, Sargent." Summer—stays with the Curtises at the Palazzo Barbaro, Venice.

1900

Exhibits *The Wyndham Sisters* at the Royal Academy.

1901

Expands Tite Street studio to include number 31. Exhibits the *Crucifixion* at the Royal Academy. Sends paintings to the Pan-American Exhibition, Buffalo, New York. December—serves as chairman of a dinner given in honor of the artist Philip Wilson Steer.

1902

Exhibits *The Acheson Sisters* at the Royal Academy. Summer—visits Norway and Spain.

1903

January—installs new panels in the Boston Public Library cycle. Paints a portrait of Theodore Roosevelt. May—sails for Spain. Exhibition of portraits held at the Museum of Fine Arts, Boston. Awarded an LL.D. by the University of Pennsylvania.

1904

William Merritt Chase shown at the St. Louis World's Fair. Spends the first of five consecutive summers at Purtud, in the Val d'Aosta, Italy; travels to Milan and Venice in the fall. Awarded a D.C.L. by Oxford University. Elected to the Royal Water-Colour Society.

1905

Exhibits at the inaugural exhibition of the Albright Art Gallery, Buffalo, New York. Fall—takes second trip to Palestine. Exhibits *Madame X, Nude Egyptian Girl*, and forty-eight other works at the Carfax Gallery, London.

1906

January 21—Mrs. Sargent dies. Summer—stays in Purtud, with trips to Siena, Rome, and Bologna.

1907

Paints *The Brook* at Purtud; takes trips to Rome and Florence. Offered an English knighthood; declines on the grounds of his American citizenship. Exhibits at the First Biennial Exhibition of Art, Corcoran Gallery, Washington, D.C.

1908

Summer and fall—visits Purtud and Majorca.

1909

Awarded the Order of Merit by France and the Order of Leopold by Belgium. Exhibits with Edward D. Boit in Boston.

1910

Summer—travels in Italy. Exhibits at the Royal Academy, Berlin, and the *Exhibition of American Art*, Munich.

1911

Summer—visits the Simplon Pass, Switzerland. Fall—visits Carrara, Italy.

1912

Summer—visits Ariès, the French Alps. Fall—travels in Spain. Exhibits at the inaugural exhibition of the Toledo Museum of Art, Ohio. Exhibits with Edward D. Boit in New York.

1913

Paints *Henry James*. Awarded an LL.D. by Harvard University.

1914

May—*Henry James* attacked by a suffragette. August—World War I begins. Sargent caught in the Austrian Tyrol with friends; unable to return to London until December. Husband of niece Rose-Marie killed in action.

1915

Exhibits thirteen paintings, including *Madame X*, at the Panama-Pacific International Exposition, San Francisco. Exhibits at the inaugural exhibition of the Minneapolis Institute of Arts.

1916

The Metropolitan Museum of Art purchases *Madame X* for one thousand pounds. May—visits Boston to install the last of Public Library murals; trustees invite him to decorate the rotunda of the Boston Museum of Fine Arts; sets up a studio at 22 Columbus Avenue, Boston. Summer—visits the Rocky Mountains of Montana and British Columbia. Awarded an LL.D. by Yale University and a Doctor of Arts by Harvard University. November—returns to London.

1917

Paints a portrait of President Woodrow Wilson for the benefit of the Red Cross. Visits Vizcaya, Ormond Beach, Florida. Exhibition of Sargent's and Winslow Homer's watercolors held at the Carnegie Institute, Pittsburgh.

1918

March 29—niece Rose-Marie killed in a German bombardment. Bas-reliefs installed in the rotunda of the Boston Museum of Fine Arts; returns to London. June—travels to France as an official war artist; stationed near the front lines. Joined by Henry Tonks in July. August—travels to Arras. September—makes sketches, near Pernne, for *Gassed*. Pressed to accept the presidency of the Royal Academy; successfully resists.

1919

Returns to Boston for further work on Museum of Fine Arts murals.

1920

Summer—returns to London; begins *Some General Officers of the Great War*. Exhibits at the Rhode Island School of Design, Providence.

1921

January—sails for New York; after a short stay, travels to Boston. October 20—decorations for the rotunda of the Boston Museum of Fine Arts unveiled; returns to London. November—trustees commission another set of murals to decorate the museum's stairwell.

1922

Remains in London until spring, when *Some General Officers of the Great War* is finished, then returns to Boston. Executes and installs murals for Widener Library, Harvard.

1923

Exhibits at the inaugural exhibition of the Baltimore Museum of Art, Maryland. Works on stairwell decorations, in Boston studio.

1924

February–March—major exhibition held at the Grand Central Art Galleries, New York; attends opening, then leaves America for the last time.

1925

Spring—completes murals for the Boston Museum of Fine Arts stairwell. April 4—dies of degenerative heart disease; buried at Woking, twenty miles from London. April 24—memorial services held at Westminster Abbey. July 24 and 27—studio contents put up for auction in London; sale includes works by Sargent and others. November 3—stairwell decorations unveiled at the Boston Museum of Fine Arts, where a memorial service is held.

1926

Memorial exhibitions held at the Metropolitan Museum, New York, and at the Royal Academy, London.

Bibliography

"The Academy.—II." *Spectator* 78, no. 3595 (May 22, 1897): 731–33.

Addison, Julia de Wolf. *The Boston Museum of Fine Arts*. Boston: L. C. Page and Company, 1924.

"American Members of the British Royal Academy." *Pearson's Magazine* 11, no. 64 (April 1901): 434–43.

Armstrong, Walter. "The Royal Academy." *Black & White* 1, no. 14 (May 9, 1891): 461.

"Art Chronicle." *Portfolio* 38 (May 1887): 104.

"Art Chronicle." *Portfolio* 38 (June 1887): 125.

"Art: Royal Academy." *Spectator* 56, no. 3018 (May 1, 1886): 580–81.

"Art: Royal Academy." *Spectator* 60, no. 3070 (April 30, 1887): 591.

Baignères, Arthur. "Première exposition de la Société des Peintres et Sculpteurs." *Gazette des beaux-arts* 26 (1883): 187–92.

Baker, C. H. Collins. *British Painting*. London: Medici Society, 1933.

Baldry, A. L. "The Art of J. S. Sargent, R.A.: Part I." *International Studio* 10, no. 37 (March 1900): 3–21.

———. "The Art of J. S. Sargent, R.A.: Part II." *International Studio* 10, no. 38 (April 1900): 107–19.

Banner, D. H. "John Singer Sargent." *Nineteenth Century and After* 99, no. 588 (March 1926): 298–312.

Baxter, Sylvester. "Sargent's 'Redemption' in the Boston Public Library." *Century* 66, no. 1 (May 1903): 129–34.

Bell, Clive. "Sargent." *New Republic* 42 (May 20, 1925): 340.

Bell, Quentin. "John Sargent and Roger Fry." *Burlington Magazine* 99, no. 656 (November 1957): 380–82.

Belleroche, Albert. "The Lithographs of Sargent." *Print Collector's Quarterly* 13, no. 1 (February 1926): 31–45.

Bird, Jon. "Representing the Great War." *Block*, no. 3 (1980), pp. 41–52.

Birnbaum, Martin. *John Singer Sargent: A Conversation Piece*. New York: William E. Rudge's Sons, 1941.

Blackall, C. H. "The Sargent Decorations in the Boston Museum of Fine Arts." *Architect* 108, no. 2795 (July 14, 1922): 27–30.

Blanche, Jacques-Emile. *Portraits of a Lifetime: The Late Victorian Era, the Edwardian Pageant: 1870–1914*. Translated and edited by Walter Clement. New York: Coward-McCann, 1938.

Blashfield, Edwin H. *Mural Painting in America*. New York: Charles Scribner's Sons, 1913.

———. "A Definition of Decorative Art." In *Brochure of the Mural Painters*, pp. 9–10. New York: Mural Painters, 1916.

———. "John Singer Sargent: Recollections." *North American Review* 221 (June 1925): 641–53.

———. "John Singer Sargent." In *Commemorative Tributes to Cable, Sargent, Pennell*, pp. 9–44. New York: American Academy of Arts and Letters, 1927.

Borglum, Gutzon. "John Singer Sargent—Artist: Greatest of American Portrait Painters." *Delineator* 102 (February 1923): 15.

Brinton, Christian. "Sargent and His Art." *Munsey's Magazine* 36, no. 3 (December 1906): 265–83.

Bryant, Lorinda Munson. *Americans and Their Painters*. New York and London: John Lane; Toronto: S. B. Gundy, 1917.

Burke, Doreen Bolger. "*Astarte*: Sargent's Study for *The Pagan Gods* Mural in the Boston Public Library." In *Fenway Court: Isabella Stewart Gardner Museum, 1976*, pp. 9–20. Boston: Trustees of the Isabella Stewart Gardner Museum, 1977.

Caffin, Charles A. "John S. Sargent: The Greatest Contemporary Portrait Painter." *World's Work* 7, no. 1 (November 1903): 4099–116.

———. *American Masters of Painting: Being Brief Appreciations of Some American Painters*. New York: Doubleday, Page and Company, 1906.

———. *The Story of American Painting: The Evolution of Painting from Colonial Times to the Present*. New York: Frederick A. Stokes Company, 1907; reissued, New York: Johnson Reprint Company, 1970.

———. "Drawings by John Sargent." *Metropolitan Magazine* 30, no. 4 (July 1909): 413–18.

———. *How to Study Pictures*. New York: Century Publishers, 1912.

———. "Comparison of Whistler and Sargent." *St. Nicolas* 32 (October 1925): 1094–98.

Carter, A. C. R. "The Royal Academy of 1899." *Art Journal* 61 (June 1899): 161–84.

Carter, Huntly. "Art." *New Age* 6, no. 16 (February 17, 1910): 378–79.

A Catalogue of the Memorial Exhibition of the Works of the Late John Singer Sargent, exhibition catalog. Boston: Museum of Fine Arts, 1925.

Champier, Victor. "The Salon from a Frenchman's Point of View." *Art Journal* 44 (September 1882): 271–75.

Chard, Cecil. "John S. Sargent, R.A.: The Work of a Great Portrait Painter." *Pall Mall Magazine* 39, no. 170 (June 1907): 643–51.

Charteris, Evan. *John Sargent*. New York: Charles Scribner's Sons, 1927; reissued, New York: Benjamin Blom Publishers, 1972.

Child, Theodore. "The Paris Salon." *Art Amateur* 19, no. 1 (June 1888): 1–2.

C.L.H. "Art: Portraits, Sunshine and Snow." *Academy* 62, no. 1566 (May 10, 1902): 488–89.

Coburn, Frederick W. "The Sargent Decorations in the Boston Public Library." *American Magazine of Art* 8, no. 4 (February 1917): 129–36.

———. "Sargent's War Epic." *American Magazine of Art* 14, no. 1 (January 1923): 3–6.

Coffin, William A. "Sargent and His Painting, with Special Reference to His Decorations in the Boston Public Library." *Century* 52, no. 2 (June 1896): 163–78.

Cortissoz, Royal. "John S. Sargent." *Scribner's Magazine* 34 (November 1903): 515–33.

———. *Art and Common Sense*. New York: Charles Scribner's Sons, 1913.

———. "Sargent, the Painter of Modern Tenseness—the Nature of His Art." *Scribner's Magazine* 75, no. 3 (March 1924): 345–52.

"Cost and Value of 'Sargents.'" *Literary Digest* 45 (December 7, 1912): 1065.

Cox, Kenyon. *Old Masters and New: Essays in Art Criticism*. New York: Fox, Duffield & Company, 1905; reissued, Freeport, N.Y.: Books for Libraries Press, 1969.

Craven, Thomas. *Modern Art: The Men, the Movements, the Meaning*. New York: Simon and Schuster, 1934.

"Current Art—I." *Magazine of Art* 10 (May 1887): 271–77.

"Current Art—IV." *Magazine of Art* 10 (August 1887): 376–84.

"Current Art: The New Gallery." *Magazine of Art* 12 (May 1889): 289–93.

Decorations of the Main Stairway and Library. John Singer Sargent. Boston: Museum of Fine Arts, 1925.

"Demurring at Sargent Prices." *Literary Digest* 86 (September 12, 1925): 27–28.

Denvir, Bernard. "Mostly Upstairs." *Art & Artists* 14, no. 3 (July 1979): 14–17.

Dezarrois, André. "Une exposition d'art americain: Winslow Homer, John Sargent, Paul Manship." *Revue de l'art* 49, no. 248 (July–August 1923): 142–55.

Dixon, Marion Hepworth. "Mr. John S. Sargent as a Portrait Painter." *Magazine of Art* 23 (January 1899): 112–19.

Downes, William Howe. *John S. Sargent: His Life and Work*. Boston: Little, Brown and Company, 1925.

D.S.M. "The Academy.—II. The Rape of Painting." *Saturday Review* 91, no. 2377 (May 18, 1901): 632–33.

Easton, Malcolm. "Friends and Enemies: Writers and Artists in England." *Apollo* 93 (February 1971): 84–89.

Ely, Catherine Beach. "Sargent as a Watercolorist." *Art in America* 11, no. 2 (February 1923): 97–102.

Epes Sargent of Gloucester and His Descendants, arranged by Emma Worcester Sargent. Boston and New York: Houghton Mifflin Company, 1923.

"The Exhibition at the Royal Academy." *Art Journal* 46 (August 1884): 240–47.

Fairbrother, Trevor J. "The Shock of John Singer Sargent's 'Madame Gautreau,'" *Arts Magazine* 55, no. 5 (January 1981): 90–97.

———. "A Private Album: John Singer Sargent's Drawings of Nude Male Models." *Arts Magazine* 56, no. 4 (December 1981): 70–79.

Fenollosa, Ernest F. *Mural Painting in the Boston Public Library*. Boston: Curtis and Company, 1896.

Field, R. "John Sargent's Boyhood Sketches." *St. Nicolas* 53 (June 1926): 774–77.

"Fine Arts." *Athenaeum* 87, no. 3059 (June 12, 1886): 784–86.

"Fine Arts: The Royal Academy." *Athenaeum* 83, no. 2956 (June 21, 1884): 798.

"Fine Arts: The Royal Academy." *Athenaeum* 87, no. 3059 (June 12, 1886): 786.

"Fine Arts: The Royal Academy." *Athenaeum* 89, no. 3105 (April 30, 1887): 580–83.

Fiske, Charles Henry. "The Story of American Painting VI: Modern Portrait Painting." *Chautauquan* 50, no. 1 (March 1908): 3–88.

"A Flier in Sargents." *Literary Digest* 86 (August 22, 1925): 24–25.

Flint, Ralph, and Clark, Walter C. *An Exhibition of Drawings by John Singer Sargent*, exhibition catalog. New York: Grand Central Art Galleries, 1928.

Fourcaud, Louis de. "Le Salon de 1884." *Gazette des beaux-arts* 29 (1884): 465–92.

Fry, Roger. "Wertheimer Portraits." *New Statesman* 50 (January 13, 1923): 429–30.

———. "J. S. Sargent as Seen at the Royal Academy Exhibition of His Works, 1926, and in the National Gallery." *Nation* (1926); reprinted in *Transformations*, pp. 169–82. Garden City, N.Y.: Doubleday Anchor Books, 1956.

———. "John S. Sargent: A Critical Estimate." *Vanity Fair* 29 (December 1927): 66, 110.

Fyfe, H. Hamilton. "Mr. Sargent at the Royal Academy." *Nineteenth Century and After* 49, no. 292 (June 1901): 1022–27.

Gerdts, William H. "The Square Format and Proto-Modernism in American Painting." *Arts Magazine* 50, no. 10 (June 1976): 70–75.

Greta. "Art in Boston." *Art Amateur* 18, no. 1 (December 1887): 3–4.

———. "Art in Boston: The Sargent Portrait Exhibition, etc." *Art Amateur* 18, no. 5 (April 1888): 110–11.

Gribbon, Deborah. "Mrs. Gardner's Modern Art." *Connoisseur* 198 (May 1978): 10–19.

Hadley, Rollin van N. *Drawings: Isabella Stewart Gardner Museum*. Boston: Trustees of the Isabella Stewart Gardner Museum, 1968.

Hale, Mary Newbold Patterson. "The Sargent I Knew." *World Today* 50, no. 6 (November 1927): 565–70.

Hardie, Martin. *J. S. Sargent, R.A., R.W.S.* London: The Studio; New York: William Edwin Rudge, 1930.

Harrison, Charles. *English Art and Modernism: 1900–1939.* London: Allen Lane Publishers; Bloomington: Indiana University Press, 1981.

Hartmann, Sadakichi. *A History of American Art.* Vol. 2 of 2. Boston: L. C. Page and Company, 1902.

Hind, C. Lewis. "John Sargent." *Fortnightly Review* 125, no. 711 (March 1, 1926): 401–12.

Hoopes, Donelson F. "John Singer Sargent and Decoration." *Antiques* 86, no. 5 (November 1964): 588–90.

———. "John S. Sargent: The Worcestershire Interlude, 1885–89." *Brooklyn Museum Annual* 7 (1965–66): 74–89.

———. *Sargent Watercolors.* New York: Watson-Guptill Publications, Metropolitan Museum of Art, Brooklyn Museum of Art, 1976.

Houssaye, Henri. "Le Salon de 1883." *Revue des deux mondes* 57 (June 1, 1883): 597–627.

———. "Le Salon de 1884." *Revue des deux mondes* 63 (June 1, 1884): 560–95.

H.S. "Art: The New Gallery." *Spectator* 78, no. 3592 (May 1, 1897): 625–26.

———. "The Academy.—I." *Spectator* 80, no. 3645 (May 7, 1898): 654–55.

———. "Art: The New Gallery." *Spectator* 82, no. 3696 (April 29, 1899): 610–11.

———. "Art: The Academy.—I." *Spectator* 82, no. 3697 (May 6, 1899): 641–42.

———. "Art. The New Gallery." *Spectator* 85, no. 3748 (April 28, 1900): 599–600.

———. "Art: The Academy.—I." *Spectator* 84, no. 3749 (May 5, 1900): 631–32.

Hurll, Estelle M. *Portraits and Portrait Painting.* Boston: L. C. Page and Company, 1907.

Hyde, H. Montgomery. *Henry James at Home.* New York: Farrar, Straus and Giroux, 1969.

Irwin, Grace. *Trail-Blazers of American Art.* New York: Harper and Brothers, 1930; reissued, Port Washington, N.Y., and London: Kennikat Press, 1971.

Jackson, M. Phipps. "The New Gallery." *Magazine of Art* 18 (June 1895): 285–88.

Jacomb-Hood, G. P. "John Sargent." *Cornhill Magazine* 59 (September 1925): 280–90.

James, Henry. "John S. Sargent." *Harper's Magazine* (October 1887). Reprinted with emendations as *Picture and Text.* New York: Harper and Brothers, 1903.

———. *The Letters of Henry James.* 2 vols. Edited by Percy Lubbock. New York: Charles Scribner's Sons, 1920.

———. *The Painter's Eye: Notes and Essays on the Pictorial Arts.* Edited by John L. Sweeney. London: Rupert Hart-Davis, 1956.

———. "The Pupil." In *The Portable Henry James.* Edited by Morton Dauwen Zabel. Revised by Lyall H. P. Powers, pp. 137–93. New York and Harmondsworth, England: Penguin Books, 1968.

———. *Henry James Letters: 1883–1895.* Vol. 3 of 3. Edited by Leon Edel. Cambridge: Harvard University Press, Belnap Press, 1980.

John Singer Sargent; His Own Work, exhibition catalog. New York: Coe Kerr Gallery and Wittenborn Art Books, 1980.

Karo, Rebecca W. "Ah Wilderness! Sargent in the Rockies, 1916." In *Fenway Court: Isabella Stewart Gardner Museum, 1976*, pp. 21–29. Boston: Trustees of the Isabella Stewart Gardner Museum, 1977.

La Farge, John. "Sargent the Artist." *Independent* 51 (April 27, 1899): 1140–42.

L[ane], J[ames] W. "Sargent; Brabazon." *Artnews* 40, no. 3 (March 15–31, 1941): 46.

L.M. "John Singer Sargent." *American Magazine of Art* 16, no. 6 (June 1925): 285–87.

Lomax, James, and Ormond, Richard. *John Singer Sargent and the Edwardian Age*, exhibition catalog. Leeds, England: Leeds Art Galleries; London: National Portrait Gallery; Detroit: Detroit Institute of Arts, 1979.

Lucas, E. V. *Edwin Austin Abbey, Royal Academician: The Record of His Life and Work.* 2 vols. London: Methuen and Company; New York: Charles Scribner's Sons, 1921.

Manson, J. B., and Meynell, Mrs. (Alice Christiana Thompson). *The Work of John S. Sargent, R.A.* 2 vols. London: William Heinemann; New York: Charles Scribner's Sons, 1927.

Mather, Frank Jewett, Jr. *Modern Painting.* Garden City, N.Y.: Garden City Publishing Company, 1927.

McKibbin, David. *Sargent's Boston, with an Essay & a Biographical Summary & a Complete Checklist of Sargent's Portraits*, exhibition catalog. Boston: Museum of Fine Arts, 1956.

———. "Sargent's Water-Colours of Venice at Fenway Court." In *Fenway Court: Isabella Stewart Gardner Museum, 1970*, pp. 19–25. Boston: Trustees of the Isabella Stewart Gardner Museum, 1971.

Mechlin, Leila. "The Sargent Exhibition: Grand Central Art Galleries, New York." *American Magazine of Art* 15, no. 4 (April 1924): 169–90.

"Memories of Sargent by a Friend." *Living Age* 325, no. 4221 (May 30, 1925): 445–48; reprinted from the London *Observer*, April 19, 1925.

Merson, Olivier. "Le Salon de 1882." *Le monde illustré* 50, no. 1313 (May 27, 1882): 330–31.

Meynell, Alice Christiana. *The Work of John Sargent, R.A.* London: William Heinemann; New York: Charles Scribner's Sons, 1903.

Michel, André. "Le Salon of 1884." *L'art* 37 (1884): 9–16.

Mills, Evan. "A Personal Sketch of Mr. Sargent." *World's Work* 7, no. 1 (November 1903): 4116–18.

Minchin, Hamilton. "Some Early Recollections of Sargent." *Contemporary Review* 127 (June 1925): 735–43.

Morris, Edward. "Edwin Austin Abbey and His American Circle in England." *Apollo* 104, n.s. 175 (September 1976): 220–21.

Mount, Charles Merrill. *John Singer Sargent: A Biography.* New York: W. W. Norton Company, 1955.

———. "New Discoveries Illumine Sargent's Paris Career." *Art Quarterly* 20, no. 3 (Autumn 1957): 304–16.

———. "Carolus-Duran and the Development of Sargent." *Art Quarterly* 26, no. 4 (Winter 1963): 385–417.

"The New English Art Club." *Art Journal* 49, n.s. 26 (May 1887): 158–59.

"The New Gallery." *Athenaeum* 97, no. 3315 (May 9, 1891): 609–12.

"The New Gallery." *Athenaeum* 109, no. 3630 (May 22, 1897): 686–87.

"The New Gallery." *Magazine of Art* 14 (May 1891): 259–63.

"The New Gallery." *Saturday Review* 75, no. 1959 (May 13, 1893): 510–11.

"The New Gallery: Second and Concluding Note." *Athenaeum* 93, no. 3213 (May 25, 1889): 668–70.

"The New Gallery. Second Notice." *Saturday Review* 75, no. 1963 (June 10, 1893): 627–28.

"The New Gallery Summer Exhibition, 1899." *Art Journal* 61 (June 1899): 185–88.

Ormond, Richard. "The Case of John Singer Sargent." In *The Saturday Book* 25, pp. 17–29. Boston and Toronto: Little, Brown and Company, 1965.

———. *John Singer Sargent: Paintings, Drawings, Watercolors.* New York and Evanston: Harper and Row, 1970.

———. "John Singer Sargent and Vernon Lee." *Colby Literary Quarterly*, series 9, no. 3 (September 1970), pp. 154–78.

———. "Sargent's El Jaleo." In *Fenway Court: Isabella Stewart Gardner Museum, 1970*, pp. 2–18. Boston: Trustees of the Isabella Stewart Gardner Museum, 1971.

"Our Foremost Portrait Painter." *Munsey's Magazine* 29, no. 5 (August 1903): 686, 687–89.

Paget, Violet (Vernon Lee). "Imagination in Modern Art: Random Notes on Whistler, Sargent and Besnard." *Fortnightly Review* 68 (n.s. 62), no. 370, (October 1, 1897): 513–21.

———. "J.S.S.: In Memoriam." In Charteris, Evan. *John Sargent.* New York: Charles Scribner's Sons, 1927; reissued, New York: Benjamin Blom Publishers, 1972.

Pennell, E. R., and Pennell, J. *The Whistler Journal.* Philadelphia: J. P. Lippincott Company, 1921.

———. *The Life of James McNeill Whistler.* Philadelphia: J. P. Lippincott Company, 1925.

Phillips, Claude. "Expositions de la Royal Academy et de la Grosvenor Gallery." *Gazette des beaux-arts* 30 (1884): 90–96.

———. "Fine Art: The Royal Academy." *Academy* 30, no. 993 (May 16, 1891): 471.

Porter, Fairfield. "Sargent: An American Problem." *Artnews* 54, no. 9 (January 1956): 28–31, 64.

Portland, John Arthur Charles James Cavendish

Bentinck, Sixth Duke of Portland. *Men, Women, and Things: Memories of the Duke of Portland, K.G., G.C.V.O.* London: Faber and Faber, 1937.

"Portraits at the Royal Academy." *Saturday Review* 77, no. 2016 (June 16, 1894): 639.

Pousette-Dart, Nathaniel. *John Singer Sargent*, with an introduction by Lee Woodward Zeigler. New York: Frederick A. Stokes Company, 1924.

Proust, Antonin. "Le Salon de 1882." *Gazette des beaux-arts* 25 (1882): 533–54.

Rensselaer, Mariana Griswold van. "Mr. Sargent's Portrait of La Carmencita." *Harper's Weekly* 34, no. 1747 (June 14, 1890): 457, 467.

———. "Another Portrait by Sargent." *Harper's Weekly* 35, no. 1826 (December 19, 1891): 1012.

———. "American Artist Series: John S. Sargent." *Century* 43, n.s. 21 (March 1892): 798.

———. "John Singer Sargent: 1856–1925." In *Memorial Exhibition of the Work of John Singer Sargent*, exhibition catalog. New York: Metropolitan Museum of Art, 1926.

Retrospective Exhibition of Important Works of John Singer Sargent, with excerpts from the writings of Charles H. Caffin, John C. Van Dyke, and Royal Cortissoz. New York: Grand Central Galleries, 1924.

Rewald, John. *The History of Impressionism*, rev. New York: Museum of Modern Art, 1961.

———. *Post-Impressionism: From Van Gogh to Gauguin*. New York: Museum of Modern Art, 1962.

Richardson, Edgar P. "Sophisticates and Innocents Abroad." *Artnews* 53, no. 2 (April 1954): 20–23, 61–62.

Rinder, Frank. "The Royal Academy of 1900." *Art Journal* 62 (June 1900): 161–83.

———. "The Royal Academy of 1901." *Art Journal* 63 (June 1901): 161–82.

Robertson, W. Graham. *Life Was Worth Living*. New York and London: Harper and Brothers, 1931.

———. "Whistler, Sargent and Others." *Harper's Magazine* 163 (October 1931): 550–62.

Ross, Robert. "The Wertheimer Sargents." *Art Journal* 73 (January 1911): 1–10.

"The Royal Academy. I." *Saturday Review* 75, no. 1958 (May 6, 1893): 487–88.

"The Royal Academy. III." *Saturday Review* 75, no. 1961 (May 27, 1893): 567–68.

"The Royal Academy." *Saturday Review* 77, no. 2011 (May 12, 1894): 493–94.

"The Royal Academy Exhibition." *Art Journal* 49, n.s. 26 (June 1887): 245–48.

"The Royal Academy Exhibition.—II." *Magazine of Art* 18 (June 1895): 281–85.

"The Royal Academy Exhibition." *Magazine of Art* 26 (June 1902): 356–60.

"The Royal Academy (First Notice)." *Athenaeum* 97, no. 3314 (May 2, 1891): 572–78.

"The Royal Academy: Fifth Notice." *Athenaeum* 109, no. 3635 (June 26, 1897): 846–48.

"The Salon from an Englishman's Point of View." *Art Journal* 44 (July 1882): 216–19.

"The Salon, Paris." *Athenaeum* 85, no. 3005 (May 30, 1885): 702.

"The Salon. II." *Academy* 25, no. 632 (June 14, 1884): 427.

"The Salon and Royal Academy." *Saturday Review* 79, no. 2063 (May 11, 1895): 616–18.

Sargent, John S. "Foreword." In *Exhibition of Paintings by Ignacio Zuloago*, p. 7, exhibition catalog, with an introduction by Christian Brinton. Boston: Copley Society; Brooklyn: Brooklyn Museum, 1916.

Sargent and Boldini, exhibition catalog. San Francisco: California Palace of the Legion of Honor, 1959.

The Sargent Exhibition: 1926. London: Walter Judd Publishers, by Authority of the Royal Academy, 1926.

"Sargent as a Painter of War." *Arts & Decoration* 11 (June 1919): 87.

"Sargent's Sculpture: The Crucifixion," *Vanity Fair* 7 (November 1916): 76.

Sharp, William. "The Paris Salon." *Art Journal* 46, n.s. 23 (June 1884): 179–80.

Sickert, Walter. "Encouragement for Art." *New Age* 4, no. 23 (April 7, 1910): 4–5.

———. "Sargentolatry." *New Age* 7, no. 3 (May 19, 1910): 56–57.

Sitwell, Edith. *Taken Care Of*. New York: Atheneum, 1965.

Sitwell, Osbert. *Left Hand, Right Hand!* Boston: Little, Brown and Company, 1945.

Smith, Preserved. "Sargent's New Mural Decorations." *Scribner's Magazine* 71, no. 3 (March 1922): 379–84.

"The Society of American Artists' Exhibition." *Critic* 29, no. 840 (March 26, 1898): 220–21.

Stevenson, R. A. M. "J. S. Sargent." *Art Journal* 50 (March 1888): 64–69.

———. "General Impressions of the Royal Academy of 1893." *Art Journal* 55 (August 1893): 240–44.

———. *Velazquez*. Revised and annotated by Theodore Crombie, with a biographical study of the author by Denys Sutton. London: G. Bell and Sons, 1962.

Stokes, Adrian. "John Singer Sargent, R.A., R.W.S." *Old Water-Colour Society's Club: 1925–1926* 3 (1926): 51–65.

Stokes, Isaac Newton Phelps. *Random Recollections of a Happy Life*, rev. ed. New York: privately printed, 1941.

Sturgis, Russell. "The Boston Public Library." *Architectural Record* 15 (May 1904): 422–30.

Sutton, Denys. "The Yankee Brio of John Singer Sargent." *Portfolio* 1 (October–November 1979): 46–53.

Sweet, Frederick A. *Sargent, Whistler and Mary Cassatt*, exhibition catalog. Chicago: Art Institute of Chicago, 1954.

Tharp, Louise Hall. *Saint-Gaudens and the Gilded Era*. Boston and Toronto: Little, Brown and Company, 1969.

Tintner, Adeline R. "Sargent in the Fiction of Henry James." *Apollo* 102 (August 1975): 128–32.

Troyen, Carol. *The Boston Tradition: American Paintings from the Museum of Fine Arts, Boston*, exhibition catalog. Boston: Museum of Fine Arts; New York: American Federation of Arts, 1980.

Underwood, Eric. *A Short History of English Painting*. London: Faber and Faber, 1933.

Van Dyke, John C. *American Painting and Its Tradition*. New York: Charles Scribner's Sons, 1919.

Watson, Forbes. "Sargent, Boston and Art." *Arts & Decoration* 7 (February 1917): 194–97.

———. "John Singer Sargent." *Arts Magazine* 7, no. 5 (May 1925): 243–46.

Weinberg, H. Barbara. "John Singer Sargent: Reputation Redivivus." *Arts Magazine* 54, no. 7 (March 1980): 104–9.

Weller, Allen S. "Expatriates' Return." *Art Digest* 28, no. 8 (January 15, 1954): 6–7, 24–25.

"What the Artists Think of Sargent's 'Beatrice.'" *Harper's Weekly* 34, no. 1794 (May 9, 1891): 346–47.

Wick, Peter Arms. *A Handbook to the Art and Architecture of the Boston Public Library*. Boston: Associates of the Boston Public Library, 1977.

Wilson, Richard Guy, et al. *The American Renaissance: 1876–1917*, exhibition catalog. Brooklyn: Brooklyn Museum, 1979.

Witt, Robert Clermont. *How to Look at Pictures*. London: George Bell and Sons, 1903.

"Young Men of New York." *Harper's Weekly* 35, no. 1809 (August 22, 1891): 649–52; no. 1810 (August 29, 1891): 662–63.

"The Younger Painters of America." *Century* 20, no. 1 (May 1880): 1–14.

Index

Acknowledgments

A critical appreciation of an artist's work must rely heavily on the scholarly efforts of historians and biographers. There are many to whom I owe a great deal. In particular, I would like to acknowledge Evan Charteris, Charles Merrill Mount, and Richard Ormond for the invaluable help provided by their numerous important contributions to the field of Sargent studies. In addition, I wish to express my gratitude to my editor at Abbeville Press, Nancy Grubb, whose patience and insight were essential to the completion of this essay. I would also like to thank Christopher Sweet for his help in assembling reproductions of Sargent's paintings and drawings, and Howard Morris for his strikingly handsome design of this book. C.R.

Photography Credits

All photographic material was obtained directly from the collection indicated in the caption, except for the following: Reprinted from *Art Quarterly* 26, no. 4 (Winter 1963): plates 51, 338; Christie's, New York: plate 285; Cliché des Musées Nationaux, Paris: plates 44, 60, 119, 151, 173, 174; Coe Kerr Gallery, Inc., New York: plates 5, 263; John Constantine (Hallam Design), Sheffield, England: plates 335, 336: Double Exposure, Gloucester, Massachusetts: plates 26, 27: D. Gulick/courtesy of *St. Louis Post Dispatch*: plate 10; Helga Photo Studio, Upper Montclair, New Jersey: plate 290; Christopher Hurst, Cambridge, England: plates 45, 54, 271; M. Knoedler & Co., Inc., New York: plate 108; Philadelphia Museum of Art: plate 64; David Preston, New York: plates 127, 172, 176, 287; Schopplein Studio, San Francisco: plate 131; Tom Scott Photographers, Edinburgh, Scotland: plate 239; Soprintendenza ai Beni Artistici e Storici di Firenze, Gabinetto Fotografico, Florence: plate 276; John Webb, Cheam, Surrey, England: plate 1.